PICTURE TITLES

PICTURE TITLES

How and Why Western Paintings
Acquired Their Names

Ruth Bernard Yeazell

PRINCETON UNIVERSITY PRESS
Princeton & Oxford

LIBRARY OF CONGRESS CATALOGING-IN-PUBLICATION DATA

YEAZELL, RUTH BERNARD.
Picture titles : how and why western paintings
acquired their names / Ruth Bernard Yeazell.
pages cm
Includes bibliographical references and index.
ISBN 978–0-691-16527–1 (hardcover : alk. paper) 1. Titles of works of art.
2. Painting. I. Title.
N7560.Y43 2015
702.8—dc23
2014035489

British Library Cataloging-in-Publication Data is available

This book has been composed in Adobe Caslon Pro

Printed on acid-free paper. ∞

Printed in Canada

1 3 5 7 9 10 8 6 4 2

The Title

—as in Gauguin's *The Loss of Virginity*—
how inessential it is to the composition:

the nude body, unattended save by a watchful
hound, forepaw against the naked breast,

there she lies on her back in an open field,
limbs quietly assembled—yet how by its

very unrelatedness it enhances the impact
and emotional dignity of the whole . . .

> —William Carlos Williams, *Pictures from Brueghel
> and Other Poems* (1962)

In art, the problems of language are never really settled: language always circles back on itself. Hence it is never naïve (despite the intimidations of culture, and above all, of specialist culture) to ask, in front of a canvas, *what it represents*. Meaning sticks to man: even when he wants to create non-meaning or extra-meaning, he ends by producing the very meaning of non-meaning or of extra-meaning. . . .

Twombly faces the problem squarely, if only in this: that most of his canvases are titled.

> —Roland Barthes, "The Wisdom of Art" (1979),
> trans. Richard Howard

CONTENTS

ILLUSTRATIONS

Color Plates (following page 80)

Figures

PICTURE TITLES

PROLOGUE (THIS IS NOT A TITLE)

Ceci n'est pas une pipe: "This is not a pipe." Perhaps few words more readily summon up a painted image than does René Magritte's paradoxical commentary on the nature of representation. Both the pipe and its legend have become familiar icons of modern culture, appearing on everything from T-shirts and perfume bottles to the cover of an influential book by Michel Foucault. Yet the picture that so many people think they know does not, strictly speaking, exist. Though Foucault evidently titled his own work after the object that inspired it, there is in fact no painting called *Ceci n'est pas une pipe*. The photograph that Foucault reproduces with that caption does closely resemble Magritte's first painting of the subject, but according to the catalogue raisonné of the artist's work, that painting was completed in 1929 (not 1926, as Foucault has it) and was named by its creator *La trahison des images*: "The Treachery of Images" (fig. P-1).[1] The five volumes of the catalogue record many versions of this treacherous image—in this, as in so much else, Magritte was happy to repeat himself—but none of them bears the title with which it is routinely associated.[2]

I say that none of them "bears" the title in question because that is a common idiom for the relation of a painting to the words that identify it. But the question of where, if anywhere, we should expect to find such a title is by no means a settled one. Though modern publishers typically place a title below the picture it identifies (as Foucault's do with Magritte's painting) and museums often place a label somewhere on the wall adjacent to the painting itself, both of these practices are subject to considerable variation; and the latter in particular, as we shall see, is of quite recent date. (It was still rare, for example, when Magritte first produced his famous image.) To adopt a useful term from Anne Ferry's study of poetic titles in English, paintings lack a "title space": a fixed location where the viewer of a picture can expect to find the words that name it.[3] More immediately to the point, the titles of most easel

I

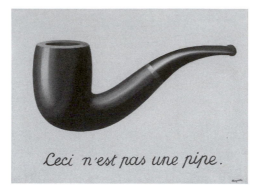

P-1. René Magritte, *La trahison des images* (1929). © 2014 C. Herscovici/Artists Rights Society (ARS), New York. Oil on canvas. Los Angeles County Museum of Art. Digital Image © Museum Associates/LACMA. Licensed by Art Resource, NY.

paintings—the original version of *La trahison des images* included—are not physically part of the work they name. Though Ferry makes clear that the convention of placing a title above a poem has a history of its own, that convention was pretty much stabilized by the culture of print in the late seventeenth century; and the fact that both poem and title inhabit the same medium obviously strengthens the connection. Even when an artist has painted a title directly on the canvas, reading the words remains different from looking at the image.

That Magritte did inscribe the words "Ceci n'est pas une pipe" in large characters across his painting no doubt explains why so many people misidentify it. Those who make the error might find further justification in the fact that the first reference to the authorized title did not appear until a letter from the artist of 1935—six years after the work itself was completed. Though in most cases Magritte followed the practice of writing a title on the back of a canvas, the catalogue raisonné records no such inscription for the original version of *La trahison des images*. As early as January of 1929 the artist had published a small drawing of the idea in a French journal, but this consisted simply of a pipe (facing the other way) with the words "Ceci n'est pas une pipe" written below; and when Salvador Dalí described the finished work for a Barcelona newspaper later that spring, he also invoked only the pipe and its apparently self-negating legend. Not until Magritte dispatched a second version of the image for a New York show—this one with the legend painted in English and the title written in French on the back—did the artist apparently refer to the earlier painting, too, as *La trahison des images*.[4] Whether he had always thought of it by that name is not clear. By the time

that the second version appeared in New York, it would hardly be surprising if some people assumed there was already a picture called *Ceci n'est pas une pipe*.[5]

Does it really matter what we call Magritte's famous painting? This book will contend that titles always make a difference, but some titles clearly make more of a difference than others. Indeed, the very fact that Magritte includes some words in his painting—not to mention the force of the proposition they articulate—makes *La trahison des images* a special case for the problem examined here, if not perhaps for the history of image making more generally. For it is above all when individual pictures appear to float free of words that the question of what to call them becomes most salient. W.J.T. Mitchell has argued persuasively that no image can ever be wholly independent of verbal context; and this book takes for granted that he is right.[6] But an image that comes physically embedded in such a context—an illumination in a medieval manuscript, say, or an illustration in a nineteenth-century novel—may not even require a separate name; and any name that does identify it will have less effect than it would if that same image were extracted from its context and circulated independently. The case of pictures that include words is less obvious; but all things being equal, they too will depend less on their titles than will those from which all verbal characters have been excluded. (I except for the moment the artist's signature.) Sometimes, of course, the words within the picture *are* its title—whether because we know that the artist intended them as such, or because no tradition of a separate title exists.[7] This book will conclude with a series of works by Magritte's American successor, Jasper Johns, that deliberately exploit such a possibility by making their own titles integral to the painting. Had Magritte's letter of 1935 been lost, the canvas that currently hangs in the Los Angeles County Museum might well be labeled *Ceci n'est pas une pipe*.

As an artist who combined words and images, Magritte long appeared an exception to the standard account by which modern art had progressively emancipated itself from language. Both practice and theory have increasingly challenged that historical trajectory, as the development of so-called conceptual art and the experiments of groups like Art & Language have helped to undermine a narrative whose end point was the "will to silence" of mid-twentieth-century abstraction.[8] Beginning with Tom Wolfe's broad satire on modern art in *The Painted Word* (1975), commentators have also noted that even that purported silence was inevitably belied by the theorizing that accompanied it, as the words ostensibly banished from the image itself returned with a vengeance in the writing it generated.[9] "However abstract the work of art," Philip Fisher has observed, "it is seldom free of the splash of modern

explanation which is, in effect, a very long title that the work carries with it, a title known to some and not to others."[10] This aptly summarizes one important way in which images are still dependent on a verbal culture.

Yet the difference between such coterie knowledge and the picture's actual title is instructive. Unlike the extended account that the work figuratively "carries" only to those already in the know, the title's shorthand typically does travel with the picture—at least under modern conditions of reproduction and display—and it is ordinarily available to any viewer. Historically speaking, in fact, the need for titles first became pressing when large numbers of paintings began to circulate, and when local knowledge of one sort or another could no longer be taken for granted among the increasingly heterogeneous public who came to view them. For such a public—which at one time or another includes all of us—the title of a painting often provides the first and even the only language by which the image will be construed. "Everyone who has visited a museum or a gallery will know the curious sensation of moving on from one painting to the next and almost before taking in the new image at all, of finding the eyes suddenly plunging down to the tiny rectangle of lettering below or beside it," Norman Bryson has written.[11] In this sense, as I shall argue, the history of the title belongs to the democratizing of art—even, or especially, when painters resist the legibility it threatens.

But just what counts as a title? In the last decades of the twentieth century, a few philosophers and other writers tried to wrestle with the problem, mostly by generalizing across the arts.[12] Though their answers vary, the usual impulse is to bring some order to the investigation by ruling certain possibilities out of court. Thus an editor of the *Journal of Aesthetics and Art Criticism* contends that the "unique purpose of titling is hermeneutical" and chooses to view as "legitimate" only those titles that "refer to exhibited features" of the work—a definition that rules out those that just name the place where a work originated, like Mozart's *Prague* symphony, or those that merely identify it in sequence, like Jackson Pollock's *Number 1A, 1948*. According to this formula, a title "relates to the work itself—rather than to the circumstances of its creation . . . or to the circumstances of its display or performance." Titling, the author sensibly observes, "permits discourse about artworks," but since he limits such discourse to interpretation only, neither words identifying a medium ("watercolor") nor those merely naming a genre ("sonata, ode") make the cut.[13] Nothing is said of "landscape" or "still life," but presumably these, too, should not be regarded as titles.

Others want to draw the line not at reference but at authorship. For those who argue in this vein, only artists are entitled to title their work—the etymological connection is part of the argument—and any title thus bestowed is

both "integral" to the work in question and a reliable guide to its meaning. There are titles and titles, in other words, but we should confine our talk to what one philosopher calls "*true* titles—those given by the *artist* at roughly the time of creation or constitution of the work" (emphases in the original).[14] Such a stipulation certainly clears a lot of ground, and it has the obvious appeal of keeping the focus on the documented intentions of a work's creator. It might indeed prove useful, if by no means unproblematic, for distinguishing among literary titles since the age of print. But like other rules that betray an unconscious bias toward literature—the claim that titles appear "at the commencement of an artwork," for example[15]—this identification of artists and authors is misleading. In the case of painting, I would contend, the purity of such theorizing is achieved only by sweeping aside the complications of history—both the often tangled history by which most paintings that hang in our museums actually acquired their titles and the history that still attends the baptizing of many a modern canvas. At least since the eighteenth century, when the circulation of individual pictures to an increasingly wide and diverse public first made the need for titles salient, there have indeed been cases that would pass the test; and this book will examine some of them. But the "true" title of a painting, as we shall see, remains as often as not a phantom.

What should we call *La trahison des images*, for that matter, if the artist's first use of that title was not recorded until six years after he began to paint such images? Though the problem posed by this particular painting may seem anomalous—few pictures, after all, are inscribed with a memorable competing tag like "Ceci n'est pas une pipe"—neither the difficulty of determining exactly when Magritte decided to name his picture nor the persistence with which others choose to rename it is exceptional in the history of Western painting. Indeed, for much of that history paintings didn't have titles in a modern sense; and when the conditions of display and marketing began to require them, they were often composed by persons other than the artist, after the fact. Even when painters themselves more routinely took over the practice, titling remained as much a function of responding to pictures as of creating them, and everyone from dealers and publishers to critics and ordinary viewers got into the act. Sometimes artists openly invited their friends to look at a painting and help decide what to call it—a game that Magritte and his fellow surrealists liked to play, though there is no evidence that they did so for *La trahison des images*.[16] Nor have such games ended with the digital age, as anyone who has been tempted by Google's invitation to help label the images that circulate on the Web can testify. While there are clearly exceptions to the rule, the baptism of a painting is apt to be a messy affair: post hoc (sometimes *very* post hoc), informally negotiated with the artist's public,

and even repeatedly renegotiated as the image itself travels from one context to another. Any theory of picture titles, in other words, will always find itself entangled in a history of reception.

Like paintings, literary works didn't always have titles, and the titles they did possess didn't always originate with their creators. Before the seventeenth century, as Anne Ferry has shown, the short poem in English typically acquired its title not from the poet but from the person who presented it to the reader. Both in the manuscript tradition and in the early culture of print, the act of titling was customarily reserved for those I would term middlemen: in Ferry's taxonomy, such a person "might be copyist, editor or commentator, translator, printer, publisher, or bookseller."[17] Ferry credits Ben Jonson with being the first poet in English to take the titling of his poems seriously, though authors of longer works had surely been composing titles well before the age of print. (It was Dante who called his long poem the *Commedia* [c. 1314–21], even if the adjective *Divina* is a later addition that first appeared on a printer's title page in the mid-sixteenth century.) Throughout the first half of the seventeenth century, Ferry suggests, poets could exploit the remaining uncertainty as to the status of their titles by creating "the fiction that someone else was responsible for presenting their verse"—a fiction that continued to influence the grammatical form of many a title long after the question of authorship was more or less settled.[18]

Ferry's observations as to how poets' titles often follow the conventions originally adopted by middlemen (referring to the speaker of the poem in the third person, for example) have significant resonance for the practice of picture titling, as we shall see. But for now it is the difference between picture titles and the literary kind that I want to emphasize. The most obvious, of course, is the difference in medium. While Ferry doesn't say so explicitly, our working assumption that the poem and its title have the same author is surely facilitated by the facts that both are made of words and that they customarily appear as contiguous marks on the same sheet of paper. In the case of longer works, the title may seem somewhat more divided from the text itself by the presence of the title page, but the very standardization of print that produced such a page in the first place partly overrides that distinction:[19] by concealing any signs that title and text might be the products of different hands, print encourages us to approach them as the continuous creation of a single mind. Many books probably have owed their titles more to their publishers than to their authors, but the appearance of the final product has made this division of labor relatively easy to ignore.[20] The development of the printing press also meant that both work and title could be multiplied indefinitely, and that they could circulate together with relative ease. With the partial exception of the reproductive print—an object that is not of course the painting itself but its

6

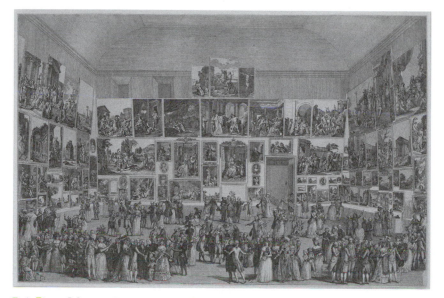

P-2. Pietro Martini, *Exposition au Salon du Louvre en 1787*. Engraving. © Trustees of the British Museum, London.

translation into another medium—and those special cases where the title of the picture appears to be inscribed on the canvas by the hand that created it, none of this holds true for painting. And even when a picture and its title are physically united in the same object, the difference in medium still demands different kinds of reading.

For much of its history, in fact, the individual oil or watercolor was unlikely to be displayed in close proximity to its title. Contemporary museums have accustomed us to look for the label on the wall immediately adjacent to the painting, but such exhibition styles are of quite recent vintage. Throughout the eighteenth and nineteenth centuries, the pictures on display in public galleries and other venues were typically hung frame-to-frame, with no room for commentary of any sort on the walls themselves: to identify the image verbally, one consulted a catalogue. (Figure P-2 depicts the Paris Salon in 1787, and figure P-3 shows the exhibit of the same year at the Royal Academy in London.)[21] Although aesthetic pioneers like James McNeill Whistler and the owners of the Grosvenor Gallery in London began to pare down this crowded hanging style in the 1870s, the practice lasted well into the first decades of the twentieth century: even the famous show of avant-garde paintings at the New York Armory in 1913 was hung accordingly. Not until the Museum of Modern Art in the same city helped to establish more spacious hangings as the norm did the custom of providing wall labels become stan-

7

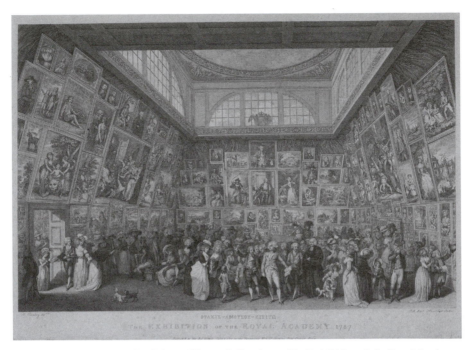

P-3. Pietro Martini after Johann Heinrich Ramberg, *The Exhibition of the Royal Academy, 1787*. Engraving and etching. © Trustees of the British Museum, London.

dard, though some exhibits, including the 1929 opening at MoMA itself, continued to reserve titles and other verbal information for the catalogue.[22]

Unlike literary titles, in other words, picture titles long appeared at a certain remove from the works they named—a remove at once physical, as in the gap between painting and catalogue, and often temporal too, as in the countless works that did not acquire the titles by which they were sold or displayed until years and even centuries after they were painted. By the end of the eighteenth century, artists were expected to accompany their submissions to the Paris Salon or the Royal Academy with some identifying language for the catalogue, but the young woman who consults her copy in the doorway of figure P-3 might well be forgiven for thinking of such language as more like a brief interpretation of the painting than a part of the work itself.

At the same time, such an interpretation was likely to shape her experience of the image in a way that few literary titles could match. We have learned to be skeptical of Gottfried Lessing's famous distinction between the temporal and the spatial arts, but precisely because the temporal sequence by which we view a painting is not conventionally structured—because the

words that name it do not come at its "commencement"—the title of a painting retains a greater power to shape our experience of the whole.[23] The words of a literary title are succeeded by other words that may diminish or efface them—many words indeed in the case of longer forms like novels or plays—but the words of a painting's title typically stand alone, with little other than the artist's name to qualify or counter their effect. Of course, this difference between picture titles and the literary kind is not absolute: in the eighteenth and nineteenth centuries, catalogues like the one being read by the young woman in Martini's print sometimes followed up their titles with extracts from poetry or other texts, while in our own day museums provide expository labels for selected works on display. And technologies for replicating images mean that a version of the painting, if not the painting itself, can theoretically be accompanied by a verbal explanation of any length, whether in a book containing a reproductive print or photograph, or digitally on a screen. But to the degree that the title serves as the invariant shorthand for the image wherever it travels—a shorthand that persists through accounts that otherwise may vary radically—its words will always retain their privileged status. Until visual recognition software becomes as accurate as the verbal kind, people who search for a particular painting on the Web will continue to do so by its title. Art historians who thoroughly disagree about the meaning or significance of a particular painting will continue to call it by the same name. And even when they seek to argue that a painting should in fact be designated differently, its traditional title, as we shall see, may prove stubbornly resistant to change.

In 2009 the National Gallery in London organized an exhibit designed to highlight Pablo Picasso's continuing dialogue with the masters who had preceded him. Commenting on the exhibit for the *London Review of Books*, the journal's regular art critic, the late Peter Campbell, singled out for particular notice a cubist work of 1910 (fig. P-4). "Without the title," Campbell wrote, "you would be hard pressed to relate any detail of *Still Life with Glass and Lemon* to an object. Only after you have decided that there is a central stand or table and objects on it can the game of interpretation begin. Old art is a substrate, but in this case the viewer borrows an idea to look with rather than the painter an idea to build on."[24] Campbell was surely right about the force of this title, though his distinction between the viewer's idea and the painter's tellingly equivocated about its status, as if he couldn't quite believe that the way in which we are invited to classify the painting corresponds to the original intention of its maker. So great is the apparent distance between this severe instance of analytic cubism and the pictorial tradition to which the title alludes that the critic half suspects the latter of being an afterthought.

9

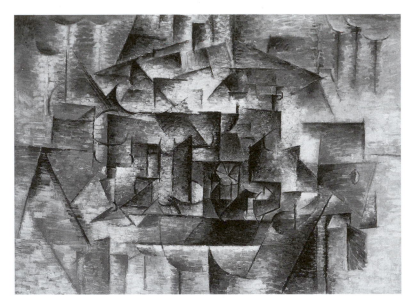

P-4. Pablo Picasso, *Still Life with Glass and Lemon* (1910). © 2014 C. Herscovici /Artists Rights Society (ARS), New York. Oil on canvas. Cincinnati Art Museum, Bequest of Mary E. Johnston/Bridgeman Images.

Presumably he would not likewise pause to remark the title currently borne by Willem Kalf's *Still Life with Lemon, Orange, and Glass of Wine* (fig. P-5), for instance, or the numerous variations on the formula by which so many paintings since the seventeenth century have been identified. Yet these too are ideas to look with, and despite their seeming self-evidence, they also have their place in a theory of picture titles. Rather than assume once again that the story of modern painting begins when the French impressionists break with the Académie in the middle of the nineteenth century—the assumption that governs the only substantial work on picture titles we have to date[25]—this book contends that we need to look further back, to the anonymous classifications and other names under which large numbers of easel paintings began to circulate in the late seventeenth and eighteenth centuries. It is not enough to say, with Arthur Danto, that the history of titles before impressionism "is simply the history of motifs." Danto suggested that titles become interesting for art history only when they begin to call attention to "certain features of painting as painting"[26]—when Whistler, for example, chooses to call his portrait of his mother *Arrangement in Grey and Black* (see fig. 14-4). But a generic title like "still life" or "landscape" is also a way of attending to painting as painting; and so too, for that matter, is the "portrait"

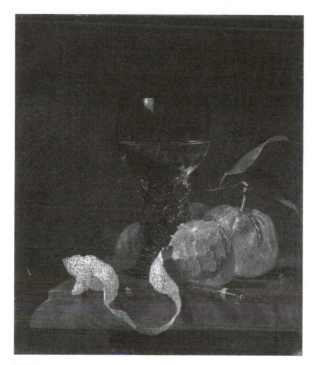

P-5. Willem Kalf, *Still Life with Lemon, Orange, and Glass of Wine* (1663–64). Oil on canvas. Staatliche Kunsthalle, Karlsruhe.

that subtitles Whistler's painting of his mother. The degree to which we have come to take such categories for granted should not obscure their capacity to shape the viewer's experience of an image.

Nor is the naming of motifs ever as simple—or as visually innocent—as the dismissive generalization implies. In a related argument, Leo Hoek has characterized many such titles as merely "denotative" and hence "transparent," but the very act of singling out some features of the image has an effect, whether or not the viewer consciously pauses to register it.[27] *Portrait of the Painter's Mother* is not the same as *Portrait of an Old Woman*; and the effect would change yet again if we just subtitled the work *An Old Woman*—or, in a subtly different move, *The Old Woman*. In that case, of course, we would have turned Whistler's portrait into a genre painting (though the definite article might render that classification slightly ambiguous)—a gesture we may well wonder that the artist himself didn't make, since he later insisted that his personal feelings for his mother should have nothing to do with others' responses to the painting. Yet the formula that Whistler did adopt has an impersonality of its own, since the implicit speaker of such a title is not in fact

the artist who created the work but someone who beholds and identifies it—a person who might be anyone from the portrait's owner to the compiler of an inventory, a dealer, a curator, an art historian, or just an ordinary viewer.[28] That such a formula is so conventional is one more sign of how thoroughly the naming of pictures is entangled with the history of their reception. And the history of reception, in turn, continues to affect both the choices contemporary artists make when they set about titling their pictures and the way ordinary viewers approach those pictures and their titles alike.

For purposes of coherence and manageability, this book focuses on Western painting from the Renaissance to the present, but analogous questions might be raised about other cultural traditions, both as they established their own conventions for titling pictures and as those pictures began to circulate in an increasingly global market. To what degree did the mobility of Asian art, for example, likewise depend on short verbal formulae for identifying images, and how, if at all, did such practices change when Western paintings began to arrive in the East and vice versa? What names did Europeans adopt, for that matter, when collecting and displaying the visual art of Latin America or Africa? Many of the paintings examined here owe their titles to persons who baptized them after the fact, but the problem of identifying works at a distance only intensifies when that distance is cultural as well as chronological: a Japanese print arriving at a Parisian dealer's at the end of the nineteenth century, for instance, or an Aboriginal bark painting acquiring its label from a contemporary curator in Los Angeles. Nor is painting the only medium that poses such challenges. Many sculptures also can travel, and their interpretation, too, will be shaped by the words that accompany them. And then there is photography—an art that from the first has invited viewers to witness imagined scenarios as well as to see anew a world they already know. When the English photographer Julia Margaret Cameron gave the title of *Circe* to a photo of a woman's head in 1865, she chose to shape viewers' understanding of her image as deliberately as Whistler did six years later in titling the portrait of his mother.

I shall eventually return to the examples of Whistler and Magritte, among others, when I consider how selected artists from the eighteenth century to the present have responded to the expectation that paintings have titles. If few artists are as self-conscious about language as the creators of the *Arrangement in Grey and Black* or *La trahison des images*, all participate in a culture in which the painter becomes, however minimally or reluctantly, also an author. Yet by the time that artists were routinely engaged in titling their work, they were entering a field in which many of the paintings that now hang in our museums had already acquired their names. This is particularly true of count-

less Dutch and Flemish paintings, whose titles, such as they are, may have come down to us from the anonymous compilers of inventories and auction records, or from the dealers who increasingly circulated that art through Europe in the seventeenth and eighteenth centuries—not to mention the publishers of reproductive prints, whose habit of supplying anecdotal titles for many a Northern genre painting still complicates our reading of these images. But the decline of religious and aristocratic patronage, in which the subject of a work was understood between patron and artist, and the growth of an international art market meant that Italian paintings, too, often acquired their titles from middlemen. As with Northern painting, the culture of print—both published commentary and reproductions of the images themselves—helped to determine the names by which many such works are still known. It may be from reproductive printmakers, in fact, that Western Europe first grew accustomed to thinking of the words that accompanied a picture as its "title."

Naming in this sense partly precedes authoring, and the book that follows replicates this sequence. The story begins with the decline of patronage and the rise of the art market in the seventeenth and eighteenth centuries, but a principal turn comes with the public displays organized by the newly formed academies in France and England, where for the first time living artists were being invited to show their work to heterogeneous crowds who could not always be expected to recognize what they were seeing. The actual development of the practice proved uneven; and it is only at the close of the eighteenth century that the convention seems to have been articulated with any explicitness. In the meantime, the establishment of public art museums, the growth of print journalism, and the beginnings of art history as a discipline meant that many more people were getting into the business of interpreting pictures by naming them. Though the nineteenth century seems to have shared our default assumption that a painting's title originates with its creator, older practices of identifying and circulating images continued well after artists themselves took up the work. Even in the twenty-first century, many art lovers are probably unaware how often the titles they consult on museum walls testify to a work's reception history rather than the words of the painter.

Titles would be useless without people to read them; and in the design of this book, reading, too, comes before authoring. The second part introduces some paintings whose titles have strongly determined how they have been seen, even when those titles did not originate with their creators. The painters in question range from Rembrandt to Jackson Pollock, while a separate section focuses on Bruegel's *Landscape with the Fall of Icarus*—an image that has probably inspired more verbal artistry over the past century than any other.

But most readers of titles are not poets, and the capacity of such titles to shape the experience of ordinary viewers is a crucial part of the argument. That argument primarily concentrates on the last three hundred years because the same period witnessed both a new mobility of the image and a dramatic growth in the number of people capable of decoding the words that identify it. Were it not for paintings' increased tendency to circulate, a viewer wouldn't be confronted by an unfamiliar image; and were it not for her ability to read, that same viewer wouldn't try to interpret what she saw by looking for its title.

Consider once again the young woman entering on the left in the print of the 1787 exhibit at the Royal Academy (fig. P-3). Commenting on the implicit hierarchy the image establishes between this marginal figure and the Prince Regent at its center, one sharp-eyed critic has noted how their relation to the exhibition catalogue drives home their difference. While the gaze of the young woman is "pointedly regulated," as C. S. Matheson puts it, "by the institutional text," the Prince Regent "negligently" turns away from his open copy and attends instead to Sir Joshua Reynolds, the Academy's president, who is evidently discoursing about one of the major history paintings in the exhibit. Matheson wants to emphasize how this "oral dissemination of connoisseurial information"—a practice she associates with the guided tours offered distinguished visitors to noble or private collections—outranks the mediation of print on which the young woman is compelled to rely.[29] But the point might easily be reversed to highlight instead the democratizing effect of printed texts, as persons otherwise excluded from connoisseurship acquire at least some knowledge of what they are viewing. Together with the name of the artist who created it, the title of a painting is the first and often the only such knowledge the viewer acquires—a knowledge that is dependent, obviously, on the spread of literacy.

From the artist's perspective, however, the culture of print proves more problematic, as the very words that help to explain and market a painting threaten to trump the painting itself. When few could read, pictures were often thought to communicate more directly than words, but in an age of widespread literacy, almost anyone can experience that "curious sensation," to quote Norman Bryson again, of eyes drawn to the text that accompanies an image "almost before taking in the . . . image at all."[30] Whether that text ends by limiting what the viewer sees or whether the viewer protests, as viewers often do, that the work fails to represent what its title promises, such conflicts of reading continue to trouble the history of painting's reception—and not only, as we shall see, among the less sophisticated members of the viewing public. Mocking pictures for their failure to fulfill the program announced in

14

the catalogue—reading against the title, as I call it—Denis Diderot's witty accounts of the eighteenth-century Salons inaugurate a mode of criticism that will have a long afterlife.

This book concludes with case studies of paintings, from Jacques-Louis David's *Oath of the Horatii* (1784–85) to Jasper Johns's *No* (1961), whose titles originated, more or less, with the artists who created them. While many painters over the last centuries have been relatively content to leave the naming to others, each of those considered here was acutely sensitive to the power of words to shape his work's reception, and each approached the business of titling accordingly. Contemporary artists may well find models, or perhaps only cautionary tales, in these accounts of aggressive authorship. But I begin with the assumption that such acts of authorship can best be understood in relation to a larger field of activity—a field in which beholders, too, participate, and in which the naming of pictures is also a way of reading them.

I

Naming and Circulating: Middlemen

$$\left[\ 1\ \cdot\ \text{BEFORE TITLES}\ \right]$$

Anyone who frequents a contemporary museum or gallery knows more or less what *Untitled* means—that the artist who has produced this work has chosen not to name it and implicitly prefers that the painting speak for itself. Yet I suspect few pause to register how the label acquires its meaning from the convention it violates: *Untitled* signifies precisely because we have learned to expect that in the ordinary course of things, a painting will have a title. Every time our eyes search for one only to find its negation instead, we testify to the force of that convention.

Under modern circumstances of display and reproduction, in fact, *Untitled*, too, is a kind of title: a word that routinely accompanies the work as it circulates in the culture and that instructs us, if only by negation, how to view it.[1] But if we attend to the history of the paintings on our museum walls rather than to the labels that accompany them, the problem of the untitled work appears quite different. For the vast majority of European paintings before the eighteenth century, the absence of a title testified not to a deliberate refusal of prevailing custom but to the default condition of artistic practice. That these are not the works we presently designate as *Untitled* has more to do with reception, broadly understood, than it does with production. Such pictures have their names, but we do not owe those names to their makers. With rare exceptions, the work of baptizing them has been the province of middlemen.

To say that most pictures before the eighteenth century lacked titles in the modern sense is not to say that they lacked subjects, or that the viewers for whom they were intended would have failed to understand what they were seeing. On the contrary: the need for titles is more likely to be felt when such understanding threatens to break down, whether because geographical distance makes face-to-face explanation impossible or because artist and viewer

no longer share a common culture. Titling, as E. H. Gombrich has observed, "is a by-product of the mobility of images";[2] and before the rise of the art market, the growth of public exhibitions, and the development of the reproductive print, the mobility of images was distinctly limited. As long as European art was dominated by a system of patronage, much work was site-specific and literally incapable of motion: think of a fresco on the wall of a monastery, for example, or the decorated ceiling of a princely palace. Easel paintings, of course, were free to move; and it was the increasing circulation of such images through Europe that would eventually make the need for titles salient. Yet to the degree that such images originated in commissions rather than the open market—as did most Italian painting before the eighteenth century—they, too, were often designed for a particular space, where most viewers could be expected to recognize what they were seeing.[3] The person who worshipped at the altar of a local church or chapel, the family and friends afforded access to the private quarters of a nobleman: such viewers could rely on a common culture and informal means of exchange to identify the images before them. Even today, few pictures that hang in private homes are provided with labels.

More immediately to the point, the practice of commissioning art meant that the subject and meaning of an image were typically the product of a mutual understanding between artist and patron. Most scholars of Renaissance art no longer share Bernard Berenson's belief that the subject matter of a painting was simply dictated by the patron—or "employer," as Berenson called him—who "gave his orders as he would to a carpenter, tailor or shoemaker."[4] Even an influential account of Cosimo de' Medici as "author" of the works he commissioned invokes "the reciprocity of the patronage exchange between patrons and their artists" and concedes that the balance shifted toward the artist at the close of the fifteenth century.[5] But while there has been much debate over the relative contributions of both parties to the transaction and how these altered over time, there is widespread agreement that the final result emerged from a process of negotiation—a process that was only partly documented in contracts or letters. A recent study of the commissioning of art in Renaissance Italy concludes that contracts varied in the detail with which they spelled out the subject matter of the works at issue and suggests that many such texts remained vague because they depended on discussions that had preceded or would follow the formal recording of the document. Unlike other aspects of commissioned art—the size and shape of an altarpiece, for example, or decisions about the materials to be used—the subject of a picture was less a matter for economic and legal stipulation than an understanding to be developed more or less fluidly over

the course of the work.[6] The number of figures might be altered as painting proceeded; one saint might be substituted for another; an artist might suggest that a particular episode from scripture be included in the plan—as when Lorenzo Lotto proposed Lot and his daughters for a series of *intarsie* (images made of inlaid wood) he was designing for a church in Bergamo, "because the theme of the five cities of Sodom pleases me and because my name Lotto is included there."[7]

Where the patron's initiative is concerned, the possibilities ranged from the detailed program that Isabella d'Este drew up in 1503 for "a battle of Chastity against Lasciviousness" by Perugino to the vague request for something from the Old Testament "or some story from Ovid or another" in a letter from the bishop of Trent about one of the frescoes he had ordered for his palace in the early 1530s.[8] Or a patron might simply hire an artist and leave the subject to him, as in one late seventeenth-century commission that specified size only and added, "As to the subject, I leave it to you whether to make it sacred or profane, with men or with women." Francis Haskell, who cites this particular letter, does not report what became of the commission in question;[9] but there seems little reason to doubt that by the time the painting was delivered, its owner would have known what he was getting. Informal understanding in such cases was greatly aided by the common culture that bound artist and patron, and by the familiar repertoire of scenes and symbols on which most artists drew. That contracts could refer to the figures "usually" or "commonly" included in a particular subject without further specifying only confirms how much could go without saying.[10]

Sacred images in particular could be recognized by a wide audience; but in sixteenth- and seventeenth-century Italy the vast majority of secular paintings were based on a comparatively limited stock of classical narratives, whose iconographic conventions became more or less codified over the years.[11] When a Florentine scholar named Giovan Battista Adriani was consulted for a suitable story to inspire some tapestries being made for Cosimo I in the late 1550s, he argued against "novel inventions" and opted instead for the pleasures of recognition: "I would be of the opinion that it would be risky to deviate from stories that are known to many people," he wrote—adding later, "For in my opinion he who paints something entirely unknown, or known by very few, will give less satisfaction, especially as these decorations are being made for display and are meant to please a wide audience. . . . Nor does it disturb me in the least if this subject has already been painted by other artists; on the contrary, the more frequently and skilfully it is represented the happier I shall be." He suggested the story of Theseus, "the details of which are very well known."[12]

Of course it would be a distortion to suggest that patrons would always have understood at first glance what they had purchased. The newer or more recondite the subject, the more explanation was called for—especially if the idea for the picture originally came from the artist. Haskell tells of a wealthy businessman from Lucca, Stefano Conti, who began collecting paintings in the first decade of the eighteenth century. Perhaps inspired by Conti's habit of paying according to the number of figures in an image, one Bolognese artist proposed an elaborate scheme from Trojan history: "Pyrrhus killing Polyxena in the temple and there will be Chalchas, the soothsayer, and other half-length figures or heads depicting Aeneas and Antinorus—in fact everything that is needed for the history, and also the tomb of Achilles, the father of Pyrrhus." Conti appears to have accepted the plan, but when the picture itself arrived, Haskell dryly reports, its owner "wrote to ask once more what exactly it represented."[13] The story suggests in part why even a patron less concerned with public display than a Medici duke might prefer to avoid novel inventions—and how the need for words may increase as distance, both physical and mental, intervenes between the maker of an image and its viewer. The "shared visual culture" that characterized the contracts of an earlier moment in Italian history is no longer at work in this transaction.[14]

Only a few years after Conti puzzled over his picture, the abbé Du Bos was already pointing the moral. First published in 1719 and successively revised and expanded over the decades that followed, Du Bos's *Réflexions critiques sur la poésie et sur la peinture* is concerned less with the patrons of art than with its public—a body that in his conception distinctly includes an enlightened bourgeoisie.[15] Like Cosimo's adviser before him, Du Bos implicitly assumes that the wider the potential audience for an image, the more desirable that its subject be easily recognized; but when he announces that the painter "should only introduce on his canvas figures of whom everyone . . . has heard," he has in mind a much larger and more heterogeneous group of viewers than any that might have had access to the ducal tapestries in mid-sixteenth-century Florence.[16]

In contrast to the poet, Du Bos argues, the painter cannot arouse our interest in unknown persons by granting them appealing characters and thus must confine himself to representing figures we already know: "his great merit consists in making us recognize these figures with certainty and ease." Yet while all visual artists face this limitation by Du Bos's account, the discussion that follows makes clear that he is thinking above all of easel paintings and of the particular challenge posed by their capacity to travel. "If the subject of frescoes painted on great walls or of those large pictures that remain always in the same place is not well known, it may become so," he argues; but

"easel paintings, destined often to change place and owner alike," apparently do not benefit from such local continuities. Indeed, it soon becomes evident that the sort of mobility he has in mind extends well beyond national boundaries: hence the claim that scenes taken from scripture or classical mythology are to be preferred to those drawn from modern history, because the former are "generally known," while "every country has its saints, its kings, and its great figures, who are very well known and whom everyone there recognizes easily, but who are not so recognized in other countries." To think of pictures traveling like this is to worry lest even "a head of Henry IV" or "the heroes of Tasso and Ariosto" should prove inadvisable, since the first "would not render the subject of a picture comprehensible in Italy, as it would in France," while the second "are not so well known in France as in Italy." Ancient history and myth, on the other hand, pose no problem, since it is now "the custom established . . . among all the polite peoples of Europe" that children be required to study the "fables and histories" of the Greeks and Romans.[17]

To think of pictures traveling like this is also, apparently, to wish for something very like titles:

> I have many times been surprised that painters, who have such a great interest in making us recognize the figures they want to use in order to move us, and who must encounter so many difficulties in making them recognized with the aid of the brush alone, do not always accompany their historical pictures with a short inscription. Most spectators, who are otherwise very capable of doing justice to the work, are not learned enough to guess the subject of a picture. For them it is sometimes like a beautiful woman who pleases but who speaks a language they do not understand at all. People soon grow tired of looking at her, because the duration of such pleasures, in which the mind has no part, is very short.[18]

Here Du Bos seems to be dwelling more on the relative democratization of the viewing public than on its international character, since he says nothing about the language in which the "short inscription" should be recorded. Yet if "most spectators . . . are not learned enough to guess the subject of a picture," there is apparently no question in Du Bos's mind that such spectators are literate.

I shall return to this assumption that more people know how to read than to interpret pictures in part 2. But there is another premise of Du Bos's argument: one that also has broad implications for the history of picture titles. Having recorded his wonder that painters don't routinely avail themselves of

writing in order to identify the subjects of their pictures, Du Bos pauses to register that artists have not always been so reluctant to incorporate words in their images. "The sense of the Gothic painters, however coarse it was, made them realize the utility of inscriptions for understanding the subjects of pictures," he remarks—only to add immediately: "It is true that they made as barbarous a use of this knowledge as of their brushes. They took the strange precaution of making rolls coming out of the mouths of their figures, on which they wrote whatever they claimed to make these lazy figures say; it was truly making these figures speak." These rolls have "disappeared together with the Gothic taste," and Du Bos is evidently happy to see them go. Yet he can't help registering the loss, even as he looks around for some other means by which writing could come to the aid of images: "Sometimes the greatest masters have judged two or three words necessary in order to render the subjects of their works intelligible," he observes rather defensively; "and they even have not scrupled to write them someplace on the surface of their pictures where they would do no harm."[19]

Though Du Bos does not trouble to spell out what he means by this remark, both his dismissal of the "Gothic" banderole and his concern lest the words inscribed on a picture injure the work itself take for granted an ideal of pictorial illusion that had been operative only since the Renaissance; and that ideal, which more or less coincided with the development of easel painting, was another crucial factor in the rise of picture titles. Illuminated manuscripts are also potentially mobile, after all, and so, for that matter, are ancient Greek vases; but it was primarily when images were extracted from a verbal context and writing in turn "banish[ed] . . . from the picture space," as Gombrich has put it, that the need to identify those images became a problem.[20] Of course that banishment was never absolute: the fusion of word and image in the emblem tradition continued long after the development of linear perspective; and Meyer Schapiro has noted certain other exceptions as well, including the powerful portrait of the duchess of Alba by Francisco Goya (1797), in which the artist recorded the words *solo Goya* ("Goya alone," or "only Goya") on the ground at her feet.[21] That example also reminds us that painters devised numerous techniques for inscribing their signatures on canvases without seriously disrupting the illusion of a three-dimensional space. While the divorce of word and image was a powerful impetus, paradoxically, to the development of titles, the convention of titling would persist even after words began once more to enter the picture. (Witness the case of Magritte's *La trahison des images*.) Paintings acquire titles for many reasons, some of which have little to do with viewers' difficulty in recognizing their subjects.

[2 · DEALERS AND NOTARIES]

There is, to begin with, the need for record keeping. Paintings are material objects; and the more they circulate, the more important it becomes to devise some means of identifying and tracking them. Markets for art developed unevenly over the course of the centuries and between northern and southern Europe.[1] In Italy, most commentators agree, the patronage system dominated the production of art until at least the middle of the seventeenth century, though some artists had begun working to spec and selling the results directly from their shops several hundred years earlier.[2] For the most part, these tradesman-like wares—"bought off the rack," as Creighton Gilbert has put it—are not the pictures that have come down to us.[3] But while there are records of third-party dealing in Italian pictures that go back as far as the 1370s, it is in northern Europe, especially in the sixteenth- and seventeenth-century Netherlands, that a market for ready-made art first developed on a significant scale, and that the buying and selling of pictures became in large measure the province of middlemen.[4] Both the first building specifically constructed for the exhibition and sale of art in Europe and the first major print publishing house appeared in Antwerp in the sixteenth century.[5] Well into the eighteenth century Netherlandish artists, like those elsewhere, sometimes worked to commission; but paintings had been sold at fairs and by lottery since at least the fifteenth century.[6] Between the relative absence of aristocratic and church patronage, particularly in Protestant Holland, and the vigorous expansion of a commercial economy, Dutch and Flemish painters were among the first—and certainly the most productive—participants in something that resembles the modern art world.

When Arthur Danto coined the term "artworld" in the 1960s, it served as a shorthand for the modern institutions of theory and art history—as well as the individuals who participate in them—that effectively constitute a work of art. Thus it is the contemporary "artworld," to choose one of Danto's promi-

nent examples, that determines why Andy Warhol's Brillo boxes, but not the original boxes themselves, should be understood as art. For Danto, an "art-world" entails "something the eye cannot de[s]cry"—a function of theoretical "atmosphere" and historical knowledge rather than the concrete properties of a work—though when "museums, connoisseurs, and others" are said to be "makeweights in the Artworld," he comes closer to the sociological under-standing of the term later elaborated by Howard S. Becker.[7] In Becker's ac-count the art world is "the network of people whose cooperative activity, or-ganized via their joint knowledge of conventional means of doing things," produces art; and everyone from literary editors and set designers to critics and viewers belongs to the company. Becker has less to say about art theory as such than about the practical activities by which art is made, but like Danto, he treats creation and reception, in the ordinary sense of those acts, as insepa-rable. In Becker's aggressive formulation, "art worlds, rather than artists, make works of art."[8] By thinking of the sixteenth- and seventeenth-century Neth-erlands as a nascent art world, we can begin to see how this proposition has historically held true when paintings acquire their titles. The rest of this book is devoted to demonstrating why this is not a trivial claim.

At one point in Danto's essay, the philosopher conducts a thought experi-ment to suggest how the act of "artistic identification," in his phrase, serves to constitute a work of art, by imagining how two different works could be gen-erated by the very same arrangement of color and line under two different titles. In Danto's hypothetical scenario, the titles are announced in advance: the artists are asked to decorate the walls of a science library with frescoes to be called *Newton's First Law* and *Newton's Third Law*, respectively, and when the otherwise identical images are unveiled, each artist proceeds to explain his work in accord with his original assignment. Because these different in-terpretations prove incompatible, by Danto's account, the result of the experi-ment is two different artworks.[9] Danto doesn't say whether his argument would still hold if it turned out that the titles followed rather than preceded the works in question—or if we had no way of knowing the difference.[10] But for most of the paintings that have come down to us from before the eigh-teenth century—and for many since then—that is precisely the situation in which we find ourselves. Rather than a report of the original assignment, as in Danto's example, or documented evidence of the artist's act of titling, what we have are predominantly records of identification and classification after the fact. Though not all such identifications make as radical a difference as Danto's imaginary ones, even simple acts of classifying, I shall argue, help to shape what we see. The compilers of inventories and auction lists belong to the art world in this sense, and so too, if more obviously, do collectors and

dealers, the authors of catalogues, and the makers of reproductive prints. Only the latter, however, seem to have consciously thought of themselves as engaged in the business of titling.

Consider the following list of paintings, drawn from the inventory of a dead man's estate in seventeenth-century Delft:

A painting of Martha and Maria
A vanitas
A landscape
Two small paintings of musicians.[11]

How shall we think of a list like this? The notary who recorded these phrases was presumably not concerned with providing anyone with interpretations of the images in question, only with keeping track of the possessions being bequeathed to the dead man's heirs. But in fact the doing of the one for him necessarily entailed the other—or at least it did so because he took these paintings seriously enough to think them worth distinguishing. He could, after all, simply have grouped the entry as "five paintings," before going on to enumerate the remaining objects in the estate. But with the partial exception of the two musicians, he chose to identify each work separately, an act that in turn required him to recognize and classify it. This particular collection, though small, covered a significant range of pictorial types; and the skills involved in the case ran a similar gamut, from the seemingly straightforward ability to decode a picture of a person playing music to elementary iconographical knowledge ("Martha and Maria") and a familiarity with generic classification ("A landscape"). And both genre and iconography came into play with the decision to register the remaining image—probably a still life with a timepiece, skull, or some other form of memento mori—as "A vanitas."[12]

It is always possible that the notary did not himself decide how to characterize these pictures, but simply put down what he was told by a member of the late owner's family or by anyone else who happened to be present at the time. In any case, what got recorded clearly testifies to a common understanding of pictorial conventions: hence the tendency to register the images as members of a class rather than single instances. But just because the citizens of seventeenth-century Delft, like those of fifteenth-century Florence, inhabited a shared visual culture does not mean that everyone in the city shared that culture equally. For these purposes, it is the understanding recorded in the list that matters, not the artistic sophistication of any particular notary. Conversely, there also remains a chance that whoever identified the

images may have gotten something wrong, in the sense that what he or she described was not what the artist intended. Perhaps what the inventory calls a picture of Martha and Mary was from the artist's perspective only a painting of two women in a domestic interior; or perhaps what appears as "a landscape" included a figure who had originally been meant as the saintly focus of the image. Given the tightly knit world of seventeenth-century Delft, such possibilities seem unlikely; but over time and space they increase exponentially.[13] Nor do such redescriptions necessarily entail a clear-cut error on the part of the viewer. The question recently asked by a scholar of Northern Renaissance art—"When does a painting of a saint in a landscape become a painting of a landscape with a saint?"—is intended as a question about the history of genres; but it is also, inevitably, a question about the naming of individual works.[14] Absent firm evidence of an authorial title—which is to say, almost always—the decision about what to call such a painting has historically rested with its viewers.[15]

Why did the makers of such images *not* title them? For all its anachronism, the question is worth asking, if only to register how comparatively recent in the history of European painting is the convention of authorial titling. I have argued that a shared understanding between artists and patrons ordinarily precluded the need for formal titles, but the seventeenth-century Netherlands was not primarily a culture of patronage. If the growth of the art market was among the principal conditions for the birth of the modern picture title, then why did the "first mass consumers' art market" in Europe—the phrase is Simon Schama's[16]—not already expect artists themselves to title their images?

Any attempt to account for historical absence must of course remain speculative, but studies of the Netherlandish market suggest several related answers. As John Michael Montias has demonstrated, there were a number of ways that painters made their living in the period, only some of which involved producing ready-made work for the open market. Though long-term employment by institutions or individuals was comparatively rare—particularly, Montias suggests, once an expanding economy made artists prefer entrepreneurial risk taking to the constraints of extended service[17]—many painters did work to order, whether through oral negotiations or more formally, by contract. Some did their own negotiating, while others worked through dealers, at least some of whom were themselves painters who bought and sold art on the side. Even arrangements recorded in writing, however, were often quite local; and both parties seem to have relied on tacit understandings to fill in the details, at least where the subject of a picture was concerned.[18] (In the Netherlands as elsewhere, an exception should be made for

the commissioning of portraits.) Those who worked for the open market, by contrast, typically competed by specializing: some focused on producing landscapes; others concentrated on peasant scenes or market pictures; still others gained a reputation for tempests at sea or flower still lifes.[19] Such artists could build up a stock of related images, in the expectation that buyers interested in a particular type of picture would seek them out; or they might work for dealers who themselves specialized in certain kinds of images. Both the generic variety of Netherlandish art and the formulaic repetitiveness within genre so noticeable in work of the period arose from this process of specialization. And so too, clearly, did many of the classifications that turn up in the inventories. "A landscape," "A vanitas": phrases like these are not so much titles in our modern sense as records of collective agreements that have been implicitly negotiated over time in the marketplace.[20]

This is not to say that such terms always corresponded unambiguously to the images they designated. Even in the tightly knit art world of the seventeenth-century Netherlands, there always remained a potential gap between the paintings themselves and the retrospective language of the classifiers. Some terms had multiple references: a word like *bancquet*, for example, could identify either a picture of people consuming a meal or the arrangement of food and utensils in a still life. A similar ambiguity hovered over the referent of *vanitas*, since the signs of evanescence registered by the term might appear in a painting of the human figure—a person holding a skull, say, or even someone blowing bubbles—as well as among a painted collection of inanimate objects. Other terms varied by geography: the category of *stil leven*—from which we derive our "still life"—shows up earlier and more consistently in Amsterdam than in Antwerp, where the notaries long clung to words like *bancquet* and *vanitas*. By registering a time lag between the production of certain kinds of paintings and the appearance of new words in the inventories, Montias has also called attention to the conservatism of the classifiers' language—"the tenaciousness," as he puts it, "with which notaries and their clerks held on to conventional, generic terms, sometimes for decades, in spite of their inherent imprecision and ambiguity."[21] Yet it is from such terms that many of our modern titles have evolved—and not only in the sense that labels very like them still identify countless Netherlandish paintings in our museums and art books. When the twentieth-century painter Giorgio Morandi tells an interviewer that "the only titles I chose for these paintings [works of 1916–19] were conventional, like *Still Life*, *Flowers* or *Landscape*," he indirectly pays tribute to the way in which generic terms continue to organize our viewing, even as he makes authorial titles from what was first the language of the record-keepers.[22]

That language got written down, of course, because property was changing hands. Notaries were summoned to record a marriage agreement or to document a loan; they inventoried the estates of the dead, as in our Delft example, or drew up a list of the debtor's assets in the course of bankruptcy. We owe an inventory of paintings in Rembrandt's possession to his filing for debt in 1656.[23] In the case of relatively modest collections, like the one we have been examining, notaries often didn't bother to record the names of those who had created the images; it is not even clear that they could have done so had they wanted. Particularly in the first half of the century, people seem to have been more inclined to buy pictures by type than to view them as works whose value derived from the hands of their makers.[24] Perceptions of value also seem to have influenced how many words were lavished on an image: other things being equal, the subject of a large and important painting was more likely to be identified than that of a small and insignificant one, and many works entered the inventories without being described at all. (Recall how the Delft notary grouped two "small" paintings in a single entry.) Not surprisingly, the inventories of wealthy collectors contain more attributed works than those of people of lesser means, and their paintings are apt to be described in more detail.[25] Wealthy collectors were also more likely to have bought their paintings from dealers who had acquired the works at a distance. So much art was produced in the seventeenth-century Netherlands that almost anyone could afford the work of a neighbor; but if you were willing to pay for the privilege, you could also buy paintings that had traveled both spatially and temporally. At the high end of the market, dealers traded from city to city; and when their stock was inventoried, the lists included Italian pictures, as well as works of the previous century.[26] The notaries who compiled such lists were beginning to cope with the new mobility of the image.

[3 · EARLY CATALOGUERS]

Notaries obviously did not intend their lists for a wide readership. They recorded their evidence in the course of local business; and their handwritten documents were deposited in city archives, where they would remain until scholars began to publish them at the turn of the twentieth century.[1] Yet I would like to suggest that we think of these manuscripts as belonging to a literary genre—call it the list of already-made pictures—that would expand dramatically in the following centuries, as the growing mobility of the image was both accompanied and enabled by the still greater mobility of print. Auction and sale catalogues, Salon *livrets*, dealers' hand lists, museum guidebooks, even the published inventories of wealthy collectors: these together form a genre that found its readership among the increasing numbers of people who were engaged in viewing images they had in no way helped to create. Whether such images had been expressly intended for the market or had once been commissioned and were now being put to new use, the public who came to look at them needed their already-made picture lists to identify what they were seeing.

Printed versions of such lists go back at least to the early 1600s, and here, too, the Netherlands led the way, having more or less invented the public auction catalogue at the beginning of the century.[2] The earliest I have been able to trace appeared in 1616.[3] By the 1680s and 1690s, however, similar documents were appearing in London, while across the Channel the French had already begun to make their own contribution to the form by issuing lists of pictures and works of sculpture to accompany a few early exhibits of the Académie. The first of these occasional publications appeared in 1673, to be followed by two others in 1699 and 1704. But it is in the eighteenth century that the lists really took off, as occasions for the public display of paintings increased exponentially. Auction catalogues multiplied rapidly in response to a burgeoning international art market, centered first in Paris and later in Lon-

don as well.[4] Regular showings of the French Académie resumed in 1737, and the official guide to these exhibits, the so-called Salon *livret*, sold in increasing numbers over the decades that followed. Even foreign art lovers unable to attend the Salon itself managed to keep up with the scene by arranging for someone to send them the latest *livret*.[5] Some thirty years later, the British artists who founded their own Royal Academy in partial emulation of the French provided a similar document for the price of admission to their annual exhibits.[6] What Francis Haskell has dubbed "the ephemeral museum"—the temporary display of Old Master paintings, usually under the sponsorship of an aristocratic collector and located in a church or cloisters—had originated in Roman customs of the previous century; only in 1706 (and in Florence), however, did such displays, too, begin to acquire their catalogues.[7]

Museums of a more permanent kind took longer to develop, but the gradual opening of princely and royal collections to public viewing across Europe also prompted early efforts to record their holdings in print. In 1778 the emperor Joseph II summoned a Basel engraver, art dealer, and publisher named Chrétien de Mechel to organize and document the collection that would eventually form the nucleus of the Kunsthistorisches Museum at Vienna.[8] The resulting volume—published both in German (1783) and in French (1784)—emphasized Mechel's decision to arrange the holdings chronologically and would have a significant influence on the historicism of many similar institutions in the century to follow.[9] By 1793, one year after the abolition of the French monarchy, the doors of the Louvre were formally opened to the people and a guide to the collection was published: the first catalogue of what is widely regarded as the first truly public museum in Europe.[10] From another perspective, however, that document itself was only the latest in a long line of already-made picture lists.

Family resemblance, of course, is not identity; and in emphasizing the generic affinities of such lists, I don't mean to deny their local variations or to pretend that they were always aimed at the same audience. The circulation of auction catalogues, for example, was primarily confined to dealers and the occasional private collector[11]—readers whose specialized knowledge about the items on sale made them potentially quite different from the heterogeneous crowds who evidently frequented the French Salons.[12] (Not everyone who attended the Salon even troubled to buy a *livret*; indeed it was partly to keep such mixed crowds at bay that the Royal Academy levied an admission charge for its exhibits.) The different conventions of national markets also made a difference in the format of catalogues: unlike the British, who appear to have been interested in publishing just enough information to move their large inventories as swiftly as possible, the Dutch and French typically com-

piled detailed records of the paintings they sold—records that continue to prove a valuable resource for scholars.[13] At their most elaborate, the Continental catalogues offered mini-essays, at once descriptive and evaluative, on each item, as well as a specific account of its provenance—as in this page from a French catalogue of 1791, compiled by the painter and art dealer Jean-Baptiste-Pierre Lebrun (fig. 3–1). The entry under Augustin Carrache (Agostino Carracci) reads in English:

> 4. The Holy Family; life-size figures, visible to below the knees: the Virgin is seated, holding on her [lap] the infant Jesus, while she looks at Saint Joseph. She has her head covered with a light, violet-colored drapery, and is wrapped in another blue drapery and a red tunic. Her left leg, elevated in front on a pedestal, reveals the sole of her bare foot: the child has his eyes turned toward the spectator, and holds in his right hand a goldfinch. This painting, of the noblest character, is one of his major productions, and a find of the greatest rarity. It comes from the sale of the Prince de Conti, no. 59, and sold for 3700 livres. It can serve as the pendant to the Virgin by Van Dyck.—Height, 56 inches; width, 40. [The "T." in fig. 3–1 stands for "Toile"—Canvas; the asterisk indicates the location at which the painting could be seen.]

Because the economical British, by contrast, kept their words to a minimum—nothing but the artist's name, in many cases, and a brief phrase following the lot number—a page from one of their catalogues looks much more like a list of picture titles. (Figure 3–2 comes from a London sale of 1783). Indeed, to the degree that titling is a form of shorthand that encourages the efficient circulation of the objects it identifies, the British practice may have anticipated that of the modern art world more generally, where even titles themselves—whether of visual or of verbal works—tend to grow shorter over time. Just as the long descriptive titles of eighteenth-century novels gave way to two- or three-word labels in the nineteenth, as Franco Moretti has demonstrated,[14] so the extended descriptions of the Continental cataloguers were gradually overtaken—if not quite replaced—by the brief phrase we call a picture title. (Such extended descriptions survive in catalogues raisonnés and, of course, in the writing of art history and criticism, but usually as a supplement to a title, rather than an alternative.) Yet the analogy with novels of the same period is far from exact—and not only because most of the novelists in question presumably had some say in how their works were designated. Unlike the person who titles a novel, whether writer or publisher, the British dealers were not necessarily engaged in providing a fixed way of

ECOLE D'ITALIE. 9

ECOLE D'ITALIE. 9

M. de Louvois, est d'une beauté et d'une per-
fection rares. — Hauteur, 54 pouces ; largeur,
39 pouces et demi. T.

AUGUSTIN CARRACHE.

4. La Sainte-Famille ; figures de grandeur
naturelle, et vues jusqu'au dessous des genoux:
la Vierge est assise, tenant sur elle l'enfant
Jésus, tandis qu'elle regarde Saint Joseph. Elle
a la tête couverte d'une légère draperie vio-
lette, et est enveloppée d'une autre drape-
rie bleue, et d'une tunique rouge. La jambe
gauche, élevée en avant sur un socle, laisse
voir la plante du pied qui est nu : l'enfant a le
regard tourné vers le spectateur, et tient de
la main droite un chardonneret. Ce tableau du
plus grand caractère, est une de ces produc-
tions capitales, et de la plus grande rareté à
rencontrer. Il vient de la vente de M. le Prince
de Conti, n°. 59, et vendu 3700 liv. Il peut
servir de pendant à la Vierge de Vandick.
— Hauteur, 56 pouces ; largeur, 40. T. *

PAR LE MÊME.

5. Une belle tête d'homme, portant mous-
taches, à cheveux courts et noirs. Il est vêtu
d'une draperie blanche, dans sa bordure de

3–1. Page from J.B.P. Lebrun, *Catalogue d'objets rares et curieux . . .* (Paris, 1791).

referring to the objects they were selling. Once a title is established, I shall argue, it can function as a proper name; but if we look closely at the entries in the London catalogue, we can see that they, too, are mostly descriptions, however abbreviated, and that the dealer (whose own name was Mr. Barford) had more interest in characterizing his wares than in naming them. He may have been less precise than his French counterparts, but he was still involved in the same kind of activity.

Notice, for one thing, how many of the entries begin with indefinite articles: "*An* old country woman sleeping," "*A* Madona [*sic*] and child," "*A* girl's head," "*A* girl's portrait," "*A* candle-light," etc. (emphases mine). This is the language of classification rather than of naming—language, like that of our Dutch notary, that aims to place the work among a group of similar objects rather than to distinguish this work in particular. Some of these classifica-

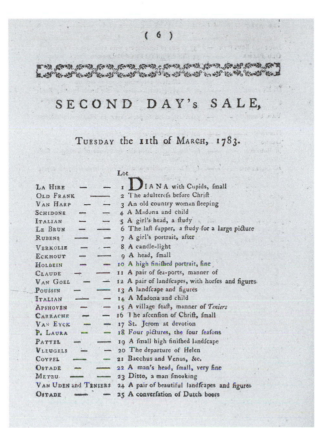

3–2. Page from *A Catalogue of a Capital, Genuine, and Valuable Collection of Pictures, of the late John Stewart. Esq. . . .* (London, 1783). Thomas J. Watson Library. Metropolitan Museum of Art, NY.

tions are genres we still recognize—"portrait" and "landscape," most notably—while others are more like subgenres ("A candle-light"), and still others are closer to the identification of motifs: "A Madona and child," "A village feast," "A conversation of Dutch boors." To this day, the distinctions among such classes remain blurry: contemporary scholars of Netherlandish painting might well speak of the latter two also as genres. Unlike Lebrun, Barford doesn't trouble to record the dimensions of his paintings, but he does occasionally characterize a work as "small," while terms like "fine," "beautiful," or "high finished" substitute for the more lavish appraisals the Frenchman offers his customers. Present convention would make clear where a title ends and evaluation or description begins, but no consistent practice, whether typographical or grammatical, marks off such adjectives from the rest of the entry.

(27)

Tintoret	——	90 CHRIST WASHING THE FEET OF THE APOS- TLES. RIDOLFI in the life of TINTORET, fays, he painted two pictures for the church of *St. Ennacora at Venice*, which fhewed him learned in his art: this is one of the fubjects defcribed; a copy of it has been put in its place
Palma, Junior	—	91 THE BATTLE OF JOSHUA. Much fpirit and ge- nius is difplayed in this grand compofition: the late proprietor very juftly efteemed it as the moft capita. picture extant of the mafter
Rubens	——	92 A WILD BOAR HUNTING. A fubject admirably calculated to difplay the unbounded genius of RUBENS, who animated all objects by the powers of his fancy— the compofition is truly noble, and replete with merit, to juftify its being efteemed one of his firft rate per- formances
Ditto	——	93 HERCULES AND OMPHALE. RUBENS in tafte and elegance here furpaffed himfelf; the colouring has all that fplendid richnefs, which no painter but himfelf ever yet acquired. From the collection of the late COUNT BRUHL at *Drefden*
Wouvermans	—	94 A MOST CAPITAL LANDSCAPE, with a royal chafe and the portraits of the *Prince and Princefs of Orange*. If an appeal is made to judgment and tafte, a more beautiful, correct, and extenfive fcene cannot be conceived; the fuperiority of this mafter's figures com- bine to render it an object worthy to grace a princely cabinet. It is in the higheft ftate of prefervation
Raphael	——	95 THE MADONA, INFANT CHRIST, AND ST. JOHN. This picture fufficiently proves the great fuperiority of RAPHAEL's admired tafte and elegance: the lovely fweetnefs and attention expreffed in the madona, the admiration in the St. John, the delicacy and beauty of the infant Jefus fleeping, all combine to render it *unique*
L. da Vinci	—	96 THE PORTRAIT OF MONA LISA, THE WIFE OF FRANCO DEL GIOCONDO. This por- trait, " SAYS VASARI, muft be feen to form an adequate idea how far art can be carried. When the beautiful

3–3. Page from *A Catalogue of the Capital . . . Collection of Pictures . . . late the Prop- erty . . . of Sir Joshua Reynolds . . .* (London, 1795). Beinecke Rare Book and Manuscript Library, Yale University.

One painting may be recorded as "Diana with Cupids, small," while another appears as "A small high finished landscape." And sometimes a collective term gathers several works under a single lot number, like the "two small paintings of musicians" in the Dutch inventory: item 11, for example, "A pair of sea-ports, manner of [Claude]"; or item 18, "Four pictures, the four seasons."

But if "A pair of beautiful landscapes and figures" (no. 24) is obviously not a title by modern standards, what about "The adulteress before Christ" (no. 2) or "The departure of Helen" (no. 20)? And what about "La Sainte-Famille"— the phrase with which Lebrun begins his entry on the Carracci painting quoted above? That surely looks like a title, especially since a semicolon marks it off from the text that follows (see fig. 3–1). Yet no title-like formula intro- duces Lebrun's next entry on the same painter, which plunges immediately

3–4. Page from *A Catalogue of . . . Valuable Pictures . . . the Property of the Right Hon. Charles Alexander de Calonne, Late Prime Minister of France . . .* (London, 1795). Yale Center for British Art, Paul Mellon Collection.

into description: "Une belle tête d'homme, portant moustaches, à cheveux courts et noirs" (A beautiful head of a man, sporting whiskers, with short black hair).

In other catalogues of the period, we can almost see titles emerging visually from the texts in which they are embedded, as dealers—or their printers—exploit typographical differences to highlight phrases that will at once identify and advertise their pictures. Note the use of capitals in a page from Christie's 1795 catalogue of Joshua Reynolds's collection, for example (fig. 3–3), or the roman typeface that appears to divide title from description in the catalogue of an important French collection issued by another London auction house that same year (fig. 3–4). So we have "HERCULES AND

OMPHALE" or "THE PORTRAIT OF MONA LISA, THE WIFE OF FRANCO DEL GIOCONDO" in the Reynolds catalogue; "Martha and Mary in the Kitchen" or "Rembrandt's Mother" among the pictures once owned by the late prime minister of France. On closer inspection, however, these already-made picture lists still inhabit the uncertain territory we have been examining. "A MOST CAPITAL LANDSCAPE" may be a fine advertisement for a painting by Wouwerman (fig. 3–3, no. 94), but it is not a title; nor, in the ordinary course of things, is "His own Portrait"—this last said to be the work of a painter "esteemed the Van Dyck of Holland" (fig. 3–4, no. 29).

In truth, these are all forms of description, or identification after the fact, even if some of them rely on the specialized knowledge that we now call iconography. What contributes to the title-effect in many of these cases is partly the definite article, which in designating a singular subject appears to designate the painting that represents it as well: "The adulteress before Christ," "The departure of Helen," "The Holy Family." ("A Holy Family" is a type of picture, but "The Holy Family" seems to name both subject and painting alike.) So, too, with the way that proper names identifying the figures in a history painting or portrait can double as the name of the painting itself: "Hercules and Omphale," "Amnon and Tamar," or—most obvious of the examples cited above—"Mona Lisa." Strictly speaking, of course, the Reynolds catalogue registers a difference between person and picture by calling the latter "The Portrait of Mona Lisa," but the very fact that the name alone would make most twenty-first-century readers think first of the painting rather than the person suggests how hard it can be to preserve such distinctions. Like other proper names, that of "Mona Lisa" has been passed down from link to link in a chain of communication that in this case stretches back to Giorgio Vasari's *Lives of the Artists* (1550–68);[15] and though Vasari's gossip is not always reliable, there is no particular reason to question his identification of Leonardo's sitter. But while it would be meaningless to say that the person named Lisa Gherardini should really have been called Marie, the very possibility that the painting known as the *Mona Lisa* could turn out to be the portrait of another woman makes clear that its proper name still entails a description. At the same, however, the history of picture titles also makes clear that with a painting as famous as this one, even an erroneous name will eventually behave like a proper one—which is to say that it will continue to identify the image long after its accuracy has been called into question. As we shall see, once a title has circulated widely enough, the middleman who named the painting after the fact might as well have been present at the baptism.

[4 · ACADEMIES]

Public arrangements of pictures for display rather than sale became an eighteenth-century phenomenon. Yet conventions for identifying such pictures remained as unsettled whether people were being invited simply to look or encouraged to purchase. When Chrétien de Mechel published his account of Vienna's imperial gallery in 1783–84, he adhered to the practice of describing the pictures in some detail (fig. 4–1). But revolutionary politics meant that the first cataloguers of the Muséum français (1793) could not afford the luxury of taking anything like the five years Mechel devoted to his project; and the shorthand that resulted suggests once again how the need for efficiency has helped to determine modern conventions for identifying pictures (fig. 4–2).

Like the authors of other such documents, the compilers of this catalogue presumably drew in their turn on the language of earlier inventories and on any notations that previous middlemen had marked on the pictures themselves. How they thought of that language is not recorded. But when the Grande Galerie of the Louvre was closed for repairs a few years later, and plans were underway for parts of the collection to hang for the duration in the Salon instead, those charged with organizing the exhibit had also to arrange for a new *livret* to accompany it. "In order to avoid the inconvenience of changes," the minutes of the Conservatoire reported in 1796, "the titles of the paintings [*titres des tableaux*] to make up the Catalogue can only be listed once the paintings are in place."[1] To the best of my knowledge, this is the earliest evidence that the kinds of descriptions we have been examining had begun to morph into "titles."

The particular worry faced by the Conservatoire on this occasion was hardly new. The officers of the Académie had confronted a similar tension between words and images ever since they began to issue *livrets* to accompany the biennial exhibits of members' work in the same Salon. If they waited

39

ÉCOLE FLAMANDE. 91

DE FERDINAND BOL.

29. Un Philofophe lifant dans un gros livre pofé fur une table, fur laquelle on voit plufieurs manufcrits, un globe & une tête de mort.

Sur bois. Haut de 1 pied 5 pouces ; large de 1 pied 1 pouce.

Petite figure.

DE LÉONARD BRAMER.

30. La Fragilité des chofes humaines repréfentée par un tas de débris d'uftenciles, d'armes, de cuiraffes, &c. au milieu defquels on voit un Philofophe tenant un écriteau, fur lequel on lit : *Memento mori* , & auquel un fquelètte préfente une tête de mort.

Sur bois. Haut de 2 pieds 6 pouces ; large de 1 pied 10 pouces.

Petites figures.

* DE RIMBRANDT.

31. Le Portrait de Rimbrandt lui-même où il s'eft repréfenté dans un âge plus avancé qu'au No. 21. Il eft vêtu d'un pourpoint rouge avec une peliffe brun-foncé par-deffus : fa tête eft couverte d'un grand chapeau rond.

Sur toile. Haut de 1 pied 6 pouces ; large de 1 pied 3 pouces.

Bufte , grandeur naturelle.

DE RIMBRANDT.

32. Le Portrait d'un homme de qualité , la tête couverte d'une toque de velours. Il eft peint dans une guirlande de fleurs de la main de *Daniel Seghers*.

Sur bois. Ovale. Haut de 1 pied 11 pouces ; large de 1 pied 9 pouces.

Petit Bufte.

4–1. Page from Chrétien de Mechel, *Catalogue des tableaux de la Galerie impériale et royale de Vienne* (Basel, 1784).

until a hanging was complete in order to print the *livret*, the public complained about navigating the opening days without a guide; if the *livret* was printed in advance, it often failed to correspond to the sequence in which the pictures were exhibited. The earliest Salon *livrets* simply followed the physical arrangement of the display around the room. Beginning in 1740, the Académie had experimented with a variety of formats to address the problem, first by attaching numbers to the paintings and other works so that they could be rearranged at the last minute and still be identified by number in the text, and later by subdividing the *livret* into the "general divisions" of painting, sculpture, and engraving, so that the number of a particular work could be located more easily.[2] (Previous *livrets* had been organized by the academic

16

REMBRANT.

60. Un philosophe en méditation.
H. 9 po. L. 1 pi.

SUBLEYRAS.

61. La Madeleine aux pieds de Jésus
chez le Pharisien.
H. 8 po. L. 1 p.. 11 po.

REMBRANT.

62. Un philosophe lisant.
H. 9 po. L. 1 pi.

LE GUIDE.

63. Une vierge dite la Couseuse.
H. 8 po. L. 6 po. 6 l.

GÉRARD D'OW.

64. Le marchand de gibier.
H. 10 po. L. 8 po.

N. POUSSIN.

4–2. Page from *Catalogue des objets contenus dans la galerie du Muséum français . . .*
(Paris, 1793).

rank of the artist, without regard to genre.) With the advent of the Revolu-
tion, the format changed repeatedly, as the organizers struggled to accom-
modate the shifting rules for who was entitled to exhibit and to avoid invidi-
ous distinctions by listing names alphabetically, for example, within the
generic subdivisions of the catalogue.

The details of these arrangements need not concern us here. But what is
worth remarking is how these protracted struggles with the *livret* testified to
the public's dependence on the document. As the official notice put it when
the Académie announced that publication would no longer be delayed until
after the Salon's opening, "we became aware that the Public was growing ex-
tremely impatient during the first days while it awaited this Explication."[3]

Between the relatively arcane subject matter of much academic painting in the period and the practice of hanging large canvases so high that their details were scarcely decodable (see fig. P-2), the *livret* must indeed have seemed indispensable for all but the most sophisticated of spectators.[4]

There is some evidence that the Académie did entertain the alternative of placing inscriptions directly below the paintings themselves: the Salon of 1738 briefly experimented with labels for artists and their subjects,[5] while an argument in support of the practice was delivered to the assembled academicians in 1751 and met with apparent approval by the current director, Charles-Antoine Coypel. But there is no indication that the experiment of 1738 was ever repeated—and this despite the fact that the minutes of the later discussion drive home just how word-dependent academic painting was expected to be, as when Coypel argued that routinely adopting such inscriptions would enable artists to avoid being attacked for getting things wrong if they chose to illustrate a literary work that had tinkered with history for imaginative purposes. As for the less educated, Coypel observed, those of good faith would be happy to have the assistance, and those who feared revealing their ignorance would be spared having to ask embarrassing questions.[6] Such viewers might also have been spared the need to shell out a dozen sous for the *livret*—a consideration that Coypel did not mention, but which probably explained the Académie's reluctance to pursue an experiment that would have deprived it of a reliable source of income.[7] Whatever the motive, most paintings continued to be produced without words attached; and absent any other means of identifying the images—recall that the crowded hangings of the period left no space on the walls themselves—the majority of Salon-goers evidently relied on their *livrets* to navigate their way through the exhibit. Although it did not take long for the practice to become a subject of mockery, as critics attacked both artists and viewers for depending so heavily on the mediation of print, the *livret* would continue to dominate the experience of Salon attendance well into the nineteenth century.

The members of the Conservatoire in 1796 were mostly artists themselves; and by the time they undertook to produce a *livret* for the temporary exhibit at the new museum, they would have been long familiar with the genre. But there was a crucial difference between the display they were arranging—a selection of Old Masters that had been acquired by French monarchs over several centuries—and the biennial Salons in which members of the Académie had exhibited their work to the public. Unlike the catalogue of the former royal collection, the Salon *livrets* documented the work of living artists, who presumably had some say in how their work was identified. No significant distance, whether geographical or temporal, separated the compilers of

these already-made picture lists from the intentions of the pictures' creators. Surely here, one might think, is the decisive break in this history: the moment at which the printed record coincides with the language of painters themselves, and the true title emerges from the belated interventions of middlemen.

The twenty-first-century painter who inscribes a title on the verso of her canvas before shipping it off to a dealer or museum adheres to a custom whose origins can indeed be glimpsed in the practice of the Académie some three hundred years earlier, when painters first submitted their work in the knowledge that it would be immediately identified in print. The very fact that a *livret* could bear witness to works announced yet not delivered—in one case the compiler responded by leaving several entries blank in a second edition—suggests that the initiative for such verbal notice rested at least in part with the artist.[8] In the possibility of seizing that initiative, I shall argue, lay an occasion for authorship that some artists would exploit quite aggressively, as they acted to shape their work's reception by choosing the language by which it would thenceforth be identified. It is difficult to specify the moment when such authoring first became the norm of painterly practice rather than an exception, but Jacques-Louis David was in this, as in many ways, a pioneer; and in a subsequent chapter, I shall return to the case of the painting known in English as *The Oath of the Horatii*—a painting entered in the *livret* of 1785 as "Serment des Horaces, entre les mains de leur Pere" (*sic*). Yet the relation between artistic authorship in this sense and the text of a *livret* or Royal Academy catalogue is far from straightforward; and it is only very gradually—and unevenly—that we can see something like modern practice emerging from earlier modes of describing and classifying.

The *livret* itself appears to have been compiled by an individual academician assigned to the task;[9] and for much of the century, the evidence suggests, most artists were content to leave the precise wording of the entries to him. Though some short entries are indistinguishable from modern titles, in many more the voice of the text remains that of someone describing the paintings in question rather than recording the language of others: pictures are characterized as "representing" a particular subject rather than given a name as such, and terms for physical properties of the canvas mingle indiscriminately with those for the representation itself. So, for example, the *livret* for 1753 lists seven entries for "M. [Jean-Baptiste-Siméon] Chardin, Conseiller de l'Académie," each of which begins by registering the presence of the physical object before going on to note what the object represents: item 60 is "Un Tableau représentant un Philosophe occupé de sa lecture" (A Picture representing a Philosophe occupied with his reading); item 61, "Un petit Tableau représent-

ant un Aveugle" (A small Picture representing a Blind Man); item 62, "Autre, représentant un Chien, un Singe & un Chat, peints d'après nature" (Another [i.e., another small picture], representing a Dog, a Monkey, and a Cat, painted after nature). By comparison to the entries for some ambitious history paintings, those for genre or still life were typically brief, though even such pictures might elicit several lines, as did Chardin's first contribution that same year:

> 59. Two Pendant Paintings, under the same number. One represents a draftsman working from the Mercury of M. Pigalle, and the other a young Girl who is reciting her Gospel. These two paintings, taken from the Cabinet of M. de la Live, are copied after Originals placed in the Cabinet of the King of Sweden. The Draftsman is exhibited for the second time, with some changes.[10]

Had the Académie in fact adopted the recent proposal to place inscriptions below the paintings themselves, space constraints might have produced something that looked more like titles, but the format of the printed text apparently imposed no such restrictions. Though the earliest *livrets* had been officially designated as "lists" of the works on exhibit—and most entries were comparatively short—the heading for the volume issued when the Salons resumed in 1737 was *Explication des peintures, sculptures et autres ouvrages . . .* ; and with a few variants during the Revolution, it was as *explications* that the *livrets* continued to appear well into the nineteenth century.

Just who determined the form those entries would take is far from clear, however. For obvious reasons, complex allegories often came with elaborate explanations, though not all entries recorded in the *livret* as "allégories" received them. One long account of "an allegorical sketch" in terra-cotta submitted by the sculptor Lambert-Sigisbert Adam to the Salon of 1750 ended by announcing, "The author wished that this Description be thus set out."[11] Yet if in this case the "author" of artwork and text was evidently one and the same, the very specificity of the *livret*'s pronouncement suggests that in many other cases the painter or sculptor was not so exacting. Was it always the artist who decided to explicate an image with an apposite quotation from a literary source, or was the relevant learning sometimes that of the fellow academician charged with compiling the *livret*? Since Coypel was a dramatist as well as a painter, it seems likely that he himself chose the extract from Racine's preface and composed the summary of the relevant scene when he submitted a picture based on the latter's *Athalie* to the Salon of 1741. Yet the *livret* for that year is among those credited to Jean Baptiste Reydellet, whose name had begun to appear at the end of the volumes a year after the Salons

l'Expofition des différens Ouvrages qui font l'objet des travaux de l'Académie?

En ordonnant cette Expofition, SA MAJESTÉ donne un témoignage glorieux à l'Académie de fon attention à la perfection des Arts qu'Elle cultive: quel nouveau motif pour Elle de redoubler fes efforts pour répondre aux vûes d'un Prince dont l'approbation eft le gage le plus certain de l'immortalité! Objet qui, en faifant naître les Arts, eft leur plus flateufe récompenfe.

Par M. *Coypel*, ancien Profeffeur, Ecuyer, Premier Peintre de Monfeigneur le Duc d'Orléans.

Nº 1. Un grand Tableau pour le Roy, en largeur d'environ 22. pieds fur 11. de haut, répréfentant Armide, qui voulant poignarder Renaud, va céder à l'Amour prenant ce Heros fous fa protection; la fuite de ce dieu rit de la colere de l'Enchantereffe & célebre d'avance le triomphe de fon Maître. Comme ce Tableau a déjà paru en petit, on a crû devoir fe fervir de la même defcription.

2. Autre en largeur de cinq pieds fur quatre. « Athalie entreprit d'éteindre entierement la race Royale de David, en faifant mourir tous les enfans d'Okofias, fes petits-fils; mais heureufement Jofabeth, fœur d'Okofias & fille de Joram, [mais d'une autre mere qu'Athalie], étant arrivée lorfqu'on égorgeoit les Princes, fes neveux, elle trouva moyen de dérober du milieu des morts le petit Joas encore à la mammelle, & le confia avec fa nourrice au Grand Prêtre, fon mary, qui les cacha tous deux dans le Temple, où l'enfant fut élevé fecrétement jufqu'au jour qu'il fut proclamé

Roy de Juda. » (Préface de la Tragédie d'Athalie).

Voilà en peu de mots le fujet de la plus belle Tragédie du célebre Racine. On a tâché de rendre en Peinture le fpectacle de la Scene VII. du fecond Acte de cette Piece, où Jofabeth, pour obéir aux ordres d'Athalie, luy préfente en tremblant Joas fous le nom d'Eliacin, & revêtu d'un fimple habit de Levite.

Athalie reconnoît avec terreur dans les traits de ce jeune Prince, ceux d'un enfant qu'elle a vû en fonge, prêt à la poignarder, & cependant elle ne peut s'empêcher d'admirer fa grâce & fa nobleffe. Zacharie & Salomith, enfans du Grand Prêtre & de Jofabeth, accompagnent leur mere. Abner, l'un des principaux Officiers des Rois de Juda, eft auprès d'Athalie. La Scene fe paffe dans un Veftibule de l'appartement du Grand Prêtre.

3. Autre, de même grandeur, repréfentant Jofeph reconnu par fes Freres.

Par M. *Tournière*, ancien Profeffeur.

4. Un Tableau repréfentant le Portrait jufqu'aux genoux, de Monfeigneur de Briffac, Evêque de Condon.

5. Autre, de même grandeur, repréfentant M. le Comte de Coffé, Colonel du Régiment Royal Piedmont, & Brigadier des Armées du Roy.

6. Autre de même grandeur, repréfentant Madame Coufin & M. fon Fils : ce Tableau a pour fujet l'éducation de Télémaque par Minerve.

7. Autre de forme plus petite, repréfentant M. Moreau de Maupertuis, Penfionnaire de l'Académie Royale des Sciences, en habit de Lapon.

4–3. Pages from *Explication des peintures* . . . (Paris, 1741). Sterling Memorial Library, Yale University.

resumed in 1737; and it seems suggestive, if by no means definitive, that this is the first of the texts that he is explicitly said to have edited (*rédigé*) rather than simply to have compiled (*recueilli*). How much writing or rewriting that work entailed remains a mystery.

Whoever composed the entry for Coypel's painting, he was not really engaged in titling it. The paragraphs devoted to it are wholly discursive: though they certainly identify the picture's subject, there is nothing in their language or format to mark out a particular phrase as a title (fig. 4–3). The Musée des beaux-arts de Brest, where the work now hangs, calls it *Athalie interrogeant Joas*. Other entries more nearly resemble the wall labels we are accustomed to see in a modern museum, in which a brief phrase summarizing the action of a history painting or identifying the locale of a landscape is followed by a paragraph or more that further explicates the image in question. To our eyes, such entries may appear to suggest a dual origin—as if the painter had submitted a title-like phrase and the *livret*'s compiler had chosen to supplement

12 PEINTURES.

douleur, lui prend la main, & femble fe plaindre aux Dieux de la mort de fon époux; Aftianax, conduit par fa nourrice, tend les bras à Andro-maque fa mere, qu'il voit éplorée : Pâris & Hélène craignant les reproches, fe tiennent à l'écart der-riere Andromaque; & Caffandre, qui a prédit tous ces malheurs, paroît s'être jettée fur une des roues du char, arrêté à la porte de Troye; le corps du Héros eft repréfenté dans un état de confervation, qu'il devoit aux foins de Vénus & d'Apollon.

Ce Tableau, de 13 pieds de large fur 10 de haut, eft ordonné pour le Roi.

ADJOINTS A RECTEUR.

Par M. *de la Grenée*, l'aîné, Directeur de l'Académie de France à Rome, Membre de l'Académie de Saint-Pétersbourg, Honoraire de celle de Touloufe, Adjoint à Recteur.

2. Mort de la femme de Darius.

Alexandre, averti par un Eunuque que la femme de Darius venoit d'expirer, quitte le cours de fes expéditions Militaires, vient au pavillon de Sifi-gambis, qu'il trouve couchée par terre, au milieu des Princeffes éplorées, & près du jeune fils de Darius, encore enfant; Alexandre, accompagné d'Epheftion, les confole & partage leur douleur.

Ce Tableau, de 13 pieds de large, fur 10 de haut, eft ordonné pour le Roi.

3. Ubalde & le Chevalier Danois.

Charles & Ubalde allant chercher Renaud retenu

PEINTURES. 13

dans le Palais d'Armide, rencontrent des Nimphes, qui les engagent à quitter leurs armes, & à fe rafraîchir avec des fruits qu'elles leur préfentent. Mais Ubalde, muni de la baguette d'or que la fage Méliffe lui a confiée, & averti par elle du danger de céder à leurs perfides careffes, diffipe par cette même baguette, les preftiges enchanteurs qu'Armide avoit fait naître fur leur paffage, pour les empêcher de lui enlever fon amant.

Tableau de 4 pieds 4 pouces de large, fur 3 pieds 2 pouces et demi de haut.

PROFESSEURS.

Par M. *Amédée-Vanloo*, Peintre du Roi de Pruffe, Profeffeur.

4. La Fille de Jephté allant au-devant de fon pere.

Jephté avoit fait vœu, s'il remportoit la victoire fur les Ammonites, d'immoler à Dieu le premier qui s'offriroit à lui, en arrivant dans fon Palais. Sa propre fille, informée de fa victoire, court au-devant de lui, fuivie de fes femmes, jouant des inftrumens. Le pere déchire fes vêtemens, tombe dans les bras de fon Ecuyer, & fa fille fe préci-pite à fes pieds, pour apprendre la caufe de fa douleur.

Ce Tableau, de 10 pieds de haut, fur 8 de large, eft ordonné pour le Roi.

XXXIII 2

4–4. Pages from *Explication des peintures* . . . (Paris, 1785). Sterling Memorial Library, Yale University.

it with a fuller description (fig. 4–4). Yet the effect may be an illusion produced by the formatting, rather than a reliable clue to the division of responsibilities between painter and middleman. Despite a tendency for this format to become somewhat more typical in the later decades of the century, no consistent pattern emerges to mark the advent of artistic authorship.

It is not really surprising that members of the Académie appear not to have worried this issue too closely. Membership was, after all, restricted to a small elite; and by the time a painter had been admitted to its company, there had been considerable opportunity for formulating a shared understanding of the images he—or the occasional she—had produced. Minutes of the Académie's early years suggest that it began by inviting aspirants to provide advance notice in writing of the works they intended to present for approval. A resolution of November 1659 announced that "no one shall present either the sketch or the painting that he has been ordered to make without informing the Company by billet and giving notice of the subject." Four years later the

minutes record that in order to encourage "emulation" among its members, the Académie had decided that painters competing for a prize on the general theme of the heroism of the king should be granted the freedom to submit what they wished, provided that they let it be known as soon as possible what particular subject they had chosen.[12] In 1682 artists who intended to present allegorical works for their so-called *morceaux de reception* (pieces qualifying their makers for admission) were instructed to provide a "petit mémoire" explaining the subjects to be expressed in their pictures.[13]

Yet for every indication that the initiative for choosing subjects—and explaining them—had shifted to the artist, there are many more that speak to the institutional context in which the identification of pictures was articulated. By 1685 members seem to have been gathering routinely for an "explication allégorique" delivered by one academician on the work of another.[14] Throughout the century that followed, the minutes reflect an institution that had developed numerous procedures for establishing a consensus as to how its collective work was to be understood. An occasional applicant for admission—Antoine Watteau is probably the most famous—was still invited to determine the subject of his own *morceau de reception*.[15] But such gestures were far outweighed by the Académie's custom of assigning pictorial subjects—assignments that were issued collectively for the annual prize competitions among its students and individually for the painters and other artists who presented themselves as candidates for membership. Subjects for student prizes, typically scenes from the Old Testament, were duly spelled out in the minutes; those for particular *morceaux de reception* appeared more erratically. Sometimes the secretary recorded the subject of an individual reception piece in advance (the subjects of portraits were always thus registered); more often he simply noted that an aspirant had been referred to the current director, who would issue the assignment. Frequently, but not always, the minutes would specify the picture's subject when the aspirant had returned with a sketch or with the finished painting whose approval constituted formal admission to the Académie.

Unlike the *livrets*, the Académie's minutes were not intended for public consumption, and there was no need to develop a systematic practice of recording the images in such a way that outsiders could recognize them. What matters for our purposes is the comparative standardization of academic subject matter to which the minutes testify and the many opportunities members had to familiarize themselves with one another's work in advance of the public exhibits. Regulations formulated in the 1740s in fact required that Salon pieces be brought in beforehand in order to assure that they merited display, though it is not clear that the rule was always observed. Since only academicians and registered candidates for membership were permitted to

show their work at the Salons, those charged with compiling the *livrets* might well have believed themselves able to characterize it. The precise balance between artistic initiative and editorial practice doubtless varied from case to case; but as long as the Académie remained a comparatively closed institution, the question of how to identify an individual work would rarely register as a problem.

Indeed, it was only when the Revolution effectively disrupted this consensus that the record began to reflect an anxiety about the identification of works to be submitted for exhibit. The minutes for 1790 register not only a struggle for power between the Académie's officers and a faction led by David, but the first open acknowledgment since the seventeenth century that the burden of verbally identifying a work of art rested with its creator. Having determined that it could no longer afford the printing costs of the *livret* supplement that traditionally listed late submissions, the beleaguered Académie ruled that thenceforth artists who failed to announce their pieces in time would be obliged to inscribe the relevant information on the objects themselves.[16] The following year, the National Assembly decreed that future Salons would be open to all comers.[17] The last *livret* under the monarchy had 350 entries; under the Assembly, the count more than doubled. (The Académie itself was officially abolished in 1793.) By 1796 the distance between the volume's compiler and the over 800 works on exhibit had evidently become so great that it could be traversed only by an explicit statement of intent from the artists themselves. For the first time, the official notice at the beginning of the text invited artists "to propose to the Conservatoire that which they think useful to insert or to cut in the *livret*, so that one can find there what will promote the arts and enlighten art-lovers [*amateurs*] and what can be found nowhere else." Together with their names and addresses, the names of their masters, and whether they owned the works in question, artists were enjoined to include a precise account of each piece:

> In works of history or genre, the action shall be specified. In the historical narrative that the artist sends in, he shall indicate the real action of the painting, by underlining the passage that particularly designates this action or the moment of the action. By this means, when the editor gives the extract from the historical narrative he will be sure to state the true subject of the picture.[18]

Had the members of the Conservatoire explicitly spoken here of "les titres des tableaux," as they had done when compiling the exhibit of Old Masters at the Louvre that same year, it would be tempting to proclaim 1796 as the

birth date of the French picture title. History, of course, is messier than that;
and in asking that artists specify an action or underline a crucial passage, the
compilers of the *livret* were not so much inaugurating a new requirement as
formalizing one that had been more or less implicit all along. But if this an-
nouncement does not mark a complete break with earlier practice, it none-
theless registers an important shift. An official request for this information
was reiterated in urgent terms at the opening of the *livret* for the next Salon
two years later, with an additional warning about the importance of keeping
the account of a picture's action short and to the point.[19] The democratization
of the Salon meant that it was not only the public who needed help in iden-
tifying what was on view. The more heterogeneous the art world, the greater
the need for titles.

Something of the same trajectory, though on a shorter timescale, can be
traced in Britain as well. The Royal Academy was founded in 1768; and for
the next thirty years ads in the London newspapers announcing its annual
exhibits simply invited artists who wished to participate to submit their
works by a specified date. (The only restrictions were no copies, nor any pic-
tures without frames.) It was not until 1798 that the ad explicitly began to
ask entrants to provide the wording that should accompany their submis-
sions: "The Artists are desired to send in their several Performances, properly
framed, &c. with the Descriptions in writing, and the Names of the Portraits
(for insertion in the Catalogue)."[20] Yet the near coincidence of this change
with the analogous one in France masks a significant difference in institu-
tional cultures. Unlike the French, the Royal Academy in Britain had always
permitted nonmembers to participate in its exhibits: hence the announce-
ment in the newspapers. And unlike the French, who consistently determined
to keep their academy aloof from commerce, the British included works for
sale in their exhibits from the start.[21]

The combined effect of these differences may help to explain why even in
its early years the Royal Academy catalogue more nearly resembled a list of
titles than did its French equivalent (fig. 4–5). While the *livret* frequently
indulged in page-length *explications* of individual works, the British cata-
logue typically confined itself to brief notations of the items on display, whose
title-like efficiency calls to mind the related preference of British auction
houses for short, commercially functional ways of identifying their wares.
(Works available for purchase after the exhibit were marked in the catalogue
with an asterisk.) The fact that British artists produced many more por-
traits—and far fewer allegories—than their French counterparts would have
encouraged this habit of brevity, even if it also meant that numerous entries

[15]

EDWARD PENNY, R.A.
Professor of Painting to the Royal Academy, Charlotte-street, Rathbone-place.

142 Imogen discovered in the cave. Cymbeline, Act 3.

MAT. WILLIAM PETERS,
Welbeck-street, Cavendish-square.

143 A girl making lace.

BIAGIO REBECCA,

144 A tablet, a chiaro oscuro.

Sir JOSHUA REYNOLDS, R.A.
President of the Royal Academy, Leicester-Fields.

145 The portraits of two gentlemen.
146 Ditto of a lady and child. } whole lengths.
147 Ditto of a child.
148 A lady, half length.
149 The children in the wood.
150 A portrait of a gentleman.
151 Ditto. } three quarters.
152 Ditto.

JOHN RICHARDS, R.A.
Tavistock-row, Covent-garden.

153 * A landscape and figures.
154 * A piece of ruins.
155 * A view of Oakhampton castle in Devonshire.

MICHAEL ANGELO ROOKER,
Queen's-court, Great Queen-street.

156 A view of Buildwas Priory, in the county of Salop.

4–5. Page from catalogue for the second exhibition of the Royal Academy (London, 1770). Yale Center for British Art.

in the catalogue were so generic as to render their authorship moot. The Academy's catalogues weren't always as laconic as this example suggests, particularly in those years when artists were permitted to submit extracts from poetry and other texts to elucidate their entries. But the contrast with the *livrets* remains very marked.

For members of the Academy, and especially for its officers, the requirement to submit "Descriptions in writing" may well have operated quite loosely, even after that requirement was made explicit at the close of the century. As the institution's president, Joshua Reynolds presumably had as much say over his catalogue copy as he wished; but would he really have needed to inform the secretary that item 148 in the 1770 exhibit was "A lady, half length," or item 150, "A portrait of a gentleman, three quarters"? That Reynolds and his fellow academicians were apparently content when some works appeared simply as "Ditto"—a shorthand often adopted in inventories and other commercial records—also suggests that they weren't overly concerned about such matters. While it seems likely that most entries would have had at least the artist's sanction, it is far from obvious that everyone

who chose to exhibit at the Royal Academy took advantage of the opportunity for authorship.

Nor is it obvious when British artists began to think of verbally identifying their pictures as titling. By the middle of the nineteenth century, as we shall see, viewers on both sides of the Channel took for granted that paintings had titles and that artists supplied them. But it was not until 1875—more than a century after its founding—that the Academy formally altered its instructions and invited painters to inscribe "a Title *or* Description of the Picture" (my emphasis) at the back of each frame. Despite this change, entrants were still told to accompany their submissions with "a note . . . describing them as they are meant to be inserted in the Catalogue"—a formula that had first appeared in 1819 and remained unaltered until 1885, when it was replaced by instructions that officially treated "Titles" themselves as part of the catalogue copy.[22] No doubt institutional inertia helps to explain why it took so long for the Academy to catch up with popular understanding of its practice. But the lag time also underscores just how slowly and unevenly the authorial title emerged as the default language by which a painting was to be identified. Even in our own day, the work of naming pictures often remains—as it began—the province of middlemen.

[5 · PRINTMAKERS]

It is to one kind of middleman in particular—the printmakers—that we probably owe the very idea of a painting's "title" in the first place. Prints had titles before paintings themselves did; and at least since the middle decades of the eighteenth century, the French had been accustomed to speaking of the *titres* that engravers had bestowed on them. The idiom first appears in the Académie minutes for December 1737, when the secretary used it to record an inscription on a reproductive print that had been submitted by the engraver Jean Moyreau after a painting by the seventeenth-century Dutch artist Philips Wouwerman. "M^r *Moyreau*, Académicien, a présenté à la Compagnie deux épreuves d'une planche qu'il a gravée d'après *Vovremens*," the minutes report, "ayant pour titre 'Quartier de rafraichissement.'"[1]

There was nothing particularly unusual about this episode. Unlike the Royal Academy in Britain, which would long resist the admission of engravers, the French had accorded them membership since the middle of the seventeenth century, and Moyreau was only the latest of a series to present the company with a sample of his work so that it could receive official approval.[2] Though he had been assigned a reception piece the previous year based on a painting by another academician, Moyreau had initially made his bid for consideration with a print after Wouwerman; and he would go on to specialize in that artist for a number of years to come, eventually publishing a series of eighty-nine engravings after Wouwerman's work. Nor is there anything remarkable about the language with which Moyreau had chosen to label this particular print, which showed several cavalrymen and assorted followers drinking and otherwise disporting themselves at a tent encampment (fig. 5–1). But while the minutes of the Académie had occasionally alluded to the "title" of a lecture or a book, this is the first instance in which they employ that idiom for a work of visual art.

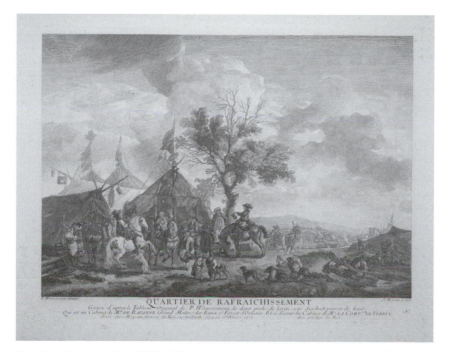

5–1. Jean Moyreau after Philips Wouwerman, *Quartier de rafraichissement* (1737). Engraving. From Moyreau, *Oeuvres de Phpe. Wouvermens hollandois* (Paris, 1737–[80?]). Beinecke Rare Book and Manuscript Library, Yale University.

Over the next decades, however, "titre" and variants like "intitulé" (entitled) appeared with some frequency in the secretary's recording of images and always in connection with reproductive prints. There are many more allusions to the prolific Moyreau and his engravings after Wouwerman, but "titles" also show up for prints after other seventeenth-century painters—most notably, Rembrandt—as well as a range of contemporary French artists, from still-famous figures like François Boucher and Chardin to more obscure academicians like Jacques de la Joüe and Nicolas Vleughels. Apart from Moyreau, the printmakers include Charles-Nicolas Cochin, Louis Surugue, Jacques-Philippe Le Bas, and F. B. Lépicié—the last of whom was serving as the Académie's secretary when he twice recorded the presentation of his own prints after Chardin as having the "titre" of "la Gouvernante" (1740) and "La Mère Laborieuse" (1741), respectively.[3] Though such titles would typically be entered in the *livrets* when the prints were exhibited at the Salons, the word itself occurs there very rarely. I have identified only three occasions in the

eighteenth century when a *livret* explicitly refers to a picture's "title"; but the first two of these, both in the 1770s, also concern reproductive prints. Not until 1796 is a painting at the Salon said to have a title.[4]

Even in the minutes, of course, this new idiom didn't suddenly displace all its predecessors. Often the secretary continued to note what engravings represented or briefly described their subject matter, despite the fact that the work in question almost certainly carried an inscription. So Le Bas's reception piece of 1743, for example, appears in the minutes as "un morceau d'après M. *Lancret*, dont le suject représente une conversation galante," though the print itself clearly displays the last two words as its title (fig. 5–2).[5] And just because some academicians began intermittently to adopt this new idiom in 1737 is no reason to assume that the entry for Moyreau's engraving represents the first time that the French—or Europeans generally—began to think of an image's title.[6] Both the French *titre* (originally *tiltre*) and the English *title* derive from the Latin *titulus*, a word meaning inscription or label that had been associated since classical times with the lettering inscribed on a work of art. The use of the word for the label of a book, in fact, actually derives from this earlier sense. But it is precisely because the history of painting since the Renaissance had tended to divorce word and image that the titling of reproductive prints made a difference. With a few exceptions, the images themselves had no inscriptions. Those who wished to multiply and publish the images supplied them.

The birth of the modern picture title is thus intimately connected to the history of print. Though woodcuts on paper had in fact antedated Gutenberg's invention, the technological revolution whereby text and image could be easily reproduced on a single page meant that increasing numbers of such pages had been circulating through Europe since the last decades of the fifteenth century. Whether in the form of single leaves or as illustrations to printed books, the rapid proliferation of these "imagetexts," to adopt W.J.T. Mitchell's coinage,[7] afforded numerous occasions for construing the words adjacent to an image as its caption or title. While early modern engravers often collaborated with painters in order to publicize the latter's designs, the evolution of the self-consciously reproductive print—one intended as a faithful imitation of a painted original—took somewhat longer. In their magisterial history of the Renaissance print, David Landau and Peter Parshall date this change roughly to the mid-sixteenth century in Italy and associate it with an important shift in the collective understanding of artistic creativity. As long as pictorial *inventio* was primarily located in the structure of a composition, they argue, an engraver could "borrow piecemeal" from it without thereby "destroying [its] integrity." Only when such *inventio* came to be iden-

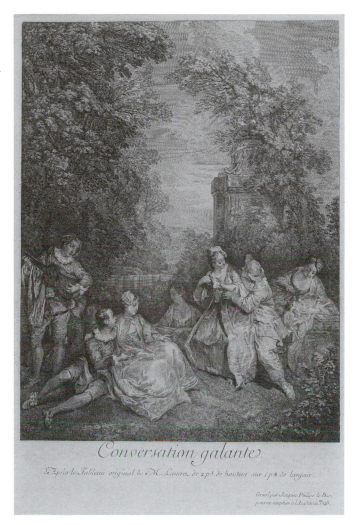

Conversation galante.

5–2. Jacques-Phillipe Le Bas after Nicolas Lancret, *Conversation galante* (1743). Engraving and etching. Print Collection, Miriam and Ira D. Wallach Division of Art, Prints, and Photographs, The New York Public Library, Astor, Lenox and Tilden Foundations.

tified with the unique painting in all its complexity—not just the work's structure but tonal values and brushstrokes, subtleties of movement and expression, and the like—did the engraver's role correspondingly shift and the fully reproductive print emerge. Rather than adapt elements of the painter's composition to his own ends, the engraver now set out to emulate the other's work as fully as possible in a different medium.[8]

Landau and Parshall offer an "undistinguished" print of Raphael's *Trans-figuration* published in 1538 as the first dated example of such consciously reproductive printmaking. Though that print carried an inscription—including the name of the painter, the location of the picture, and the name of the publisher—it did not yet carry a title. Nor, for that matter, did it identify the engraver.[9] But the presence of the inscription underscores the crucial fact that prints, unlike easel paintings, conventionally have a title space; and by the time that Moyreau and his fellow engravers were submitting their work to the Académie two centuries later, they and their publishers had become accustomed to filling it.

Even when an artist deliberately created images to be engraved, as did Pieter Bruegel the Elder, for example, the verbal identification of the images typically fell to others. In Bruegel's case, most of his inscriptions have been attributed to his Antwerp-based publisher, Hieronymus Cock, who in turn may have hired writers to compose them. That Cock aimed the prints at an international market also meant that they sometimes left his workshop with their bottom margins blank—the words to be added at a later stage in a variety of languages. The traditional title of one such print apparently derives from Flemish verses that were engraved on its blank margin some forty years after the print itself was first issued.[10] A still greater distance, at once geographical and temporal, separated the work of an Old Master like Wouwerman from the French academician who set out to replicate it more than a half century later. Especially when the picture in question was not a familiar scene from history or myth but one of the countless genre paintings, landscapes, and anonymous portraits that increasingly dominated the burgeoning print market,[11] the act of titling it could well become an exercise in creative interpretation.

Thanks to the meticulous records kept by one of the finest of eighteenth-century engravers, Jean Georges Wille, we have at least some access to the self-conscious titler at work. Like many of his fellow craftsmen, the German-born Wille (1715–1808) had migrated as a young man to Paris, where he began as an engraver of portraits before earning international acclaim for his prints of Dutch genre paintings, a number of which remain well known to this day. The French journal that he started keeping in 1759, a few years after his first great success with a print after Gerrit Dou, makes clear that the paintings themselves had no titles—at least none known to Wille before he chose to publish them. (Wille's shop did the publishing as well as engraving.) Indeed, the distinction between describing a painting and titling it is nowhere sharper than in Wille's account, where pictures typically enter the record under a brief description—or sometimes merely under the artist's

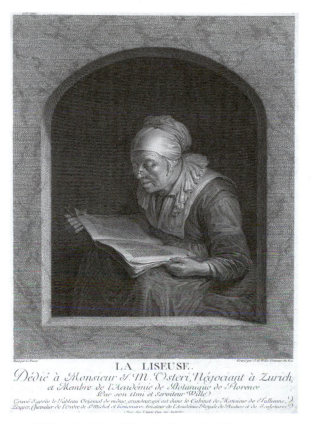

LA LISEUSE.
*Dédié à Monsieur S. M. Osteri, Négociant à Zurich,
et Membre de l'Académie de Botanique de Florence
Par son Ami et Serviteur Wille).*

5–3. Jean Georges Wille after Gerrit Dou, *La liseuse* (1762). Engraving and etching. © Trustees of the British Museum, London.

name—only to be translated into print and accorded a title of his devising. So a "very beautiful" painting by Gerrit Dou that arrived in Wille's shop on loan from its owner first appears in his journal of 1761 as "an old woman with glasses who reads in a big book," or simply "an old woman who reads," before it resurfaces on its publication the next year as *La liseuse* (fig. 5–3)—selling more than three hundred copies, Wille notes happily, on the first day. It was designed as a companion piece to his earlier print after the artist, which he had titled *La dévideuse mère de G. Douw*—roughly, "The Woman Unreeling Threads, Mother of G. Dou." An entry of 1767 records the purchase of "a superb picture composed of five figures, four men and a young woman, who are making music" by Godfried Schalcken: "among the most beautiful and the most significant by this master, though it's only twenty-one inches high by seventeen-and-a-half inches wide. I intend to engrave this good picture,"

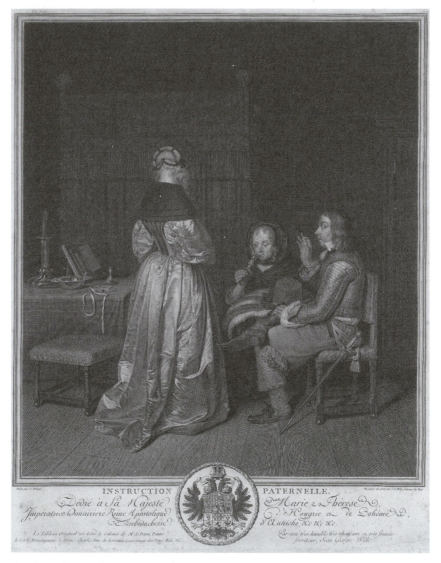

5–4. Jean Georges Wille after Gerard ter Borch, *Instruction paternelle* (1765). Engraving. © Trustees of the British Museum, London.

he immediately adds—an intention evidently realized two years later when he reports the dedication of "my new print" whose "title . . . is the *Concert de famille.*" Other such paintings figure in the journal chiefly by the titles he bestowed upon them: thus he announces the publication in 1760 of "la *Gazettière hollandoise* [*sic*], which I have engraved after a painting by ter Borch

that is not one of his best," or simply notes seven years later the appearance of "a new small plate that I have engraved after Mieris under the title: *l'Observateur distrait.*" An invitation in the spring of 1766 to dedicate his latest work to the dowager empress of Austria prompts him to identify what will prove his most celebrated image. "My print has for a title: *Instruction paternelle*" (fig. 5–4).[12] So famous did that particular title become that in 1809 Goethe was still inquiring rhetorically, "Who does not know Wille's magnificent copper engraving of this painting?"[13]

The painting in question was another ter Borch (fig. 5–5), one that Wille presumably judged far superior to the work he had tackled six years earlier. But the journal itself never confuses ter Borch's picture with the titled image, which Wille always treats as his own creation: "mon *Instruction paternelle,*" he often says, just as he says "mon *Observateur distrait,*" or "mon *Concert de famille.*"[14] That possessiveness is understandable. As Alexandra M. Korey has noted, the culture of reproductive printmaking did not necessarily preclude the copyist's being judged a distinctive artist in his own right;[15] and if ter Borch was famed for his ability to render the look of satin in paint, Wille could deservedly claim credit for having translated its shimmering surface to print. When *L'instruction paternelle* and *L'observateur distrait* appeared at the Salon of 1767, Denis Diderot urged his readers to "grab everything that comes from this one's burin [engraving tool]."[16] Yet unlike an engraving wholly designed for that medium, the reproductive print always references an absent original; and by titling such prints and publishing them, Wille and his colleagues inevitably managed to attach their words to the paintings as well. Not every title of a reproductive print has held through the centuries; but by the time photographs had begun to render such prints obsolete, many a painting had permanently acquired its name from the intermediaries who copied and circulated it.

Well into the nineteenth century, in fact, the European public for art was largely composed of subscribers to prints. Before the Orléans exhibit of 1793 brought a major collection of Old Masters to London, most Englishmen knew such works principally through the mediation of engraving.[17] Even those who had the wealth and leisure to acquaint themselves with the originals typically relied on prints to refresh their memory. As with other aspects of the art market, the French initially dominated the trade, but by the last decades of the eighteenth century the English had begun to overtake them—their sales extending, as one contemporary newspaper put it, "from one end of Europe to the other."[18] Wherever the place of publication, printmakers often titled their works in Latin or French for the international market, while others solved the linguistic problem by adopting double inscriptions, including

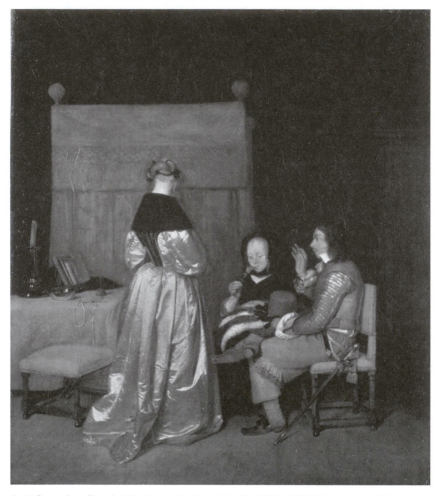

5–5. Gerard ter Borch, *The Paternal Admonition* (c. 1654–55). Oil on canvas. Gemael-degalerie, Staatliche Museen, Berlin. bpk, Berlin/Art Resource, NY.

one in the local vernacular. But once an inscription was recorded, the image and its words went everywhere together—a physical conjunction intensified by the apparent continuity of medium.[19] Despite the fact that the words in question often originated with someone other than the painter, their tendency to stick surely owes something to the way in which print tends to homogenize visual and verbal signs, especially when both appear in the black-and-white of a reproductive engraving.

At the same time, the fact that a brief phrase could travel more easily and cheaply than a complex image meant that the titles of reproductive prints

circulated far more extensively than the prints themselves.[20] On both sides of the Channel, publishers advertised their latest wares by announcing them in the newspapers; and one did not need to purchase an image, or even see it, in order to become familiar with its title. The most prominent such venue, the *Mercure de France*, regularly featured ads for new prints in its pages, sometimes together with the latest books and musical scores and sometimes in a separate section devoted to "Estampes Nouvelles" or "Gravures."[21] By the midcentury, London-based newspapers were the main source for such advertisements in England—their national circulation in turn facilitating an increasing distribution of the prints themselves. Several publications also attempted to market English prints to foreign purchasers, though none matched the long-lived *Mercure* in its pan-European readership.[22]

A study of the French print market demonstrates how certain key words figured over and over again in newspaper ads during the second half of the eighteenth century. Noting that most consumers seem to have chosen their prints by subject matter rather than by artist or engraver, Pierre Casselle concludes that the title bestowed by a publisher could be an important element in a print's commercial success. "Amour," not surprisingly, tops his list, followed by "Venus," with "mère, maternal" a notable runner-up; other fashionable words in his collection include "enfance, enfant," "petit," "amour" (lowercase), "bain, baigneuse," "espagnol," "heureux," and "repos." A cluster of further terms gives to "amour" in its lowercase sense the character of something forbidden or risky ("abandonée," "inattendu," "danger, dangereux," "surprise," etc.), while still others evoke the small adventures of social life ("confidence," "indiscrétion"), the sensibility associated with the raising of children and charity toward the poor, or a sentimentalized curiosity about the countryside and its more or less idealized inhabitants. A title could also lure potential purchasers by hinting at double meanings—as the announcement of a print after Boucher called *Les plaisirs innocens* might serve to conjure up those pleasures' guilty opposite.[23]

Such preoccupations suggest to Casselle that these ads were aimed at a primarily aristocratic audience: reproductions of famous paintings didn't really trickle down to the petite bourgeoisie until the advent of cheap lithography in the early decades of the nineteenth century.[24] Yet the printmakers' very reliance on titles had a wider resonance, encouraging the expectation that paintings, too, should acquire them. The abbé Du Bos, whose worries about the intelligibility of the mobile image we examined earlier, was quick to make the connection. "Painters, whose works are engraved, are already beginning to appreciate the utility of these inscriptions," he remarked in 1719; "and they put them at the bottom of the prints made after their pic-

tures."[25] Though Du Bos had no cause to mention it, both the compilers of catalogues and the increasing number of art critics found the practice useful as well, since it provided a convenient shorthand with which to identify an image without the labor of describing it. By the time that a disciple of Diderot took up the argument some seventy years later, the case for extending the convention to painting seemed yet more compelling. "A large number of paintings do not give the pleasure that they should, because the subject or the idea of the artist can't be understood," Pierre-Charles Lévesque observed in the multivolume *Dictionnaire des arts* he coauthored in 1792. "A print at least carries a title [*Une estampe porte du moins un titre*], and it would be easy to write something similar on the frame of a painting."[26] Though the inscribing of words directly on a frame remains a minority practice, Lévesque's proposal that painters should take their cue from the printmakers offers one more reason for identifying the 1790s as the crucial decade in the emergence of the modern picture title. It was only four years later, after all, that the members of the Conservatoire referred directly to the "titres des tableaux" that they planned to exhibit—as if even the Old Masters in the royal collection had titles.

Du Bos's observation that painters had begun to recognize "the utility of these inscriptions" should also remind us, however, that the titles of reproductive prints were not always the work of middlemen. To the degree that living artists were accustomed to collaborating with their printmakers, the words at the bottom of their prints might well be understood as authorial—or at least as carrying the artist's sanction. Just how involved individual painters were in the business of reproducing their work can be difficult to determine, and it clearly varied from case to case. Though reproductions of Chardin's genrelike subjects were immensely popular with eighteenth-century consumers, the artist's relations with his engravers seem to have been relatively distant; and modern interpretations of his work still turn on the question of what authority, if any, should be granted to the moralizing glosses of the printmakers.[27] That a painting could appear under one description at the Salon only to acquire a new title—and sometimes even a new genre—upon publication suggests at the very least that the artist did not have a deep investment in the verbal identification of his images. So a painting originally exhibited at the Salon of 1738 as "Le Portrait d'une petite fille de M. Mahon, Marchand, s'amusant avec sa Poupée" (the portrait of a small daughter of M. Mahon, merchant, amusing herself with her doll) became in printed form *L'inclination de l'âge* (*The Inclination of her Age*)—a title further glossed, as such titles often were, with didactic verses that here warn the viewer not to look upon her

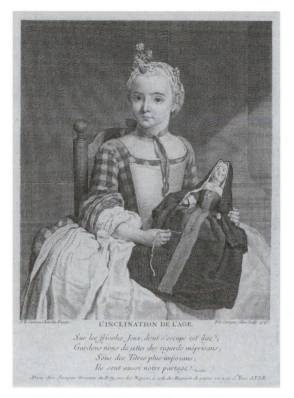

5–6. P. L. Surugue after Jean-Baptiste-Siméon Chardin, *L'inclination de l'âge*. Engraving (1743). Victoria and Albert Museum, London.

"frivolous games" with scorn, since under "more imposing titles," they are ours too (fig. 5–6).[28]

Jean-Baptiste Greuze was also among the most reproduced of living artists in eighteenth-century France. But unlike Chardin, he seems to have kept tight control over his engravers, whose capacity to advertise his pictures became even more crucial after his failure to be admitted to the Académie as a history painter in 1769 prompted him to withhold his work from future Salons. (The engravings themselves continued to be exhibited by their makers.) Surviving contracts spell out in considerable detail the terms by which particular subjects were to be reproduced, while most of the resulting prints were signed on the back by both artist and engraver.[29] When a pair of paintings that had originally appeared as sketches at the Salon of 1765 circulated as prints more than a decade later, the title of the first had morphed, presumably

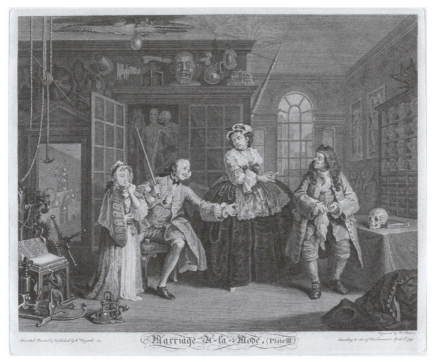

5–7. William Hogarth, *Marriage A-la-Mode*, Plate 3 (1745). Engraving. Courtesy Louis Walpole Library, Yale University.

with Greuze's blessing, from "Le fils ingrat" (*The Ungrateful Son*) into *La malédiction paternelle* (*The Paternal Curse*)[30]—the title by which both paintings are often collectively identified to this day. (The second of the pair, "Le fils puni" [*The Punished Son*], retained its title in printed form.) And perhaps the most verbally self-conscious of eighteenth-century painters, William Hogarth, acted as his own printer—his words circulating together with his images throughout the European continent.

Although the example of Hogarth suggests that a painter could turn author well before the 1790s, the fact that many of his works originated as prints rather than easel paintings—that they began as mixed media, that is, rather than as pictures to be translated into words—makes his role in this history less straightforward than it might seem. So, too, does his habit of identifying the individual prints in his great sequences like *A Harlot's Progress* (1732) or *Marriage A-la-Mode* (1745) only by their numbered position in the series, as if what he wanted viewers to register was not the name of a particular scene but that of an entire narrative: "*Marriage A-la-Mode*, plate III," for

example (fig. 5–7), rather than "The Inspection," as Hogarth identified the painted version in a printed sales proposal,[31] or "The Visit to the Quack Doctor," as that same painting was later inscribed on its frame. The series title alone also appeared in the newspaper ads for the *Marriage*.[32] Though modern scholars have sometimes lamented the effacement of Hogarth's own titles for individual images in the series,[33] the artist himself seems not to have worried the issue too closely. Still more important, the densely verbal nature of Hogarth's work as a whole means that the title of any individual painting signifies less than it would with a more purely visual image—which is to say that the very characteristics that have prompted so many commentators, beginning with Hogarth himself, to liken him to a playwright or novelist make him an anomalous figure in the development of the modern picture title. In the language of his autobiographical notes: "Subjects I consider'd as writers do[:] my Picture was my Stage and men and women my actors who were by Mean[s] of certain Actions and express[ions] to Exhibit a dumb shew."[34] As far as the verbal identification of his images is concerned, however, Hogarth mostly succeeded in cutting out the middlemen.

[6 · CURATORS, CRITICS, FRIENDS—

AND MORE DEALERS]

Earlier modes of naming and circulating pictures continue long into the era of artistic authorship. Middlemen scarcely disappeared when painters began to title their works; and well into our own time, paintings both old and new still acquire their names from persons other than those who created them. Even when an artist does choose to title a work, it remains a challenge to assure that the words will stick as the picture they identify travels away from its maker.

As with the owners of manuscripts in previous eras, collectors have long had title to title their possessions—especially when no strong tradition of alternative naming exists.[1] A Rembrandt painting of a man in armor that was engraved in the eighteenth century as *Achilles* derived its name from its then owner, Joshua Reynolds, who also lectured on it under that title in his eighth *Discourse* of 1778.[2] By the time that the London dealer John Smith compiled his important *Catalogue Raisonné of the Works of the Most Eminent Dutch, Flemish, and French Painters* in the 1830s, the picture had migrated to the Hermitage in St. Petersburg, where, Smith reported, it was "styled 'Alexander.'" The warrior in question remains unidentified. Another "capital picture" by Rembrandt, which Smith himself had purchased before selling it to a collector, he called *The Birthday Salutation*—though it has had a longer history under a title bestowed, with equal lack of warrant, by its subsequent owner: *The Jewish Bride*.[3] As we shall see, perhaps no titles have been more fiercely disputed than those that have been assigned over the centuries to Rembrandt.[4]

Smith also took the liberty of naming pictures even when he had no personal claim to them: the ter Borch that appears in the Metropolitan Museum

in New York today as *Curiosity*, for example, owes its anecdotal title to this nineteenth-century Englishman. At other times, Smith's influential work simply helped to perpetuate titles already familiar from popular prints, as when he described a painting by ter Borch that he called *Paternal Instruction* or one by Gerrit Dou that he identified as *La femme hydropique* (*The Dropsical Woman*)—the latter engraved at the beginning of the century after a picture that still hangs, as it did then, in the Louvre (fig. 6–1).[5] A nineteenth-century favorite, the *Femme hydropique* is perhaps less beloved these days than many works by Dou's contemporaries, but its title continues to stick—and this despite the fact that some scholars have since contended that the woman in question is more likely to be suffering from pregnancy.[6] As Smith's shrewd contemporary, the French critic Théophile Thoré, remarked of a yet more famous painting, the so-called *Ronde de nuit* (*Night Watch*) by Rembrandt: "But how change a name popular for such a long time in all languages?" (Ironically, Thoré was himself writing under a pseudonym—William Bürger— adopted in the wake of the 1848 revolution and will henceforth be called, as is customary, by his double name.) Thoré-Bürger conceded that the strange lighting effects of Rembrandt's picture, "so phenomenal at first sight," had doubtless contributed to the "absurd name" with which custom had identified it. Yet even as he went on to protest that the painting no more represented a watch than it did a night scene and that it should rightly be called "*la Sortie des arquebusiers*," the rest of his book continued to speak, not surprisingly, of the *Ronde de nuit*.[7]

Such long-established titles pose a particular challenge for modern museums, which must continually negotiate between the latest scholarship and fidelity to a tradition, however misguided, that has itself become part of a picture's history. In the case of the Rembrandt, the Rijksmuseum currently settles for "The Militia of District II under the Command of Frans Banninck Cocq, known as the 'Night Watch,'" though most of those who seek it out, whether in situ or on the Net, surely do so by the latter title. Museums, too, are in the business of naming; and many of the otherwise untitled works that have entered their collections over the centuries have perforce acquired their titles from those employed to catalogue and exhibit them. In some cases, paintings that arrived at the Enlightenment origins of an institution were inadvertently secularized. So a Holy Family by Rembrandt entered the Louvre in 1793 as *Famille hollandaise dans un intérieur*, only to be renamed *Le ménage du menuisier* (*The Carpenter's Household*)—a title by which it still appeared in the museum's catalogue at the middle of the nineteenth century (fig. 6–2).[8] A similar fate befell another Holy Family by Rembrandt at Kassel, which became *The Woodcutter's Family*.[9]

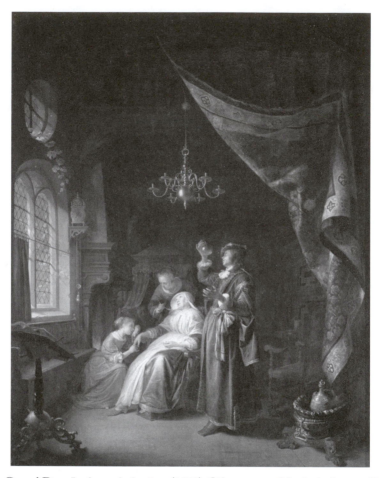

6–1. Gerard Dou, *La femme hydropique* (1663). Oil on canvas. Musée du Louvre, Paris. Erich Lessing/Art Resource, NY.

Other problems of naming were more subtle. Both the Louvre and the National Gallery in London included among their early collections a number of works by the seventeenth-century French artist Claude Lorrain that represent figures from a classical, biblical, or historical narrative in an idealized setting that dominates the surface of the canvas. A hybrid genre that mediates between history painting and landscape, such pictures pose an obvious challenge to classifiers. Are the human subjects represented in figure 6–3, for instance, the true focus of the painting, or are they merely an excuse for the representation of an ancient seaport? When a Louvre catalogue of 1838 gave the title of the picture as *Le débarquement de Cléopâtre* (*The Disembarkation of*

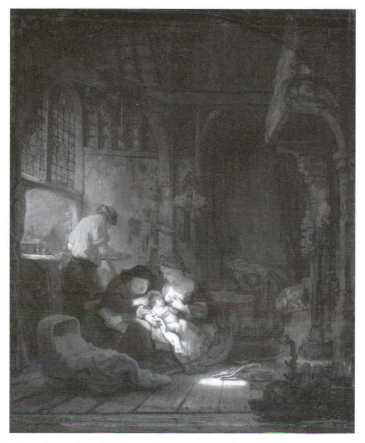

6–2. Rembrandt van Rijn (and pupil?), *Sainte famille* (1640). Oil on wood. Musée du Louvre, Paris. © RMN-Grand Palais/Art Resource, NY.

Cleopatra), it implicitly answered that question by identifying Claude's work with a proud tradition of French history painting—as it did several other Claudes in the museum's collection, two of which in fact represented scenes from the nation's history.[10] A decade later, however, a strikingly similar work appeared in a guide to the National Gallery as *A Sea-Port: The Embarkation of the Queen of Sheba on the occasion of her visit to King Solomon* (fig. 6–4). Indeed, the guide adopted a related formula for every Claude in the museum's posses-sion, consistently subordinating the historical action of his pictures to their initial designation as a "Sea-port" or "Landscape." The only exception among the ten listed in the guide is a work simply identified as *Study from Nature*.[11] By comparison to the French, the British had a relatively weak tradition of history painting; but they excelled in the art of landscape, and they saw their

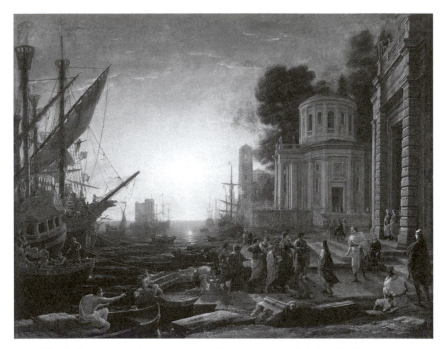

6–3. Claude Lorrain, *Le débarquement de Cléopâtre à Tarse* (1642–43). Oil on canvas. Musée du Louvre, Paris. Erich Lessing/Art Resource, NY.

Claudes accordingly. More than a linguistic difference separated such British titles from their French counterparts. And even as both kinds of titles registered the artistic biases of those who recorded them, they subtly reinforced such biases by instructing viewers how to look.

This is not an argument for curatorial conspiracy, only for acknowledging that choices are inevitable and that they always entail interpretation. Consider the history of another painting in the National Gallery, a Rembrandt currently displayed under the neutral-sounding title of *Saskia van Uylenburgh in Arcadian Costume* (fig. 6–5). Modern scholarship has traced its provenance to the middle of the eighteenth century, when it surfaced in a French sales catalogue as yet another Jewish Bride. (The Judaizing of Rembrandt's subjects in earlier centuries is a story unto itself.) The entry proceeds with the characteristic detail that makes such catalogues so useful to subsequent scholars, even when, as here, they no longer accept the interpretation that governs it: "Une Mariée Juive les cheveux épars, et une couronne de fleurs sur la tête, elle pose la main droite sur une canne qui est parallement entourée de fleurs, et de la gauche elle tient un gros bouquet" (A Jewish bride with di-

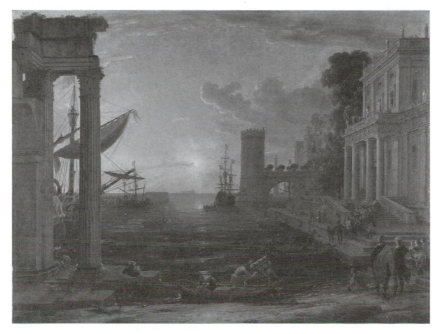

6–4. Claude Lorrain, *Seaport with the Embarkation of the Queen of Sheba* (1648). Oil on canvas. © National Gallery, London/Art Resource, NY.

sheveled hair and a crown of flowers on her head, she places her right hand on a cane that is similarly surrounded by flowers, and with her left she holds a large bouquet).[12] Purchased by a British aristocrat for his private collection, the painting was first publicly displayed at the Manchester Art Treasures Exhibition in 1857, where it appeared under the far more cautious rubric of *Female Portrait*.[13] Though the National Gallery bought the painting from the descendants of its eighteenth-century owner in 1938, only in 1960 did it settle on the present title. By so labeling the picture, the museum not only identified the woman in question as Rembrandt's first wife, Saskia, but implicitly accepted its earlier classification as a portrait. Yet both decisions remain debatable—and this despite the existence of a documented drawing of Saskia from 1633, just two years before the date recorded on the painting.[14] Nor is there any more consensus on the museum's account of her flowery outfit.

The naming of portraits whose subjects have gone unrecorded is a constant challenge; and the difficulties are only exacerbated by the fact that an accepted identification significantly increases a picture's value on the market.[15] For at least one scholar, the wish to see Rembrandt's wife in this paint-

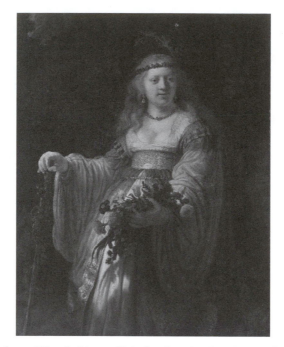

6–5. Rembrandt van Rijn, *Saskia van Uylenburgh in Arcadian Costume* (1635). Oil on canvas. National Gallery, London/Art Resource, NY.

ing has simply overridden the evidence. But the problem of what to call the picture concerns more than the question of whether the woman's features sufficiently resemble the drawing to identify her with Saskia. As with so many paintings before the widespread practice of authorial titling, Rembrandt's image also poses an iconographical puzzle. In characterizing her costume as "Arcadian," the museum implies that she represents an idealized shepherdess; but others have decided that her flowery accoutrements instead associate her with the goddess of spring, Flora—an association encouraged by a note on another drawing in which Rembrandt alluded to three "floora(e)" in his studio.[16] According to the official *Corpus* of his paintings issued by the Rembrandt Research Project, this is in fact what she represents.[17]

But while the RRP therefore call the painting *Saskia as Flora*, others do more than opt for the goddess over the shepherdess: they also deny that we should approach the work as a portrait. For even if Rembrandt's first wife did serve as a model, it by no means follows that he expected us to recognize her. To those who argue in this vein, the woman's features are too generalized to qualify her as the picture's subject.[18] Like *Saskia van Uylenburgh in Arcadian Costume*, *Saskia as Flora* remains the representation of a particular individual,

though one who deliberately poses in the character of another. The technical term for such a picture, whose subject may pretend to be a character from history or literature as well as myth, is *portrait historié*. To call the picture *Flora*, on the other hand, is to contend that the identity of the model has no relevance. By this account—and every title accounts for a picture—the artist set out to depict a goddess, while the woman who happened to pose for her was meant to be forgotten.

Had Rembrandt belonged to a culture in which painters routinely titled their work, controversies like this one would presumably have been avoided. Yet the problem of naming pictures did not disappear with the advent of authorial titling; and many a middleman continued to intervene in the business. Indeed, one could well argue that the possibilities for such intervention only multiplied in the nineteenth century, as new modes of displaying and circulating pictures gradually replaced the role of the academies. In a sociological study focused on the careers of the French impressionists, Harrison and Cynthia White have termed these developments the "dealer-critic system"—a system that itself, as the Whites make clear, long outlasted the heyday of impressionism.[19] Dealer and critic alike still shape our modern art world; and even as both parties pay lip service to the convention that a painting's title originates with the painter, neither has been shy, to say the least, about contributing to the process.

Writing of his apprenticeship as a dealer in late nineteenth-century France, Ambroise Vollard tells an amusing anecdote about his encounter with a passerby who had been attracted to the shop by a prominently displayed painting of a bull by Édouard Debat-Ponsan. The potential customer, whom Vollard had taken for an ironmonger, "looked at the Debat-Ponsan with growing admiration":

"This powerful bull and these delicate flowers, what a pleasing antithesis!"

I thought: "This is an ironmonger-poet."

"And what is the title of this picture?" he asked.

"*Virility*," I began to say. And I was about to add: "It is the title chosen by the Master himself," when I broke off, so clearly did the face of my interlocutor betray his disappointment. Debat-Ponsan had authorized me to change the title of his pictures according to the circumstances. I therefore continued: "That, at least, is the title that might be imagined by a mind insensitive to the poetry with which this canvas is so saturated."

"So then, the picture is called?"

"*April*," I announced with assurance: "*April*, the month in which flowers are born, when nature, beneath the fragrances of springtime . . ."

The countenance of the "ironmonger" radiated happiness. He could therefore carry this picture home with him, introduce it to his household, without having to blush in front of a possibly dissatisfied spouse, or scandalize his daughters.

"*April*, what an admirable symbol! . . . Monsieur, I am professor of aesthetics at the Faculty of Letters of X . . . I shall teach my students the name of Debat-Ponsan. April! To evoke in the mind so many images by the magic of a word! I will buy this picture."[20]

The dealer who would go on to champion artistic innovators like Cézanne and Picasso tells this story with evident cynicism. Elsewhere he notes dryly that Debat-Ponsan, who "specialized in cows," had declared himself equally pleased to turn out "horses, donkeys, sheep, or even poultry," if these would better suit the taste of his customers.[21] But it would be wrong to assume that it is only the Debat-Ponsans of the art world who permit others to rename their pictures. Consider, for example, the history of Claude Monet's first breakthrough—the full-length figure of a woman in a contemporary dress that the artist submitted to the Salon of 1866 under the title *Camille*. The canvas, which is over seven feet high, shows a woman in a green-and-black-striped gown and a black jacket trimmed with fur posed against a red curtain, her back angled to the viewer, her face partly visible as she turns her head over her shoulder and raises one gloved hand in a gesture both elegant and ambiguous (fig. 6–6). Though the painting had its detractors, it was certainly an attention-getter; and Monet's woman was soon being hailed as the queen of Paris. Among the enthusiasts was Thoré-Bürger, who contributed to the buzz by reporting that the entire canvas had taken only four days. The report was untrue; but, like another of his claims for the picture, it stuck.[22] "Désormais," he declared, "Camille est immortelle et se nomme la *Femme à la robe verte*": "Henceforth, Camille is immortal and will be called *The Woman in the Green Dress*."[23]

It is not clear whether Thoré-Bürger thought the painting's original title a fiction, like Manet's sensational *Olympia* of the year before, or had gotten wind of the fact that the twenty-five-year-old Monet had recently acquired a young mistress named Camille Doncieux, whose face and form had served for the woman in green. But by simultaneously proclaiming her immortal and obliterating her identity, the critic summed up her fate: *Camille* entered history only by disappearing from memory. More immediately to the point,

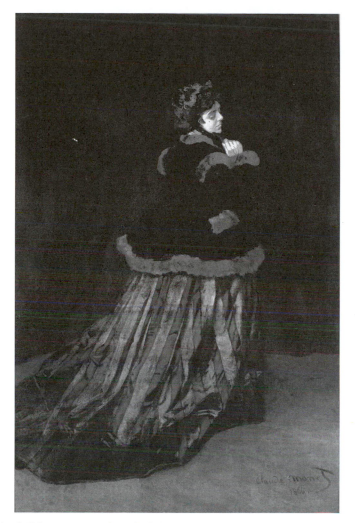

6–6. Claude Monet, *Camille* (1866). Oil on canvas. Kunsthalle, Bremen. Erich Lessing/Art Resource, NY.

his title effectively turned Monet's portrait into a genre painting. Unlike Rembrandt, Monet had been expected to title his work and had responded accordingly; but though he would go on to marry the woman in the picture, in later years he, too, adopted the generic title. When its present owner, the Bremen Kunsthalle, acquired the painting in 1906, what they bought was *The Woman in the Green Dress*. *Camille* had been the representation of a particular

individual, but the museum's acquisition had become, in Monet's own words, "merely a Parisian figure of that time."[24] Only in our time has it been identified, once again, as a portrait.

Monet is far from the only modern artist to accept—or invite—such acts of naming. We still don't know whether Paul Cézanne titled his works at all, though we do know that at least some of his early paintings owe their titles to his friend and fellow artist Antoine Guillemet.[25] Most of the verbal cues by which the works of Pablo Picasso's cubist period have come to be identified were apparently supplied by Picasso's dealer at the time, Daniel-Henry Kahnweiler—though Picasso sometimes assisted the process by recording on the back of a picture the particular motifs on which he had drawn for the painting. Thus Kahnweiler's *Bottle of Marc de Bourgogne, Wineglass and Newspaper* presumably derived from the artist's inscription on the verso of the canvas: "On a round table / a bottle of *marc de Bourgogne* / a glass and a newspaper / in the background a mirror / 1913 / Picasso." It was Kahnweiler who later irritably informed the Columbus Gallery of Fine Arts in Ohio that no Picasso should be called *Abstraction*, the label given by the museum to a cubist watercolor in its collection: the picture now goes by the title of *Seated Man with a Pipe, Reading a Newspaper*.[26] Well aware that many of Jackson Pollock's paintings acquired their evocative titles from dealers and collectors, the compilers of the catalogue raisonné duly attempt to sort out the artist's own language from the contributions of the middlemen. Yet the title of *Pasiphaë* (plate 1), which the catalogue treats as authorial, actually originated with a curator from the Museum of Modern Art, who happened to be on the scene when Pollock's patron, Peggy Guggenheim, objected to the artist's original choice of *Moby-Dick*. "Who the hell is Pasiphaë?" Pollock reportedly inquired; but like Monet before him, he appears to have acquiesced in his picture's rebaptism.[27]

In an interview of 1946, Picasso professed never to title his works, even as he deplored "the mania of art dealers, art critics, and collectors for christening pictures." A decade later, he was still insisting that he had nothing to do with the names of his pictures. "It isn't I who gave the painting that title," he said of a work in the Cleveland Museum known as *La vie*: "A painting, for me, speaks by itself; what good does it do, after all, to impart explanations? A painter has only one language." Yet according to Kahnweiler, Picasso was not always so indifferent to the words that accompanied his images. "*Les Demoiselles d'Avignon*, how this title irritates me," he wrote to the dealer in 1933: "Salmon invented it. You know very well that the original title from the beginning had been *The Brothel of Avignon*."[28] In this case, it was a critic, André Salmon, who had taken upon himself to substitute the more decorous title

when Picasso's bordello was first exhibited to the public in 1916. The painting had been completed in 1907; but despite the fact that Picasso's friends spent the next nine years speaking of his *Bordel*, it is the *Demoiselles* who have become world famous as a monument of modernism.[29] Artists have been titling their paintings for over two centuries; but even those far more committed to words than Picasso, as we shall see, have not always managed to keep middlemen out of the picture. A title that holds is a work of aggressive authorship.

I I

Reading and Interpreting: Viewers

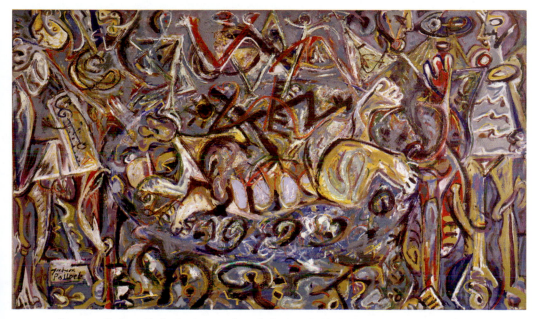

PLATE 1. Jackson Pollock, *Pasiphaë* (1943). © 2014 Pollock-Krasner Foundation/Artists Rights Society (ARS), New York. Oil on canvas, 56 1/8 × 95″ (142.6 × 243.8 cm). The Metropolitan Museum of Art, Purchase, Rogers, Fletcher, and Harris Brisbane Dick Funds and Joseph Pulitzer Bequest, 1982 (1982.20). Image © The Metropolitan Museum of Art.

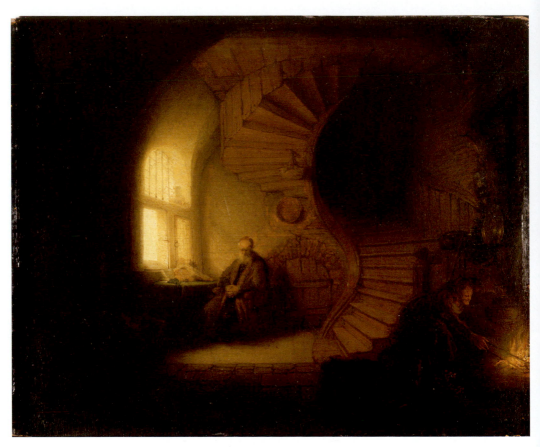

PLATE 2. Rembrandt van Rijn, *Philosophe en méditation* (1632). Oil on panel. Musée du Louvre, Paris. © RMN-Grand Palais/Art Resource, NY.

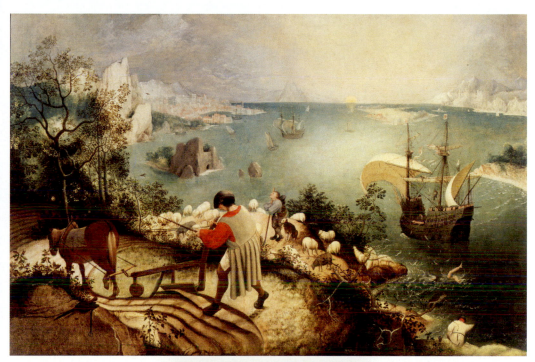

PLATE 3. Pieter Bruegel the Elder (?), *Landscape with the Fall of Icarus* (1555–58?), and detail. Oil on canvas. Musée d'art ancien, Musées royaux des beaux-arts de Belgique, Brussels. SCALA/Art Resource, NY.

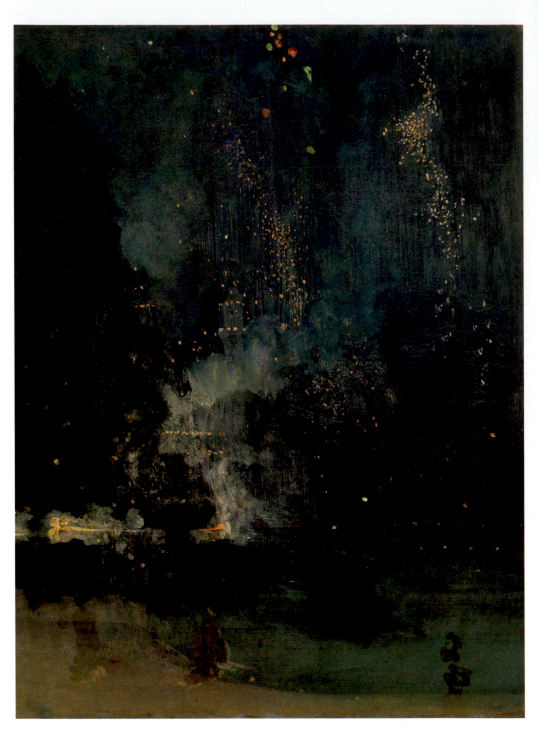

PLATE 4. James Abbott McNeill Whistler, *Nocturne in Black and Gold: The Falling Rocket* (c. 1875). Oil on panel. Detroit Institute of Arts. Erich Lessing/Art Resource, NY.

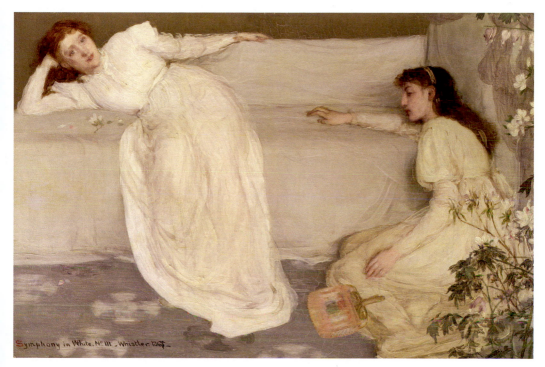

PLATE 5. James Abbott McNeill Whistler, *Symphony in White, No. III* (1865–67). Oil on canvas. The Barber Institute of Fine Arts, University of Birmingham/Bridgeman Images.

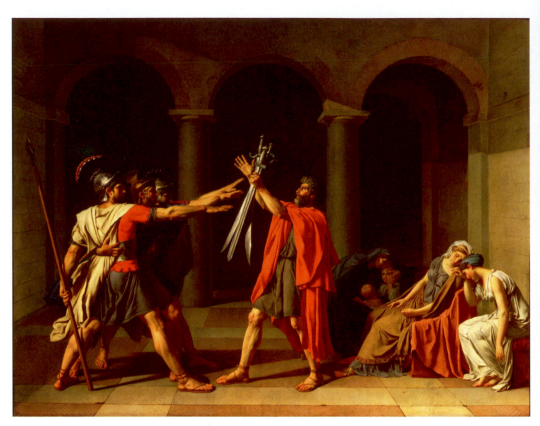

PLATE 6. Jacques-Louis David, *Serment des Horaces, entre les mains de leur père* (1784–85). Oil on canvas. Musée du Louvre, Paris. SCALA/Art Resource, NY.

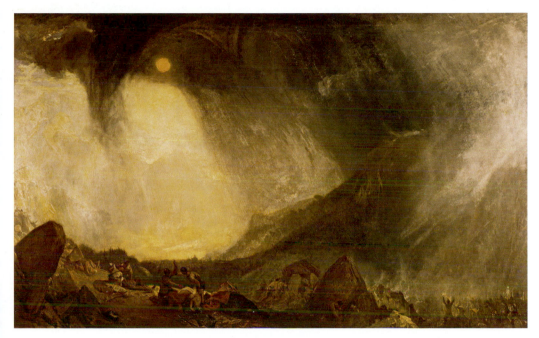

PLATE 7. J.M.W. Turner, *Snow Storm: Hannibal and his Army crossing the Alps* (1812). Oil on canvas. Tate, London/Art Resource, NY.

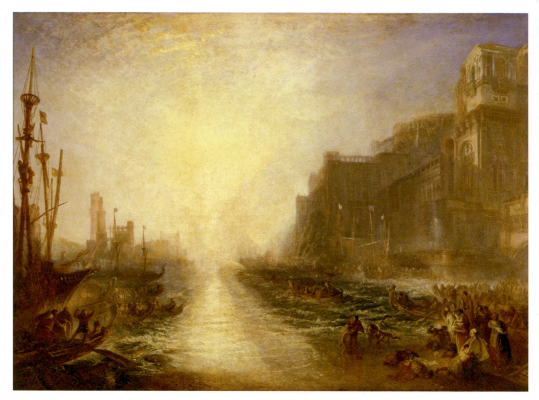

PLATE 8. J.M.W. Turner, *Regulus* (1828; reworked 1837). Oil on canvas. Tate, London/
Art Resource, NY.

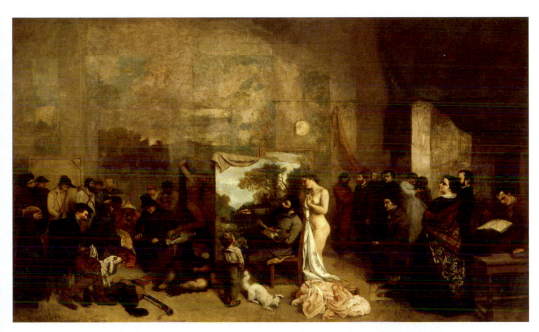

PLATE 9. Gustave Courbet, *L'atelier du peintre: Allégorie réelle déterminant une phase de sept années de ma vie artistique* (1855). Oil on canvas. Musée d'Orsay, Paris. Gianni Dagli Orti/The Art Archive at Art Resource, NY.

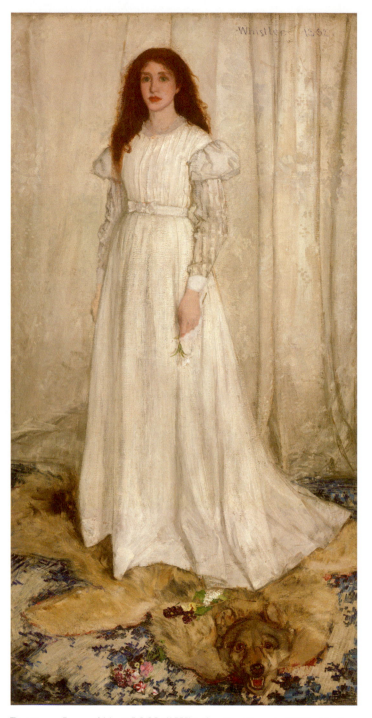

PLATE 10. James Abbott McNeill Whistler, *Symphony in White, No. I: The White Girl* (1862). Oil on canvas. National Gallery of Art, Washington, DC.

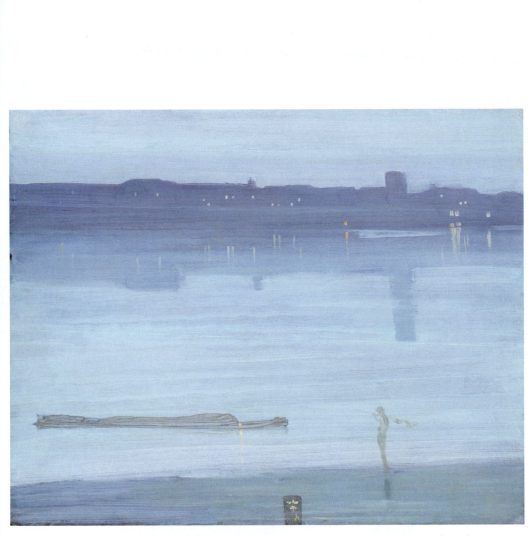

PLATE 11. James Abbott McNeill Whistler, *Nocturne: Blue and Silver—Chelsea* (1871).
Oil on wood support. Tate, London/Art Resource.

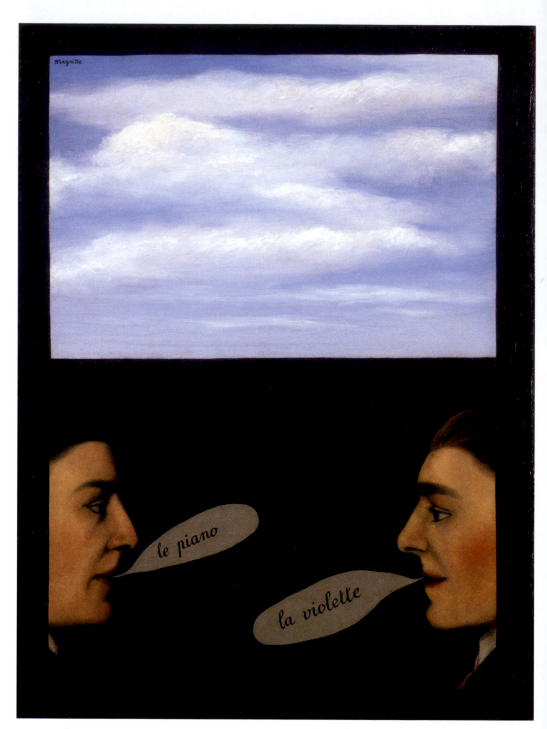

Plate 12. René Magritte, *L'usage de la parole* (I) (1928). © 2014 C. Herscovici/Artists Rights Society (ARS), New York. Oil on canvas. Private collection. Banque d'Images, ADAGP/Art Resource, NY.

PLATE 13. René Magritte, *La malédiction* (1960). © 2014 C. Herscovici/Artists Rights Society (ARS), New York. Oil on canvas. Private collection. Banque d'Images, ADAGP/Art Resource, NY.

PLATE 14. René Magritte, *Les vacances de Hegel* (1958). © 2014 C. Herscovici/Artists Rights Society (ARS), New York. Oil on canvas. Private collection. Gianni Dagli Orti/ The Art Archive at Art Resource, NY.

PLATE 15. Jasper Johns, *No* (1961). Encaustic, collage, and sculp-metal on canvas with objects, 68 × 40″. Private collection. Art © Jasper Johns/Licensed by VAGA, New York, NY.

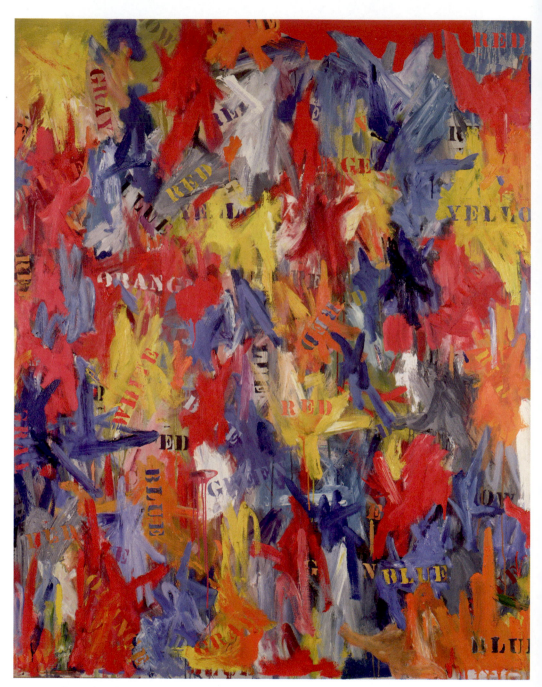

Plate 16. Jasper Johns, *False Start* (1959). Oil on canvas. Private collection. Art ©
Jasper Johns/Licensed by VAGA, New York, NY. Giraudon/Bridgeman Images.

[7 · READING BY THE TITLE]

The title of a painting serves as a directive for viewers. Under modern conditions of circulation and display, it typically provides our first key to interpreting—or, as we often put it, to "reading" the image.[1] That such a logocentric idiom has become commonplace in discussions of the visual arts has sometimes been deplored, but its very ubiquity testifies to a culture in which the literacy of the image's beholders can simply be taken for granted.[2] For those especially devoted to the word—poets and novelists, of course, but also essayists, journalists, and even art historians—the lure of a picture's title can prove irresistible. Seeing what it tells them to see, such viewers have often ended by spinning entire narratives from its cues. Yet in an age of mass literacy, ordinary viewers, too, read by the title—perhaps even more so, ironically, than the wordsmiths. The history of the picture title over the last three centuries has turned as much on the democratization of reading in those years as it has on new modes of access to the images themselves.

Unlike works of literature—or paintings, for that matter—titles as such are generally not subject to copyright in modern legal systems.[3] Like proper names, which also lack copyright protection, they are presumably thought too easily replicable to qualify: while every "Still Life," however conventional, is unique, the number of canvases that might legitimately lay claim to the title may be surpassed only by the number of persons who could accurately claim to be called "Mary" or "John." In everyday use, titles nonetheless share with proper names the function of singling out one individual in particular: though neither "Still Life" nor "Mary" in the sentence above acts as what the philosopher Saul Kripke calls a "rigid designator," the context in which we ordinarily use such a term makes its referent unique. If I had alluded to what the *Still Life* represented or Mary had done, you would rightly expect to know which "Still Life" or "Mary" I had in mind.[4] The very fact that scholars and the pub-

lic alike continue to refer to a painting by its traditional title long after the latter's accuracy has been called into question tends to confirm this analogy with proper names: an art historian who argued that the *Night Watch* did not in fact represent a night watch after all would not usually be viewed as contradicting herself, only as contributing to a debate about a particular painting that hangs in the Rijksmuseum. At the same time, it is very hard for most people, professionals included, to distinguish sharply between a title that merely points to a picture and a title that characterizes it. When Guillaume Apollinaire observed of contemporary painting in 1913 that "the titles in catalogues are like names which designate individuals without describing them," he was registering a genuine aspiration among some practitioners of modern art. But the only example he went on to offer immediately served to muddle the distinction: "Just as there are very thin people called Legros and very dark people called Leblond," he remarked, "so I have seen canvases entitled *Solitude* featuring several human figures."[5] Few people, if any, would struggle to reconcile Leblond's name with his hair color, but only the most literal of viewers would conclude that the presence of more than one figure deprived *Solitude*'s title of relevance. We are capable, in fact, of finding meaning in juxtapositions considerably more challenging than that. The requirement to label pictures—even for the simple purpose of assuring that one canvas in a crowded competition can be distinguished from the next—is always bumping up against the viewer's appetite for significance.

Just how much viewers' understanding of an image could depend on its title may be briefly illustrated by the history of a painting by Chardin that first appeared at the Salon of 1737 as "Un Chimiste dans son Laboratoire" (fig. 7–1).[6] The painting was engraved seven years later as *Le soufleur* (*The Glass-blower*)—a title clarified, or complicated, by an ad announcing the print as representing an alchemist in his laboratory, "attentively reading a book on alchemy," and by some moralizing verses appended, as in many prints after Chardin, to the engraving itself (fig. 7–2).[7] Word and image combined to suggest that this was a man wasting his time in useless speculation; but when the picture surfaced once again at the Salon of 1753 as "un Tableau représentant un Philosophe occupé de sa lecture," viewers were inclined to judge its figure more charitably.[8] The abbé Laugier, for one, saw "an air of intelligence, reverie, and obliviousness that [was] infinitely pleasing." This is "a truly philosophical reader," Laugier added, "who is not content merely to read, but who meditates and ponders, and who appears so deeply absorbed in his meditation that it seems one would have a hard time distracting him."[9] Both the picture's moral, if any, and its generic status were further unsettled when at

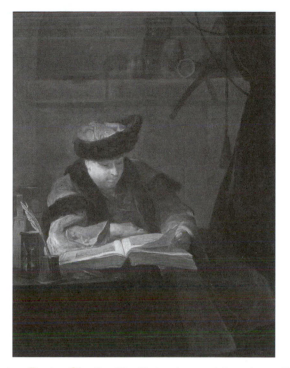

7–1. Jean-Baptiste-Siméon Chardin, *Un chimiste dans son laboratoire,* or *Un philosophe occupé de sa lecture* (1737). Oil on canvas. Musée du Louvre, Paris. Erich Lessing/Art Resource, NY.

least one sharp-eyed critic in 1753 recognized it as a portrait of Chardin's fellow painter, Joseph Aved.[10] Some sources now identify the work primarily as a portrait, though the Louvre still gives pride of place to its first title, and as of 2014 there is a website based in China from which you can order a hand-painted oil reproduction of "Le Souffleur."

The evidence suggests that Chardin's philosopher had been commissioned as such by its first owner, the comte de Rothenbourg—after whose death in 1735 the picture reverted, perhaps in lieu of payment, to the artist. Whoever composed the entry in the *livret* when the work made its second public appearance eighteen years later may in this sense have been restoring rather than subtly revising its identity.[11] But if the painting itself gives us no cause to question that designation, neither does anything in the image alone serve to settle the issue. Absent an iconographical tradition that distinguishes one man absorbed in reading from another, only the written word authorizes us to see a philosopher in the picture.

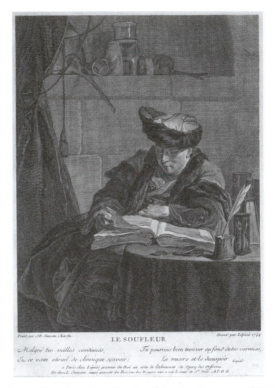

LE SOUFLEUR

7–2. F. B. Lépicié after Jean-Baptiste-Siméon Chardin, *Le soufleur* (1744). Engraving. © Trustees of the British Museum, London.

Chardin's was not the only "philosophe" to appear at the Salon in 1753. Among the prints submitted that year was Louis Surugue's *Le philosophe en méditation*, the first of two influential works said to be engraved after paintings by Rembrandt (fig. 7–3).[12] Surugue rapidly followed up his success with a companion piece entitled *Le philosophe en contemplation* (1754), which he advertised at length in the *Mercure de France* the following spring. "It represents another Philosopher seated in front of a table very near to a window, whence comes the light which illuminates the subject," the announcement read in part; "the attentive attitude of the head and the hands placed together in his lap show that he is absorbed, so to speak, by the contemplation of some abstract idea" (fig. 7–4).[13] Neither the designation of these figures nor the belief that they were intended as a pair appears to have originated with the print-maker, since the paintings' first recorded owner in France—the marquis de Voyer d'Argenson—was already describing them as "deux philosophes" several

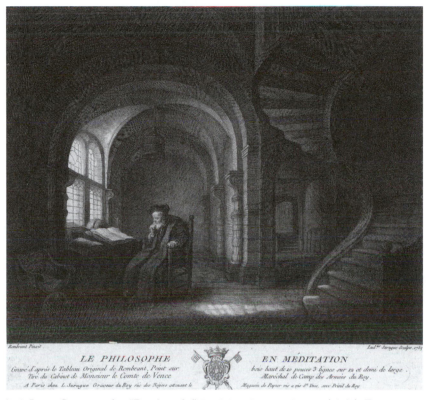

years earlier. But it was the circulation of the prints that established their identity with a wider public; and when other printmakers followed in Surugue's wake—as a number did—they seem to have taken that identity as a given. By the time that the paintings themselves entered the royal collection in 1784, they both were known, interchangeably, as Rembrandt's *Philosophes*.[14]

The other details of Surugue's titles proved less stable over the years. In 1793 the first catalogue of the Louvre listed the *Philosophe en méditation* as *Un philosophe lisant* and turned the original of Surugue's *Philosophe en contemplation* into *Un philosophe en méditation* (plate 2), while by the middle of the nineteenth century, the museum identified both paintings as *Le philosophe en méditation*.[15] But the *Philosophes* themselves remained a touchstone of commentary on Rembrandt, even as their contemplative aura increasingly tended to hover over their creator. So the French poet Aloysius Bertrand, for exam-

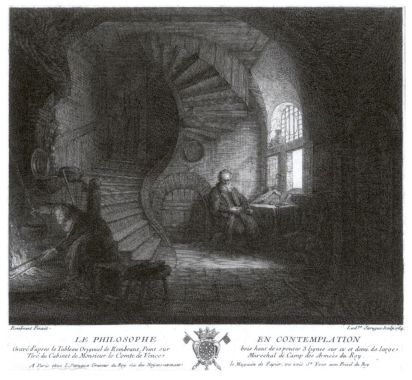

ple, prefaced his posthumously published collection *Gaspard de la nuit* (1842)—itself subtitled "fantaisies à la manière de Rembrandt and de Callot"—by identifying Rembrandt himself as the philosopher:

> Rembrandt is the philosopher with the white beard who curls himself up like a snail in his cubbyhole, who occupies his thoughts in meditation and prayer, who closes his eyes to commune with himself, who converses with spirits of beauty, science, wisdom, and love, and who wastes away in penetrating the mysterious symbols of nature.[16]

Théophile Gautier may have been recalling this philosopher curling himself up snail-like in his "réduit" a decade later when he, too, evoked the paintings' "réduit plein de mystère, d'ombre et de recueillement" (cubbyhole full of mystery, shadow and contemplation) as a model for the protagonist's studio in Goethe's *Faust*.[17] In his *Guide* to the Louvre of 1882, Gautier elaborated on the association of Rembrandt's philosopher with Rembrandt:

It appears that in painting *Le philosophe en méditation* Rembrandt wished to create an interior in which to house his mysterious thought in accordance with his dreams. This painter with the ways of an alchemist must have longed to have for a studio and laboratory a great hall vaulted like this one, its corners filled with shadows from which staircases ascend in a spiral. . . . We believe we see the very genius of Rembrandt in this figure with the face of a rabbi dreaming under a beam of light in the midst of shadows that deepen as they recede from him. Rembrandt has twice repeated this subject with some variants. In one of the paintings, the philosopher is absolutely alone with his Doctor Faustus clutter. In the other, domestic life circulates around the dreamer, discreet, silent, walking on tiptoe.[18]

Writing in 1956, Aldous Huxley further allegorized both painting and title, as he turned *Le philosophe en méditation* into "a 'Méditation du Philosophe,'" whose "symbolical subject matter," according to Huxley, was "nothing more nor less than the human mind" itself: "its teeming darknesses, its moments of intellectual and visionary illumination, its mysterious stairways winding downward and upward into the unknown."[19]

Huxley did not say which of the two paintings he was invoking, but this interpretive history had already been partly unsettled the previous year, when X-ray examination confirmed that at least one of the *Philosophes* was not the work of Rembrandt; and in 1986 the scholars of the Rembrandt Research Project (RRP) sought to put an end to such readings altogether by removing its companion from the corpus as well.[20] Unlike the original of Surugue's *Philosophe en méditation*, whose quality had troubled commentators for some time (and which is now attributed to a member of the artist's circle named Salomon Koninck), the authenticity of the painting that had inspired Surugue's second print had mostly gone unquestioned. But when the RRP set out to dismiss this one too, they seem to have been less concerned with the merits of the work than with the very kinds of interpretation we have been tracing. Though they partly argued that the painting's brushwork was atypical of Rembrandt, they reserved their greatest impatience for the tradition of reading that the print's title inaugurated. As they put it: "In the later part of the 18th century the painting enjoyed a great reputation in France as '*Le philosophe en contemplation*' and it helped to determine the image of Rembrandt's work to an unwarranted extent."[21]

In their zeal to discredit the painting together with its title, these official guardians of the corpus appear to have overlooked some relevant evidence, since they could discern neither the artist's signature nor the date.[22] The sig-

nature by itself is not definitive; but in a compelling article on the subject that appeared in 1990, Jean Marie Clarke made a case for retaining the work's traditional attribution, even as he implicitly concurred with the RRP's doubt as to the identity of the "philosophe." While Koninck's solitary figure may well have been intended as a philosopher, Clarke argued, the presence of the woman by the fire in Rembrandt's painting, as well as of another woman (barely visible) toward the top of the stair, casts doubt on Surugue's title, since philosophers were not usually depicted in female company. Clarke speculated instead that the old man in the painting was the biblical Tobit—accompanied here, as so often in the art of the period, by his wife, Anna.[23] The identification has some warrant in an entry for a picture showing "Tobias, and a winding stair" in the record of a 1738 sale at Brussels, but the work can probably be traced still closer to the artist's time in a Dutch inventory of 1673 that refers simply to "a spiral staircase with an old man seated on a chair, by Rembrandt van Rijn." The inventory of another Dutch estate from 1687 speaks even more briefly of "a winding stair by Rembrandt van Rijn."[24] Though none of this proves conclusively that the artist actually painted the picture now in the Louvre, the chain of attribution speaks in its favor; and so, too, Clarke contended, does the very difficulty of pinning down the painting's subject, whose ambiguous iconography is characteristic of Rembrandt. (Most pictures of Tobit and Anna, for example, show her with a spinning wheel.) Along similar lines, Clarke countered the RRP's verdict that the work was both atypical of the master and probably a studio product by sensibly asking why the studio would have turned out a "Rembrandt" that didn't obviously look like one.[25]

For the time being, at least, the art world seems to have been persuaded by Clarke's argument: not only does the Louvre continue to display the painting as a Rembrandt, but even the RRP now seems to view it as genuine. Rather than speculate about iconography, which in this case "yields very little of interest," the latest volume of the *Corpus* suggests that we should approach the work primarily as a study in interior light.[26] Yet despite the agreement of all parties concerned that Rembrandt never intended to represent a philosopher, both the museum's catalogue and websites throughout the world continue to identify it as his *Philosophe en méditation*. And both in print and on the Web the habit of reading the picture through its title continues to override any iconographical evidence to the contrary. So a blogger in 2009 finds in the painting "a commentary or speculation by Rembrandt himself on the very same issues that philosophers think about," while the author of a sophisticated study of word and image that appeared in 1993 expounds at length on the connection between Rembrandt's painting and Plato's Allegory of the

Cave, even as he goes on to argue that the "terms of the image exceed those mandated by the Platonic allegory."[27] Whether this essentially deconstructive reading of Rembrandt's work would have been possible had it never been identified as a *philosophe* in the first place seems very doubtful.

If Rembrandt did intend to paint an image of Tobit, his picture's subsequent history might partly be understood as a process of secularization, like that which temporarily turned his *Holy Family* in the same museum into a *Carpenter's Household* (see fig. 6–2). By this account, Rembrandt's Tobit would owe his loss of identity to a weakening of iconographical knowledge and an Enlightenment culture more familiar with *philosophes* than with the obscurer narratives of the Bible. But it was not only sacred pictures from the seventeenth-century Netherlands that were read—or misread—through their eighteenth-century titles. Recall the genre painting by ter Borch that circulated through Europe under the title of *Instruction paternelle* (see figs. 5–5 and 5–4). A half century after Wille published his engraving, Goethe imagined a group of friends who seek inspiration for some *tableaux vivants* in three famous prints. By including among their choices the painting he identified, interestingly, as "the so-called *Paternal Warning*, by Ter Borch," the author of *Elective Affinities* (1809) managed at once to celebrate Wille's work and to further its fame by elaborating the narrative implicit in the printmaker's title:

> For the third picture they had chosen the so-called *Paternal Warning*, by Ter Borch; and who does not know Wille's magnificent copper engraving of this painting? A noble knight sits, with crossed feet, evidently severely lecturing his daughter, who faces him. A superb figure in a white satin dress with rich folds, she can only be seen from the back; but her whole posture seems to indicate that she is controlling herself. The expression and gesture of her father tells us, however, that his reproof is not too violent or humiliating; and the mother seems to hide a slight embarrassment while she gazes into the glass of wine she is about to sip.[28]

When Mary Ann Evans toured the Berlin museum in the winter of 1854, she found herself "pleased . . . to recognize among the pictures," as she put it in her journal, "the one . . . which Goethe describes in the Wahlverwandtschaften as the model of a tableau-vivant. . . . It is the daughter being reproved by her father, while the mother is emptying her wine glass." The future George Eliot was looking at the Berlin original, but her memory for its titular narrative was evidently stronger than her recall of the painter

himself, since the same journal entry attributes the picture in question to Jan Steen.[29]

The trouble, of course, is that we have no way of knowing whether ter Borch had anything like Wille's instructive scenario in mind. The painting exists in two versions—the one in Berlin and another at the Rijksmuseum in Amsterdam. By the middle of the twentieth century, the art-historical consensus had shifted the scene from a domestic interior to an upscale bordello, as the standing figure morphed into a courtesan, while her erstwhile parents turned, respectively, into a would-be client and his wine-sipping procuress. This theory appeared to receive further reinforcement when the Berlin picture revealed to some eyes the traces of a coin in the gentleman's hand; but that coin in turn has since been pronounced a phantom.[30] Even as the elusiveness of ter Borch's genre paintings has become a frequent theme of contemporary scholarship on the artist, museums and catalogues still require a title. When I last checked, the Rijksmuseum had chosen to call its version *The Gallant Conversation*, followed in parentheses by the phrase, "known as *The Paternal Admonition*"; at Berlin, the picture continued to go by the name Wille gave it.

It is no accident that Dutch art tended to inspire such readings. Painting of any kind poses an interpretive challenge when removed from its culture of origin, but the character of that challenge was significantly altered by the democratization of pictorial subject matter that first developed on a large scale in the seventeenth-century Netherlands. By appearing to take their cues from the world around them rather than from sacred or classical texts, the Dutch had created images at once more familiar and more open to interpretation than their history-painting counterparts in Italy or France. While some sacred subjects—a Virgin and Child, say, or a Crucifixion—were probably intelligible to nearly everyone at first glance, much history painting would have struck the general public as significantly in need of decoding: this was, after all, why members of the Académie had considered supplying even learned viewers with inscriptions in the first place, and there is no reason to assume that the need for such assistance diminished when the public for art expanded dramatically in the following centuries. But identifying a subject from history or myth is a different activity from baptizing a genre painting. Even as middlemen came to supply titles for paintings of all kinds, the freedom to invent those titles—and to read accordingly—was clearly much greater when the image in question had no fixed textual source.

In the same year that Wille exhibited his *Instruction paternelle* at the Paris Salon, a Scottish-born engraver named Robert Strange showed a print after the Italian Baroque painter known as Guercino that is recorded in the *livret*

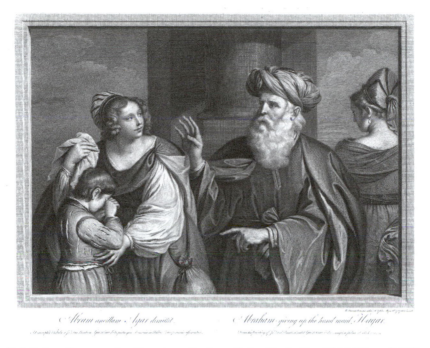

7–5. Robert Strange after Guercino, *Abraham Giving Up the Hand Maid Hagar* (1767). Engraving and etching. © Trustees of the British Museum, London.

as "Abraham répudiant Agar"—a title that appears in Latin and English on our version of the print (fig. 7–5).[31] Without the title, the uninstructed viewer might well have puzzled over Guercino's painting; but once the knowledge-able printmaker had identified its biblical narrative, potential readings of the image were correspondingly limited. Precisely because ter Borch's painting appeared to have no verbal source, Wille felt free to title it as he wished; and subsequent viewers extrapolated from his title to fill in the implied scenario. Perhaps Wille's print would not have proved as popular had he called it *La proposition* rather than *Instruction paternelle*, but it is by no means obvious that one choice is any less appropriate than the other, even if the stories that followed from the alternative title would surely have taken a different turn.

The difference between the ter Borch and the Guercino is not only—or simply—a difference between genre and history painting, however. Consider again the problem posed by Rembrandt's so-called *Philosophe*. If the picture does indeed represent Tobit, then it too is actually a history painting and should be classed with the Guercino, rather than the ter Borch—and so, of course, should the Holy Family that later centuries managed to identify as a

91

carpenter's household. Yet unlike Guercino, whose frieze-like arrangement, austere setting, and vaguely oriental costumes keep the world of his picture at a remove from the viewer, Rembrandt characteristically translates his historical subjects into the pictorial idiom of daily life. Despite the dreamlike aura of its vaulted room and winding stair, the space of the *Philosophe* appears continuous with our own—an effect compounded by the humble furnishings and the familiar gestures of the woman tending the fire in the foreground. Even the addition of figures not obviously related to the historical action increases the effect, by blurring the distinction between world-historical agents and anonymous persons going about their daily lives. To identify Abraham and Hagar in Guercino's painting is to recognize Ishmael and Sarah as well; but if the woman tending the fire in Rembrandt's *Philosophe* is indeed Anna, who is the barely visible woman disappearing up the stair? And who is the youthful and well-muscled figure laboring with his back to us in the same artist's *Holy Family*, if not a Joseph who to all appearances proves indistinguishable from an ordinary carpenter? (See fig. 6–2.) The democratization of pictorial subject matter in these cases may be an illusion, in other words, but it is an illusion that Rembrandt's own art encourages.

The relative ease with which Chardin's paintings also lent themselves to retitling is yet another sign of his often-remarked affinity with the Dutch, and with Rembrandt in particular—an affinity registered by several commentators when his "Philosophe occupé de sa lecture" returned to the Salon under its new title in 1753.[32] Just as many of Rembrandt's images appear to hover ambiguously on the border between history painting and genre (or history painting and portraiture), so Chardin's figurative works seem to occupy some undefined space between the moralizing tradition of the emblem books and the painting of ordinary life for its own sake; and the shifting titles they have accommodated have encouraged interpreters to alter their views accordingly. But without a clear iconographical tradition to anchor the meaning of an image, any painting can be read differently when someone retitles it. Indeed, both the virtual disappearance of such traditions and the radical expansion of pictorial motifs that accompanied it have arguably made modern viewers more reliant on titles than ever. The Debat-Ponsan bull that Vollard expeditiously transformed from a figure of virility into a sign of April might well have suffered the same fate had he been the work of an Old Master like Paul Potter, but his satisfied purchaser no longer inhabited a world in which communal understandings helped to determine visual meaning.

Vollard tells another story of changing titles, this one about an artist far more consequential than Debat-Ponsan. The dealer is vague as to dates, but the events in question probably took place sometime after Vollard staged his

breakthrough exhibition of Cézanne in 1895. "I was putting on a Cézanne show," says Vollard, "which included a *plein air* canvas representing some female nudes, together with a person who from his getup could be taken for a shepherd."

> The canvas had been placed in a frame from which I had forgotten to remove the former cartouche, which bore the legend: *Diane et Actéon*. In the press notices, the painting was described as if it really concerned the bath of Diana. An art critic even praised the nobility of the goddess's attitude and the modest air of the virgins who surrounded her. He admired in particular the gesture of the follower who, at the entry to the clearing, extended her arm as if to say, "Leave this place!" And he added, "One plainly recognizes in that the angry gesture of the offended virgin."[33]

One of Vollard's clients was much taken with the picture, but regretfully declined to purchase it on the grounds that he already possessed an "important *Diane au bain* by Tassaert" (probably a painting of 1842 by the French artist Octave Tassaert).

The work's titular adventures did not end with this episode, however. Sometime later, Vollard reports, he was asked to lend a *Tentation de saint Antoine* by Cézanne to another exhibit. Though he had promised to deliver it, the work was no longer in his possession, having been sold in the interim. But he still had custody of those nudes and their companion:

> I dispatched in its place the so-called *Diane et Actéon*, the frame this time bearing no designation; but since a *Tentation de saint Antoine* was expected, it was under that title that the picture I had promised was entered in the catalogue. And so it followed that a journal described the work as if it truly concerned a *Tentation de saint Antoine*. Where Diana's very noble attitude had previously been acclaimed, the journal's art critic discovered the smile, at once bewitching and perfidious, of a daughter of Satan. The follower's gesture of indignation was transformed into a seductive invitation. The pseudo-Acteon became a moving Saint Anthony.
>
> On the last day of the exhibit, I saw the collector who had refused the picture when it was baptized *Diane et Actéon*. He was holding in his hand the journal to which I have just alluded, and announced with great triumph: "I have just bought this *Tentation*. It has a striking realism!"

Presumably the satisfied collector continued to regard it as a *Temptation of St. Anthony*. As for the artist himself, he apparently had little use for these titular "avatars" of his painting. Told of his picture's adventures on his next visit to the dealer, Cézanne responded, according to Vollard, like a true precursor of formalism. "But there is no subject," the painter declared: "I merely tried to render certain movements."[34]

The painting Vollard describes appears to have vanished from the record, though it clearly belonged to the series of figural compositions that culminated in the three large canvases now known as the *Grandes baigneuses*.[35] But another of Cézanne's many variations on the theme may shed some light on its history (fig. 7–6). Here, too, the artist represents several female nudes and a male companion in a wooded glade; and as in the missing picture, several of their poses might well lend themselves to the sort of conflicting interpretations the dealer reported. It is not difficult to imagine, for example, how the partly clothed figure to the right of the canvas could look like either a noble goddess or a bewitching seductress, depending on the titular narrative through which she was read; while the gesture of the crouching nude at the left is sufficiently ambiguous to signal either refusal or invitation. Though there is no evidence of the sort of accident that baptized the *Diana and Acteon*, this picture, too, acquired a mythical title and was long known as *The Judgment of Paris*—a name apparently derived from the gesture of the young man at its center, who is handing some apples to one of the trio at the left. But in an influential essay of 1968 Meyer Schapiro pointed out that the picture's count of apples and women alike failed to accord with the myth, while the comparatively inconspicuous recipient of the fruit was hardly an obvious contender for Aphrodite. Schapiro did not exactly deny that the picture had what Cézanne called a "subject"; but in proposing to call it *The Amorous Shepherd* instead, he offered an account of the image that drew as much on the artist's personal history and private associations as on the literary texts that might have served as its stimulus.[36] I shall return to such critical retitlings in the following chapter. For now, it is more relevant to note how another sophisticated scholar several years earlier had managed to read the picture as a *Judgment of Paris*, even as he, too, registered its anomalies: rather than question its title, he had speculated that the "extraneous woman" to the right of the image "may represent the beautiful Helen, already present as Aphrodite's promised reward."[37]

By claiming that his work had "no subject," Cézanne did not mean to deny that it represented human figures—only that their arrangement was not intended to evoke any recognized episode in history or literature. This is the sense, for example, in which Eugène Fromentin, writing in 1876, had sweep-

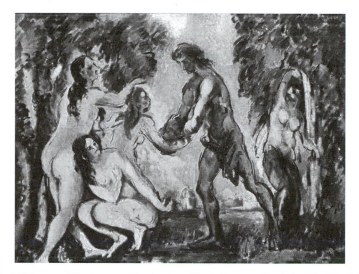

7–6. Paul Cézanne, *The Amorous Shepherd,* or *The Judgment of Paris* (1883–85). Oil on canvas. Location unknown.

ingly characterized seventeenth-century Dutch art by its "total absence of what we now call *a subject*"—an absence altogether compatible, as he made clear, with the proclivity of the Dutch for genre scenes, as well as landscape and still life.[38] While Cézanne's further contention that he had "merely tried to render certain movements" appears to acknowledge no middle ground between history painting and an art of pure form, both parts of his statement should be treated with caution. Whatever his intentions in the work Vollard describes, there seems little question that some of the artist's early canvases have identifiable sources in literature or myth, including several eccentric versions of the *Temptation of St. Anthony* produced in the 1870s.[39] And even without such a subject, images of the human figure are of course particularly susceptible to the sort of interpretations we have been tracing. If Vollard had accidently placed Cézanne's canvas in a frame whose legend read *The Amorous Shepherd,* the critics would doubtless have managed to view the picture accordingly.

But the hermeneutic power of a title is not limited to painting that aims at representation. Jackson Pollock would probably have chosen to speak of expressing movements rather than of rendering them, but when he accepted the title of *Pasiphaë* for the image he had once called *Moby-Dick,* he tacitly acquiesced in more than a convenient handle for identifying his canvas (see plate 1). William Rubin, who first called attention to the danger of relying too literally on Pollock's titles, drove home his point by confessing to his own

former "overreading" of *Pasiphaë*—a painting whose "energetic motifs" he had once identified with "sexual abandon," "physical ecstasy," and "animal passion." (Recall that it is Pasiphaë who cuckolded King Minos with a bull and gave birth to the Minotaur.) Viewing the painting's ambiguous forms in light of its title, Rubin had perceived "two figures . . . in what could well be the sexual act"—a "lower one . . . somewhat animalistic," with a "full, rounded" appearance, and "an angular black stick figure on top of it"—even as he had determined that "the frontal and symmetrical scene" in which they were engaged had "a ritual character that implie[d] a mythic ambience."[40]

By the time that he told this cautionary tale, the director of painting and sculpture at the Museum of Modern Art knew that *Pasiphaë*'s title had originated with a former curator at his own institution rather than with Pollock himself, though he also plausibly speculated that the artist would have rejected any suggestion that had no "metaphoric significance in regard to the image." What he didn't say, perhaps understandably, was whether Pollock's belated acceptance of the alternative title might constitute a license to read the image for just such metaphors. Given Pollock's resistance to the whole business of naming his pictures—according to Lee Krasner, he "hated titling and tended to put it off until the last moment, usually just before a show"—it seems doubtful that any of his titles can really be justified by a strict account of intention.[41] Had the artist continued to call the painting *Moby-Dick*, it is easy to imagine how viewers could have seen Rubin's stick figure as Captain Ahab and his "animalistic" shape as the whale; but would that reading necessarily have been any more warranted than the ones generated by *Pasiphaë*? When Frank O'Hara celebrated the work's "aura of vigorous decadence, like the pearly, *cerné* [shadowed] eyelids of Catherine the Great"—another woman legendarily consumed by the desire for sex with an animal—he presumably had no way of knowing that the artist had completed the canvas before he had ever heard of Pasiphaë's story. Having learned that Pollock's painting was once named *Moby-Dick*, we may find it impossible to share O'Hara's conviction that it "encompasses the amorous nature of bestiality," or that "the stark, staring and foreboding figure of Pasiphaë is present, with her foreknowledge of the Minotaur and her lust, as are the other figures of her fancy or necessity."[42] Yet the painting continues to hang—and to circulate— with its mythical title. And anyone able to read that title will be tempted to view the image in accord with it—even if she first has to ask, like Pollock himself, "Who the hell is Pasiphaë"?[43]

"Responding to a painting complements the making of one," Arthur Danto has written, "and spectator stands to artist as reader to writer in a kind of spontaneous collaboration."[1] Yet what is the status of the work that results when a spectator manages to see in Pollock's canvas an evocation of the mythical Pasiphaë? Should such a reading be ruled out of court, on the grounds that it fails to correspond to the artist's original intention, or did Pollock's belated acceptance of the title constitute a creative act in its own right, such that a new work—call it *Pasiphaë-after-the-fact*—came into being at that moment? (This is implicitly what the compilers of the catalogue raisonné assume when they treat the painting's title as authorial.) And what shall we do when our reading of a picture depends on a title that has no documented connection with the artist at all, as happens for so many works painted before the eighteenth century? Might we choose to argue that by this point in our collective history there is such a work as Rembrandt's *Philosophe en méditation* or ter Borch's *Paternal Admonition*, despite the fact that the titles traditionally assigned to those images—and the interpretations that follow from them— have no artistic authority?

Consider the famous painting that prompts Danto's remark on the collaboration of artist and spectator—a work that he identifies, familiarly enough, as "Breugel's *Landscape with the Fall of Icarus*" (plate 3).[2] The subject of over sixty poetic ekphrases in some half-dozen languages, including W. H. Auden's much-quoted "Musée des Beaux Arts" of 1938, this particular image has probably inspired more responses from writers in the past century than any other.[3] It is also an exemplary case of a painting whose title has proved crucial in determining how viewers see it. Danto himself makes that title central to his discussion of how pictorial interpretation works, as he imagines various scenarios in which viewers approach the painting without noticing what it is called, or with the belief that it bears some other name—

"*Industry on Land and Sea*," for instance, or "*The Departure of the Armada*." (The other possibilities he entertains are "*Plowman by the Sea*," "*Works and Pleasures*," and "*Landscape #12*.") Like many commentators on the work, Danto focuses on what might appear at first glance a minor detail: the "dab of white paint over to the lower right" that proves on closer inspection to be a pair of legs sticking out of the water (fig. 8–1). Were the painting simply identified as a landscape, he argues, those legs would probably remain insignificant—"a mere Flemish detail, like the shepherd's dog or figures winding along some distant path." If it were called "*Industry on Land and Sea*," on the other hand, they could belong to "a pearl diver or an oysterman," while "*Works and Pleasures*" might justify the Danto children in their belief that the figure is swimming. "But with the further identification of the legs as belonging to Icarus, the whole work changes." Once the viewer knows the painting's title, those partly submerged legs become the focus of interpretation, such that their very lack of salience in the composition as a whole proves the key to its meaning:

> It is not just that the plowman is not paying any attention, but that Icarus has fallen, and life goes on, indifferent to this tragedy. Think of the deep significance of this indifference, and hence of the relationship between the compositionally dominant and the cognitively dominant figures, in the light of Auden's remarkable poem on the painting.

Taking the words of the title as an instruction issued by the painter himself, Danto sees that dab of white paint as paradoxically central to the image, even as he manages to heighten the effect when he ends by referring to the work simply as "*The Fall of Icarus*."[4] As he oddly fails to recognize, however, neither the picture's full title nor its abbreviated one can be attributed to Bruegel. What the philosopher takes as evidence of artistic intention is instead the work of middlemen—a label applied centuries after the fact by persons who were themselves engaged not in making the picture but in interpreting it.[5]

The history of this particular painting and the names associated with it is even more vexed than usual. The canvas is neither dated nor signed. No record of it surfaces until 1912, when it was purchased from a London gallery by its current owner, the Musées royaux des beaux-arts in Brussels. Whether the seller had already identified the drowning boy or that was the work of the Brussels experts is not clear, though the correspondence suggests that both parties thought of the work as a "Fall"—or "Death" of Icarus.[6] But from 1913, when the picture appeared in a museum guide as *La chute d'Icare*, to the present, when a label on the wall repeats the short title while an inscription on

8–1. Pieter Bruegel the Elder (?), *Landscape with the Fall of Icarus* (detail).

the frame gives *Paysage avec la chute d'Icare,* scholars seem to have had little doubt that those white legs belong to the mythical figure who plummeted into the sea when he flew too near to the sun.[7] They have been more certain, in fact, about the name of Icarus than about that of the painter, whose identification with the elder Bruegel has been debated ever since the work was first displayed in public a century ago. Yet there is a crucial difference between the sort of iconographic research that served to establish the figure as Icarus and the decision to name the picture after him. Those who settled on the painting's current title were engaged in an interpretive act whose cultural effects, as we have already begun to see, would prove far-reaching.

The strongest verbal evidence for the picture's current title comes from a 1621 inventory of the imperial collection at Prague, which records "Eine Historia vom Daedalo und Icaro vom alten Prügl" (A History of Daedalus and Icarus by the elder Bruegel). A subsequent entry of 1647–48 refers to "Ein Landschafft. Dedalo und Icaro," but doesn't name the painter. Though some scholars have been tempted to identity these records with the painting celebrated by Auden and others, the absence of Daedalus from the present work calls that identification into question—especially since there exists another version of the image, now at the Musée van Buuren in Brussels, that shows both figures (fig. 8–2). That version, which first surfaced in a private collection in 1935, has long been viewed as a copy. An engraving and an etching after Bruegel also show a pair of tiny figures in the sky, one flying and the other plunging; and an inscription on the etching, which dates the design to 1553, includes a passage about Daedalus and Icarus from Ovid's *Tristia* (fig. 8–3). The latter must be treated cautiously—not only because the inscriptions on Bruegel's prints typically originated with the publisher rather than the

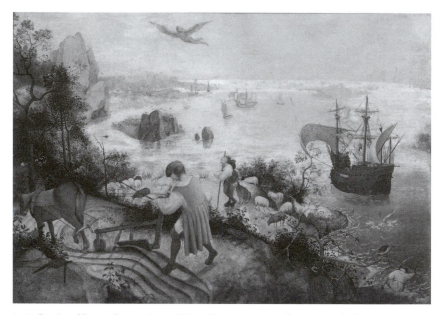

8–2. Circle of Pieter Bruegel the Elder, *The Fall of Icarus* (c. 1590–95). Oil on wood. © Musée et jardin van Buuren, Brussels.

artist, but because the etching was not published until several decades after the date it records, by which time the artist was dead. There is also the possibility that the mythical figures in both prints were added by other hands. Yet even without the support of sixteenth-century emblem books and editions of Ovid, with their contemporary images of a falling Icarus (fig. 8–4), details in the painting itself help to confirm the connection to the version of the myth in the *Metamorphoses*.[8]

Most obvious is the presence of each of the witnesses specified by Ovid—"An angler fishing with his quivering rod, / A lonely shepherd propped upon his crook, / A ploughman leaning on his plow"—though the fact that only the shepherd appears to register the extraordinary phenomenon that has just taken place signals a radical shift from the poem. (In Ovid, all three "looked up / And gazed in awe, and thought they must be gods / That they could fly.")[9] Sharp-eyed observers have also detected a more subtle allusion to the *Metamorphoses* in the partridge who clings to the branch on the right, directly below the figure of Icarus (see fig. 8–1).[10] According to the Ovidian narrative that immediately follows Icarus's death, this is the metamorphosed form of Daedalus's nephew, Perdix, whose inventive gifts prompted his uncle to hurl him in a jealous rage from the Acropolis. Rescued by Athena and transformed into a bird that never flies because of its permanent fear of heights,

8–3. Simon Novellanus after Pieter Bruegel the Elder, *Allegorical Landscape* (*River Landscape with Daedalus and Icarus*) (c. 1595). Etching. © Trustees of the British Museum, London.

8–4. Anonymous woodcut of Daedalus and Icarus for Albrecht von Halberstadt and Jorg Wickham, *P. Ouidji Nasonis dess aller sinnreichsten Poeten Metamorphosis . . .* (Mainz: [Schöffer], 1545), fol.82r. © Warburg Institute.

Perdix appears in the *Metamorphoses*—and presumably the painting as well—in pointed contrast to the tragically high-soaring Icarus.

Picture titles can have a zooming effect, as Leo Hoek has shrewdly noted, and no title better demonstrates that effect than *Landscape with the Fall of Icarus*.[11] The process, of course, is circular: the painting acquired its title from knowledgeable viewers who recognized the drowning Icarus in the small figure to the right, and that title in turn prompts subsequent viewers to zoom in on the figure. The very clarity with which the detail is painted—a clarity arguably heightened in reproduction—further encourages the effect, as if Bruegel's meticulous style were itself a kind of zoom lens before its time. Few art historians can resist the temptation to provide a version of the detail in figure 8–1, even when they wish to direct our attention to other aspects of the image. But for those whose principal dedication is to the word, the combination of picture and title has proved irresistible. "The design is striking," the Belgian poet Émile Verhaeren wrote a year after the canvas was first exhibited, and "the attention is all the more attracted and highly excited because it must make an effort to find the subject of the poem. Hence as soon as it has taken hold of it, it never lets go, and this *Fall of Icarus*—treated by Bruegel, people say, in a manner contrary to common sense and logic—is what remains most obstinately engraved in the memory of the spectator."[12] To the best of my knowledge, Verhaeren never expanded on his response by writing a poem himself. But in stressing the excitement of ferreting out what he tellingly termed "the subject of the poem" from a painting that seemed to resist the effort, and in speaking of that subject as thenceforth "engraved" in memory—a word that hovers ambiguously between a visual image and an act of printing—he had already begun to articulate the unusual power of the work for generations of poets to come.

"About suffering they were never wrong, / The Old Masters," the most influential of such responses famously begins, as Auden generalizes his case by drawing loosely on two other Bruegels—one imaginatively transported to Brussels for poetic purposes—before turning to the only image he names:

> In Breughel's *Icarus*, for instance: how everything turns away
> Quite leisurely from the disaster; the ploughman may
> Have heard the splash, the forsaken cry,
> But for him it was not an important failure; the sun shone
> As it had to on the white legs disappearing into the green
> Water; and the expensive delicate ship that must have seen
> Something amazing, a boy falling out of the sky,
> Had somewhere to get to and sailed calmly on.[13]

The inverted syntax of the first line, like the reduction of the picture's tradi-
tional title to the italicized name of the drowning boy, intensifies the zoom-
ing effect by turning what is compositionally a small area into the emotional
center of the image: Bruegel's picture is "about" the suffering it appears to
minimize—or, more precisely, about how "everything turns away" from "the
disaster."[14] The painter may have treated Icarus as a mere detail, but only two
of the poet's eight lines contain no direct reference to his fate.

That Auden should have zeroed in on the drowning figure is not surpris-
ing. "To me, Art's subject is the human clay," he had written two years earlier,
"And landscape but a background to a torso."[15] This is far removed from Wil-
liam Carlos Williams's celebrated dictum, "No ideas but in things."[16] For
Williams, who published a sequence of poems inspired by Bruegel in 1960,
the painter's appeal may have partly inhered in the very concreteness of his
images—what one critic terms his "obdurate reproduction of the materiality
of the world."[17] Yet even a poet of Williams's sensibilities begins and ends his
response to this painting with the human subject of its title, "Landscape with
the Fall of Icarus":

According to Breughel
when Icarus fell
it was spring

A farmer was ploughing
his field
the whole pageantry

of the year was
awake tingling
near

the edge of the sea
concerned
with itself

sweating in the sun
that melted
the wings' wax

unsignificantly
off the coast
there was

a splash quite unnoticed
this was
Icarus drowning[18]

Rather than a mere "background to a torso," the landscape in Williams is at
the very center of the poem; and the indifference that here greets Icarus's fall
is as much a matter of that landscape's resistance to human concerns as of the
human limitations implicated by Auden. It is "the edge of the sea" or perhaps
"the whole pageantry / of the year" that is "concerned / with itself," rather
than the other figures in the painting, and the wings melt "unsignificantly"
rather than "insignificantly"—not just trivially, but without signifying at all.
Yet in designing his poem as a visual icon both of Icarus's fall and of the jour-
ney made by the viewer's eye as it travels through the canvas in search of his
figure, Williams also takes his cue from the traditional title of the painting.[19]
Like others who have responded to the image in Auden's wake, he manages
to see in the picture what Verhaeren termed "the subject of the poem"—a
subject that proves to be Ovid's as well as his own.[20]

Landscape with the Fall of Icarus is not the only composition in which
Bruegel appears to obscure his true subject. Several paintings on biblical
themes likewise challenge the viewer to distinguish their sacred protago-
nists, whose scale and placement render them difficult to identify in a scene
crowded with figures apparently unaffected by the historical drama unfolding
in their midst. The tiny Christ who staggers beneath the cross in the middle
distance of *The Way to Calvary*, for instance, or the heavily cloaked Virgin,
who arrives on a donkey pulled by Joseph in the foreground of *The Census at
Bethlehem* (fig. 8–5), would seem to confirm the poets' assumption that Ica-
rus, too, is the hidden center of the work in which he appears. And indeed *The
Census*, which also hangs in the Musées des beaux-arts in Brussels, is clearly
among the images that Auden had in mind when he generalized about
human indifference in the opening lines of his poem:

How, when the aged are reverently, passionately waiting
For the miraculous birth, there always must be
Children who did not specially want it to happen, skating
On a pond at the edge of the wood

Yet *Landscape with the Fall of Icarus* is also the only painting in this com-
pany that invokes classical myth rather than scripture, and not every com-
mentator has been persuaded that its traditional title directs our gaze where
the artist intended. Rather than equate the laborers who ignore the drown-

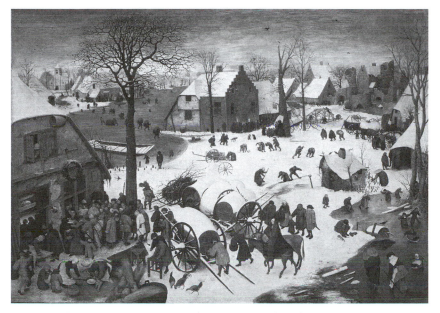

8–5. Pieter Bruegel the Elder, *The Census at Bethlehem* (1566). Oil on panel. Musée d'art ancien, Musées royaux des beaux-arts de Belgique, Brussels. SCALA/Art Resource, NY.

ing boy with the crowds indifferent to the advent of Christ, several modern art historians have argued that the plowman who dominates the canvas visually is also its moral focus, his steady attention to his labor serving to counter the foolish ambition of the high-flying Icarus. Citing Luke 9:62, "No one who puts a hand to the plow and looks back is fit for the kingdom of God," as well as the more ominous German proverb, "No plow stops for the sake of a dying man," these accounts emphasize the image's evocation of a social order in which the humble peasant knows his place. In support of this reading, they call attention to the dagger or knife that has apparently been set aside on the rock to the left—an implicit disarming whose significance would have been particularly felt at a time when anxieties about peasant uprisings were still very much in the air (see plate 3). They also remark the comparative dignity of the plowman's costume and suggest that what appears to be a corpse in the bushes (not visible in reproduction) doubles the applicability of the plow's proverbial refusal to stop for a dying man.[21] Ovid still figures in such accounts of the painting, but mainly as the author of the *Tristia*, whose brief lines on the myth conclude, "He who lies low, lives well, believe me; one should / Remain within the limits of one's lot."[22] Rather than a representation of indifference to human suffering, the painting be-

comes by these accounts "a vision of the world in order," whose diminishment of Icarus's fate is altogether in keeping with the dutiful absorption of its principal figure.[23]

Most art historians are content to advance such arguments even while adhering, for the sake of convenience, to the traditional name of the image. But a recent account of the painting challenges that consensus too, by proposing that the work would be better understood if it were titled "*World landscape at sunset with a plowing farmer, an idle shepherd, a hopeful fisherman, a merchant vessel, a dead body, and the Fall of Icarus.*" As this unwieldy title suggests, Lyckle de Vries contends that the impulse to zero in on the figure of Icarus has distorted our perception both of the work's genre and of its individual elements, a number of which have been too readily assumed to take their principal significance from their relation to the myth. Though he joins his fellow art historians in viewing Icarus as a sign of fallen pride rather than of human suffering, de Vries is more inclined than the others to see that tiny figure as incidental to the whole. For de Vries, the absence of Daedalus from this version and the marginal placement of his son are clear indications that this "is no history piece . . . and its interpretation should not center on Icarus." By calling it instead a "world landscape"—a term he derives from Walter Gibson—he means to emphasize not just the relative subordination of the human figures to their natural surroundings but the "high horizon and helicopter view" that create the effect of "an armchair traveler's look upon the structure of the earth compressed into a narrow space." Such a perspective takes in the activities of cultivating the land and sailing the seas as parts of a well-ordered scene: the ship, for example, appears as a tribute to industry and trade rather than in relation to the drowning Icarus. Had Bruegel wished to emphasize that relation, de Vries argues, he would have made the vessel larger. At the same time, de Vries seeks to account for another aspect of the painting that has long puzzled its commentators: the fact that the sun seems to be setting rather than high in the sky, where it should presumably appear if it has just melted the wings of Icarus. According to de Vries, the explanation for this and other conspicuous details is to be found in the eleventh chapter of Ecclesiastes, whose sixth verse—"In the morning sow thy seed, and in the evening withhold not thine hand"—serves as a gloss on the dutiful labor of the plowman; while its fourth verse—"He that observeth the wind shall not sow; and he that regardeth the clouds shall not reap"—comments adversely on the shepherd, who is idly gazing upward rather than attending to his flock. As for the corpse in the bushes and the drowning Icarus, these become reminders, in the resonant language of the same book, that "To every thing there is a season . . . A time to be born, and a time to die; a time to plant, and

a time to pluck up that which is planted" (Ecclesiastes 3:1–2). By this reading, the picture's Ovidian allusions ultimately drive home the wisdom of Solomon.[24]

De Vries offers his account as a sober corrective to the imaginative distortions of Auden and the others, whose strong misreadings of the image, he suggests, have unfortunately led scholars astray. "By following the lead of a great poet, art historians were seduced into working against the painting's composition, just as Auden had done," he writes, even as he wistfully confesses that he, too, still prefers the interpretation of the poets. Yet in distinguishing between "poetic license" and the "scholarly discipline" with which he aligns himself, he fails to register how much the poets in turn were following the lead of an earlier generation of scholars.[25] The impulse to see the painting as focused on the drowning boy began—though it clearly did not end—with those who first titled the painting *Landscape with the Fall of Icarus*.

For the poets themselves, of course, the very degree to which the painting appears to impede the interpretation implicit in its title has proved a powerful catalyst for writing. Whether or not Bruegel deliberately composed the image "to frustrate verbal appropriation," as James V. Mirollo has argued, there is an obvious tension between the importance accorded Icarus by the design of the picture and the poets' own allegiance to language. Approaching the work as a self-conscious entry in the traditional struggle between the arts known in the Renaissance as the *paragone*, Mirollo sees both the visual marginalization of Ovid's figure and the way all the others look away from him as Bruegel's silent claim to painting's dominance over its literary rival—a challenge to which the modern poets then respond when they seek to wrest from the mute canvas their stories of Icarus.[26] Even Williams, whose Icarus falls "unsignificantly," belongs in this company, as does the contemporary poet Dannie Abse, whose witty variation on the theme, "Brueghel in Naples" (1989), gives voice to the falling boy himself as he plunges toward his death. Abse's poem closes with Icarus crying out in vain to the potential witnesses, who tellingly include not just the other figures in the painting but the artist quietly depicting them:

> Lest I leave no trace
> but a few scattered feathers on the water
> show me your face, sailor,
> look up, fisherman,
> look this way, shepherd,
> turn around, ploughman,
> Raise the alarm! Launch a boat!

My luck. I'm seen
only by a jackass of an artist
interested in composition, in the green
tinge of the sea, in the aesthetics
of disaster—not in me.

I drown, bubble by bubble,
(Help! Save me!)
while he stands ruthlessly
before the canvas, busy busy,
intent on becoming an Old Master.

Unlike Auden's, this Old Master cares only for "the aesthetics / of disaster"—
the "composition" rather than the "human position" of suffering. Yet for all
the irony with which Abse treats his self-absorbed protagonist—"These days,
workmanship, I ask you. / Appalling," he complains, as the wings designed by
his father begin "to moult not melt" in this sunset landscape—the picture of
this poem, too, focuses on the fall of Icarus.[27]

Not every picture title, even one with a mythical name, has the power of
Landscape with the Fall of Icarus. The precision with which the truncated form
of Icarus is rendered confirms the sense of discovery with which a viewer
lights on his figure—an experience very different from the potentially baffled
search for visual evidence of the titular protagonist in Pollock's *Pasiphaë*, for
example. The title of the painting tells the viewer where to look, and the style
of the painting reinforces the title, a mutually authenticating process that is
further enhanced, many times over, by the poetic ekphrases that keep readers
and viewers alike focused on the fall of Icarus. (Of course, the style of *Land-
scape with the Fall of Icarus* also helped to confirm the iconographic work that
produced the title in the first place: absent the word of the artist, it is hard to
imagine a similar post hoc effort arriving at the name of Pollock's *Pasiphaë*.)
Auden's influence in particular has had a momentum of its own, so that it is
almost impossible to say at this point whether subsequent poets are respond-
ing more directly to the painting or to its image as refracted through the
language of their predecessors. Surely many of us who are not poets first en-
counter "Brueghel's *Icarus*" on the page of "Musée des Beaux Arts" rather
than in the Brussels building from which the poem itself gets its title.

And that picture seems likely to endure, though it may prove a poetic fic-
tion in more senses than one. For if we mean by "Brueghel's *Icarus*" the canvas
that currently hangs in the Musées royaux in Brussels, then it seems increas-

ingly certain that the attribution to the master's hand may be more mislead-
ing than the titular emphasis on the drowning boy. Questions of authenticity
have hovered over the work ever since it first surfaced in 1912, prompted in
part by the mystery of its sudden reappearance, as well as by the absence of a
signature and the poor condition of the canvas. Though most scholars were
quick to conclude that the other version of the image was a copy, its differ-
ences from the work in the Musées royaux further complicated the puzzle,
leading some to wonder whether a later hand had altered or cut down the
present painting.[28] In recent years, however, radiocarbon dating and other
scientific techniques appear to have settled the question, by showing that the
oldest parts of the canvas could not have been produced before 1600—more
than thirty years after the elder Bruegel's death. Nor can it be identified with
the younger Pieter Brueghel (he spelled his name with an "h"), whose works
are often confused with his father's. According to the latest word from the
laboratories, the painting that has inspired so much poetry should now be
identified as just another copy: an anonymous artist's version of an absent
original.[29] What remains of Bruegel himself is at best the composition,
though we still don't know which of the two copyists followed it more closely.
Perhaps the sun was originally blazing and the shepherd gaping at Daedalus,
as in the version at the Musée van Buuren (see fig. 8–2). Or perhaps we
should assume that the very obviousness of that solution argues against it,
and that the mysterious deviations from the expected scenario in our version
reflect the true inventiveness of the Master.[30]

Presumably the canvas in the Musées royaux will soon acquire a new label,
and some editions of the poems may even follow up with a note. The truth
about this—or any—painting matters to history, as well as to connoisseur-
ship. But if "Brueghel's *Icarus*" no longer names a particular object in Brussels,
the idea of the painting will not disappear so readily. The readings generated
by its title have entered into the cultural imagination, and they will continue
to circulate—often accompanied, as they already have been, by a photograph
of the image. Call it perhaps a virtual painting: not exactly a material object,
nor merely a creation of words, but a combination of title and image whose
hold on us proves stubbornly resistant to debunking. It seems ironically ap-
propriate that this is a painting said to look "beautiful above all in reproduc-
tion," and that Williams took his idea of the picture not from the canvas itself
but from an art book—and, of course, from his reading of Auden.[31]

[9 · MANY CAN READ PRINT]

Mark Twain offered his own wry commentary on the power of titles. "In Rome," he observed in a well-known passage from *Life on the Mississippi* (1883), "people with fine sympathetic natures stand up and weep in front of the celebrated 'Beatrice Cenci the Day before her Execution.' It shows what a label can do. If they did not know the picture, they would inspect it unmoved, and say, 'Young girl with hay fever; young girl with her head in a bag'" (fig. 9–1).[1] Immensely popular in the nineteenth century—Nathaniel Hawthorne thought it "the very saddest picture that ever was painted, or conceived"—the so-called portrait of Beatrice Cenci depended for its appeal on the legend of Beatrice as a tragic avenger of paternal incest, a legend powerfully invoked by writers from Shelley and Stendhal to Hawthorne himself.[2] Though by Twain's time both the picture's subject and its attribution to Guido Reni had begun to be questioned, tourists continued to flock to it.[3] Those weeping viewers, Twain suggested, were not so much looking at a painting as reading a label.

At least he was apparently confident that the viewers in question would know when they were looking at a human figure. Forty years earlier, another satirist had already been more skeptical. Consider what transpires in Honoré Daumier's *Bourgeois au Salon* of 1842 (fig. 9–2). Loosely translated, the caption reads:

> Let's look a bit . . . What's this? . . . [reading in his catalogue], "No. 387. Portrait of Mr. B***, stockbroker . . . Well . . . well! . . . Ah! What an idiot I am . . . It's 386 that's the portrait of Mr. B***. This one here is the portrait of a bull by Mr. Brascassat . . . I'd say, too . . . the idea of having himself painted with horns as big as that . . . After all, those stockbrokers, ain't nothing that sort can't get away with.

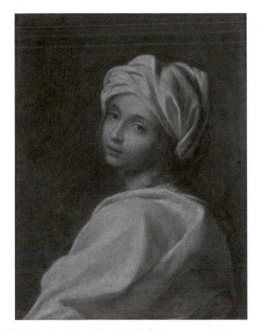

9–1. Guido Reni (?), *Beatrice Cenci* (first half of the seventeenth century). Oil on canvas. Galleria Nazionale d'Arte Antica, Rome. SCALA/Art Resource, NY.

The joke has many targets, the power and vanity of wealthy stockbrokers obviously among them. The specific association of bulls with a rising stock market can be traced to the beginning of the eighteenth century in England; and the print offers good grounds for believing that it was current in Daumier's France as well, despite its absence from contemporary dictionaries. There's probably also a jibe at the painter of the "portrait," since Brascassat seems to have had a reputation for making good money by appealing to the popular taste for animal pictures. In a Salon commentary written three years after Daumier's print, Thoré-Bürger slyly inquired as to whether Brascassat's bulls had been growing in size recently, with the distinct implication that the artist expected his prices to rise with their weight.[4] But the most interesting target of the satire from our perspective is Daumier's hapless bourgeois, whose first impulse when looking at a picture is to consult his catalogue. Though part of the joke may turn on the city-dweller's failure to know a bull when he sees one, his extended confusion of an animal painting with a human portrait has its origin in an act of reading. The title, in short, dictates what he sees.

Charles Baudelaire, who much admired Daumier, claimed that "the legends that are written at the bottom of his drawings don't have much use,

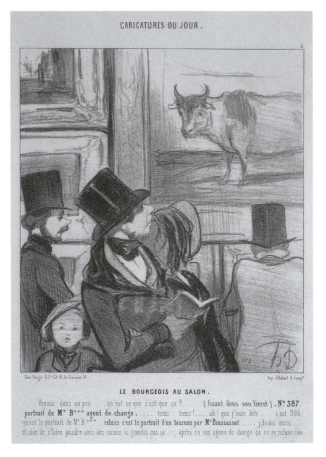

9–2. Honoré Daumier, *Le bourgeois au salon* no. 4 from the series *Caricatures du jour* (1842). Lithograph. 20.8 × 18.2 cm (image); 34.2 × 26. 5 cm (sheet). Chez Bauger et cie (publisher). Aubert et compagnie (printer). Bruno and Sadie Adriani Collection 1956.166, Fine Arts Museums of San Francisco.

since the drawings could generally do without them,"[5] but the meaning of this image is thoroughly dependent on the words that accompany it: take away its caption, after all, and this satire on those who read rather than look would be nothing but a picture of a man looking at a picture of a bull. In a later variation on the theme, a family at the Salon puzzle over the relation between word and image in Manet's *Olympia*, with the husband apparently assuming that the name belongs to the servant—"Why the devil is that fat red woman in her undershirt called Olympia?"—and the wife speculating that it instead applies to the cat: "But my dear, perhaps it's the black cat who's named something like that?" (fig. 9–3). Unlike the earlier print, this one re-

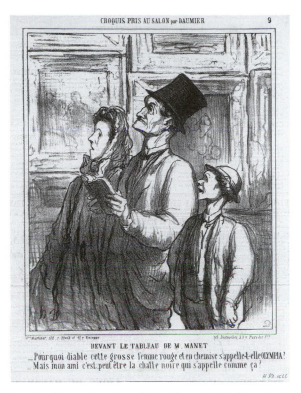

9–3. Honoré Daumier, *Devant le tableau de M. Manet* (1865), from *Le charivari*, 19 June 1865. Lithograph. © Trustees of the British Museum, London.

quires its audience to possess some visual memory of an absent original, and the joke presumably targets not only the bewildered Salon-goers with their catalogue but the high-flown name that Manet had notoriously bestowed on his naked courtesan (fig. 9–4).[6] But despite Baudelaire's claim that with Daumier "you look, and you have understood,"[7] this joke, too, works only if the viewer is also a reader. Without its title and the accompanying dialogue, Daumier's print would simply be an amusing caricature of a family in a picture gallery. The ideal of visual purity implicit in Baudelaire's praise has no purchase on such composite productions, whose own satires of a word-dependent culture would be impossible apart from the conditions they satirize.[8] Visually arresting as they may be, Daumier's prints take for granted that everyone can read.

Viewed from a historical perspective, in fact, perhaps the most striking aspect of these satires is their implicit reversal of some long-standing hierarchies of word and image. Whether one thinks of the medieval commonplace

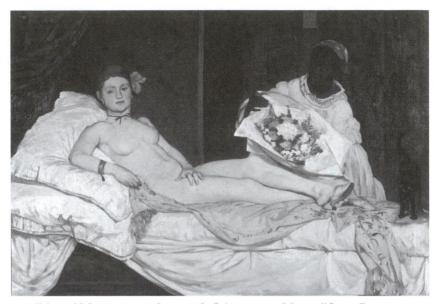

9–4. Edouard Manet, *Olympe* (1863–65). Oil on canvas. Musée d'Orsay, Paris. SCALA/Art Resource.

that images were the "books" of the illiterate—a proposition first articulated around 600 CE by Pope Gregory the Great—or the frequently reiterated contrast between the "natural signs" of the painters and the arbitrary ones of the poets, the belief that images are more accessible than written texts has a venerable lineage. This is not to say that such images really spoke for themselves, though casual invocations of Gregory's dictum have sometimes implied otherwise. As recent scholars have rightly emphasized, most medieval art came thoroughly embedded in a verbal context.[9] Even the simplest of religious subjects—a painting of the Virgin Mary with the Child on her lap, for example—would not have conveyed its meaning to someone who had never heard the Christian story. But hearing that story and reading it in Greek or Latin were very different activities; and for most viewers before the age of print, understanding an image was a matter of oral instruction, not the decoding of letters. Like the modern child who learns to identify an object in a picture book by hearing another person speak its name, such persons learned to recognize a visual sign through speech rather than writing. And while the evidence suggests that people do find some visual signs easier to construe than written ones—we start children on picture books, after all, before we teach them to read—the distinction between "natural" signs and conventional ones has proved impossible to maintain.[10] What I wish to emphasize here,

however, is less the difficulty of distinguishing between nature and culture than the elite aura that had long attached itself to the written word and the small number of persons who could decipher it. The very fact that Gregory's dictum was so often invoked over the centuries testifies to how stubbornly entrenched, too, was its corollary: the belief that images were the lesser folk's medium.

With the spread of literacy, that belief is no longer self-evident. When anyone can read—or so it seems—the written word loses much of its aura, and its relation to the image undergoes an important shift. Daumier's confused Salon-goers have no trouble reading a *livret*: what baffles them is decoding a picture.[11] Just when mass literacy was actually achieved in Western Europe is a vexed question, and much depends on how it is understood: the ability to grasp a complex piece of literature is obviously not the same as the ability to decipher a simple caption, and even owning books, as historians of the subject have been quick to observe, says little about the owner's capacity or inclination to read them.[12] Literacy rates grew unevenly from region to region, as well as by gender, religion, and class. There were also sharp differences between urban areas and rural ones: Daumier's Parisians were more likely to be literate than their country cousins. But most scholars agree that the cultural revolution initiated by the printing press in the mid-fifteenth century had accelerated rapidly by the end of the Enlightenment, and that the nineteenth century saw the greatest advances in the democratization of reading.[13] And as often happens with such large transformations, the perception of change kept somewhat ahead of the reality. By the late eighteenth century, a German traveler was already reporting that "everyone in Paris is reading."[14]

It was the advent of that readership, then, as much as the mobility of the image, that furnished the conditions for the modern picture title. Though I have argued that titles acquired their power when pictures began to circulate, that power would obviously have been moot if few people could read. In truth, however, the spread of literacy more or less coincided with the increasing circulation of pictures themselves, and the very centuries that witnessed the democratization of access to art were also those that witnessed the democratization of reading. When Henri-Gabriel Duchesne and Pierre-Joseph Macquer argued for the usefulness of their portable guide to cabinets of natural history in 1771, they did so by analogy to the familiar benefits of such works in picture galleries:

> When a man enters a vast portico ornamented with paintings, he admires their beauty, elegance, and skill; if a book that explains their subjects to him is put into his hand, his attention awakens. Nothing es-

capes him; he enters into all the ideas of the painter. He becomes the judge of his intention and of his execution. In a word, he penetrates into his most secret thoughts.[15]

Duchesne and Macquer still imagined their own reader as "a man of taste, an enlightened amateur." But the anonymous critic who protested the absence of labels from the revolutionary Louvre some two decades later clearly had a larger public in mind. After deploring the museum's failure to hang the paintings chronologically within each school—an arrangement that would prove instructive for aspiring artists and "the people" alike—he advanced another proposal for the benefit of everyone:

> It is again for the utility of the public, to facilitate its instruction, that we propose to write the subject and the name of the painter at the bottom of each picture. One can't imagine how many false ideas the people bring back from a stroll in the Museum, for want of being able to guess the subject of the painted scenes they had before their eyes. A so-called connoisseur often explains to numerous groups of auditors, with much emphasis and presumption, that which he doesn't understand himself, giving them Roman personages for Greek ones; for Romans, Hebrews; and instead of a real scene [*une réalité*], an allegory. A short legend would remedy this abuse; it would leave imprinted on the memory the most interesting features of ancient and modern history, as well as the names of celebrated artists.

Note how the oral acquisition of knowledge here takes a backseat to reading: the "connoisseur" who presumes to lecture on the pictures is both a snob and a fool. At the same time, our critic dismisses the solution of a catalogue, not only because of the effort involved in searching for the numbers of the entries but because not "everybody" can afford one. He takes for granted, however, that the "men and women of all classes" who now frequent the museum would have no trouble deciphering labels.[16]

Though the Louvre itself was slow to adopt this advice, virtually everyone involved in the great age of museum building appears to have shared the belief that the public for pictures was perforce a public of readers. When the Berlin Royal Gallery opened in 1830, its enlightened director, Gustav Friedrich Waagen, not only supplemented its large catalogue raisonné with a shorter and presumably less expensive work, but arranged to hang "a little paper" with the relevant information, including each picture's subject, on the adjacent wall. Invited to testify before a committee of the House of Com-

mons in 1835, Waagen recommended that the British likewise adopt such labels for their own recently formed National Gallery; and in the 1850s the museum belatedly followed through on his recommendation, having first taken the related step of cutting the price of their catalogue from a shilling to fourpence.[17] Like the custom of hanging pictures at eye level rather than crowding them frame-to-frame, the provision of wall labels did not become standard practice in European museums until the twentieth century. Indeed, the two developments were closely related, since older hanging styles left little room for text on the walls themselves, while eye-level placement allowed words, as well as pictures, to be easily scrutinized.[18]

The turn from catalogues to labels—and hence to the minimal picture title—was also driven by the need for efficiency. Everybody may now be literate, but even among those who can afford a catalogue, few have leisure to read it. When the American George Brown Goode began his influential lecture titled "The Museums of the Future" in 1889, his emphasis on the speed of modern life appeared to return communicative primacy from texts to pictures: "In this busy, critical, and skeptical age, each man is seeking to know all things, and life is too short for many words. The eye is used more and more, the ear less and less, and in the use of the eye, descriptive writing is set aside for pictures, and pictures in their turn are replaced by actual objects." Yet it is also in this lecture that Goode memorably defined "*the efficient educational museum*" as "*a collection of instructive labels, each illustrated by a well-selected specimen*" (his emphasis). Though Goode had begun his career in natural history before being appointed to oversee the Smithsonian's comprehensive collections in 1887, he made clear that his maxim applied to displays of arts and sciences alike. Modern museum-goers might have been too busy for descriptive writing, but they evidently had all the more need for labels. The first thing a viewer would do in "the people's museum," as Goode called it, was a little reading.[19]

People did not have to head for the museum to do the kind of reading that Goode had in mind, however. Many could—and did—encounter the titles of pictures even when they were not looking at pictures at all. The nineteenth century saw a growing flood of publications about art: not just newspaper and periodical reviews but more historical studies too, as something like the modern discipline of art history emerged from earlier modes of writing over the course of the century.[20] Expensive combinations of letterpress and engravings had circulated among a limited clientele since the first decades of the eighteenth century;[21] now pictures began to appear in cheaper and more ephemeral publications as well. Wood engravings of famous paintings could be found in the British *Penny Magazine* as early as the 1830s, and some inex-

No. 960. "*Baby's better.*" M. E. STAPLES.
Roses blooming upon the wall, and upon a fair little face just brought out into the sun.

No. 962. "*Waiting for the King's Favourite.*" LANCELOT J. POTT.

No. 970. "*The Burgomaster.*" SEYMOUR LUCAS. Clever genre.

No. 971. "*The Aiguille verte, from Argentière.*" JOHN COLLIER.
A very fine Swiss landscape, not seen to advantage here.

No. 974, "*A Blue-stocking.*" Mrs. ALMA-TADEMA ; No. 978, "*A Little Server : St. Patrick's, South Kensington*," Mrs. E. CRAWFORD.

In a corner here is a very little work, No. 977, "*When Peggy's arms her dog imprison,*" by F. SMALLFIELD, the only contribution

by a clever artist, whose best picture, "*The Inventor of Sails,*" was unfortunately not placed.

Two portraits should be mentioned here—No. 981, "*MacLeod of MacLeod,*" JAMES ARCHER, and, on the opposite side of the door, No. 988, "*Sir Harry Verney, Bart.,*" W. B. RICHMOND.

Next are three pictures full of interest and action—No. 935. "*Tracking in Holland,*" W. L. WYLLIE ; No. 988, "*Hero Worship.* 1852," A. STOCKS ; and No. 987, "*Louis XI. and Cardinal Balue,*" H. WALLIS. In the latter, the king, in olive green cloak and tight hose of the period, stands quaintly regarding the caged cardinal.

Near the foregoing is—
No. 992, "*Cordelia.*" T. F. DICKSEE.

No. 998. "*Imprisoned Spring : Children of the Great City.*" F. WILFRID LAWSON.

An almond tree in bloom in a dingy London square is the first sign of spring to two "children of the great city." This is the second of a series (begun last year) to illustrate the life of London children. No better theme could be chosen, or more earnest exponent than Mr. Lawson.

There are next some landscapes and sea-pieces to be especially noticed—No. 1004, "*The Last of the Light,*" H. MOORE ; No. 1016.

"*Glorious Autumn,*" C. E. JOHNSON ; and No. 1017, "*When snow the pasture sheets,*" J. FARQUHARSON ; the latter excellent

9–5. Pages from *Academy Notes*, edited by Henry Blackburn (London, 1877). Yale Center for British Art.

pensive museum guides in that decade also carried reproductions. Later in the century one could purchase illustrated guides to contemporary exhibits, like the series of *Academy Notes* illustrated with facsimiles of sketches by the artists that Henry Blackburn began to produce for the Royal Academy shows in 1875, or the *Catalogues illustrés* with which F. G. Dumas followed his example for the Paris Salon several years later.[22] Yet despite a sequence of technological developments that helped to reduce the cost of illustration in the period, the rapid expansion of writing about art was not matched by an equivalent circulation of images.

Partly because costs still favored the reproduction of text—at least till the latter half of the century—and partly because a title always takes less room on the printed page than a readable image, most such works continued to name many more pictures than they documented visually (fig. 9–5). Well into the 1890s, as Francis Haskell has noted, Bernard Berenson's influential taxonomies of Italian Renaissance painting carried only one illustration.[23] Even extended discussions of a single work—think of Goethe's evocation of "the so-

called *Paternal Warning*, by Ter Borch" or Gautier's account of Rembrandt's meditating philosopher—frequently appeared without the corresponding image. One reason that so many traditional titles took hold in the nineteenth century, in fact, is that people were far more likely to encounter the title of a picture than the picture itself. Thoré-Bürger's lament about Rembrandt's so-called *Night Watch*—"But how change a name popular for such a long time in all languages?"—was published in a book that repeated the name through two volumes, while never reproducing a single painting.[24] Only when print fully gives way to digital media, perhaps, will readers no longer experience that ratio of words to images.

When John Constable decided to add verbal commentaries to his plates on the grounds that "many can read print & cannot read mezzotint," he thus testified to a phenomenon that by the early decades of the nineteenth century was increasingly shaping the commentary on visual art. (Constable was writing in 1834.)[25] Renaissance thinkers like Leonardo had once confidently pronounced the work of the painter more immediately accessible than that of the poet: now some appeared to think that an age of mass literacy favored the poem.[26] Only in the nineteenth century, I suspect, would a philanthropist argue that painting should imitate poetry not in order to elevate the art but to broaden its appeal: the question was whether painting would remain, by T. C. Horsfall's account, the preserve of "a few thousands of highly educated people" or would "become, as poetry now is, a source of greatly needed ennobling pleasure to the hundreds of thousands of busy people of the middle and working classes."[27] And only in the nineteenth century would a theologian welcome Dante Gabriel Rossetti's practice of supplementing his paintings with poetry, on the grounds that it helped "ordinary people" to understand his images.[28] If such testimonies to the appetite for poetry in late-Victorian Britain seem rather improbable, especially by comparison to what we know about the popularity of the novel at the time, they nonetheless provide further evidence of the belief that decoding pictures now presented a greater challenge to the average person than did reading.

For Victorians like these, the democratization of literacy was not a cause of alarm but a condition to be exploited. Horsfall took for granted that painting functioned best when it took its inspiration from books: he only worried that too many pictures were based on obscure or trivial works, and that the modern expansion of knowledge meant that artists could no longer count on a communal understanding of their images. His proposed solution—that the Royal Academy each year designate a single piece of "noble literature" to illustrate—was meant to promote a public culture in which everyone could participate, but the very eclecticism of Victorian reading habits that prompted this high-minded proposal helped to assure that it would have little effect.

Given Horsfall's assumption that painting could flourish only as an adjunct of literature, he might nonetheless have taken comfort from the fact that the kind of works he named—"a book of the Old Testament, a play of Shakespeare, a poem by Wordsworth or Tennyson, a novel by Scott or Thackeray or George Eliot"—were already being abundantly invoked by the titles listed in the Academy's catalogues.[29]

For many in the nineteenth-century art world, on the other hand, the dominance of the written word increasingly registered as a problem. When George Moore complained in 1893 that "for the last hundred years painters seem to have lived in libraries rather than in studios," his immediate target was the tradition of literary painting at the Royal Academy, but his protest against an art pressed into service "as a sort of handmaiden to literature" had numerous parallels on the Continent as well.[30] In midcentury France, the word "littéraire" and its variants became a term of opprobrium for many artists and critics, even as those same scorners of the literary continued to deploy it selectively for images that they wished to praise.[31] Baudelaire's own first contribution to print, a review of the Salon of 1845, made a point of mocking picture captions that catered to a popular taste in reading matter: "M. Guillemin, whose execution certainly has merit, wastes too much talent in support of a bad cause—the cause of *wit in painting*. By this I mean providing the printer of the *livret* with captions for the Sunday public." The object of this attack, a minor genre painter named Alexandre-Marie Guillemin, had submitted five works to the exhibit; and while Baudelaire did not make clear which of the captions [*légendes*] he had in mind, he may well have been aiming at the sentimental poem that Guillemin supplied as a gloss on one of his titles rather than the titles themselves. But there is no mistaking the working-class identity of that "Sunday public," or the bourgeois aspirations invoked by Baudelaire's next sentence, when he inquires whether another painter hopes to please "the Saturday public" by choosing subjects from Shakespeare and Victor Hugo.[32] Though Baudelaire himself was perfectly capable of praising subjects from Shakespeare when they were painted by his beloved Delacroix, his contention that "the ape of sentiment relies above all on the *livret*," as he put it in his "Salon" of the following year, manages to include in one scornful formula both the artist who counts on words rather than paint to convey his meaning and the public whose susceptibility to those words testifies to its dubious taste in reading matter.[33] Daumier's foolish bourgeois, whose automatic recourse to print trumps his ability to look, is a reductio ad absurdum of a possibility that continually troubled the nineteenth-century art world.

Even the marketing of reproductive prints—the very medium that had helped to establish the convention of the picture title—may have encouraged

this condescension toward words, since the first and most expensive proofs were typically issued before the addition of accompanying texts: *avant la lettre*, as the practice had come to be known by Daumier's time. (This is in fact the original sense of that familiar idiom.) Regarded as a guarantee that the proof in question had been taken early in the print's run, as well as evidence that its production was likely to have been overseen by the artist himself, the absence of lettering typically doubled or even tripled the cost of a print—thus assuring that such wordless images would become luxury items, well beyond the budget of the average consumer.[34] An entry in Wille's journal for December 1771 excitedly reported that a provincial dealer had ordered twelve proofs *avant la lettre* of a new print: "they sell for twice the price of those with letters."[35] So valuable were such proofs, in fact, that unscrupulous printers sometimes managed to mask or erase the title space, in order to pass off later impressions as earlier ones.[36] To be "before" letters in this sense was a mark of distinction rather than otherwise, while those who might once have belonged among the unlettered themselves now settled for titles. That the idiom does not appear to have entered the dictionaries until the 1820s and 1830s, though Wille and others were evidently using it more than a half century earlier, suggests that such differences were not widely registered until the advent of mass literacy.[37]

Providing lists of ridiculous titles became a regular feature of Baudelaire's Salon criticism, as he continued to mock both the painters who resorted to them and the readers at whom they were aimed. "If I had time to amuse you," he wrote in his final contribution to the genre in 1859, "I could easily manage it by leafing through the catalogue and making an extract of all the ridiculous titles and comical subjects that aspire to attract the eyes." Note how the eyes that should be devoted to the works on display are instead diverted to the catalogue, where reading has once again taken the place of looking. What follows is a brief taxonomy of title-types, from "the comic title in the manner of the *vaudevillistes*" and "the sentimental title that lacks only an exclamation point" to "the deceptive or ensnaring title"—all implicitly characterized as cheap verbal tricks by which painters attempt to short-circuit the work of the brush. Where once artists trusted to their own powers to communicate with their public, Baudelaire suggests, now both parties to the transaction have "so little faith in painting" that they "constantly seek to disguise it and to cover it up like a disagreeable medicine in sugar pills—and what sugar, great God!"[38]

Émile Zola, whose own art reviews began to appear in the following decade, would continue Baudelaire's polemics, as he scornfully compiled lists of titles ("nothing but almanac pleasantries, proverbs, and other pretentious vul-

garities") and railed against the invasion of the Salon by the "low literature" of the newspaper and the periodical. Though both writers liked to associate "this embourgeoisement of art"—the phrase is Zola's—with peculiarly French weaknesses, the impression that picture galleries were filled with people clinging to snippets of second-rate literature was hardly confined to nineteenth-century France.[39] The most popular reading matter in the period was, of course, prose fiction; and observers on both sides of the Channel remarked the particular appetite for titles that evoked such narratives, whether by invoking actual publications or by implying that the picture itself told a story. Commenting on the London picture season of 1877, Henry James alluded scornfully to the "taste of the British merchant and paterfamilias and his excellently regulated family," which "appears to demand of a picture . . . that it shall have a taking title, like a three-volume novel or an article in a magazine; that it shall embody in its lower flights some comfortable incident of the daily life of our period, suggestive more especially of its gentilities and proprieties and familiar moralities, and in its loftier scope some picturesque episode of history or fiction which may be substantiated by a long explanatory extract in the catalogue."[40] James was hardly an opponent of the word— let alone narrative—but his contempt for such pictures is impossible to separate from his contempt for the kind of writing that attaches to them.

The most uncompromising critic of this taste in picture reading was James McNeill Whistler. In a celebrity interview published a year after James's remarks, the artist laid out his case: "The vast majority of English folk cannot and will not consider a picture as a picture, apart from any story which it may be supposed to tell," he complained, even as he aggressively defended his own refusal to cater to such impulses. Claiming that his friends had urged him to name one of his *Harmonies* after a character from Dickens in order to increase its value on the market, Whistler dismissed such a gesture as "a vulgar and meretricious trick" aimed at people who had no understanding of the painter's art. In this declared "war . . . between the brush and the pen,"[41] we can hear the beginnings of a polemic that would reach its greatest intensity in the era of abstract expressionism, when Clement Greenberg would influentially call for a rigorous division between media and insist that "the purely plastic or abstract qualities of the work of art are the only ones that count." But while the ideal of "purity in art," in Greenberg's formula, did not fully take hold until the mid-twentieth century, it is hard not to sense something of an earlier avant-garde's distaste for the reading habits of the multitude in that later attempt to purge painting from the contamination of words.[42]

"If they really could care for pictorial art at all," Whistler said of his English public, "they would know that the picture should have its own merit,

and not depend upon dramatic, or legendary, or local interest." Whistler, of course, became famous for titling his paintings so as to counter such "interest," and I shall return to some of the paradoxical effects of that exercise in a subsequent chapter. But what I wish to stress here are the continuing reverberations of his aristocratic contempt for the "vast majority" who "will not consider a picture as a picture" in the unease that still afflicts so many of us when we find ourselves hastily glancing at a painting's title.[43] When everyone can read, and the printed word offers the quickest means of acquiring information, a reverse snobbery dismisses those who clutch at words in order to know what they are seeing. Whether one invokes Wassily Kandinsky's sardonic vision of the public strolling "book in hand" through an exhibit, "reading names" of artists and their pictures, and departing "neither richer nor poorer" than when they came, or Roland Barthes's allusion to "that thin line of words which runs along the bottom of the work and on which museum visitors first fling themselves," the doubtful status of the nineteenth-century picture title has had a long afterlife.[44] Kandinsky's jaundiced vision of the public who never look up from their list of names is an artist's nightmare of the gallery-goer in an age of mass literacy.

In practice, of course, the gallery-goer who does no looking at all is still more of a satirical fiction than the visitor to the Salon who temporarily confuses a painting of a bull with a portrait of a stockbroker. Daumier's bourgeois may begin by allowing words to determine what he is seeing, but even he manages to correct himself, when he belatedly pauses to compare the image in front of him with the words in his *livret*. Indeed, it is precisely because viewers do try to connect word and image that a title whose sense is not obviously contradicted by the picture to which it points—a *Philosopher in Meditation*, say, or even a *Pasiphaë*—can powerfully shape how that picture is understood. But to provide a picture with a title is not only to shape interpretation; it is also to equip every literate viewer with a potential ground of criticism. The complaint that a painting fails to live up to the words in the catalogue is almost as old as the catalogue itself.[1]

The complaint already appears in a work often termed the first piece of modern art criticism, Étienne La Font de Saint-Yenne's commentary on the 1746 Salon entitled *Réflexions sur quelques causes de l'état présent de la peinture en France* (1747). The target is a pair of allegorical paintings by François Boucher that are identified in the *livret* as "Un Tableau de forme chantournée [with a curved top], représentant l'Eloquence, avec ses Attributs" and "Son Pendant de même forme, représente l'Astronomie."[2] La Font passes over "Astronomy" in silence, but "Eloquence," he implies, is not eloquent enough to be recognizable without the catalogue:

> The layout is pleasant, the draperies meticulously arranged and light, their tones varied and well enough contrasted. It would, however, be quite difficult to guess at Eloquence by the physiognomy of the figure who represents her, and who is extremely cold and without character. What fire, what vehemence should strike us in the features that an-

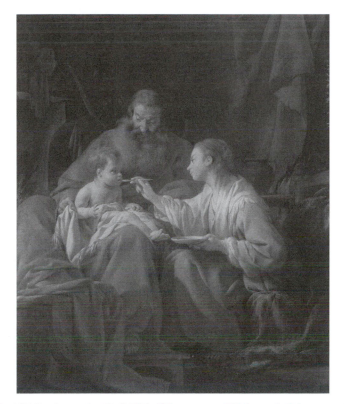

10–1. Noël Hallé, *Sainte famille* (1753). Oil on canvas. Wadsworth Athenaeum Museum of Art, Hartford, CT/Art Resource, NY.

nounce this so powerful art, which subdues minds and overcomes at its will all our passions![3]

While the entry in the *livret* still hovers ambiguously between description and title, the critic takes for granted that it speaks for the artist, and he judges the latter's failure accordingly.

Though La Font found much to praise in the Salon exhibits, his criticism of Boucher and others roused a firestorm. Among those who rallied to their defense was the abbé Le Blanc, who published a booklet later that year—with frontispiece by Boucher—attacking La Font's arguments.[4] Yet when Le Blanc in turn came to review the Salon of 1753, he too called attention to the gap between word and image, even if he took a somewhat different tack toward the significance of that disparity. The picture in question, by an academician named Noël Hallé, was identified in the *livret* as "Un petit Tableau de Cabinet, représentant une sainte Famille" (fig. 10–1).[5]

There are several paintings of M. Hallé which can only add to the repu-
tation that he has made among the history painters. The most piquant
of these is that indicated at No. 54. It represents a young woman with a
very nice face, who is giving some gruel to her child. That little face is
nature itself: the ardor with which the child presents himself to receive
his gruel is expressed with a striking truth. An elderly person with a
large beard looks at him with all the indulgence of a good man. I do not
know why this painting has been called a Holy Family. The manner in
which it is treated and the action represented do not have enough no-
bility to answer that idea; the gluttony [*gourmandise*] of this child
would degrade the Infant Jesus, who should never be depicted in any-
thing belonging to the baseness of humanity.

 This is not a Holy Family at all, but it is a most pleasant *bambochade*.
I do not think that the skillful artist, to whose talent so precious a pic-
ture is due, could take offense at this remark. An author should be
content with his work, when nothing can be found to correct in it but
the title.[6]

Unlike La Font, who implies that an Eloquence who fails to live up to her
name is not worth painting, Le Blanc claims to admire this picture, even as
he insists that it falls short of its sacred title. "This is not a Holy Family at
all," he contends, "but it is a most pleasant *bambochade*"—a term for a small
low-life or peasant scene, so-called after a seventeenth-century Dutch
painter known as *Il Bamboccio* (puppet) because of his deformed body. What
is wrong by this account is not anything on the canvas itself but only in the
livret, which misrepresents an all-too-human family as a holy one. Le Blanc
even manages to spare Hallé full responsibility for the mislabeling, since he
adopts the impersonal form when invoking it: "je ne sçais pourquoi on a ap-
pellé ce Tableau une Sainte Famille," he writes, almost as if the fault were one
of cataloguing rather than the artist's intention. At the same time, by calling
those misleading words a "titre"—a notably early use of the term for a paint-
ing, rather than a reproductive print—Le Blanc seems to anticipate a line of
attack that would become much more common in the following century,
when critics took for granted that paintings had titles for which their cre-
ators were accountable. Indeed, the whole passage is a masterpiece of equivo-
cation, from the dubious claim that the making of this *bambochade* will some-
how add to Hallé's reputation "among the history painters," to the professed
admiration of the baby's natural appetite, which would nonetheless "degrade"
the infant Jesus.

While Le Blanc explicitly set out to say "something good" about every painter he mentioned,[7] Diderot could approach the Salons with no need for such diplomacy, since he was writing not for the public but for a small group of European aristocrats, who subscribed to his reports in manuscript. Unlike Le Blanc, who expected his readers to visit the exhibit with his *Observations* in hand, Diderot was also writing after the fact for an audience that had no access to the paintings themselves, and he was therefore particularly dependent on his ability to conjure up an image verbally.[8] But his own reliance on words hardly inhibited him from mocking those recorded by the Académie. On the contrary: as his evident delight in such mockery makes clear, one of his favorite strategies for criticizing a picture was remarking how it deviated from the catalogue. Variations on the formula "This is not an *X*" would serve him repeatedly over the decades, as he gleefully exploited the gap between the words in the *livret* and the paintings as he saw them.

Consider the following examples, which begin with another contribution from the unfortunate Hallé and include, in order, works by Jean-Bernard Restout, Boucher, Hallé again, Gabriel Briard (twice), Nicolas-Guy Brenet, Joseph-Marie Vien, and Louis-Jean-François Lagrenée (twice) :

I see again in the *livret* a flight of the Virgin into Egypt. Without it no one would ever know that she was in the Salon. (1759)

The Meal Given by Ahasuerus to the Leaders of his Realm This is not a meal. The painter has misspoken: this is a large place setting that awaits some guests. . . . The table hides the important figures; we see only the tops of a few heads toward the back. If what occupies the most space, fills the middle, arrests the eye, and makes itself exclusively visible is the principal subject in a picture, here the table has all these characteristics. (1763)

It has pleased the painter to call this *Angelica and Medoro*; but that will be all that pleases me. I defy someone to show me what it is that characterizes the scene and designates these figures. . . . The Angelica is a little tripe seller. Oh the nasty word! Very well, but that's what we see. Rounded, slack drawing, and flabby flesh. (1765)

The Emperor Trajan, Departing on a Very Urgent Military Expedition, Dismounts his Horse to Hear a Poor Woman's Complaint The woman, whose facial expression should produce all the pathos of the scene and

who arrests the eye quite well by her large blue garment, is seen only from the back. I said "the woman," but maybe it is a young man. On this point I must rely on her hair and the *livret*; there's nothing that characterizes her sex. (1765)

Psyche Abandoned The subject of this piece is uncertain. Here indeed is a woman abandoned by Cupid; but many others are in this situation. Why is this one Psyche? What tells me that this Cupid is a lover, and not one of those allegorical figures so common in works of painting? Here's the truth. The subject of this is a landscape pure and simple, and the figures were only introduced to animate it—which they don't do. (1765)

I beg you, my friend, just to stop and ask yourself the subject of this painting . . . But don't tire yourself uselessly; it's what the artist has been pleased to call the *Encounter of Psyche and the Fisherman*. Once more, what tells me this is Psyche? Where's the Fisherman? Where's the encounter? What does this woman seated on the ground with her dog signify? And this boatman? And his boat? And this squatting woman? And her net? The Psyche encountered isn't any more pleasing than the unconscious Psyche; nor does it inspire any great interest in the so-called Fisherman. (1765)

Cupid Caressing his Mother to Recover His Arms. The Venus is lying down; we only see her from the back. The Cupid, in the air and further back, kisses her. And is this to recover his arms? And what is it that tells me that? The *livret*. Here there is only a child who kisses his mother. (1765)

Caesar, Landing at Cadiz, Finds the Statue of Alexander in the Temple of Hercules, and Laments Being Unknown at an Age when that Hero was Already Covered with Glory Close your eyes to the rest of the composition, and tell me if you recognize the man destined to be the conqueror and master of the world. . . . This one's a loan shark, a cold fish, a snot-nosed kid from whom you'd expect nothing great. . . . The head of Caesar is recorded in a thousand works of classical art; why make one from the imagination that is not as handsome, and that, without the inscription, would render the subject unintelligible? (1767)

The Robe, or Justice Disarmed by Innocence to the Applause of Prudence. Is it possible to imagine anything more impoverished, cold, and flat? And if a legend hadn't been written at the bottom of the painting, who would have understood the subject? In the center, Justice. If you'd have it so, M. Lagrenée, for you can make of this gracious young head anything you please—a virgin, the patron saint of Nanterre, a nymph, a shepherdess—since it's only a matter of assigning names. (1767)

The Return of Ulysses and Telemachus to Penelope Of a character so well known as this Ulysses, so shrewd, so cunning, and at a moment whose feeling should be so clear, what has he made? An ignoble rustic, foolish and stupid. Put a shell in his hand, and throw a sheepskin over his shoulders, and you would have a Saint John ready to baptize Christ. (1767)[9]

Academic history painting obviously proved a tempting target for such attacks, since the subjects it purported to represent could be measured against the sophisticated reader's knowledge of the relevant literature: this is not the Virgin Mary; Ariosto's Angelica; the mythical Psyche; the returning Ulysses. Sometimes Diderot complains of a radical deviation from the imagined original: the "tripe seller" (*tripière*) who replaces Ariosto's heroine, for example, or the rustic idiot who stands in for Ulysses. At other times, it is less a failure of matching that he protests than of specificity: the *livret* invokes the adventures of Psyche, or speaks of Cupid recovering his arms from Venus, but the visual signs alone prove too general to convey such a meaning. ("Here there is only a child who kisses his mother.") To read against the title is always to approach the work with a written template in mind, but in cases like these that template itself is primarily textual: what Diderot misses from such paintings is a convincing incarnation of something he has hitherto encountered only in words—or, in the case of particularly popular subjects like the Virgin Mary, in other images. This holds as true for Lagrenée's *Justice Disarmed by Innocence* as it does for his *Return of Ulysses*, though the former is presumably an allegory recorded for the first time in the *livret* and the latter, as Diderot says, the representation of a scene "well known" by everybody. Even historical persons like Trajan or Caesar are chiefly textual in this sense, since no eighteenth-century viewer has ever encountered them except in books—though an exception should be made for the "thousand works of classical art" that record the look of Caesar.

But when Diderot protests that "this is not a meal" or complains that it is impossible to tell whether a figure with her back to us is a woman, his stan-

dard of comparison is rather different. The meal and the woman may be taken
from history, but in such cases the critic requires no bookish knowledge in
order to conjure up the relevant models. What counts is only his sense of
what such words signify in ordinary life, and how well the paintings succeed
in conveying their referents. It was not literature, presumably, but daily expe-
rience that prompted Diderot's sharp response to another work at the Salon
of 1765, this one a painting by Jean-Jacques Bachelier recorded in the *livret*
as "Un Enfant endormi" (a sleeping child). "Il ne dort pas, il est mort,"
Diderot dryly observed, as he exploited a verbal echo not available in En-
glish. "He's not sleeping, he's dead." The mordant commentary continues:
"His parents should be informed, his small brothers flogged, so that the same
accident doesn't happen to them; and this one should be buried and never
spoken of again."[10]

This, too, is reading against the title, but it is a mode of reading that for
obvious reasons proves more applicable to pictures whose titles appear to
signal that their intentions are simply mimetic. That not every picture bear-
ing such a title is in fact intended as a straightforward representation of what
its title names—whether because the title was bestowed after the fact, or be-
cause the artist deliberately sought to frustrate any simple identification of
word and image—is a complication to which we shall return in subsequent
chapters. But what should be noted here is how quick Diderot is to identify
the language of the *livret* with the words of the artist ("the painter has mis-
spoken") and to judge the image itself by what those words seem to promise.
If the gap between word and image is vast enough, he suggests in yet another
attack on poor Briard, perhaps the artist should abandon his attempt to con-
vey something visually and just inscribe his words directly on the canvas.
Here the creator of the Psyche pictures was apparently attempting a genre
scene:

> *The Village Soothsayer* They say that a well-meaning painter who'd
> put a bird in his picture and wanted that bird to be a cock, wrote below
> it: "This is a cock." Without expecting any more subtlety here, M. Bri-
> ard would have done very well to write under the figures of his paint-
> ing: this one's the soothsayer; that one is a girl who's come to consult
> him; the other woman is her mother; and here is the girl's lover. If one
> were a hundred times more prophetic than his soothsayer, how would
> one guess that the laughing figure is in collusion with him? It's there-
> fore necessary to write again: this young rascal and that old one there
> have an understanding. One must be clear—no matter the means.
> (1765)[11]

10–2. Charles Robert Leslie, *Dulcinea del Toboso* (1839). Oil on panel. Victoria and Albert Museum, London. V & A Images, London/Art Resource, NY.

Though Diderot does not speak of "titres"—to the best of my knowledge, he uses that term only once in over two decades of Salon commentary[12]—his practice already anticipates almost the entire litany of protests that critics would lodge against titles in the following century. There was the allegory that depended on title alone to convey its meaning; the professedly sacred subject whose pictorial incarnation proved all too material; the literary or historical painting that failed to correspond with the critic's conception of the original; the landscape or genre scene whose title identified places or people that the critic professed not to recognize in the image itself. On both sides of the Channel, variations on "This is not an *X*" became a common weapon in the critical arsenal, a particularly efficient means of at once evoking and dismissing a painter's pretensions.[13]

According to an anonymous reviewer of the Royal Academy show in 1839, for example, the title of Charles Robert Leslie's *Dulcinea del Toboso* (fig. 10–2) was "a misnomer": "It is not a portrait of the inamorato [*sic*] of Don Quixote ... although a very carefully painted picture of a buxom country wench," the reviewer wrote, perhaps forgetting that Quixote's beloved, who is in fact only a country wench herself, never actually appears in the novel.[14] In 1855 John Ruskin launched a related critique of Charles Eastlake's *Beatrice*

10–3. William Powell Frith, *Juliet* (1863). Oil on canvas. Private collection.

by inquiring rhetorically, "But who is the lady? Dante's Beatrice, or Benedict's? She can hardly be either: her face indicates little piety, and less wit."[15] (Eastlake was both president of the Royal Academy and director of the National Gallery at the time, but Ruskin was not one to pull his punches accordingly.) The following year a watercolor entitled *Lucy Ashton* (after the heroine of Walter Scott's *Bride of Lammermoor*) prompted another critic to remark that "it might with equal propriety be called either the 'Maid of Orleans' or the 'Witch of Endor'";[16] while William Powell Frith's *Juliet* of 1863 (fig. 10–3) elicited a similar note of facetiousness from the *Athenaeum*'s reviewer. "Surely Juliet was not this ringletted girl, fresh from a boarding-school, clad in white satin, and posed at a window," the reviewer protested. "Mr. Frith, no doubt, meant to style his picture 'Study after the Opera.'"[17]

Even Henry James got into the act when confronted by a *Milton and his Daughters* (1875) by the American painter Eastman Johnson—a picture whose inadequacy to its title inspired the novelist to some creative "defilializing." (The coinage is his.) "To speak of the work at all kindly," James wrote, "we must cancel the Milton altogether and talk only about the daughters." Not until he had thereby erased the tie between the painting's female figures and their titular father could the critic proceed to salvage the work's remaining merits. "By thus defilializing these young ladies, and restoring them to their proper sphere as pretty Americans of the year 1875," as James mischievously put it, "one is enabled to perceive," for instance, "that their colouring is charming."[18]

The British love of pictures inspired by literature afforded numerous occasions for such criticism, and works titled after famous heroines seem to have been particularly apt to trigger it, perhaps because readers were more than ordinarily committed to their mental images of such figures. At the same time, a Victorian artist could scarcely choose a name like Juliet or Beatrice

without calling up a literary referent: note how Ruskin's attack on Eastlake begins and ends with the assumption that the artist could only have chosen his title because he intended to paint the heroine either of Dante's *Commedia* or of Shakespeare's *Much Ado about Nothing*.[19] Yet it would be wrong to conclude that this version of the formula—call it "This is not *Her*"—was exclusively Victorian. One of the great hits at the 1868 Salon was a pair of pendants by Charles-François Marchal showing two women in modern dress entitled, respectively, *Pénélope* and *Phryné*.[20] Though the pair were presumably intended as a contrast in sexual morality (Phryne was an ancient Greek courtesan), not everyone was convinced that *Pénélope* in particular merited her title (fig. 10–4). For Jules-Joseph Guiffrey, "This young girl, with her vented sleeves, is not at all the chaste and pure middle-class woman whom the author calls, I don't know why, Penelope. . . . It seems to me that she's of the same stuff as her neighbor."[21] While not unsympathetic toward Marchal's achievement, Thoré-Bürger amused himself along similar lines, as he advised the viewer to forget all about "the virtuous wife of Ulysses," the Trojan War, and the history of ancient Greece. "With Marchal—I thank the gods for it!—it's not a question of all that":

> Madame Penelope is a middle-class woman in a very simple gray dress, and who does her embroidery standing in front of a small work table, on which are some balls of wool and a flower in a vase. . . .
>
> She doesn't have the air of thinking about her hundred and sixteen importunate suitors. At the very most she is daydreaming that she will go to the Opera this evening with her father and her husband, if he arrives in time from his odyssey. Between us, I advise Ulysses to land as quickly as possible on the quay de la Rapée. For we are no longer at Ithaca and customs have changed since Homer.[22]

Reading against the title, the critic sketches an alternative narrative—not an ancient epic, but a modern novel of a restless housewife in middle-class Paris.

Many of the works that made themselves vulnerable to this sort of attack have since vanished from history, or were painted by artists whose reputations have significantly declined since the nineteenth century. The luscious beauties of Alexandre Cabanel, for example, have mostly become period pieces, though they were a favorite target of Zola, who loved to observe how little they measured up to the famous figures they purported to represent. Placing himself aggressively on the side of the moderns, Zola dismissed Cabanel's *Sulamite* (1876) as a "penny odalisque," while the artist's *Phèdre* (1880) had so little character that she "could just as well be Cleopatra or Dido" (fig.

10–4. Charles-François Marchal, *Pénélope* (c. 1868). Oil on canvas. The Metropolitan Museum of Art, New York. Image copyright © The Metropolitan Museum of Art. Image source: Art Resource, NY.

10–5). The novelist was particularly scathing on the mismatch between the ardent words from the Song of Songs that Cabanel had recorded for his *Sulamite* and the figure herself—"a woman of wax, like those who turn in front of hairdressers' windows."[23]

But artists considerably in advance of Cabanel and company could provoke an analogous response, even among those who recognized their skill with the brush. When Eugène Delacroix exhibited his *Madeleine dans le*

10–5. Alexandre Cabanel, *Phèdre* (1880). Oil on canvas. Musée Fabre, Montpellier Agglomération.

désert at the Salon of 1845 (fig. 10–6), the editor of the principal artistic journal at the time, Arsène Houssaye, found himself torn between admiration of the painting and bafflement at its title:

> I cannot understand his *Magdalen.* Passing in front of this bold sketch, I immediately recognized the work of a powerful hand, but I did not recognize Mary Magdalen in the desert: the Magdalen whose heart still beats among us, Magdalen, that poetic symbol of Christian love, Magdalen, the most beloved woman during her life, the most beloved saint after her death. . . . The Magdalen of M. Delacroix is beautiful neither in form [*lignes*] nor in feeling. The suffering expressed by the painter is human, but wholly material; one looks in vain for a ray of divine love. One wonders, seeing this head fallen back on the stone of the cave, if this is the figure of a woman who dreams, of a woman who sleeps, or of a woman who has just died. M. Eugène Delacroix wanted to paint a figure whom suffering has beaten into a torpor. He has doubtless succeeded, but why baptize this work with the sacred name of Magdalen?[24]

135

10–6. Eugène Delacroix, *La Madeleine dans le désert* (1845). Oil on canvas. Musée Delacroix, Paris. ©RMN-Grand Palais/Art Resource, NY.

The sense of disjunction here is a more extreme version of the abbé Le Blanc's response to Hallé's *Holy Family*: a refusal, in effect, to take the Christian doctrine of incarnation as literally as the artist does when bestowing a "sacred name" on his all-too-human image. It is a measure of Houssaye's sensitivity as a viewer that he nonetheless cannot bring himself to judge the work a failure. Rather than take its title as a sign of intention, he chooses to conclude that Delacroix wanted to paint just what the critic actually sees: not the Magdalen, but "a figure whom suffering has beaten into a torpor."

A similar bafflement greeted the Pre-Raphaelite painter William Holman Hunt in 1856, when he chose to exhibit a luridly colored painting entitled *The Scapegoat* at the Royal Academy (fig. 10–7). Hunt, who intended his image as a typological representation of Christ's sacrifice, took care to gloss the work with relevant passages from scripture on the frame, as well as a paragraph in the catalogue explaining the ritual of the scapegoat in ancient Judaism.[25] But his verbal insistence failed to persuade the *Athenaeum*'s reviewer, who refused to see in the picture any of the sacred aura implied by its title. "Brute grief was never more powerfully expressed," the reviewer conceded; and "we need no bishops to tell us that the scene is eminently solemn.... Still, the goat is but a goat, and we have no right to consider it an allegorical

10–7. William Holman Hunt, *The Scapegoat* (1854–56). Oil on canvas. © Lady Lever Art Gallery, National Museums Liverpool/Bridgeman Images.

animal." The very materiality of Hunt's "mere goat" made the title's claim to transcendence impossible to credit.[26]

Perhaps no nineteenth-century artist more consistently frustrated those who sought to read his paintings in accord with their titles than did J.M.W. Turner. What typically baffled critics in his case was not an apparent gap between sacred meaning and painted matter: Turner rarely attempted biblical subjects, and when he did, as in his *Dawn of Christianity (Flight into Egypt)* of 1841, the painting was more apt to be found incomprehensible than insufficiently spiritual. (*The Dawn of Christianity* "is really quite horrible," said the reviewer for *Blackwood's*, "and happily unintelligible without the description.")[27] But nearly every other version of the formula we have been examining appeared in response to his work, from the denial that this was in fact the literary figure or episode announced in the catalogue to the refusal to recognize the depiction of a particular landscape or action. Almost three decades before the *Athenaeum* mocked Frith's ringletted *Juliet*, another critic was commenting derisorily on Turner's *Juliet and her Nurse*. "Shakespeare's Juliet?" sniffed the *Times*. "Why it is the tawdry Miss Porringer, the brazier's daughter of Lambeth and the Nurse is that twaddling old body Mrs. Mac'Sneeze who keeps the snuff-shop at the corner of Oakley-street."[28] In 1835 a reviewer for *Fraser's* had summed up the "failure" of *Keelmen Heaving Coals by Night* by simply negating its title: "The night is not night; and the

10–8. J.M.W. Turner, *Approach to Venice* (1844). Oil on canvas. National Gallery of Art, Washington, DC.

keelmen and the coals are any thing."[29] Turner's *Ulysses Deriding Polyphemus* (1839), according to the *New Monthly Magazine*, "by any other name, would look as sweet,"[30] while the *Art-Union* would later issue a similar judgment on his *Approach to Venice* (fig. 10–8): "That which we may suppose to be Venice lies ahead in red mist; and so generally indistinct is the view that it might serve for the approach to any low-lying city open to the sea." In *Fishing-boats Bringing a Disabled Ship into Port Ruysdael* (1844), said the same critic, "Nothing of the port is visible, nor is it very obvious how the crowd of boats are bringing the vessel in, or that they are even doing so at all."[31]

Yet if these protests sound familiar enough, there is also something new in the resistance to Turner's titles, and it is a change that will continue to reverberate in the history of modernism. With the exception of the attack on *Juliet and her Nurse*—this is not Shakespeare's heroine, says the *Times*, but "the tawdry Miss Porringer"—Turner's critics do not so much substitute their own accounts of what a painting represents as complain that they cannot see anything distinctly at all. Rather than name what they do see, they throw up their hands: though the title has promised them a recognizable subject, the painting itself appears to renege on that promise. Viewing anachronistically, one might say that the very aspects of Turner's art that appear to anticipate modern abstraction come into conflict with the traditional expectations generated by his titles. Just how much Turner intended to unsettle viewers in this

way is a difficult question, though there is no doubt that he cared for the language that accompanied his paintings, even to the point of including extracts from an unfinished poem of his own composition to supplement some of his entries in the catalogue. An exemplary instance of the artist as author, Turner anticipates later developments not only in the appearance of his canvases but in his titling practice, as I shall argue below. And he does so, paradoxically, despite the fact that the titles themselves often appear to look backward, naming the kinds of subjects conventionally thought to have been left behind with the advent of modernism.

In this, Turner would seem to be the virtual opposite of the openly avant-garde Whistler, whose polemics on the topic would have such an obvious influence on the century that followed. Unlike Turner, Whistler made no secret of his impatience with traditional titles and with the habits of viewing— or reading—their language encouraged. Indeed, it was precisely to forestall the kinds of response we have been examining that he claimed to have adopted titles that would discourage the viewer from a literal matching of word and image. Though he himself testified that his *Nocturne in Black and Gold* (plate 4) "represent[ed] the fireworks at Cremorne Gardens" (a popular pleasure garden in London), he also explained why he had chosen not to name it accordingly: "If it were called 'A View of Cremorne,' it would certainly bring about nothing but disappointment on the part of the beholders." That characteristic bit of insouciance provoked laughter in his audience, but Whistler clearly knew whereof he spoke. "It is an artistic arrangement," he continued: "That is why I call it a 'nocturne.'"[32] As we shall see, Whistler would not find it so easy to arrive at titles that would make viewers do as he wished. The artist might choose to call a painting *Symphony in White, No. III* (plate 5), but even his inscribing those words directly on the canvas did not prevent a critic from resisting their claims. "It is not precisely a symphony in white," Philip Hamerton objected, since he could also see a number of other colors—which he then proceeded to enumerate. Although the artist responded with his signature wit, he managed to have the last word only by implicitly conceding that the title did, after all, direct the viewer to the mimetic aims of the image: "*Bon Dieu!* did this wise person expect white hair and chalked faces? And does he then, in his astounding consequence, believe that a symphony in F contains no other note, but shall be a continued repetition of F, F, F? Fool!"[33]

III

Authoring as well as Painting: Artists

[11 · THE FORCE OF DAVID'S *OATH*]

"J'exprime mes idées avec mon pinceau," Gustave Courbet proudly declared in 1861: "I express my ideas with my brush." The sentiment seems unimpeachable, even if the artist was soon boasting to his father of how his profession of faith had swiftly sold out the entire edition of the newspaper that recorded it.[1] Few painters did more than Courbet to focus our attention on the material surface of the painting itself, yet few better anticipated how modern systems of circulation and publicity would continue to require that words, too, enter the picture.

Until 2014, when the Royal Academy began to require digital submission of works for its first round of judging, would-be entrants to its summer exhibits were anxiously instructed to make sure that they attached the correct labels to each piece they submitted—an injunction that tacitly registered not just the distance that was presumed to separate the aspiring exhibitor from the committee that judged her but the lack of connection that might otherwise be felt between a particular label and the work it purported to identify. As in the eighteenth century, anyone can submit a painting to the Academy's exhibits, but still more than in the eighteenth century, the relation between a painting and its title can be far from self-evident. Henceforth the problem will presumably be addressed by the barcodes and self-affixing labels that the Academy proposes to generate from artists' submission forms once they have passed the first round. Yet even as it devises new means for assuring that labels and works coincide, nothing in the Academy's instructions specifies that those labels be originally composed by the artists themselves. Indeed, while the instructions explicitly make the artist's intellectual property right in her work a condition of entry, they also allow for the possibility that a third party will have submitted that work on her behalf—requiring only that such "a gallery, agent or other representative" will have consulted the artist when filling out the necessary forms.[2]

When Picasso decried "the mania of art dealers, art critics, and collectors for christening pictures," he tacitly exempted the artist, whose clear preference, by his account, would be to forgo words altogether. "A painting, for me, speaks by itself; what good does it do, after all, to impart explanations? A painter has only one language."[3] Though even Picasso didn't always manage to adhere to that position, his implicit refusal of verbal authorship is hardly anomalous. The countless works that appear in our galleries and museums as "Untitled" presumably testify to a similar impulse, as do those labeled simply with numbers or dates rather than names—a practice Jackson Pollock, for example, adopted in the late 1940s as a means of forestalling viewers' "preconceived idea of what they are to be looking for."[4] Numbers "are neutral," Lee Krasner explained at the time: "They make people look at a picture for what it is—pure painting."[5] As she later acknowledged, however, they may be less effective at helping people to identify and recall what they have seen. Perhaps she was thinking of canvases like Pollock's *Number 1A, 1948*, which apparently acquired its letter when the artist wished to distinguish it from another painting of that year at his second solo exhibit in 1949 (fig. 11–1). By the mid-80s, in any case, Krasner herself seems to have taken a more relaxed view of titles, agreeing with an interviewer that they could be helpful for both viewers and critics as "clues for contemplation."[6]

Pollock's fellow abstract expressionist Clyfford Still held more consistently to the ideal of a painting unmediated by words. "My paintings have no titles because I do not wish them to be considered illustrations or pictorial puzzles," he wrote. "If properly made visible they speak for themselves." One wonders whether he would have registered the irony had he seen a wall label at Tate Modern in 2005 that quoted these lines before continuing:

> In a letter discussing this work, he explained that the red at the lower edge was intended to contrast with and therefore emphasise the depths of the blue. He saw the yellow wedge at the top as "a reassertion of the human context—a gesture of rejection of any authoritarian rationale or system of politico-dialectical dogma."

The Tate's label nicely demonstrates Philip Fisher's point about how "the splash of modern explanation" that inevitably accompanies abstract painting becomes "in effect, a very long title"—though by posting these words on the wall, the museum was obviously trying to democratize what by Fisher's account often remains a form of coterie knowledge.[7] As it happens, this particular label glossed the only Still in the Tate's collection, since the artist, who had mostly stopped exhibiting at commercial galleries in the early 1950s,

11–1. Jackson Pollock, *Number 1A, 1948* (1948). © 2014 Pollock-Krasner Foundation/ Artists Rights Society (ARS), New York. Oil and enamel paint on canvas. Museum of Modern Art, New York. Digital Image © The Museum of Modern Art/Licensed by SCALA/Art Resource, NY.

later retreated to a farm in Maryland and radically restricted the circulation of his work. It seems no accident that Still accompanied his refusal of titles with a virtual withdrawal from the art world.[8]

For many painters over the last two centuries, something closer to Picasso's de facto compromise has effectively held sway: rather than banning titles altogether, they have more or less left them to others. John Welchman has suggested that Paul Signac became "one of the first artists to delegate (or at least to defer) the titling procedure to another imagination" when he permitted the poet and critic Paul Adam to title a painting he acquired from the artist in 1888;[9] but delegating or deferring titles, as we have seen, is historically the default position in the history of picture making, and even in our own time, artists seem to have had little trouble in adopting it. The Andy Warhol who reportedly showed up at Leo Castelli's gallery in New York "with a batch of paintings—none titled" was surely not the last of his kind. "We need titles for filing cards. I recommend them," the gallery's manager recalled advising him, before proceeding to supply the missing articles.[10] Painters for whom words matter as much as brushstrokes will doubtless always remain in the minority; and so, too, perhaps, will those determined to shape the reception of their work by aggressively seizing the occasion offered

them by the demand for titles. Among such aggressive painter-authors, how-ever, have been some of the most influential artists of the last two centuries. In a charming metaphor, one late twentieth-century French draftsman com-pared a title to a cat's collar, which becomes necessary only when it's time to let the creature out the door.[11] Some titles, as I hope to show, can resonate long after the moment when the canvas quits the studio.

Jacques-Louis David's contribution to the Salon of 1785 was by all accounts a dramatic breakthrough. Both the responses of David's contemporaries and the verdict of scholars in the centuries that followed have concurred in iden-tifying the painting with a transformative moment in art history. The paint-ing, which had been announced in the *livret* as "Serment des Horaces, entre les mains de leur Pere" (*sic*)—literally, the *Oath of the Horatii, between the Hands of Their Father*—arrived in the Salon only a short time before its close, but its reputation had preceded it, and the delay in its appearance further heightened the excitement (plate 6).[12] "Les voilà ... ces sublimes Horaces," a poet exclaimed, and the language of the critics was nearly as rapturous. Of all the history paintings at the Salon, according to *L'année littéraire*, the one that "gathered the greatest number of commendations" was "the *Horaces*." The *Mercure de France* hailed it as the work of a "brilliant imagination ... the most distinguished production that the brush of a Frenchman has produced for a long time," while the *Journal général de France* announced that "by this supe-rior work M. David shows himself one of those rare men made to illustrate our Nation and mark the most glorious period in the Arts." Others invoked its "sublime execution" and "superb drawing," or pronounced it "an absolutely new composition" and "a grand conception."[13] This is not to say that the crit-ics identified no flaws in David's work, though Thomas Crow has influen-tially argued that even some of the faultfinding was a covert form of praise, as political dissidents among the commentators implicitly welcomed the paint-ing's departure from academic orthodoxy.[14] Just how much revolutionary politics can be read back into David's work of 1784–85 remains a highly vexed question, as we shall see. But three months before the fall of the Bas-tille, the curator of the king's prints was already writing that David and his pupils had made "a great Revolution" in the arts, and the association of that revolution with the events of the following decade would only gain in cur-rency over the years.[15] For most commentators, then and since, that artistic revolution had begun with David's *Oath*.

The impact of David's picture has been generally attributed to the excep-tional clarity and force of the image, especially as compared with the often arcane and elaborate history paintings typically contributed by his fellow aca-

demicians. With its shallow space, brilliant lighting, and vivid primary colors, the painting concentrates the viewer's attention on a single dramatic action—the near meeting between the three outstretched hands of the warriors at the left and the upraised hands of the central figure, one of which bears the gleaming swords whose rigid forms echo those of the warriors. Counter-pointed against the straight lines and straining muscles of the men—but clearly subordinated to them—are the curving and enervated forms of the women, whose blindness to the central action divides them from the paint-ing's viewers as well as from the figures performing it. (Only a small child, significantly gendered male, peers between his mother's hands at the scene before him.) Despite the sharp division between the masculine and feminine sides of the canvas, the composition as a whole is united by the triple rhythm of the arches at the rear and organized, as Louis Hautecoeur long ago dem-onstrated, by a strict geometrical pattern.[16] Before those arches, as on a pro-scenium stage, we are invited to witness an act at once verbal and performa-tive—the collective swearing of an oath that the title identifies as the *Oath of the Horatii.*

By identifying his warriors as the Horatii, David was conjuring up a famil-iar episode from Roman history. The story takes place in the early days of the ancient city, during the reign of Tullus Hostilius in the seventh century BCE. According to Livy, people from Rome and neighboring Alba were engaging in cross-border cattle raids that threatened to erupt into outright war, when their kings managed to avert further hostilities by sending individual cham-pions into combat instead. Seizing on the fortuitous fact that each side boasted a set of triplets, the Romans dispatched the Horatii to face off against Alba's Curatii—a conflict that ended in victory for Rome when the sole sur-viving Horatius succeeded in killing all three of the Curatii in turn. His tri-umphant return to the city was marred, however, by an encounter with a sis-ter who had been betrothed to one of the Curatii and whose tearful mourning for her dead lover so outraged the returning champion that he slaughtered her on the spot: "So may it be for any Roman woman who mourns an enemy," he is reported to have said. Torn between shock at the killing and gratitude to Horatius for saving the city, the Romans delivered him to the king, who for-mally handed off a judgment for treason to two men appointed for the pur-pose. Condemned to die, Horatius appealed to the people; and the tide turned when his father made an impassioned speech in his defense—arguing, among other things, that if he had not believed in the legitimacy of his daughter's killing he would have exercised his right as a Roman father to kill Horatius himself. The latter was pardoned—"more out of respect for his noble spirit," says Livy, "than for the justness of his cause"—and he was re-

quired to perform a ritual of expiation, while a tomb for his dead sister was constructed on the spot where she fell.[17]

Livy's account is the earliest but by no means the only version that would have been available to David when he painted his picture. The tale had also been told with some variations by one of Livy's near contemporaries, the Greek author Dionysius of Halicarnassus, and eighteenth-century historians had drawn on both sources in constructing their narratives. Commentators have often suggested that David probably consulted Charles Rollin's influential *Histoire romaine*, whose multiple volumes, first published in 1738–48, were frequently reprinted over the course of the century; and he may also have had access to translations by the abbé Bellenger of the *Roman Antiquities* of Dionysius (1723) and of Thomas Rowe's *Lives of Several Ancient and Illustrious Men, Omitted by Plutarch* (1734), the latter of which had first appeared in London in 1728. For David's contemporaries, however, the most familiar version of the legend—and the obvious inspiration of his painting— was Pierre Corneille's celebrated tragedy *Horace* (1640), which had been staged in Paris, with David in the audience, late in the winter of 1782. According to a report first published by one of his pupils after his death, the artist rushed home from the performance and committed his inspiration to paper. He originally intended, by this account, to depict a scene from the last act of the play in which the elder Horatius defends his son from the charge of treason, but he abandoned his initial idea after a group of friends persuaded him that the moment in question depended too much on words and too little on action to produce a good picture. "It is an excellent speech for the defense," the dramatist Michel Sedaine is reported to have said; but even Corneille, he implied, had been excessively seduced by his own language.[18] As the others later recalled it, David appeared to resist their advice, only to change his mind sometime later, when he chose to replace the speech of the father with the *Oath of the Horatii*.

Though this long remained the standard account of the painting's genesis, modern scholars have increasingly found reasons to question it—including, most importantly, the discovery of clear evidence that David had been toying with the subject of the Horatii at least a year before the performance of Corneille's tragedy. The original anecdote had been buttressed by a sketch, probably of 1782, that does indeed show the elder Horatius passionately defending his son; but another drawing, dated 1781, had already depicted the younger Horatius in the immediate aftermath of killing his sister (fig.11–2), and references to still another early sketch, this one of the murder itself, have turned up in the literature. There additionally exist a number of preparatory drawings unmistakably devoted to the subject of the final painting, whose

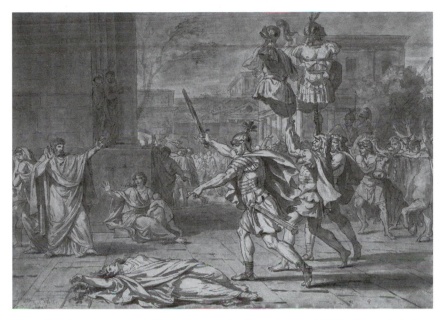

11–2. Jacques-Louis David, *Victorious Horatius Entering Rome* (1781). Pen and black ink, gray wash. Graphische Sammlung Albertina, Vienna. Erich Lessing/Art Resource.

dating remains uncertain, though if an inscription on one of these is to be trusted, David was at work on the *Oath* as early as 1782. (Whose hand recorded that date has been disputed.) We also know from a list of works proposed for the Salon of 1783 that the artist's attendance at the theater was at most a catalyst for his thinking about the father's defense of his son, since he was already planning a painting of that scene almost a year before he saw it performed at the Comédie française.[19] But for our purposes what matters is less the timing of David's plans for the picture than his final choice of subject. All the discussion of his visit to the theater long obscured a fact that was already evident to some of his contemporaries: no version of the legend, Corneille's included, makes any mention of the episode recorded in the painting's title.[20] This *Oath of the Horatii* is in every sense an invention of the artist.

David's celebrated work thus offers an exemplary case of a phenomenon still rare in the eighteenth century—a painting whose title unequivocally originates with its creator. That the title in question also happens to be unusually austere for a French history painting—particularly one on the scale of David's contribution—intensifies its effect. (The *Oath* measures thirteen feet by ten, a size whose significance I shall address shortly.) Compare the laconic entry for David's painting with that for a work by his fellow academician and

96. Mde Dupin de Saint-Julien, *Pastel.*
97. Mde la Comtesse de Clermont-Tonnerre.
98. M. Amédée Wanloo, Peintre du Roi, Professeur de son Académie.
 Ce Tableau de 4 pieds de haut, sur 3 de large, est un des morceaux de réception de l'Auteur.
99. M. Vernet, Peintre du Roi, Conseiller de son Académie.
 Ce Tableau appartient à M. Cochin.
100. M. Cochin, Graveur du Roi, Chevalier de son Ordre, Conseiller & Secrétaire de l'Académie.
 Ce Tableau appartient à M. Vernet.
101. Un Tableau (Portrait) de trois Figures en pied, représentant une Femme occupée à peindre & deux Élèves la regardant.
 6 pieds 6 pouces, sur 4 pieds 8 pouces.
102. Plusieurs Portraits peints à l'huile & au pastel, sous le même numéro.

Par M. *David,* Académicien.
103. Serment des Horaces, entre les mains de leur Pere.
 Ce Tableau de 13 pieds de long, sur 10 de haut, est pour le Roi.
104. Bélisaire.
 D'environ 4 pieds de long, sur 3 pieds de haut.
105. Portrait de M. P***

Par M. *Renaud,* Académicien.
106. Mort de Priam.

Priam voyant la ville de Troye livrée aux ennemis & aux flammes, s'étoit réfugié avec Hécube sa femme, & ses filles, dans une cour du Palais, près d'un Autel consacré aux Dieux Pénates. Polite, son fils, poursuivi par Pyrrhus, vient expirer à la vue de ses parens; ce pere infortuné voulant venger la mort de Polite, tombe sous le fer de Pyrrhus qui l'immole sur le corps du dernier de ses fils.
 Ce Tableau de 10 pieds quarrés, est pour le Roi.
107. Pigmalion amoureux de sa statue.
 5 pieds 5 pouces de large sur 4 pieds 7 pouces de haut.
108. Psiché venant à la faveur d'une lampe, pour poignarder son amant qu'elle croit un monstre : elle reconnoît l'Amour.
 Ces 2 pendants ont 1 pied de haut, sur 10 pouces de large.
109. Deux Bacchantes.
 7 pouces, sur 5 pouces & demi.

Par M. *Taillasson,* de l'Académie de Bordeaux, Académicien.
110. Philoctete à qui Ulisse & Néoptolème enlèvent les flèches d'Hercule.
 Après un accès de douleur, suivi d'un assoupissement, Philoctete s'apperçoit que ses flèches lui ont été enlevées; il reconnoît Ulisse, qui avoit conseillé aux Grecs de l'abandonner dans l'isle de Lemnos, il lui témoigne toute son indignation.

11–3. Pages from *Explication des peintures . . .* (1785). Sterling Memorial Library, Yale University.

rival, Jean-Baptiste Regnault, whose listing (misspelled "Renaud") immediately follows in the Salon *livret* (fig. 11–3). Or compare the still lengthier entry with which David's teacher and the former director of the Académie in Rome, Joseph-Marie Vien, opened the pages of the same catalogue (fig. 11–4). Though both Vien's painting and Regnault's represent familiar episodes from ancient epic—Priam's return with the body of Hector in the *Iliad* and the death of that same Priam in the *Aeneid,* respectively—the descriptions of both spell out in some detail the verbal contexts of their images. Vien's in particular troubles to make explicit the gesture of each principal figure—noting, for example, how Andromache "seems to complain to the gods of the death of her husband" and how Paris and Helen, "fearing reproaches, keep to themselves behind Andromache."[21]

David, by contrast, appears to leave his work to speak for itself—"so emblematically clear," as Robert Rosenblum has written, is the painting's "image

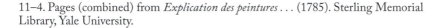

Nº 1. Retour de Priam avec le corps d'Hector.

Priam revenant du camp d'Achille avec le corps d'Hector fon fils, eft arrêté par fa famille, qui vient au-devant de lui; Hécube embraffe Hector; Andromaque, après s'être livrée à la plus grande douleur, lui prend la main, & femble fe plaindre aux Dieux de la mort de fon époux; Aftianax, conduit par fa nourrice, tend les bras à Andro-maque fa mere, qu'il voit éplorée : Pâris & Hélène craignant les reproches, fe tiennent à l'écart der-riere Andromaque; & Caffandre, qui a prédit tous ces malheurs, paroît s'être jettée fur une des roues du char, arrêté à la porte de Troye; le corps du Héros eft repréfenté dans un état de confervation, qu'il devoit aux foins de Vénus & d'Apollon.

Ce Tableau, de 13 pieds de large fur 10 de haut, eft ordonné pour le Roi.

11–4. Pages (combined) from *Explication des peintures . . .* (1785). Sterling Memorial Library, Yale University.

of sworn loyalty."[22] Yet if it is in fact true that the artist abandoned his inter-est in the father's defense of his son on the grounds that the subject was ex-cessively verbal, what he chose to represent instead was still a moment of speech as well as action. More precisely—to adopt the well-known terminol-ogy of J. L. Austin—what David chose to represent was a performative: a use of language in which speech and action are one. To swear an oath is not to describe but to *do* something, and the gestures that accompany that swearing are the visible signs of the verbal deed—an identification of word and image that Rosenblum implicitly acknowledges when he characterizes the picture's clarity as emblematic. In Joan Landes's apt formulation: "The men's taut bod-ies are straining to become instruments of the Word."[23]

That the Horatii never swore their oath before David painted them does not mean, of course, that the artist had no models for his image. Edgar Wind, who appears to have been the first scholar in the twentieth century to note the work's departure from its textual sources, suggested that David had in-stead taken his inspiration from an operatic pantomime of the legend pro-duced in Paris by the renowned ballet master Jean Georges Noverre in 1777. Elaborately reconstructing Noverre's scenario from an account of the perfor-mance by Melchior Grimm, Wind speculated that David had combined a scene in which three swords were brought onstage with a subsequent mo-ment at which a great oath was sworn on the battlefield. But Wind, who seems to have lacked access to the scenario Noverre actually published in 1777, failed to register that the oath in question was sworn by the two oppos-ing kings rather than the heroes; and his theory is further weakened by the fact that David was not in Paris for the performance, having left for the French Académie in Rome two years earlier.[24]

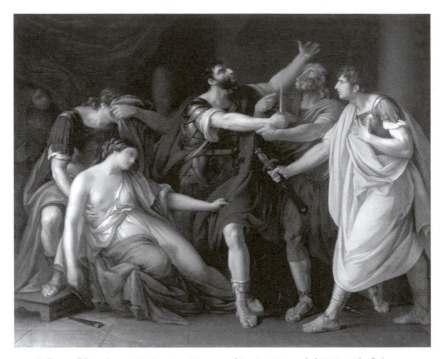

11–5. Gavin Hamilton, *The Death of Lucretia* (*Oath of Brutus*) (1763–64). Oil on canvas. Yale Center for British Art.

More convincing models for David's *Oath* have been found in the work of other painters, especially an *Oath of Brutus* completed by the Scottish artist Gavin Hamilton in 1763–64 and engraved by Domenico Cunego, with an inscription from Livy, five years later. The painting, also called *The Death of Lucretia* (fig. 11–5), represents another scene from early Roman history, when Lucius Junius Brutus swore to avenge the rape of Lucretia by the son of the tyrant known as Tarquin the Proud. While Lucretia's rape and her subsequent suicide had long been familiar subjects of European painting, Hamilton's picture departs from tradition by concentrating on the threat of vengeance and by the "stern, dramatic style," to quote Rosenblum again, with which the episode is represented. In the lines from Livy that are appended to the engraving, Brutus swears not only to avenge Lucretia but to drive out the Tarquins and assure that neither they nor anyone else will be king in Rome. Rosenblum, who first stressed "the generative power" of this image for David and other eighteenth-century artists, argued that it provided a crucial inspiration for the oath taking in the *Horatii* and also, implicitly, for the republican aura with which that gesture was invested[25]—an aura that may have gathered

further intensity from association with the oath sworn by another Brutus in Voltaire's tragedy on the death of Caesar (1735). To Brutus's injunction that his companions swear "on this sword" that Caesar will be assassinated, Voltaire's Cassius replies: "If they are tyrants, Brutus, they are our adversaries / A true republican has for father and sons / Only virtue, the gods, and the laws of his country."[26]

Closer to home, if more speculative, is the possibility that David drew inspiration from an oath that he himself had previously sworn. Though rumors of Masonic associations had long surrounded the painter's revolutionary years, it was only in 1989 that a scholar turned up decisive evidence of such membership in the minutes recorded by a Parisian lodge in late November 1787.[27] Masons notoriously swear a secret oath on joining the fraternity, but while the evidence makes clear that David was already a member before he became affiliated with this lodge, it does not tell us whether he had taken the oath by the time he conceived his famous painting.

We do know, however, that he had recently taken an oath of a very different kind, though as far as I am aware no one has ever speculated about its connection to the *Horatii*: on 6 September 1783, the thirty-five-year-old painter had been officially sworn in as a full member of the Académie. He had been working toward this goal ever since he first enrolled as a pupil in 1766, but his progress had been delayed by his repeated failure to win the coveted Prix de Rome; and it was only after he returned from that city, having finally succeeded on his fourth attempt, that he was able to begin the qualifying process that culminated in his ascent to the rank of Académicien. The *Oath of the Horatii* was, in fact, the first painting that he exhibited at the Salon under that rank; and as we shall see, he took great pains to make its advent as spectacular as possible. Whether or not he was thinking of these events when he came to title his picture is impossible to say, but the ritualistic idiom with which he characterized his imaginary oath closely echoes a formula that had resonated in the minutes of the Académie ever since its founding. Like every academician going back to the seventeenth century, the future creator of the *Serment des Horaces, entre les mains de leur père* assumed the privileges and honors of the company by pledging to observe all its statutes and regulations—a promise duly made, the minutes record, "en prêtant serment entre les mains de M. *Pierre*, Premier Peintre du Roy."[28]

I shall return to the question of just what, if anything, this echo might have signified to the artist's contemporaries. But whatever inspired his title's wording, the fact remains that in calling his picture the *Oath of the Horatii* David announced a scene no other artist had painted before him—a scene that nonetheless staked a claim to the grand tradition of history painting.

Indeed, for all the critical emphasis on the clarity of his image, it makes a nice thought experiment to consider the iconographical problem that the image might still present without its title. Most observers would surely grasp that the protagonists are making a pledge of some sort; and the more learned among them might well associate the three warriors with the famous story of the Horatian triplets, especially if they knew the tale from Corneille's version, which would help to account for the presence of three women where Livy speaks only of one. (In addition to the murdered sister, whom Corneille names Camille, the dramatist invents an Alban counterpart called Sabine— sister to the Curatii but married to the young Horatius—as well as a confidante of both women named Julie.) But what to make of the fact that no source, ancient or modern, would serve to bring these observations together? Perhaps a clever scholar would tentatively arrive at the solution, or perhaps the painting would remain a famous iconographical puzzle—a powerful image whose exact identity continued to elude us. As things stand, however, David's title decisively settles the question: this *is*—though no one has ever seen it before—the *Oath of the Horatii*. The Italian contemporary who defended the work by invoking the poet's license to invent scenes not recorded by history was closer to the truth than all those who subsequently looked to Corneille for the origins of the image: rather than paint a scene from another poet's tragedy, the artist had adapted an ancient legend to his own poetic fiction.[29]

Academic doctrine emphasized the painter's fidelity to literary sources, but the history of the *Oath* makes clear that the aggressiveness with which its creator departed from that orthodoxy was part of a larger strategy for reconfiguring his relation to his public.[30] As the *livret* registers, the *Oath* was a work commissioned for the king—a commission all the more notable for the fact that its creator was not yet an academician at the time he secured it. The order arose from a program established by the director of the king's buildings, the comte d'Angiviller, who hoped to reinvigorate French art by sponsoring a series of "travaux d'encouragement" with the aid of the king's principal painter, Jean-Baptiste Pierre—the same Pierre who would eventually administer David's oath of admission to the Académie. Yet when David was still a student at Rome, he was already engaged in seizing the initiative. In 1781 he submitted a painting to the Salon that qualified him for the first stage in the process of academic membership (*agréé*), even as it also laid implicit claim to a status already deserving royal patronage. The painting took up a legend recently popularized in a novella by Jean-François Marmontel: that of the old Roman general Belisarius, who has been cruelly reduced to begging after being blinded by the emperor Justinian (fig. 11–6). The tale had

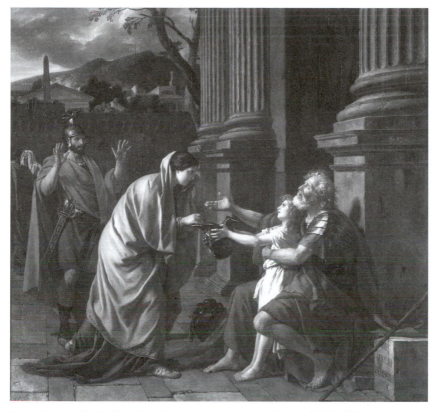

11–6. Jacques-Louis David, *Belisaire, reconnu par un soldat . . .* (1781). Oil on canvas.
Palais des beaux arts, Lille. © RMN-Grand Palais/Art Resource, NY.

already been the subject of pictures by two fellow students, and David's decision to tackle the same theme provided an obvious occasion for outdoing them. But in adopting the unusual format of a ten-foot square for his canvas—a size pointedly announced in the *livret*—he likewise arrived at a means of outdoing his superiors, the ten-foot square being a format officially designated for royal commissions that almost no one had attempted because of its difficulty. (Rectangular arrangements were far more customary.) The picture, which also drew attention to itself by arriving late at the exhibit, was a great success; and when the king's representatives attempted to buy it, David drove home his advantage by refusing to sell for less than his asking price.[31]

The result of his audacity, as Udolpho van de Sandt has shown, was a royal order for another ten-foot-square composition—an order that David eventually fulfilled only by making clear that the initiative lay with its creator.

Rather than hasten to comply with the royal charge, he settled instead on a delaying action: the king's picture would have to wait until he had first completed his reception piece and secured his own position in the Académie. The work originally commissioned in 1781 thus did not appear at the Salon until its late arrival in 1785, by which time, in the words of a contemporary, "it had long been the object of the public's impatience," having already been exhibited to great acclaim in the artist's studio at Rome.[32] Still more to the point, David had finally responded with a painting whose format and subject alike contravened the royal order. The original commission had specified a square canvas, ten by ten, showing "Horace, vainqueur des 3 Curiaces," at a standard payment for works this size of four thousand livres. When the order was renewed in January 1784, artists were apparently invited to propose one or two subjects for possible approval, and David offered two: "Horace condamné a mort pour le meurtre de sa Soeur est deffendu par son Pere à l'instant où les Licteurs viennent le saisir" (a version, in other words, of the scene in which Horatius's father defends him for his sister's murder) and—for the first time—"Le Serment des Horaces en présence de leur Pere." But despite the fact that a marginal notation in Pierre's hand registers that it was the more familiar scene from the legend that received official approval, what arrived at the Salon was, of course, the *Oath of the Horatii*—a canvas that at ten feet by thirteen, rather than the original square, now assumed the size customarily identified with the most expensive of these royal commissions.[33] As the artist himself famously put it in a letter to an aristocratic friend whose help he sought in obtaining a prime spot at the exhibit, "j'ai abandonné de faire un tableau pour le Roi, et je l'ai fait pour moi": "I ceased making a picture for the king, and I made it for myself."[34]

For David, however, to make a picture for himself was not to forgo a public but to demand that it take him on his terms. Doubtless he was telling the truth when he asserted in the same letter that he had enlarged the painting on artistic grounds alone, with no thought of further compensation, yet the fact remains that he ended by receiving the six thousand livres customarily accorded a picture of its size rather than the contracted four thousand—the only time a price set under this system changed after a work's commissioning.[35] More important than the increase in price was the widespread acclaim to which it testified: in making a picture for himself rather than the king, David had effectively gone over the heads of his official patrons and appealed to a public that in this case extended well beyond the regular audience for the Salon. He had already experimented with staging his own exhibitions as early as 1781, when he displayed his grand equestrian portrait of Count Potocki at his studio in Paris before sending it on with his other late submissions to the

Salon.[36] But the tactic he adopted with the *Oath* was on a different scale altogether: by first holding the picture back from all but a few confidential visitors while he worked at it behind closed doors in Rome and then opening those doors to the public, he assured that the painting would have an international reputation even before it appeared in Paris.[37] "He is hailed and pointed out by everyone in Rome," David's pupil Jean-Germain Drouais reported excitedly: "Italian, English, German, Russian, Swedish, I know not what, all the nations envy France's good fortune in having such a man."[38] The German painter Wilhelm Tischbein later recalled how "every day . . . was like a procession! Princes and princesses . . . cardinals and prelates, monsignori and parsons, burghers and working people, all hastened to it."[39] Even the pope requested a showing, though in the end he seems to have been one of the few people in Rome to miss the excitement, since there proved to be insufficient time to transport the picture to the Vatican before it set off for Paris.[40]

The *Oath* may have been destined for the king, but David clearly chafed at a system that kept the art of the painter from the widest circulation possible. As he complained to Tischbein, a poet could print his work, and a musician could give a concert, but a painter could only wait on a single purchaser, who then hung his acquisition in a place where he alone could see it. By comparison to the French, David seems to have believed, English artists were models of entrepreneurial endeavor: he alluded admiringly to their custom of reserving the right to exhibit their pictures to a fee-paying public for a year before surrendering them to a buyer, and he spoke of adopting a similar practice when he returned to Paris.[41] He also talked with Tischbein about taking his picture to be engraved in London, presumably in order to take advantage of the English print market.[42] Though he never followed through on either scheme in the case of the *Oath*, he did manage to keep control of the painting—and its display—far longer than his commission warranted. With the advent of the Revolution, it officially became the property of the state, but in 1791 David asked that it and other works shown at the Salon that year be returned to him for the purposes of copying; and the canvas remained in his studio at the Louvre, now known as the "atelier des Horaces," until the government finally succeeded in reclaiming it for the Musée du Luxembourg in 1803–4.[43]

After the Revolution, too, he managed to fulfill his dream of a private exhibit with paying customers for his monumental painting of *Les Sabines s'interposent entre les combattants* (1799), or *The Intervention of the Sabine Women*, whose theme of peaceful reconciliation was clearly aimed at a postrevolutionary public. The exhibit, which lasted an extraordinary five years and brought him enough money to purchase a country estate, took place in a hall

overlooking the *cour carré* of the Louvre: an arrangement seemingly in close competition with the biennial Salons and an important precedent, as we shall see, for the yet more openly confrontational exhibits later arranged by Courbet.[44]

In an accompanying pamphlet, David both justified his unusual method of appealing directly to the public and expatiated at length on the narrative represented in his painting, as he would do yet again when he arranged a similar exhibit for his *Leonidas aux Thermopyles* in the following decade. The artist, who suffered from a speech defect, has sometimes been characterized as lacking an "ability to express himself clearly in words."[45] But writing, as opposed to speaking, seems always to have figured in David's arsenal, and he never hesitated to turn author when circumstances required it. Dorothy Johnson has shown, in fact, how centrally words feature in many of his major paintings, from the Latin inscription on the stone in *Belisarius* ("Date obolum Belisario"—"Give a coin to Belisarius") to the multiple forms of writing that appear in his famous portrait of the murdered revolutionary Jean-Paul Marat (1793). The latter painting includes not only the deceitful letter carried by Marat's assassin, Charlotte Corday, in order to gain entrance to his bath chamber, but a letter on behalf of the poor that the victim himself has been composing, as well as the prominent inscription "À Marat, David" by which the artist brilliantly makes the wooden box do double service as a makeshift tombstone (fig. 11–7). Johnson argues that David was fascinated by language, both oral and written, and even before the *Oath* he also experimented with the challenge of representing speech: note the open mouths of the blind Belisarius and his young guide, for example, as they appear to articulate the words recorded on the adjacent stone (see fig. 11–6), or the similarly open-mouthed Andromache in the painter's reception piece, *La douleur & les regrets d'Andromaque sur le corps d'Hector son mari*, whose implicit words of mourning are partly glossed by the extract from the last book of the *Iliad* on the candelabra to the right (fig. 11–8).[46] Like the father in the *Oath of the Horatii*, whose mouth likewise parts to administer the oath, these earlier protagonists clearly pantomime the act of speech.

But what distinguishes the *Oath* from such paintings, as well as from similar works by the artist to come, is the simultaneous force of its imagined speech and its semantic openness. Alone among these works, it carries no inscription other than the record of its making ("L. David / faciebat / Romae / anno MDCCLXXXIV"); and alone among them, too, it refers to no scene, whether textual or historical, outside its frame. Though the picture's title affirms, of course, that these men are swearing, the words of their oath itself remain a matter of inference. If that has not prevented observers from imag-

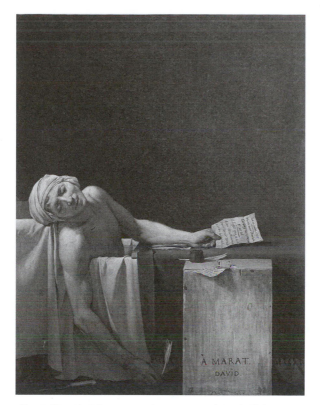

11–7. Jacques-Louis David, *Marat à son dernier soupir* (1793). Oil on canvas. Musées royaux des beaux-arts de Belgique, Brussels. Erich Lessing/Art Resource, NY.

ining that they hear what the Horatii are saying—one modern commentator even refers to "the spontaneous vigor of the oath, upheld loudly"[47]—it has also, I would argue, helped to account for the extraordinary resonance of the image. "While an entire People bent the knee before the idol that devoured it, the arts offered to our astonished eyes the ancient oath of the Horatii," a painter recalled in 1794, "and soon after, the same People shook off the shameful yoke of despotism and swore solemnly on the altar of the nation: *liberty or death*."[48] Subsequent accounts of the painting, conscious of how it thus came to serve as a revolutionary icon, have sometimes also imagined that its Roman heroes are declaring for "liberty."[49] Yet what became at the height of the Terror a paradigmatic representation of revolutionary fervor signified far more ambiguously a decade earlier. Contemporary observers who chose to imagine what the Horatii were saying conceived them as vowing to fight for their fatherland, or as swearing to conquer or die—readings surely more con-

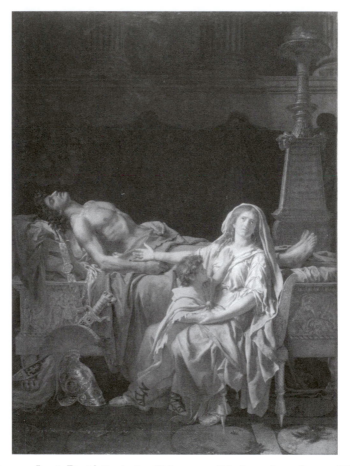

11–8. Jacques-Louis David, *La douleur & les regrets d'Andromache sur le corps d'Hector son mari* (1783). Oil on canvas. Musée du Louvre, Paris. © RMN-Grand Palais/Art Resource, NY.

sistent with the history recounted in Livy, as well as with the martial ethos of Corneille's tragic hero.[50] Even a critic who has been identified as a principal spokesman for the dissident faction in the artistic community of the time twice articulated this version of the vow, first imagining himself swearing, like the Horatii, "de mourir ou de vaincre" and then praising the spirit with which David had painted the brothers' eagerness "à jurer qu'ils alloient vaincre ou mourir pour la patrie."[51]

Since such ventriloquizing began while the painting was still at Rome, it may even have originated with the talk of the artist himself—talk, however, that significantly never made it into the *livret* in Paris. Despite the fact that

spelling out the discourse implicit in a history painting was a common practice in the Salon catalogue—the 1785 *livret* alone included two entries in which the terms of a vow were specified, as well as several others that directly quoted speeches supposed to be delivered by the figures on the canvas—David declined to say anything of his oath apart from its being sworn "entre les mains" of the father.[52] And that strategic silence was yet another sign of his determination to promote his work with as wide a public as possible. Reading between the lines of responses to the picture from political dissidents, Crow contends that the *Oath of the Horatii* "addresses itself to a new group of initiates, and carries a message for them alone." But the most obvious group of "initiates" among David's public comprised his fellow academicians; and if those in "the subculture of opposition," to adopt Crow's phrase,[53] sensed in this *Oath* a promise they did not yet fully articulate, others in the artistic community could still hear in its title the echo of a familiar ritual. Though modern commentators on the painting have sometimes suggested that oath taking is inherently contractual rather than monarchical,[54] the idiom of swearing "entre les mains du Roy" or "entre les mains du Chancelier" has a long history—one reflected, of course, in the corresponding language by which new academicians themselves swore to serve the king faithfully "entre les mains" of the king's representative.[55] David may not have represented a scene from Corneille, but there was nothing to prevent the more conservative viewers of his painting from assuming that its father would have agreed with his counterpart in the tragedy, who ends by instructing the young Horatius to trust his honor only to kings and other great ones rather than the vulgar mob.

By the time that the painting reappeared at the Salon of 1791, however, David's *Oath* had taken on a life of its own. In the intervening years his restiveness with the Académie had turned to open rebellion, and by 1789 he had clearly emerged as the leader of its dissident faction. When representatives of the Third Estate found themselves locked out of a meeting of the Estates-General in June of that year, they chose to assemble instead in an indoor tennis court, where they swore a solemn oath "never to separate and to reassemble wherever circumstances require, until the constitution of the kingdom is established and fixed on solid grounds."[56] This oath, named after its location the *Serment du jeu de paume*, was soon recognized as a critical episode in the opening of the Revolution; and it did not take long for the author of the Horatian oath to see in this extraordinary realization of his fiction the opportunity for a new kind of history painting—one that would treat the events of his own time with the grandeur and dignity hitherto reserved for ancient Rome (fig. 11–9). Sketches for the project appear in a notebook dated as early as March 1790, though it was not until the autumn that a formal proposal

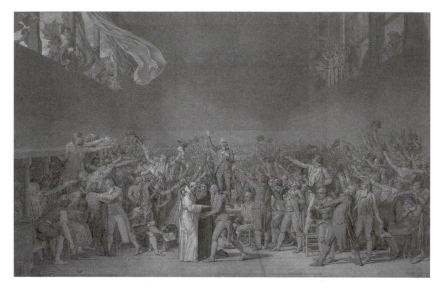

11–9. Jacques-Louis David, *Le serment du jeu de paume* (1791–92). Pen and ink. Chateau de Versailles et de Trianon, Versailles, France. Erich Lessing/Art Resource, NY.

was approved by the Jacobin Club for a canvas measuring thirty feet by twenty, to hang in the building that housed the National Assembly. (Money was to be raised for this enormous undertaking by selling subscriptions to a future engraving of the picture.)[57] By the following summer, when David exhibited a study for the work in his atelier at the Louvre, the association between his imaginary *serment* and the historical event he was now called to paint had become part of the Revolution's mythology. In a long ode on the subject, dedicated to the artist, André Chénier moved directly from the "manly oath" of the three fraternal saviors of Rome to the "far nobler oath" that "today summons the skill of so worthy a brush"—a moment at which "all swore," according to a later stanza, "to perish or to conquer the tyrants."[58] When the first revolutionary Salon opened that September, David's study of the scene hung immediately below the *Oath of the Horatii*, as if the artist who had painted for himself rather than the king had somehow both intuited and inspired the subsequent course of history.[59]

As it happened, history in this case moved too fast to be commemorated on canvas, and the huge painting was never finished, in part because David had repeatedly to confront the tricky problem of what to do with figures present at the time but subsequently denounced and sent to the guillotine.[60] Yet the artist's original *Oath* continued to serve as an emblem of revolution. Beginning in July of 1790, with a ceremony commemorating the fall of the

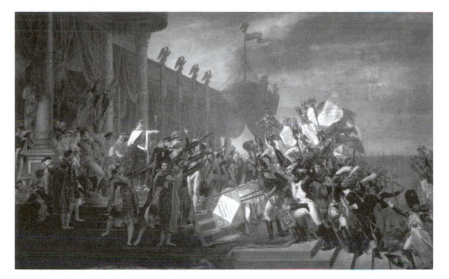

11–10. Jacques-Louis David, *Serment de l'armée fait à l'Empereur, après la distribution des aigles au Champ-de-Mars* (1810). Oil on canvas. Chateau de Versailles et de Trianon, Versailles, France. © RMN-Grand Palais/Art Resource, NY.

Bastille, and culminating in the Fête of the Supreme Being four years later, the practice of swearing a collective oath became a standard element of revolutionary ritual. At a climactic moment in the latter festival—one of several stage-managed by David himself—a crowd of youths and old men reenacted the iconic gesture of his painted Horatii.[61]

By the beginning of the new century the author of that *Oath* had transferred his allegiance to Napoleon, but the revolutionary interpretation of his fiction outlasted his own commitment to revolution. Sensing in the recent coup d'état the threat of another tyranny, some former revolutionaries plotted to assassinate Napoleon during a performance of *Les Horaces*—a new opera based on a libretto first composed in 1786, under the immediate impact of David's picture. The signal that the conspirators had chosen for the deed was, of course, the moment at which the actors onstage swore the oath of the Horatii.[62]

David himself produced one more painted *Oath*: an enormous canvas, measuring thirty feet by nineteen, whose full title is *Serment de l'armée fait à l'Empereur, après la distribution des aigles au Champ-de-Mars*—*The Army's Oath to the Emperor, after the Distribution of the Eagles at the Champs-de Mars* (fig. 11–10). One of four large paintings commissioned by Napoleon to memorialize his assumption of the throne, it was completed in 1810, two years

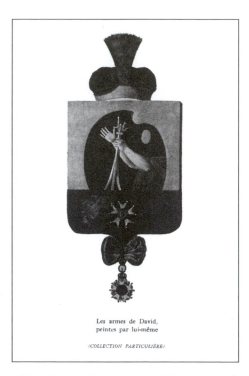

Les armes de David,
peintes par lui-même

(COLLECTION PARTICULIÈRE)

11–11. Jacques-Louis David's coat of arms, designed by the artist (1808). © Archives Wildenstein Institute, Paris.

after the better-known *Coronation*. (The other works in the series were never finished.) Like the *Serment du jeu de paume*, this represented an actual event in recent history, though one with a sharply different political resonance. The "eagles" in question may have been modeled on the aquiline standards of ancient Rome, but it was the Rome of the empire rather than the republic that David had been invited to celebrate. Laying out the picture's program to the intendant general of the army in 1806, the artist went so far as to declare, "Never was an oath better observed: what different attitudes! what varied expressions!"—almost as if he felt the need to assure his patron that this latest *Oath* would outdo his previous exercises in the genre.[63] Others have been less enthusiastic, though at least one scholar has argued that the dissonant elements of the composition intentionally convey a subversive message.[64] For our purposes, however, what the Napoleonic venture drives home is the political ambiguity that was latent in David's fiction from the start. In 1793 he had delivered an impassioned speech to the Convention proclaiming the "absolute necessity of destroying en masse all the Academies, the last refuge of

all the aristocracies"; in 1808 he officially became entitled, as a member of the Legion of Honor, to rank with the imperial nobility.[65] The coat of arms he adopted once more recalled his famous painting, but now it was the hands of the father, rather than the fraternity of the sons, with which the artist identified (fig. 11–11). The force of David's *Oath* always depended on saying just enough and no more.

[12 · TURNER'S POETIC *FALLACIES*]

Among the things on which David chose to remain silent was, obviously, the textual source of his picture. The author of this *Oath of the Horatii, between the Hands of Their Father* was the artist, and nothing external to the painting itself could offer any warrant for the moment it depicted. Yet David's was not the only means of wresting authorship for an artist determined both to evoke and to outdo the poets. J.M.W. Turner has been called "an extraordinarily literary painter," and he was certainly trained in a tradition that emphasized the artist's reliance on textual sources.[1] Writing to a fellow painter in 1817, Turner professed to hear the words of James Barry "always ringing" in his ears. "Go home from the academy, light your lamps, and exercise yourselves in the creative part of your art, with Homer, with Livy, and all the great characters, ancient and modern, for your companions and counsellors," Barry had exhorted the Academy's students at a lecture of 1793. But while scholars often cite Turner's letter as if he, too, invoked Homer and Livy, what he actually recalled of Barry's words was much more cryptic: "*Get home and light your lamp.*"[2] Like his memory of another's teaching, his attachment to others' texts was frequently complicated by his own claims to authorship.

Consider a painting first exhibited at the British Institution in 1814 that Turner entitled, with seeming awkwardness, *Appulia in search of Appulus vide Ovid* (fig. 12–1). This is, to be sure, a somewhat unusual case: although Turner officially submitted the work in response to an annual competition for the best landscape painting, both his act of submission and the painting itself appear to have been intended as a kind of provocation. The artist's "first offence," as Kathleen Nicholson has noted, "was in entering the competition at all, since it had been designed specifically to encourage young, aspiring artists, not Royal Academicians."[3] (Turner had been a full member of the Academy since 1802.) To compound the offense, he submitted the work

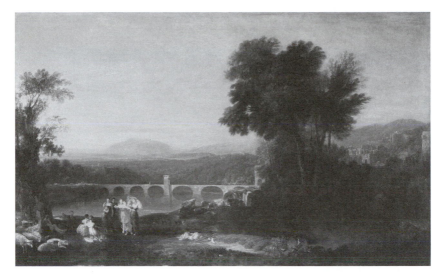

12–1. J.M.W. Turner, *Appulia in search of Appulus vide Ovid* (1814). Oil on canvas. Tate, London/Art Resource, NY.

eleven days after the official deadline—and hence was duly disqualified. But as Nicholson and others have shown, the artist seems to have been less intent on winning the prize than on making a point about the nature of imitation. More conservative than the Royal Academy, the British Institution represented connoisseurs rather than practicing artists; and its competitions were designed to elicit pictures that would be suitable companions to the Old Masters already hanging in their collections. By entering a painting that adhered closely to a seventeenth-century prototype by Claude Lorrain (fig. 12–2), Turner more than fulfilled this brief, even as he reworked the picture's biblical subject into a pseudo-Ovidian fable. The artist had taken a *Landscape with Jacob and Laban and His Daughters*, as his model was generally known, and transformed it into something he called *Appulia in Search of Appulus vide Ovid.*

Though Turner had altered some of Claude's figures and added to their number, he also knew that no viewer would be able to identify the story of Appulia and Appulus without his title. Presumably this is the reason why—in a gesture rare for him—he chose to record a variant of that title on the picture itself as well as in the catalogue: inscribed in yellow paint on the left-hand corner are the words "Appulia in Search of Appulus Hears from the Swains the Cause of His Metamorphosis," and on the tree above them ap-

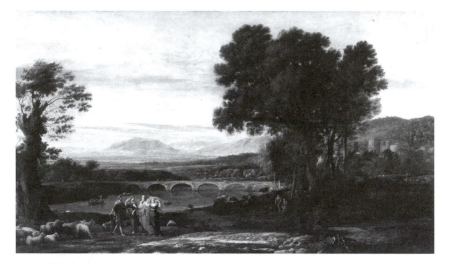

12–2. Claude Lorrain, *Landscape with Jacob and Laban and His Daughters* (1654). Oil on canvas. Petworth House, Petworth, Sussex, Great Britain. National Trust Photo Library/Art Resource, NY.

pears the name "Appulus." Book 14 of the *Metamorphoses* does tell of an Apulian shepherd who was punished for his mocking imitation of some nymphs' dancing by being turned into a wild olive tree; and the scholarly consensus is that by evoking this tale, Turner himself was obscurely mocking the British Institution's excessive emphasis on artistic imitation.[4] Yet a viewer who obeyed the catalogue's injunction to *vide Ovid* might well find herself as much baffled as enlightened. It is not just that the shepherd is nameless in the original—"Appulus" comes from a seventeenth-century English translation—but that Appulia and her search for him are wholly Turner's invention. Though a keen-eyed scholar has tracked down a visual source for her figure in a 1709 edition of Cesare Ripa's *Iconologia*, where she serves as an emblem for the region of Italy known in English as "Apulia" (fig. 12–3),[5] only in Turner does she go looking for Ovid's shepherd. The titular injunction to "see Ovid," in other words, is as much a tease as the rest.

For all its obscurity, I shall argue, Turner's feint with his literary source constitutes an important gesture in the history of the modern picture title—a gesture whose relevance for later artists will prove stronger in the end than David's aggressive assumption of authorship. The *Oath of the Horatii* also represents the painter's fiction, after all, but if it is hard to imagine its creator inviting his viewers to see Livy or Corneille in order to discover their mis-

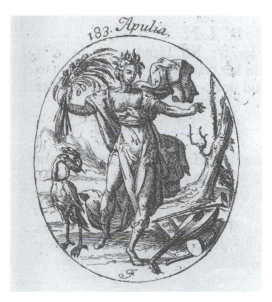

12–3. Isaac Fuller after unknown, "Apulia." Fig. 183 in Cesare Ripa, *Iconologia* (London: Benjamin Motte, 1709), 46. Yale Center for British Art, Paul Mellon Collection.

take, that is not merely because Turner's joke would have seemed quite foreign to the high seriousness of the French Académie. By comparison to David, whose *Oath* unquestionably ranked as *peinture d'histoire*, Turner dedicated himself to a kind of painting whose place in the academic hierarchy remained far more ambiguous, and the words he chose for his pictures were designed to manage that fact. It was probably Turner himself who arranged for his listing as a "Landscape" painter in an "Annual Register of Artists," first published in 1816, to be corrected in subsequent issues to a painter of "Historical Landscape"[6]—the category in which he would surely have classified both his *Appulia* and its Claudian prototype. Typically incorporating small-scale figures from biblical, mythological, or historical narrative—as in the examples above—such pictures sought to elevate the low status of landscape in the generic hierarchy by drawing on the kind of material otherwise associated with history painting.[7] We are accustomed to thinking of history painting as the most literary of genres, but precisely because historical landscapes visually subordinated the human figure, there is an important sense in which they were still more dependent on words: without their titles, the elevated associations they aimed to evoke could quite easily be lost. Especially for a growing

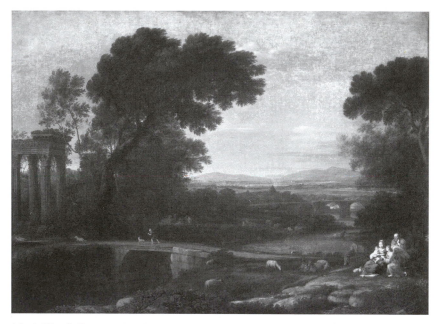

12–4. Claude Lorrain, *Landscape with Rest on the Flight into Egypt* (1661). Oil on canvas. Hermitage, St. Petersburg, Russia. HIP/Art Resource, NY.

public unversed in iconographical conventions, all except the most familiar subjects—this *Landscape with Rest on the Flight into Egypt* by Claude, for instance (fig. 12–4)—would have been very difficult to decode. And given the notorious indistinctness with which Turner represented the human figure (a weakness even his great champion, John Ruskin, acknowledged), that difficulty would only have been compounded.[8] Yet rather than conclude that Turner's titles are meant to provide the keys to images that would otherwise prove unreadable, I would like to suggest that their desired effect is more equivocal. As in the mischievous instance of *Appulia in Search of Appulus*, the artist characteristically deploys his titles both to evoke particular associations and to frustrate them.[9] Even as he conjures with the traditional prestige of literature and history, he also forces the viewer back, in partial bafflement, to the painting itself.

Turner never seems to have doubted that words had power to shape the reception of his pictures. Titles, for him, were clearly a function of exhibition: when he feared that a painting would be poorly hung at the Royal Academy in 1806, he deliberately sent it in without a title and explained to the hanging committee that the act signaled his plan of withdrawing the picture unless it

was displayed to his satisfaction. Assurances were duly given, and the painting became *Fall of the Rhine at Schaffhausen*, though in this case he was apparently outmaneuvered, since a reviewer later complained that the picture was impossible to view from the proper distance.[10] Losing a publicity battle like this was, in fact, quite rare for him. From 1790, when the fifteen-year-old artist exhibited his first watercolor at the Royal Academy, to a year before his death in 1851, when he showed four oils on the subject of Dido and Aeneas at the same venue, Turner proved keenly alert to the opportunities for self-promotion both afforded and required by a changing art world. As early as 1804 he began to supplement the annual exhibits at the Academy by showing work at a gallery of his own, first in his Harley Street house and later in a new space constructed for the purpose in 1822. When a wealthy friend staged an exhibit of the Turners in his collection in 1819, it was accompanied by a printed catalogue whose cover was designed by the artist. He was also quick to sense the potential for reproducing his work, closely supervising everything from the wording of advertisements to the details of the engravings themselves.[11] And then there was his practice of something like performance art on Varnishing Days, when he seized the occasion provided by the Academy to touch up canvases before an exhibit in order to stage bravura displays with his brush. At the same time, Turner clearly understood that his afterlife would require more permanent forms of publicity: the terms of his will, which bequeathed his work to the nation while specifying the circumstances under which it should be viewed, testify to an unusual prescience about the power of museums to define reputations in the modern art world.[12]

That prescience is only superficially at odds with practices that appear more backward-looking. In 1798 the Academy revived an earlier custom of allowing artists to follow up their entries in the catalogue with extracts of verse, and Turner immediately availed himself of the opportunity, adding lines from James Thomson's *The Seasons* and Milton's *Paradise Lost* to five of the ten pictures he submitted. (Together with Mark Akenside and Thomas Gray, these remained among his favorite poets for such purposes.) Figure 12–5 shows a page from the 1798 catalogue, with lines from book 5 of *Paradise Lost* glossing Turner's *Morning amongst the Coniston Fells, Cumberland*. To invoke Milton for a painting with no pretense of a historical subject was itself a bold move—a way of claiming for pure landscape the dignity and force of the highest epic.[13] Given the typographical layout of the catalogue, it was also, as James Hamilton has noted, a canny means of self-advertisement. The additional lines of poetry beneath Turner's title immediately draw the reader's eyes to his entry: "they stand out on the catalogue pages," in Hamilton's phrase, "like beacons."[14] The effect is all the more striking because of the

(10)

193	Portrait of the Hon. Mrs. Ferguson	M. A. Shee
194	Portrait of Mrs. Anderson	J. Fairbone
195	Portrait of the Earl of Inchequin	J. Hoppner, R. A.
196	Morning amongst the Coniston Fells, Cumberland	W. Turner

——— "Ye mists and exhalations that now rise
"From hill or streaming lake, dusky or gray,
"Till the sun paints your fleecy skirts with gold,
"In honour to the world's great Author, rise."
Milton Par. Lost, Book V.

197	A cottage near Ramsgate	L. J. Coffe
198	Portrait of an artist	J. Opie, R. A.
199	Portrait of a child of the artist	Mrs. Bell
200	Landscape	T. Taylor
201	Portrait of a cocking spaniel	S. Edwards
202	A view of Lambeth, with a group of barges, from the Horse-ferry road	D. Turner
203	A landscape, morning	R. Freebairn
204	Portrait of the Hon. Mrs. Stevenson	S. Woodford
205	A man's head, a study	T. Clarke
206	Fruit	T. Johnson
207	Portrait of a lady	T. Maynard
208 *	Infant care	H. Ashby
209	Lion and tiger fighting	J. Ward
210	Portrait of Lady Ann Lambton and children	J. Hoppner, R. A.
211	Portraits of Devonshire cattle, in the possession of Sir Henry Mildmay, Bart.	S. Gilpin, R. A. Elect.
212	Generous school boys, or the collection for a soldier's widow	W. R. Bigg, A.
213	Portrait of a dog	J. Northcote, R. A.
214	Portrait of the Countess of Oxford	J. Hoppner, R. A.
215	Portrait of Mr. J. Trotter	W. Beechey, R. A. Elect.
216	Woodman and gypsies	J. Ward
217	Landscape, evening	J. Phillips
218	A landscape	J. Phillips
219	The Son of Man, in the midst of the Seven Golden Candlesticks, appearing to John the Evangelist, and commanding him to write.—For the New Abbey at Fonthill.—Rev. 1st chap. v. 13.	B. West, R. A.
220	Richard III. in his tent the night preceding the battle of Bosworth, approached and addressed by the ghosts of several, whom, at different periods of his protectorship and usurpation, he had destroyed.	H. Fuseli, R. A.
221	Portraits of Mr. Wedderburn's children	W. Beechey, R. A. Elect.
222	Portrait of Mr. Payne	A. J. Oliver

12–5. Page from catalogue for the twenty-ninth exhibition of the Royal Academy (London, 1798). Yale Center for British Art.

comparatively short titles by which the British, as opposed to the French, were accustomed to identify their paintings. If David could call attention to the title of his *Oath* partly by keeping it simple (see fig. 11–3), Turner could achieve a similar end by reversing direction and identifying his picture with more words than usual. About a quarter of his exhibited oils were accompanied by some form of poetry—including, after 1800, lines composed by Turner himself.[15] Beginning in 1812, the catalogue attributed most of these to an otherwise unknown manuscript entitled "Fallacies of Hope." But supplying his own poetry did not necessarily make the relation between word and image simpler. Like his titles, Turner's "Fallacies" heighten his paintings' allusiveness even as they frustrate any desire to make reading do the work of looking.

The first work that Turner exhibited with a passage from his manuscript is also one of his most famous. According to an often-repeated story, the painting had its origins in some swift notes that the artist recorded on the back of a letter two years earlier, as he stood in a doorway during a raging storm at the Yorkshire estate of his friend and patron Walter Fawkes. "There," he is reported to have said to Fawkes's son after the storm had passed, "in two years you will see this again, and call it 'Hannibal Crossing the Alps.'"[16] The title under which Turner actually submitted the finished painting was *Snow Storm: Hannibal and his Army crossing the Alps* (plate 7)—a word order that nicely replicates the experience of choosing to "call" the storm in Yorkshire after a famous episode in ancient history. In fact, as Lynn Matteson has demonstrated, the subject of Hannibal had occupied the artist on and off for more than a decade, and the Yorkshire weather was at most a catalyst for the painting that he exhibited in 1812. A contemporary reported that Turner spoke admiringly of a now-lost canvas by John Robert Cozens entitled *A Landscape with Hannibal in His March Over the Alps, Showing to His Army the Fertile Plains of Italy* (1776), which the younger artist could well have seen in the 1790s; and there is strong evidence that Turner knew, and imitated, a variant drawing of the subject that Cozens produced around the same time. (Turner's own drawing appears in a sketchbook of c. 1798.) Among the other spurs to invention may have been a poem by Thomas Gisborne that invoked Hannibal's "Hope" as he gazed on Italy, and a list of imaginary paintings compiled by Thomas Gray, which proposed "Hannibal passing the Alps; the mountaineers rolling rocks upon his army; elephants tumbling down the precipices" as a fine subject for Salvator Rosa. Though all these works date from the eighteenth century, Matteson argues that both Turner's original fascination with Hannibal and his return to the subject in 1812 were prompted by the figure of Napoleon, whose repeated invasions of the Alps inspired the artist to ponder the fate of an earlier Alpine crossing. Glossed by the ominous lines from "Fallacies of Hope" that accompany it, Turner's apocalyptic image proves, by this account, all too prophetic, anticipating Napoleon's own defeat at Waterloo two years later.[17]

It is a powerful reading, and characteristic of the complex chain of associations by which scholars of Turner seek to reconstruct the sources and contexts of his pictures. Yet what is also worth noting is the very allusiveness that prompts the exercise in the first place. By subtitling the picture *Hannibal and his Army crossing the Alps*, Turner claims for it the resonance of ancient history, even as what he paints radically subordinates his purported narrative. The story of the Carthaginian's attempted conquest of Rome was first told by the Hellenistic historian Polybius in the second century BCE and later retold

by Livy; but a viewer unacquainted with their accounts might well imagine that Hannibal and his army were defeated by the challenge of their Alpine crossing. In truth, the general's invasion of Italy was initially successful; and seventeen years passed before the Second Punic War finally concluded with Rome's conquest of Carthage. Turner's poetic fragment manages to hint at this more extended narrative, only to revoke Hannibal's advance in the very act of articulating it:

> "Craft, treachery, and fraud—Salassian force,
> Hung on the fainting rear! then Plunder seiz'd
> The victor and the captive,—Saguntum's spoil,
> Alike, became their prey; still the chief advanc'd,
> Look'd on the sun with hope;—low, broad, and wan;
> While the fierce archer of the downward year
> Stains Italy's blanch'd barrier with storms.
> In vain each pass, ensanguin'd deep with dead,
> Or rocky fragments, wide destruction roll'd.
> Still on Campania's fertile plains—he thought,
> But the loud breeze sob'd, 'Capua's joys beware!'"
> —*M. S. P[oem?]. Fallacies of Hope* [18]

Capua was an Italian city that defected to the Carthaginians and served Hannibal for a number of years as his base of operations. But "Capua's joys beware!" only confirms what began in "Craft, treachery, and fraud"; and sunnier prospects have been negated even before we learn that the title of this piece is "Fallacies of Hope." By conjuring with evocative place-names while effacing that of Hannibal himself, the poet further succeeds in burying the famous general.

As in the poem, so in the painting: one reason that the anecdote about the storm has proved so memorable is that it is the storm rather than Hannibal that dominates the canvas. Just how challenging Turner's image might be to decode without his title is confirmed by another anecdote, this from the diary of Elizabeth Rigby more than thirty-five years later. Having been trained as a painter and soon to make a career for herself as an art critic, the future Lady Eastlake was hardly an unsophisticated viewer; but her first response to this image, "with all the elements in an uproar," as she described it, was to inquire "incautiously"—the adverb is hers—"The 'End of the World,' Mr. Turner?" "No, ma'am," came the reply: "Hannibal crossing the Alps."[19] Rigby saw the painting in 1846, five years before Turner's death, when he appears to have allowed his gallery and its accumulated canvases to deteriorate badly; and her

story makes clear that she had no access to a catalogue.[20] But the tension between painting and title is such that even today no one seems able to decide where among its dimly visible figures to locate Hannibal himself.[21]

Once upon a time, scholars sometimes like to imply, there was the traditional title, "denotative" and "transparent," whose straightforward relation to the image it named was first ruptured by the advent of impressionism.[22] What makes Turner such a striking case is the way his practice unsettles that history—at once conjuring with older styles of titling and anticipating the experiments of the future. Consider another historical landscape whose title also invokes the ancient conflict between Rome and Carthage, a dazzling work that the artist identified, simply, as *Regulus* (plate 8). First exhibited at Rome in 1828 and then reworked for submission to the British Institution nine years later, the picture derives its title from a Roman hero of the Punic Wars, whose legend Turner probably encountered in Oliver Goldsmith's *Roman History* (1769). Defeated and captured by the Carthaginians, Regulus was reportedly sent back to Rome after a subsequent battle in order to negotiate on Carthage's behalf for an exchange of prisoners. Rather than carry out his mission, however, the former consul urged the Senate to refuse the enemy's proposals and continue fighting, though the terms of his parole meant that he would be executed on his return to Carthage. According to legend, the Carthaginians first punished him by pulling out his eyelashes, so that he would be blinded by the sun, and then tortured him to death by sealing him in a barrel full of nails pointing inward. But what precise moment in this history does the painting represent, and where, once again, is its titular protagonist? As the *Literary Gazette* observed in 1837, "It has pleased Mr. Turner in this, as in numerous other cases . . . to give a name to a gorgeous assemblage of splendid hues, which has no, or scarcely any, connexion with the subject indicated in the title."[23]

The immediate comparison was with Turner's *Juliet and her Nurse* of the previous year, whose titular protagonists had been hesitantly discovered—"after considerable research"—"perched, like sparrows, on a housetop," but the present painting apparently baffled even such sustained efforts at decoding. "Regulus!" the critic exclaimed with good-natured exasperation: "There is certainly a little group of little men, rolling a little spiked cask into a little boat; but, *au reste!* Nevertheless," the piece continued, "who could have painted such a picture but Mr. Turner? What hand but his could have created such splendid harmony? Who is there so profoundly versed in the arrangement and management of colours? His sun absolutely dazzles the eyes."[24]

If one modern account of the painting is to be believed, the critic for the *Literary Gazette* came very close to solving the apparent mystery. The titular

protagonist is indeed absent from the picture, John Gage argued in 1969, because Turner is less concerned to depict a historical event than to evoke a visual experience: rather than represent Regulus himself, the artist chose to put us in his place, by virtually blinding our eyes with the brilliance of the sun.[25] Reports of how the artist heightened this effect on Varnishing Day by working extra coats of white into the canvas tend to confirm this reading,[26] as does the suggestion that Turner may have been recalling a passage from Edmund Burke's *Philosophical Enquiry into the Sublime and the Beautiful* (1757) in which Burke observes how "extreme light, by overcoming the organs of sight, obliterates all objects" and thus produces an impression of sublimity as powerful as that of darkness.[27] Even the very succinctness of the title has been marshaled in support of the argument: "We are enjoined to confront history on a first-name basis and deal with its unfolding through the experiences of (and *as*) an individual."[28]

Others, however, have resisted the claim that Regulus appears nowhere in the painting. Noting that when the picture was engraved for reproduction in 1840 it was entitled *Ancient Carthage—The Embarkation of Regulus* (fig. 12–6), they have cited the testimony of the engraver, Daniel Wilson, who specifically identified Regulus as "the small figure in Roman toga descending the grand flight of steps of the palace on the right." Wilson acknowledged that the figure was "not likely to be noticed in the original picture"—indeed, he was "out of sight," according to the engraver, as the picture then hung in the National Gallery (Wilson was writing in 1889). But here, too, interestingly, an argument can be made from last-minute changes, since Turner, by Wilson's account, "gave more prominence" to the Regulus figure when he touched up the proof, even as he also gave more prominence to the instrument of the hero's final torture, the barrel of nails that can just be discerned on the left.[29] Though Wilson does not mention it, the title of his engraving appears to reflect a similar impulse to clarify and specify what the painting left ambiguous, turning the evocative vagueness of *Regulus* into the more orthodox designation of a particular moment in its protagonist's history.

These alternative interpretations of the painting are not wholly incompatible.[30] Strictly speaking, the question of whether Regulus actually appears in the picture that bears his name may have only one answer, but the blinding effect remains in either case; while the fact that the protagonist is so difficult to perceive, even in the engraved version, means that most viewers will continue to experience some gap between word and image. At the very least, the case of *Regulus* unsettles the claim, advanced by Hazard Adams several decades ago, that a title "tell[s] us what is background, what is foreground" in a

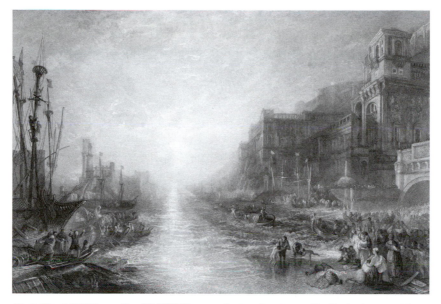

12–6. Daniel Wilson after J.M.W. Turner, *Ancient Carthage—The Embarkation of Regulus* (1840). Engraving. Yale Center for British Art, Paul Mellon Collection/Bridgeman Images.

picture.[31] Though one response to such effects in this and many other Turner paintings has been to argue that the artist intended his viewers to engage in an aggressive effort of decoding, the very sketchiness of the details to be read suggests that he was more interested in the way such strategies focused attention on the image than in a specific resolution of their difficulty. Rather than encourage us "to complete the narrative" by searching for his "principal character[s]," as one scholar has contended,[32] their final effect is to subordinate such narratives to an intensely visual experience.

This is not to say that Turner wished us to ignore the associations his titles carry with them. On the contrary: he counted on such associations to contribute to the total effect of the work, even as his practice exaggerated a tension between word and image already evident in the tradition of historical landscape. Though he never published his poetry outside of the glosses that appeared in the catalogues, he clearly liked to think of himself as an "author"—a term he incorporated, tellingly, in the elaborate title of a painting exhibited in 1842: *Snow Storm—Steam-Boat off a Harbour's Mouth making Signals in Shallow Water, and going by the Lead. The Author was in this Storm on the Night the Ariel left Harwich.* "Note Turner's significant use of this word,

instead of 'artist,'" Ruskin observed.[33] Like David, if more playfully, Turner also exerted his claim to authorship by titling pictures after scenes of his invention, as when he paid tribute to a Dutch predecessor by naming a landscape after an imaginary *Port Ruysdael* (1827), or identified another painting as *Boccaccio relating the Tale of the Birdcage* (1828), though no such tale appears in the *Decameron*. Indeed, there is also some evidence that he made up the incident he claimed to have witnessed firsthand in the title of his *Steam-Boat*, since no ship called the *Ariel* has ever been identified as operating out of Harwich or caught in a storm during the years in question.[34]

Pretending to quote poetry Turner had composed himself was partly an extension of this strategy. Though he had once believed that "Poesy & Painting, being sisters agree intirely," his notebooks testify to an increasing skepticism about the terms of that agreement—a skepticism that more or less coincided with his first attempts to substitute words of his own for those of more orthodox sources.[35] Of course those words themselves were largely derivative: echoes of his favorite poets have frequently been heard in his lines, and the very idea of "fallacious hope" was something of a commonplace in eighteenth-century literature.[36] Thomson in particular reverberates in the Hannibal passage, many of whose phrases come quite close to plagiarizing the poet's *Winter*.[37] Despite the frequent opacity of Turner's lines, their general drift is still discernible, as he repeatedly conjures with delusions of glory, sometimes associating these, through a picture's title, with the rise and fall of empire. Yet what distinguishes such lines from other extracts that appear in the catalogues is not merely that they are authored by the artist himself, but the fact that the work from which they purportedly derive has no existence apart from these fragments. As James Heffernan has aptly observed, the *Fallacies* is "an *imaginary* source created to displace and supersede the canonical ones," and the pretense of quoting from it—sometimes even beginning midsentence with a word such as "or"—only underscores the work's elusiveness, since the fragments we are given can never be anchored in a complete original.[38] The result is to intensify an effect already evident in Turner's poetic citations, which typically do more to provide a vaguely emotional tone for the paintings in question than to specify a representational program. Like his titles, in other words, the *Fallacies* continue the tradition of seeming to ground painting in literature, while assuring that the only incarnation of such language would be the canvas in front of the viewer.

At one Academy exhibit toward the end of his career, Turner even did away with the poetry altogether, simply following his titles in the catalogue with the reference "*MS. Fallacies of Hope.*" These were not historical land-

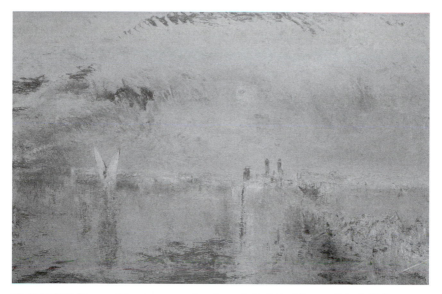

12–7. J.M.W. Turner, *Morning, returning from the Ball, St. Martino* (1845). Oil on canvas. Private Collection, USAPhoto © Agnew's, London/Bridgeman Images.

scapes, like our previous examples, but four paintings of Venice at different times of day, though the titles of two of them—*Venice, Evening, going to the Ball* and *Morning, returning from the Ball, St. Martino* (fig. 12–7)—also hint at generic subjects. ("St. Martino" appears to be another of the artist's inventions.)[39] The combination of Turner's characteristically indistinct images and the catalogue entries proved irresistible to the satirists at *Punch*, who gleefully offered to supply the extract that the artist had been "too modest to quote," since the painting—they singled out *Morning*—"really seems to need a little explanation":

> "Oh! what a scene!—Can this be Venice? No.
> And yet methinks it is—because I see
> Amid the lumps of yellow, red, and blue,
> Something which looks like a Venetian spire.
> That dash of orange in the back-ground there
> Bespeaks 'tis Morning! And that little boat
> (Almost the colour of Tomata sauce,)
> Proclaims them now returning from the ball!
> This in my picture, I would fain convey,
> I hope I do. Alas! *what* FALLACY!"[40]

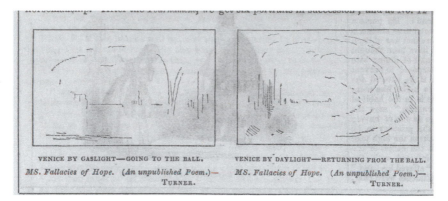

VENICE BY GASLIGHT—GOING TO THE BALL.

MS. Fallacies of Hope. (An unpublished Poem.)—
TURNER.

VENICE BY DAYLIGHT—RETURNING FROM THE BALL.

MS. Fallacies of Hope. (An unpublished Poem.)—
TURNER.

12–8. "A Scamper Through the Exhibition of the Royal Academy" (detail), from
Punch, Or the London Charivari no. 8 (1845), 233. Wood engraving. Yale Center for
British Art, Paul Mellon Collection.

The parody was a follow-up to *Punch*'s previous number, which had repro-
duced caricatures of two indecipherable canvases with labels very like the
originals, both pointedly subtitled "*MS. Fallacies of Hope. (An unpublished
Poem.)*—Turner" (fig. 12–8).

Like other attacks on the apparent mismatch between Turner's titles and
his images, *Punch*'s satire was premised on an idea of illusionistic clarity that
the artist's paintings increasingly violated: "Can this be Venice? No." Yet what
the satirists chose to see as meaningless "lumps" of color was also the aspect
of Turner's work that particularly appealed to many of the artists who fol-
lowed him; and for some of these, at least, the adoption of vague and evoca-
tive titles rather than denotative ones became an explicitly articulated strat-
egy. "The title is only justified when it is vague, indeterminate, and even
aiming confusingly at the equivocal": so Odilon Redon confided to his jour-
nal, even as he registered his impatience with the critics' desire to pin down
his meaning. "My drawings *suggest* [*inspirent*] and do not define themselves.
They determine nothing. They place us, as does music, in the ambiguous
world of the indeterminate."[41]

The artist whose last submission to the Royal Academy consisted of four
works inspired by the courtship of Dido and Aeneas (1850) clearly did not go
so far as this. Like Turner's paintings themselves, his titles look backward as
well as forward: there is nothing particularly indeterminate about *Mercury
sent to admonish Aeneas*, for example, or *The Departure of the Fleet*, even if their
author did manage to displace the expected lines of Virgil with some final
epigraphs from his own elusive *Fallacies*.[42] Having once confessed to "indis-
tinctness" as his "fault"—not, as some wishful admirers would have it, his

12–9. Cy Twombly, *The Italians* (1961). © Copyright. Oil, pencil, and crayon on canvas. Museum of Modern Art, New York. Digital Image © Museum of Modern Art/ Licensed by SCALA/Art Resource, NY.

"forte"—Turner might well have recoiled from Redon's unambiguous pronouncement in favor of ambiguity.[43] Perhaps he would also not have welcomed the homage of a modern artist like Cy Twombly, whose late triptych, *Three Studies from the Temeraire* (1998–99), pays direct tribute to a famous canvas by Turner.[44] The calligraphic style of a work like Twombly's *Italians* (fig. 12–9) could easily appear too close for comfort to the meaningless squiggles in *Punch*'s mocking rendition of his own Venetian landscapes. Yet Twombly's titles, many of which likewise conjure with classical sources, provide an exemplary case of the contradictory effects—at once verbal and inescapably visual—first induced by the titular experiments of his predecessor. Roland Barthes, who commented at length on those titles, said nothing of Turner, but his remarks on "the bait of a signification" in Twombly's work may serve as a final gloss on the earlier painter's exercises in authorship:

> Now it is impossible, seeing one of Twombly's titled canvases, not to have this initial reflex: we look for the analogy. *The Italians? Sahara?* Where are the Italians? Where is the Sahara? Let's look for them—

and, of course, we find nothing. Or at least—and it is here that Twombly's art begins—what we find, i.e., the canvas itself, the Event in its splendor and its enigma, is ambiguous: nothing "represents" the Italians, the Sahara—no analogical figure for these referents—and yet, we vaguely realize, nothing in these canvases contradicts a certain natural idea of the Sahara, of the Italians. In other words, the spectator has the presentiment of another logic . . . his gaze is beginning to work.[45]

Late in 1854 Gustave Courbet began announcing to friends and supporters that he was at work on a new project—"the most surprising painting imaginable," as he crowed to the art collector Alfred Bruyas.[1] To the writer and critic known as Champfleury the artist was less boastful but more expansive:

> Even though I am turning into a melancholic, here I am, taking on an immense painting, twenty feet long and twelve feet high, perhaps larger than the *Burial*, which will show that I am not dead yet, nor is Realism, for there is Realism in it. It is the moral and physical tale of my atelier. First part: these are the people who serve me, support me in my ideas, and take part in my actions. These are the people who live off of life and off of death; it is society at its highest, its lowest, and its average; in a word, it is how I see society with its concerns and its passions; it is the world that comes to me to be painted.
>
> You see, the painting has no title. I shall try to give you a more precise idea of it by describing it to you plainly.[2]

What followed were several long paragraphs spelling out an elaborate program for the work in progress, including not only the broad division of the canvas between those Courbet termed his "shareholders" on the right—"that is, friends, workers, devotees of the art world"—and those representing "the other world of trivial life, the people, misery, poverty, wealth, the exploited and the exploiters" on the left, but a detailed accounting of individual figures, from a bearded Jew carrying a casket on one side to Baudelaire reading a book on the other, and numbering among its many named portraits both Bruyas and Champfleury himself: "Then comes your turn in the foreground of the painting; you are seated on a stool with your legs crossed and a hat on your knees." Even the color of the cat by the chair was specified (white), as

was the fabric above the window ("great draperies of green serge"). No sooner had he enumerated these details, however, than Courbet concluded that he had explained it all quite badly. "You'll have to understand it as best you can," he told the critic. "The people who want to judge will have their work cut out for them," he added, before noting philosophically that they, too, would "manage as best they can."[3]

Such an extensive description of a painting in its creator's own words is comparatively rare in art history, and the letter to Champfleury has proved, not surprisingly, a crucial resource for scholars, who have taken it as an essential starting point for any analysis of the image. But the full text of the letter was not published until 1977;[4] and while there is no reason to assume that Courbet intended his correspondent to keep such information private—quite the contrary—these are not the words with which he first introduced his painting to the world. When he wrote to Champfleury, he said that the painting had no title, but by the time it went on display the following summer it had acquired quite an extraordinary one: *L'atelier du peintre: Allégorie réelle déterminant une phase de sept années de ma vie artistique—The Painter's Studio: A Real Allegory Determining a Seven-Year Phase of My Artistic Life* (plate 9). By that time, too, the canvas had taken its place at the center of a lively media event, designed to draw as much attention to the artist and his work as possible. Even more than Turner, Courbet was a consummate showman, keenly attuned to the publicity requirements of the modern art market; and the title of his immense painting was a key stroke in his lifelong campaign both to "make a name for [him]self," as he once put it, and "to change the public's taste and way of seeing."[5]

The occasion was the Universal Exposition of 1855, a world's fair intended by Napoleon III to rival the Great Exhibition in London four years earlier; and Courbet had originally hoped to display his *Studio* together with thirteen earlier paintings in the building that the fair's organizers had constructed for the purpose. But even before he submitted his work, he had already been contemplating a show of his own; and when the jury rejected three of his contributions, including the *Studio*, he seized the opportunity to follow through on his plan. Though his initial idea called for something like a carnival or circus tent, he eventually settled on a more permanent structure, pointedly erected on a site just opposite the Exposition's official venue for the arts.[6] There he proposed to display not only the pictures rejected by the jury but more than forty other works, making this the first individual retrospective of any importance outside of state-sponsored institutions in France.[7] (The eleven paintings accepted by the jury, however, continued to appear under state sponsorship.) The state was charging admission and Courbet, character-

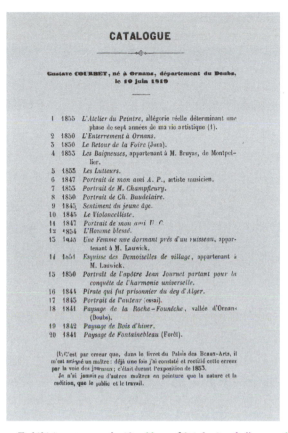

CATALOGUE

Gustave COURBET, né à Ornans, département du Doubs,
le 10 juin 1819

1	1855	*L'Atelier du Peintre*, allégorie réelle déterminant une phase de sept années de ma vie artistique (1).
2	1850	*L'Enterrement à Ornans.*
3	1850	*Le Retour de la Foire (Jura).*
4	1853	*Les Baigneuses*, appartenant à M. Bruyas, de Montpellier.
5	1853	*Les Lutteurs.*
6	1847	*Portrait de mon ami A. P.*, artiste musicien.
7	1855	*Portrait de M. Champfleury.*
8	1850	*Portrait de Ch. Baudelaire.*
9	1845	*Sentiment du jeune âge.*
10	1845	*Le Violoncelliste.*
11	1847	*Portrait de mon ami U. C.*
12	1854	*L'Homme blessé.*
13	1845	*Une Femme nue dormant près d'un ruisseau*, appartenant à M. Lauwick.
14	1851	*Esquisse des Demoiselles de village*, appartenant à M. Lauwick.
15	1850	*Portrait de l'apôtre Jean Journet partant pour la conquête de l'harmonie universelle.*
16	1844	*Pirate qui fut prisonnier du dey d'Alger.*
17	1845	*Portrait de l'auteur* (essai).
18	1841	*Paysage de la Roche-Founéche*, vallée d'Ornans (Doubs).
19	1842	*Paysage de Bois d'hiver.*
20	1841	*Paysage de Fontainebleau (Forêt).*

(1) C'est par erreur que, dans le livret du Palais des Beaux-Arts, il m'est assigné un maître : déjà une fois j'ai constaté et rectifié cette erreur par la voie des journaux ; c'était durant l'exposition de 1853.

Je n'ai jamais eu d'autres maîtres en peinture que la nature et la tradition, que le public et le travail.

13–1. Page from *Exhibition et vente de 40 tableaux & 4 dessins de l'oeuvre de M. Gustave Courbet* (Paris, 1855).

istically, decided to do likewise, making his exhibit also the direct heir of David's income-producing display of the *Sabine Women* in his studio a half century earlier. Whether or not Courbet was conscious of the precedent is unclear, though he, too, accompanied his show with a short pamphlet. But while David had devoted his text to justifying the experiment and explaining the program of his picture, Courbet confined himself to a brief polemical statement on "Realism" and a list of titles. At the head of that list was the "real allegory" of *The Painter's Studio* (fig. 13–1).

Though the statement on "Realism" began by decrying the very need for titles, the contradiction between polemic and practice is less obvious than it might seem. "The title of realist was imposed on me, as the title of romantics was imposed on the men of 1830," the statement begins: "At no time have titles given a just idea of things; if it were otherwise, works would be superflu-

ous." The rest of the statement ironically dismisses the need to pursue the relevance of a term that "no one, it is to be hoped, is required to understand very well," even as it goes on to proclaim Courbet's independence from any model, whether ancient or modern:

> No! I simply wanted to draw out, in the full knowledge of tradition, the reasoned and independent sense of my own individuality.
> To know in order to do, that was my thought. To be able to translate the customs, the ideas, the aspect of my time, according to my estimation; to be not only a painter but also a man; in a word, to make living art—that is my goal.[8]

Though Champfleury may have had a hand in drafting this statement, there is no reason to doubt that it spoke for the artist himself.[9] But Courbet's insistence that titles alone are misleading is perfectly compatible with the act of titling a painting, and calling his own work a "real allegory" did more to unsettle the idea of realism than the statement's ironic disclaimer of its relevance. Even Champfleury would prove baffled by the provocative oxymoron with which Courbet identified his *Studio*.

The myth of Courbet as an inarticulate peasant seduced by others' words had a strong hold on the nineteenth century, and Champfleury, as T. J. Clark has shown, was among those principally responsible for perpetuating it. A provincial artist who repeatedly professed his lack of formal training, Courbet clearly had his own reasons for "play[ing] the rustic," in Clark's phrase, including a canny sense of the critical distance it afforded him.[10] But recent scholarship has made clear that few artists in his day could have been more sharply attuned to the culture of print. Unlike Turner, for whom the power of the word meant above all poetry, Courbet attended almost exclusively to the influence of journalism. He arrived in Paris from his native Franche-Comté in 1839; and it did not take him long to conclude that the way to get ahead was to get his name in the papers. "I hope to read about myself in the Paris newspapers this year," he announced to his family in January of 1846. When the organizers of the Salon that year hung his only successful entry—a self-portrait—too high on the wall to be easily visible, his principal complaint was that it kept people from writing about him: "When it cannot be seen, it cannot be talked about. Yet I had hoped that this year three or four newspapers would write about me, they had promised me." In 1848 he reported excitedly that he had met an Englishman who had published a laudatory article about his work: "He asked my permission to come see me and promised to talk about me a great deal, for he writes for several newspapers."[11] Around

that same time he began to hang out at a brasserie called Andler's whose regulars constituted a veritable roll call of writers and journalists. Some of these were primarily poets and novelists (or in the case of Pierre-Joseph Proudhon, a social theorist), but a number made their careers as art critics, and several would at one time or another prove assiduous promoters of Courbet's work. The editor of his correspondence notes that he wrote more letters to people working for the press than to those in any other profession, even including fellow artists. An inventory after his death recorded a closetful of newspapers.[12]

All this eagerness to read about himself was not mere vanity. In an increasingly crowded art market, publicity of any sort had its value, and Courbet never hesitated to stir up controversy, if need be, in order to keep attention coming his way. "When I am no longer controversial," he once observed to his family, "I will no longer be important."[13] Beginning in 1851, he also wrote directly to the papers themselves, first to correct a Salon catalogue that purported to identify his teacher—he denied ever having one—and then to announce that another paper had erroneously reported his presence at a political meeting. The latter had apparently alluded to him as a "socialist painter," and even as he corrected its report of the meeting, he proudly accepted the label. "I accept that title with pleasure," he wrote, adding, "I am not only a socialist but a democrat and a Republican as well—in a word, a partisan of all the revolution and above all a Realist. But this no longer concerns M. Garcin, as I wish to establish here, for 'Realist' means a sincere lover of the honest truth." If this seems to give the lie to his subsequent claim that the title of realist had been imposed upon him, his definition of the term is sufficiently vague as to justify his later implication that no one was likely to understand it in any case. But while Courbet was soon to complicate his profession of realism, he would continue to insist, as he did here, on the importance of words. The letter closed with an urgent postscript: "Monsieur l'Editeur, I would like very much for this letter to be reproduced exactly in your forthcoming issue. I expect that from you."[14]

Though this particular editor did not comply, others would prove more accommodating; and Courbet would repeatedly turn to the letter columns of the newspaper when he wanted to address his public directly. He was also eager to collaborate in more oblique forms of authorship, but only if the words in question accurately reflected his meaning. That sharp critic of nineteenth-century picture titles Charles Baudelaire may have assisted him in composing a list of entries to the 1849 Salon, for example—the copy is partly in Baudelaire's hand[15]—while the poet and novelist Max Buchon clearly had Courbet's approval for the article he composed on a small travel-

ing exhibit that the artist undertook when the opening of the Salon itself was delayed the following year. Indeed, Courbet was so invested in the piece that he made sure to tell Buchon of the protests he had lodged against the article's editor: "I tried to make that man understand that with an art like yours no one but the author himself must alter it by so much as a word more or a word less."[16] He approached the publication of his own words with equal seriousness. When the critic Théophile Silvestre proposed to include him in a collection of essays on living artists in 1852, Courbet readily supplied him with interview copy—only to recoil with anger when he believed Silvestre's book had misrepresented him. "I don't find it to the point," he wrote to Buchon in 1856. "It seems to me that it is more his than mine, or in any case it is what he, Silvestre, thinks of me and of himself, but it is not me. He has been very awkward in quoting me, or, if he wanted to quote me, he should have let me correct the proofs."[17] Courbet might have preferred to "dash off ten roedeer than organize a sentence," as he once mischievously wrote to a government official with whom he was quarreling, but he understood very well how contemporary art was mediated through words.[18] It was not for nothing that he called more than one early painting of himself "portrait of the author."[19]

The titles on which Courbet seems to have collaborated with Baudelaire in 1849 were for the most part relatively straightforward: a list of nine paintings and two drawings, all but one either a landscape or portrait, the text is largely free of the penchant for sentiment and anecdote that had drawn the poet's scorn a few years earlier. There are only two partial exceptions: a brief "Chanson" in blank verse that glosses a landscape identified as *Les communaux de Chassagne* (*The Chassagne Commons*) and a diary-like entry that follows the more generically ambiguous painting known as *Une après-dînée à Ornans* (fig. 13–2): "It was the month of November. We were at our friend Cuenot's. Marlet returned from the hunt, and we had engaged Promayet to play the violin before my father." Apart from a "setting sun" in the "Chanson" that was appended to the title of the landscape, neither text made it into the printed catalogue—perhaps because custom usually reserved such elaborate glosses for history painting.[20] Over six feet high and nearly eight and a half wide, the very scale of the *After Dinner* already challenged generic distinctions, and naming its figures would only have driven home the challenge: who were Cuenot, Marlet, and Promayet, after all, to deserve such treatment? The figures in a genre painting were expected to remain anonymous, and by what it depicted, if not its scale, the *After Dinner* most nearly resembled a genre painting.

Though Courbet would include his three friends again on the huge canvas he entered at the Salon the following year, he made no attempt to identify

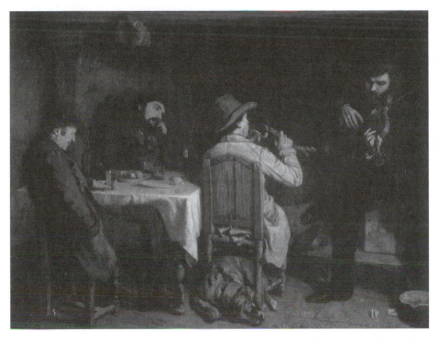

13–2. Gustave Courbet, *Une après-dinée à Ornans* (1848–49). Oil on canvas. Palais des beaux-arts, Lille. RMN-Grand Palais/Art Resource, NY.

any of its figures by name in the register. Like the *After Dinner*, the crowded canvas now known as *Un enterrement à Ornans—A Burial at Ornans* (fig. 13–3)—represents a scene in the provincial town of the artist's birth; and if one were to judge by its modern title alone, one would conclude that Courbet had chosen not to contest its status as genre painting. But it is not only the size of the canvas—at more than ten feet by almost twenty-two, the *Burial* closely approximates the scale of the *Studio*—that calls that assumption into question. Just as the voice of the *After Dinner* entry anticipated the more grandiose first person Courbet adopted for his *Studio*, so the language with which he recorded this other great image of provincial life—*Tableau de figures humaines, historique d'un enterrement à Ornans*—carried something of the later title's provocative charge.[21] Not quite a "tableau d'histoire" (the conventional formula for a history painting), Courbet's "tableau . . . historique" nonetheless managed to imply both that contemporary life also counted as history and that this particular *tableau* had historical significance—that it would acquire landmark status in the development of the art. As Michael Fried has noted, even the word "tableau" was not altogether innocent, since it conveyed an idea of pictorial unity that Courbet's work was often said to

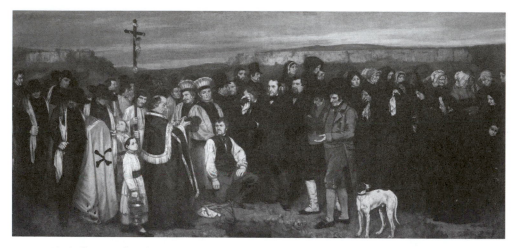

13–3. Gustave Courbet, *Un enterrement à Ornans* (1849–50). Oil on canvas. Musée d'Orsay, Paris. Erich Lessing/Art Resource, NY.

lack—the critics accusing him of painting effective bits (*morceaux*) but indifferent wholes (*tableaux*).[22] The *Burial* itself was said by one critic to be a "very bad *tableau*," even as he pronounced another Courbet at the same Salon "the best painted *morceau* in the exposition of 1850."[23] (The *morceau* in question was the self-portrait known as the *Man with a Pipe*.) Courbet's defiant rhetoric may have been always good for stirring controversy, but not until the twentieth century would the critical consensus take his words with the seriousness their author demanded.

No title of Courbet's proved more irritating to his contemporaries, however—or more generative for subsequent art history—than the elaborate gloss by which he identified his *Studio*. For most of the artist's public, his "real allegory" was a meaningless oxymoron, while the verbal swagger in "a seven-year phase of my artistic life" only confirmed the pretension of the whole. A review of the exhibit that revealingly mislabeled Courbet's picture *L'Atelier de l'auteur* impatiently dismissed "all this metaphysics" and "verbiage":

> If there is an idea in all this, does it need to be summed up? Did the great masters of Italian art ever display such conceit for their very prolific works? Truly, the self [*le moi*] these days . . . gives itself too much importance.[24]

Another simply declared this "studio of the painter . . . an unhappy allegory for a realist."[25] A satire of the image by the caricaturist known as Quil-

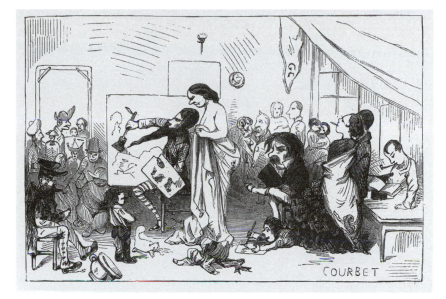

13–4. Quillenbois [Charles-Marie de Sarcus], "M. Courbet dans toute la gloire de sa propre individualité, allégorie réelle déterminant une phase de sa vie artistique. (Voir le programme, où il prouve victorieusement qu'il n'a jamais eu de maître . . . de perspective.)" Detail from "La peinture réaliste de M. Courbet," in *L'illustration*, 21 July 1855. Engraving. Private Collection. Photo © Liszt Collection/Bridgeman Images.

lenbois brilliantly summed up this line of attack by turning the brush in Courbet's hand into that of a housepainter, whose daubs are being supplemented by the famously pointed beard of the artist himself (fig. 13–4). (There is probably a visual pun on the word for beard, *barbe*, and the verb *barbouiller*—to daub clumsily.)[26] The accompanying caption combined a parody of Courbet's title with a mocking allusion to his public disclaimer of artistic instruction in the catalogue (see fig. 13–1): "M. Courbet in all the glory of his own individuality, real allegory determining a phase of his artistic life. (See the program, where he victoriously proves that he has never had a teacher . . . of perspective.)"

Even the artist's champions balked at his claim to have produced a "real allegory." Though both Champfleury and Proudhon appeared in the *Studio* among those Courbet termed his "shareholders," neither man was prepared to endorse the subtitle of the painting in which he figured.[27] "*Allégorie ré-elle* . . . Here are two words that clash together, and that trouble me a bit," Champfleury wrote in an otherwise sympathetic account of the artist's work. "An *allegory* would not know how to be *real*, any more than a *reality* could

become *allegorical*: the confusion around this famous word *realism* is great enough, without the need to fog it up more."[28] Proudhon likewise thought Courbet's phrase a contradiction in terms and pronounced it "unintelligible": "What! He calls himself a realist, and he occupies himself with allegories! This bad style, these false definitions have done him more harm than all his eccentricities."[29]

All this critical controversy underscores a striking fact. In labeling his picture as he did, Courbet was not merely providing an interpretive guide to a particular image but aggressively intervening in the theoretical idiom of his day. Nearly every word of his title—including the apparent paradox at its heart—carried programmatic associations. Even a seemingly neutral descriptor like *L'atelier du peintre* spoke to contemporary arguments. For followers of Proudhon, as James Rubin has shown, the term *atelier* signified not just a painter's studio but the fundamental unit of society: an *atelier* was an independent workshop, and only on the basis of such workshops, where every owner was his own master, could the ideal social order be constituted. Courbet's choice of *peintre*, too, was less innocent than it might seem, since to identify himself as such was to take a stance as a craftsman rather than an *artiste*—to privilege the material substrate of his art over its more spiritual associations. The odd word *déterminant* ("déterminant une phase de sept années de ma vie artistique") has also been traced to Proudhon, who in turn adopted it from Hegel, while *phase* may have been derived from the artist's patron, Alfred Bruyas, whose recently published account of the works in his collection had inscribed on its title page, "Phase d'une éducation d'artiste de la grande famille."[30]

More relevant for the future of art history was the confident self-periodizing that identified this painting with a seven-year phase in the artist's life. In thus anticipating the scholarly practice of dividing up a painter's career—think of Picasso's "Blue Period," for example[31]—Courbet characteristically aligned himself with those who would mediate visual art through language, even as his striking use of the first-person singular ("*ma* vie artistique") violated the custom of titling pictures by adopting the impersonal voice of the mediators. For all the self-promotion that characterizes artistic careers in our own day, we are still more likely to encounter a "Self-Portrait" or "Portrait of the Artist" than a painting entitled "My Portrait" or "Portrait of Myself"— and this despite the convention of labeling a written work "My Story" or "My Life." But Courbet, who had already flirted with the first person in his entry for the *After Dinner*, seems to have taken his cue here, too, from the writers. As he observed of the many self-portraits he had painted over the years that

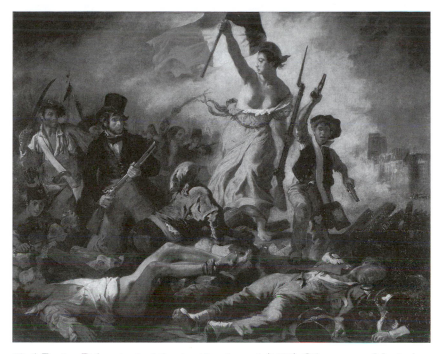

13–5. Eugène Delacroix. *La Liberté guidant le peuple* (1830). Oil on canvas. Musée du Louvre, Paris. Gianni Degli Orti/The Art Archive at Art Resource, NY.

culminated in the *Painter's Studio*: "One could say that I have written my autobiography."[32]

It was the language of "real allegory," however, that most challenged the artist's contemporaries, and it did so precisely by threatening to confound terms that seemed increasingly important to keep distinct. The possibility that a realistic-looking image might turn out to be an allegory—or vice versa—was hardly itself a new idea: recall the anonymous critic who had argued for adding inscriptions to the pictures in the revolutionary Louvre in order to forestall the possibility that a "so-called connoisseur" would mislead the public by ignorantly confusing a real scene (*une réalité*) with an allegory.[33] More recently, Delacroix's striking image of the July Revolution, *La Liberté guidant le peuple* (1830), had prompted otherwise sympathetic commentators to worry its apparent fusion of modes (fig. 13–5). "Should one condemn, should one praise the alliance of allegory and reality that governs this composition?" Gustave Planche had inquired in his discussion of the artist at the Salon of 1831, only to answer equivocally, "we will condemn the principle in

itself, but we will praise the execution—the absolute success."[34] Planche's decision to regard the painting as a great achievement despite his theoretical doubts found a responsive echo in Théophile Thoré's more confident praise of the work several years later as "at the same time history and allegory":

> Is it a young woman of the people? Is it the spirit of liberty? It is one and the other; it is, if one wishes, liberty incarnated in a young woman. True allegory [*l'allégorie véritable*] must have this character, of being at the same time a living type and a symbol. . . .
>
> Here again, Monsieur Delacroix is the first who has employed a new allegorical language.[35]

Unlike Delacroix's *Liberté*, of course, the title of Courbet's painting didn't interpret his allegory, only announced it—providing no key other than an asserted relation to a phase of his artistic career. More immediately to the point, the two decades that had separated Thoré's *allégorie véritable* from Courbet's *allégorie réelle* had begun to charge the latter adjective with a set of associations that made the apparent paradox of the title yet more difficult to reconcile. Though it was primarily in the aftermath of the 1855 exhibit that "réaliste" became a fighting term—first in the short-lived journal *Réalisme* launched by Edmond Duranty in 1856 and then in Champfleury's book of the same title published the following year—the struggle over the word and its variants had already started to heat up in the late 1840s.[36] By the early 1850s, the idea of an "école réaliste," with Courbet at its head, had gained considerable currency. Just what that contested term signified was far from clear—recall the artist's wry disclaimer, in the manifesto that accompanied his exhibit, that no one was likely to understand it—but among the many associations with which it was charged over the years perhaps none was more salient for Courbet's *allégorie* than that of materialism. Realist art, at least for its critics, was an art that attended only to the material appearances of things and that declined to transform those appearances in order to convey any deeper meaning or significance.

As the philosopher Théodore Jouffroy put it in his posthumously issued *Cours d'esthétique* of 1843, "the school of reality" in the arts

> thinks of nothing but of rendering form and renders it in all its details. There is nothing in its pictures but the more or less faithful imitation of nature. It has no pretension to do better than reality, to manifest the invisible by its style. It respects that which is, and reproduces its form scrupulously.

Jouffroy said nothing about allegory as such, but in exemplifying the contrast between the realist school and its idealist opposite by way of their different approaches to the subject of love, he ended up implicitly conjuring a visual allegory of *Amour*. While the realist could represent love only by depicting an amorous individual in "all the circumstances that modify her material form"—details of sex, age, nationality, rank, historical moment, and the like—the idealist would proceed by suppressing such circumstances in the interest of an "invisible" and "internal" phenomenon.[37] Only thus could the artist represent something beyond the material, the passion of love itself rather than a particular individual. Jouffroy's insistence that the realist's dedication to reproducing the material facts in all their circumstantial detail necessarily precludes him from representing an abstract idea helps to explain why Courbet's contemporaries should have found an *allégorie réelle* such a contradiction in terms.[38]

The inclusion of recognizable portraits in Courbet's *Studio* would seem to have removed it yet further from the realm of allegory (see plate 9). Rather than serve as models, whose identity is subsumed by the artist's idea, Baudelaire, Champfleury, and others appear as themselves in this canvas; and a viewer able to recognize them might well conclude that all of its figures were likewise nameable—a collection of particular individuals who had gathered for a massive group portrait. In fact, many of Courbet's figures, here and elsewhere, characteristically frustrate the impulse to identify them in this way, even as the concreteness with which they are rendered would appear to invite such identification.[39] But that very concreteness, together with the familiar setting of the artist's studio—a common subject in texts and images of the day[40]—seems to have made it especially difficult for Courbet's contemporaries to register any of the visual cues by which he also signaled his impulse to allegory. Despite the signs to which modern art historians have pointed—the dreamlike lighting of the whole, for example, or the fact that the various figures assembled on the canvas appear to have almost nothing to do with one another—viewers at the time persisted in interpreting the picture anecdotally, as if all these people somehow happened to drop by while the artist was busily at work on his landscape.[41]

So the English painter Richard Redgrave registered his distaste for the work's "coarseness of conception" by dwelling on the behavior of the "strong-minded woman" in the foreground, whose apparent lack of "delicacy," as Redgrave saw it, was manifested by the coolness with which she looked upon the nude model to her left. That these two figures might not necessarily be understood to occupy the same temporal and spatial coordinates seems never to have occurred to the Victorian artist, who much preferred a "refined" render-

ing of the Annunciation, by the academic painter Charles Jalabert, that stood nearby.[42] Since Redgrave appears to have seen these works as they stood in a hall awaiting the final verdict of the Exposition's jury, he presumably approached Courbet's painting without any assistance from its title. But Champfleury had no such excuse when he followed up his protest against his friend's "real allegory" by likewise remarking a social impropriety that he associated with the well-dressed woman to the right. Taking for granted that this "femme du monde" was married to the man who accompanied her and that the boy sketching at her feet was their son, he registered his skepticism as to the plausibility of such a familial visit to the studio: "Is M. Courbet really sure that a small child of the wealthy bourgeois would enter an atelier with his parents, when a nude woman is there?"[43] No more than Redgrave, apparently, could Champfleury abandon his assumption that Courbet's image was intended as a realistic representation of daily life in the studio.

Even Delacroix, who thought the work "a masterpiece," nonetheless balked at the artist's seeming failure to keep his realistic effects consistent with one another. For Delacroix, the problem was the appearance of "a *real sky*" in the midst of the painted landscape on the easel—an effect he took for an unintended ambiguity (his term was *amphibologie*),[44] but which well might look different if one approached it from the standpoint of "real allegory." As modern observers have noted, both the materiality of the paint on this patch of canvas and the echo between the rectangular shape of the landscape and that of the adjacent palette implicitly remind us that this outdoor scene is not so much imitated from nature as produced by the artist himself (fig. 13–6).[45] Rather than assume that Courbet neglected to keep his painting-within-the-painting subordinate to the scene as a whole, in other words, one might argue that he intended a certain unsettling oscillation between them—as if he were anticipating the sort of play between the painted scene and the "real" one that a surrealist like Magritte would make his artistic signature in the following century (fig. 13–7).

But if such ambiguities are indeed at the heart of Courbet's painting, they mostly failed to register on his contemporaries. For all the controversy over his title's rhetoric, the canvas itself played a comparatively minor role in the nineteenth-century reception of his art. Commentators at the time devoted far more attention to works like *A Burial at Ornans* or *The Stonebreakers* (1849) than they did to the *Studio*. Apart from Quillenbois's caricature, no reproduction of the painting would appear in the artist's lifetime, nor did Courbet himself exhibit it frequently. Unlike his other major works, it was never shown at a Paris Salon. After the 1855 exposition, the canvas was rolled up, together with two other large works, in a corner of his studio, whence it

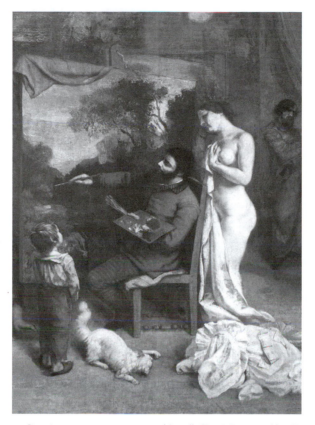

13–6. Gustave Courbet, *L'atelier du peintre* (detail). Erich Lessing/Art Resource, NY.

emerged only twice before the painter's death in 1877—first at a provincial exhibit at Bordeaux in 1865 and then at the Vienna Art Union in 1873. Not until a posthumous sale of 1881, when it was purchased by a private collector, was the first photograph of the *Studio* commissioned; and not until 1920, when a subscription was raised to acquire it for the Louvre, did the canvas finally enter the nation's museum.[46] (It was transferred to the Musée d'Orsay in 1986.) Few paintings may have been "so central to the history of modern art," as James Rubin has declared, but that centrality has largely been a retrospective construction of modern commentators.[47] Until the mid-twentieth century, Courbet's "real allegory"—the titular paradox—probably had more impact on the history of art than did the image it characterized.

Some of this deferred effect arose from practical causes. The very scale of the *Studio* made it impossible to photograph with contemporary equip-

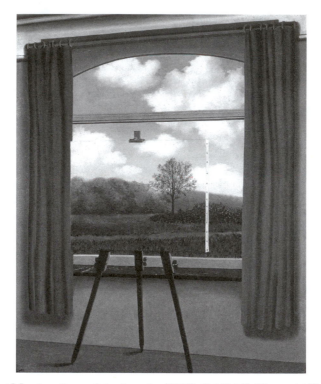

13–7. René Magritte. *La condition humaine* (1933). © 2014 C. Herscovici/Artists Rights Society (ARS), New York. Oil on canvas. National Gallery of Art, Washington, DC. Art Resource, NY.

ment,[48] and that same scale, of course, made it an unlikely candidate for private purchase. Indeed, to the extent that Courbet's title announced the close of a phase in his artistic career, the image itself may have partly been designed to announce a new one, since the years following the exhibit saw him turn away from such large programmatic paintings to the production of smaller canvases, primarily landscapes, for the popular market. From this perspective, both his massive canvas and the language that accompanied it were part of a deliberate publicity campaign, whose chief function was to advertise his more saleable work.[49] Yet Courbet hoped to attract his buyers not despite his independence but because of it, and the very fact that the *Studio* itself was unlikely to find a purchaser meant that this was also a painting by which he could advertise his autonomy. Marcel Duchamp nicely captured this posture of Courbet's when he credited him, rather extravagantly, with reversing at one blow the artist's relation to his public. Once upon a time, according to Duchamp, "the painter was a man more or less in the pay of a king or an

emperor, or even a group of collectors. But the day when Courbet began, it became the opposite. He said: 'I make a painting, Mr. Collector, you can take it or not take it; I will not change it, it is up to you to submit yourself to my wishes.'"[50] From such a perspective, the intensely self-referential character of the *Studio* was as important as the canvas itself, and the title by which it circulated functioned as a manifesto even in the absence of the image. Courbet's contemporaries may have been baffled by his "real allegory," but they could not mistake its implicit claim to meaning.

Just what specific meanings might have been intended, however, would have to await the institutions of modern scholarship and the widespread circulation of the image itself. Perhaps the beginning should be dated to the fall of 1919, when the painting was put on display in order to raise money for its purchase by the Louvre and printed copies of the artist's letter to Champfleury were distributed to the visitors.[51] "This work," declared the critic for *L'illustration* that fall, "is an essential page in the history of French painting"—his textual metaphor implicitly identifying the painting itself with the words that accompanied it. Another commentator at the time—himself a poet—likewise pronounced the artist of the *Studio* "not only a painter, as has often been said," but "also a great intellectual."[52] By 1944 the Louvre had dedicated a monograph to the work, which helpfully supplemented the curators' material and genetic account of the painting with a detailed guide to its models and figures. If the *Studio* was perhaps not the artist's "masterpiece," the authors concluded, it was "at least the keystone of his *oeuvre*."[53]

Even such a tribute did more to ratify the painting's claim to significance than to decode it, however. Not until the second half of the century did serious attempts to decipher Courbet's allegory take off, though once the business of interpretation got underway, new readings of the picture proliferated rapidly. In 1960 Werner Hofmann argued that "'L'atelier' is among other things a picture of the ages of man."[54] In 1968 Linda Nochlin suggested that Courbet had produced "a Fourierist as well as a Realist allegory," at least some of whose iconographic puzzles might best be elucidated via the conceptual schemes of the utopian socialist Charles Fourier and his followers.[55] In an extended study of the painting a few years later, Benedict Nicolson guardedly endorsed Nochlin's reading, while cautioning that the picture was "too personal to meet the requirements of any strict political programme."[56] Like most scholars of the work since the Louvre curators a quarter century earlier, Nochlin and Nicolson advanced their accounts partly by supplementing the identifications of particular figures in Courbet's letter to Champfleury. So Nochlin, for instance, found potential support for her interpretation in the possibility that one of Courbet's Fourierist friends and patrons, the art critic

François Sabatier, appeared in the picture as the gentleman accompanying the well-dressed woman on the right. (Courbet's letter had referred only to "a fashionable lady, very elegantly dressed, with her husband.")[57]

The most elaborate effort to crack the code of Courbet's allegory came with a major retrospective to commemorate the centenary of the artist's death in 1977, when a curator at the Louvre, Hélène Toussaint, published her "dossier" on the painting in the exhibition's catalogue. Taking for granted that the work was "full of hidden meanings [*intentions*]," Toussaint set out to investigate its iconography as thoroughly as possible, drawing not only on Courbet's letter but on a variety of contemporary documents, both visual and verbal.[58] While the artist had identified by name a number of friends and patrons on the right side of the canvas, he had characterized those on the left primarily by type—referring, for example, to the person behind the Jew with the casket as "a priest with a triumphant expression and a red bloated face," or the figure in front of them as "a poor old man, very skinny, an old Republican of '93." Much of Toussaint's detective work, by contrast, was devoted to uncovering potential models for these anonymous persons, such that we were invited to recognize Louis Napoleon's minister of finance, Achille Fould, in the figure of the Jew; the Catholic propagandist Louis Veuillot as the priest; or the military engineer and former revolutionary Lazare Carnot as the Republican of '93—this last painted, according to Toussaint, after a posthumous medal designed by the sculptor David d'Angers, since Carnot himself had died in 1823. A number of other figures, whom Courbet had designated yet more briefly by profession or role ("a hunter, a reaper, a muscle man, a clown, a fancy-clothes merchant, a worker's wife, a worker," etc.), likewise signified politically for Toussaint, either because they, too, could be identified with particular models or because their appearance evoked a national type, as when the clown's pigtail suggested an association with China and hence with a trade concession acquired by France at Shanghai in 1849.[59]

Toussaint's most spectacular discovery, however, concerned the identity of a figure not mentioned in Courbet's letter, but who appears prominently seated before a pair of dogs in the left foreground of the painting. According to Toussaint, this figure, dubbed by the artist's contemporaries *le braconnier* ("the poacher"), is none other than Louis Napoleon himself—his relation to France's ruler confirmed both by visual cues and by the multiple meanings of *braconnier*, which included not only a man who trains dogs, as did Louis Napoleon, but a slang sense of libertine that would also have applied to the emperor. In this reading, Courbet's very silence about the figure was further evidence of its identity, since the political censorship of the time virtually prohibited any representations of the imperial family. Indeed, for

Toussaint, even the letter itself was not to be taken at face value: rather than providing a key to the painting, she suggested, the artist had deliberately circulated the document as a blind in order to "camouflage the true meaning of the picture"—a meaning she obscurely associated with the secrets of the Freemasons.[60]

Not every commentator has been persuaded by the details of this analysis, let alone by its assumption that the best way of decoding the picture is to track down the models for individual figures.[61] Nor did Toussaint herself ever really offer a coherent interpretation of Courbet's allegory, for all the ingeniousness of her detective work. But a year after her investigation appeared, Klaus Herding followed up on its discoveries with a reading that did purport to make sense of the painting as a whole. Taking his cue from Toussaint's identification of Louis Napoleon, as well as from a letter of Champfleury to George Sand that had compared the picture to a "secret letter" addressed to the emperor by a messianic Polish philosopher, Herding argued that Courbet had intended his massive canvas as an implicit exhortation to the ruler—a visual equivalent of the "*adhortatio ad principem* . . . common in treatises on statecraft down into the nineteenth century." The mother in rags was by this account a pointed reminder of the emperor's failure to fulfill the promise announced in his *Extinction du paupérisme* of 1844; the dagger at his feet and the revolutionaries hovering in the background a tacit warning; and the landscape on its easel a promise of regeneration by means of "a direct reference to unsullied, primordial nature"—a nature to which Courbet's art gave privileged access. By incorporating the emperor but placing him on a level equal to that of other visitors to the studio, Courbet had created "a nonhierarchical visual harmony" that was itself a model of the new society toward which the entire painting gestured.[62] For Herding, the *Studio* thus deliberately responded to Louis Napoleon's original call for an Exposition that would celebrate the government's achievements by staking a counterclaim for the social role of art. As Courbet professed to have told the emperor's representative when the latter first approached him about participating in the exhibition: "I too [am] a government."[63]

This account of Courbet's allegory has gained widespread acceptance in the scholarly community, even if few subsequent commentators have been inclined to echo Linda Nochlin's extravagant claim that it marked "the end of interpretation." The "search for meaning is apparently exhausted," she announced in an essay on the painting in 1988: "there is nothing left to discover." It turned out, not surprisingly, that Nochlin intended these words more as a provocation than a conclusion, and that the interpretive impulse was not exhausted so easily. Her own essay would go on to resist what she saw

as the authoritarian effects of allegory by arguing for how the unfinished character of the canvas potentially opened it to alternative readings, and by turning the shadowy form of the ragged mother into a figure of that openness—a procedure she termed "allegorizing the 'real allegory.'"[64] Michael Fried, who appeared to have little patience for Nochlin's approach, nonetheless shared her impulse to move beyond Herding's account, so as to concentrate in his case on Courbet's representation of the act of painting. Yet no more than his predecessors was he prepared to abandon the theoretical formula with which the artist had originally characterized his picture. Even as he acknowledged that the kind of phenomenological reading he advanced would not have been legible to Courbet's contemporaries—or consciously registered by the artist himself—Fried insisted on "the primacy of metaphor or allegory in his art." Indeed, Fried took the idea of "real allegory" not only as a key to the *Studio*—he, too, called the representational dynamics he identified in the painting "an allegory"—but as the central clue to Courbet's work as a whole. All the major paintings of the 1850s would prove in this account "allegories of realism."[65]

To call something an allegory is of course to invite interpretation. If one response to Courbet's title has been to track down ever more specific meanings for individual motifs in the painting it names—identifying the cat, for example, as an emblem of Republican liberty[66]—another has been to understand it as licensing a search for meaning in realism more generally. Where once Courbet's contemporaries had been in danger of seeing such work as wholly without intellectual significance, a mere transcription of material surfaces, recent scholars have begun to warn about the risks of "overinterpretation."[67] At the time of its creation, Courbet's *allégorie réelle* primarily served to stir up controversy, but just as the huge painting itself seems to have been destined in retrospect for a museum, so his words seem to have been composed for the future of art history. That no one to this day has fully explicated his central paradox would surely not have troubled the artist who proudly wrote that his work would "keep people guessing."[68] Nor would he have been concerned by our predictable tendency to abbreviate his full title and speak simply of *The Painter's Studio*, or even, as I have repeatedly done, the *Studio*. Unlike Whistler, with whom he briefly associated in the 1860s, Courbet was sufficiently committed to the representation of the material world not to worry lest viewers identify his paintings by their dominant motifs. The full title of his huge canvas was an instruction for viewing that was intended to double both as manifesto and self-advertisement, and in all three capacities that title did its work. Courbet's attention to the physical properties of paint on the surface of his canvas has sometimes been taken as an an-

ticipation of modernism at its most austere, but his aggressive title also be-
longs to a contemporary art world in which words play almost as crucial a
role as painting. It seems no accident that the avant-garde collective Art &
Language have returned to his example, or that they freely incorporated his
own account of his work into some key scenes of their witty libretto for an
opera set in 1860s Paris. The same stolidly incompetent police inspector in
their text who can't "see pictures as pictures" and keeps mistaking the painted
nude for a corpse refuses to get Courbet's allegory either. "You don't fool me,"
he says, in response to the artist's explanation of how his figures signify. "No
one can paint ideas; / No work of art has ever pictured thought."[69] As Art &
Language know quite well, Courbet's title argued otherwise.

[14 · WHISTLER'S *SYMPHONIES* AND OTHER

INSTRUCTIVE *ARRANGEMENTS*]

Courbet's title would provide a very different lesson for James McNeill Whistler, who first arrived in Paris in the autumn of 1855, just in time to draw his own conclusions from the controversy generated by the *Real Allegory*. A few years later he joined several fellow artists at the studio of another realist, François Bonvin, where he briefly painted under Courbet's direction.[1] Whistler was not inclined to a long apprenticeship, however; and by the time that Courbet boastfully alluded to him in a letter of 1865 as "an Englishman who is my student," the latter characterization was scarcely more accurate than the former.[2] (Whistler was born in Lowell, Massachusetts.) In a letter of his own written only two years later, Whistler explicitly disavowed Courbet's example. "I'm not complaining . . . about the influence of his painting on mine," he told their fellow painter Henri Fantin-Latour: "there is none, and you will not find it in my canvases." The trouble, he implied, was "that damned Realism" and its seductive appeal to "Nature," when he really should have been learning to draw on the model of Jean-Dominique Ingres.[3] He said nothing, understandably, about Courbet's publicity campaigns, but Whistler's subsequent career would demonstrate that there was more than one way of taking his former mentor as a model.

Even as he wrote this letter, in fact, the rebellious pupil had already subscribed for two years to a clipping service.[4] More immediately to the point, he had also recently inaugurated a provocative titling system of his own, having exhibited his first painting with a musical title at the Royal Academy that summer. This was the work he called *Symphony in White, No. III*, and lest there be any doubt that he meant the title to stick, Whistler had inscribed the words directly on the canvas before shipping it off to the Academy (see

plate 5). Recorded on the work itself, rather than some other document, and certifiably painted by the artist's hand, such a title would appear to mark a clean break from the uncertainty and instability that have so often attended the names of pictures passed down from earlier centuries. Even David presumably relied on the compiler of the *livret* to enter the title of his *Oath* correctly, but Whistler's authorial gesture emphatically refuses such mediation. In 1873 he would apparently try a less radical means to a similar end, when he demanded that the French dealer Paul Durand-Ruel affix a label over each of his paintings then being exhibited at the latter's gallery showing the title as Whistler had given it. (It is not clear whether the reluctant dealer complied.)[5] When Whistler later lectured on the invidious role of "the middleman in this matter of Art," who "has widened the gulf between the people and the painter," he was thinking primarily of critics rather than dealers and catalogue-makers, but in this context, too, he was determined to cut out the middleman.[6]

Though Whistler was not, as Courbet carelessly asserted, an Englishman, the fact that he had moved more or less permanently to London in 1863 gave his lifelong embattlement a very different cast from his predecessor's. Both delighted in stirring up controversy and commanding attention in the newspapers, but only Whistler would have characterized this effort as a "war . . . between the brush and the pen."[7] Courbet, as we have seen, openly collaborated with writers and journalists, several of whom were accorded a prominent place among the "shareholders" in his *Studio*.[8] For all his defiance of conventional opinion, the French artist could always count on a small, if shifting, subset of the avant-garde to help articulate his case with the public. Though Whistler, too, had his supporters, he preferred to speak—and write— as if "the critics" were a uniform bloc, whose commitment to the word consistently thwarted the appreciation of his pictures. The difference was partly temperamental, of course, but even more a consequence of the British bias toward literature. When Whistler complained of the popular tendency to read painting as narrative, he clearly meant to include the professional art critics among the guilty. Given that their medium was the word, he seems to have reasoned, how could they help it? As he put it in his attack on the critic as "middleman":

> For him a picture is more or less a hieroglyph or symbol of story. Apart from a few technical terms, for the display of which he finds an occasion, the work is considered absolutely from a literary point of view; indeed, from what other can he consider it? And in his essays he deals with it as with a novel—a history—or an anecdote. He fails entirely

and most naturally to see its excellences, or demerits—artistic—and so degrades Art, by supposing it a method of bringing about a literary climax. . . .

Meanwhile, the *painter's* poetry is quite lost to him.[9]

It was to emphasize this peculiarly visual "poetry"—and to forestall any attempt to read instead for narrative—that Whistler decided to identify his painting of two women in white as a "Symphony."

Many ironies attend this move—not least the fact that it, too, required words, and that the painter chose to borrow the vocabulary of yet another art in order to highlight the distinctive qualities of his own.[10] In doing so, he also chose to retitle a work that he himself had once identified differently. Whistler's invocation of "the *painter's* poetry" comes from a lecture of 1885, by which time he had become famous, or infamous, for his musical titles. Like this public justification of his practice, however, the titling of *Symphony in White, No. III* was an act of retrospect. The title is dated 1867; but as Elizabeth Prettejohn has pointed out, Whistler scarcely bothered to conceal the fact that the latter date was painted over an earlier one—1865, when the image itself was first completed.[11] (Presumably that was when it was signed as well.) And indeed, when Whistler's friend William Michael Rossetti reported in March of 1867 that the artist was about to send *Symphony in White, No. III* to the Royal Academy, he identified it in parentheses as the picture "heretofore named *The Two Little White Girls*."[12] The numbering itself was a form of backdating. Whistler designated this his third *Symphony in White*, even though it was his first picture to acquire a musical title, because he now decided to rebaptize two earlier works: a painting of 1864 heretofore called *The Little White Girl* and one of 1862 that Whistler himself usually referred to as *The White Girl* (plate 10) before it became, by this retrospective accounting, his *Symphony in White, No I*. (Despite his best intentions, however, this "first" of Whistler's *Symphonies* never appeared as such in his lifetime.)[13]

If the only "*true*" title is one "given by the *artist* at roughly the time of creation or constitution of the work" (emphases in original), then *Symphony in White, No. III*, like much of Whistler's musical nomenclature, fails to qualify—and that for still more reasons than this brief history has begun to suggest.[14] But the instructive force of the renaming should not be underestimated. As Prettejohn has noted, the *Symphony in White, No. III* was not the only painting at the Academy that year to invoke music or rhythm. Like Whistler's *Symphony*, both Albert Moore's *A Musician* (fig. 14–1) and Frederic Leighton's *Spanish Dancing Girl: Cadiz in the Olden Times*—itself since renamed *Greek Girl Dancing* (fig. 14–2)—show figures arranged on a bench

14–1. Albert Moore, *A Musician* (c. 1867). Oil on canvas. Yale Center for British Art, Paul Mellon Fund.

in a shallow foreground space, their bodies draped in vaguely classicizing costumes or posed so as loosely to recall the Parthenon marbles. In all three, too, she observes, a figure on the left "establishes an asymmetrical focus, while seated figures to the right look on, listen or, in the case of the Whistler, seem lost in introspection." Prettejohn is concerned to demonstrate the visual style these pictures have in common, and the resemblances she identifies are indeed striking. Yet while Moore has his lyre-player and Leighton his dancing girl, only Whistler divorces his title from any representation of music making. Alone among them, he insists on naming his picture for a formal abstraction.[15]

Whistler's account of his titling system evolved with the titles themselves. His own first allusion to the *Symphony in White, No. III* appears in a letter tentatively dated February 1867,[16] but apart from Rossetti's passing allusion to the change, we have no immediate explanation from the artist himself as to how *The Two Little White Girls* became a *Symphony*. By the time of his 1873 exhibit in Paris, however, he had arrived not only at a set of musical terms on which to draw—the seven canvases on display included two *Harmonies*, two *Nocturnes*, two *Arrangements*, and one *Variations*—but at a standard way of characterizing them.[17] "By the names of the pictures also," he wrote to a

14–2. Frederic Leighton, *Greek Girl Dancing,* formerly *Spanish Dancing Girl: Cadiz in the Olden Times* (1867). Oil on canvas. Private collection. Photo © Christie's Images/ Bridgeman Images.

friend, "I point out something of what I mean in my theory of painting."[18] Perhaps the fullest account of that "theory" came in a celebrity interview Whistler gave to a journal called the *World* in the spring of 1878—a piece he included under the provocative title "The Red Rag" when he reprinted it in his scrapbook-like manifesto of 1890, *The Gentle Art of Making Enemies.* Whistler granted the interview while awaiting trial of the libel suit he had brought against Ruskin for defaming one of his *Nocturnes,* and he seized the occasion to offer a spirited defense of the nomenclature for which he had now become notorious.

> Why should I not call my works "symphonies," "arrangements," "harmonies," and "nocturnes"? . . .
>
> The vast majority of English folk cannot and will not consider a picture as a picture, apart from any story which it may be supposed to tell.
>
> My picture of a "Harmony in Grey and Gold" is an illustration of my meaning—a snow scene with a single black figure and a lighted tavern.

14–3. James Abbott McNeill Whistler, *Nocturne: Grey and Gold—Chelsea Snow* (1876). Oil on canvas. Fogg Art Museum, Harvard Art Museums, Cambridge, MA. © Harvard Art Museum/Art Resource, NY.

(In fact, this particular canvas had always been exhibited as a *Nocturne* [fig. 14–3]: Whistler's titles often shifted over time, but in this case he appears simply to have forgotten what he'd decided.)[19] His account of the picture continues:

> I care nothing for the past, present, or future of the black figure, placed there because the black was wanted at that spot. All that I know is that my combination of grey and gold is the basis of the picture. Now this is precisely what my friends cannot grasp.
>
> They say, "Why not call it 'Trotty Veck,' and sell it for a round harmony of golden guineas?"—naïvely acknowledging that, without baptism, there is no. . . . market!
>
> But even commercially this stocking of your shop with the goods of another would be indecent—custom alone has made it dignified. Not even the popularity of Dickens should be invoked to lend an adventitious aid to art of another kind from his. I should hold it a vulgar and meretricious trick to excite people about Trotty Veck when, if they

really could care for pictorial art at all, they would know that the picture should have its own merit, and not depend upon dramatic, or legendary, or local interest.

As music is the poetry of sound, so is painting the poetry of sight, and the subject-matter has nothing to do with harmony of sound or of colour.[20]

Trotty Veck is the impoverished protagonist of Dickens's second Christmas Book, *The Chimes* (1844), and the evidence suggests that some of Whistler's fellow artists did indeed engage in the sort of strategic renaming he thus mockingly repudiates. Among many cases in point, Richard Altick cites a painting of 1848 entitled *The Streets of London—A Female Dombey* that seems to have had no relation at all to the novel that appeared in book form the same year, though it does include an "overdressed" woman whose refusal to help a begging girl could presumably be seen to exemplify the Dombey pride.[21] Calling his own work not "Trotty Veck" but a "Harmony"—or "Nocturne"—in "Grey and Gold," Whistler aggressively disclaims such representational interest. To approach this particular painting through its title is not only to forgo the temptation of narrative—to "care nothing for the past, present, or future of the black figure"—but to overlook its human associations altogether, to understand that the figure belongs here only because "the black was wanted at that spot."

A viewer inclined to resist such rhetoric might wish to protest that the spot in question nonetheless assumes a recognizably human shape. But even when Whistler had evidently devoted far more attention to a figure than this, he liked to pretend that any response to the person represented was irrelevant. Though Algernon Swinburne would praise the first *Arrangement in Grey and Black* (1871) for its "expression of living character," that was in a review so offensive to Whistler that the two men quarreled irrevocably.[22] Despite the subtitle of the painting in question—which was, of course, *Portrait of the Painter's Mother* (fig. 14–4)—the artist insisted that it was only the "arrangement" that should matter to the public. "To me it is interesting as a picture of my mother," he conceded in the interview, "but what can or ought the public to care about the identity of the portrait?"[23] With characteristic insouciance, he said nothing about the fact that his own subtitle had invited that identification in the first place.

This was far from the only occasion on which Whistler might be said to have had it two ways. As Aileen Tsui has shown, a similar disingenuousness had already characterized the marketing of *The White Girl*, even before it became a *Symphony*. Having been rejected by the Royal Academy, the painting

14–4. James Abbott McNeill Whistler, *Arrangement in Grey and Black, No. 1: Portrait of the Painter's Mother* (1871). Oil on canvas. Musée d'Orsay, Paris. Erich Lessing/Art Resource, NY.

was first exhibited at a London gallery in 1862 as *The Woman in White*—a title that would have been familiar to most Victorian viewers at the time from the best-selling sensation novel by Wilkie Collins that had first appeared in serial form three years earlier. Only when an anonymous reviewer complained that the woman in the picture bore no resemblance to her supposed prototype—"The face is well done, but it is not that of Mr. Wilkie Collins's 'Woman in White'"—did the artist respond by firing off the first in what would become a long series of indignant letters to the press. Contending that the proprietors of the gallery had chosen the title without any sanction from him, Whistler claimed to have had "no intention whatsoever of illustrating Mr. Wilkie Collins's novel; it so happens, indeed," he added, "that I have never read it. My painting simply represents a girl dressed in white standing in front of a white curtain."[24] Whistler could play fast and loose with the facts—at the Ruskin trial, for instance, he testified under oath that he had

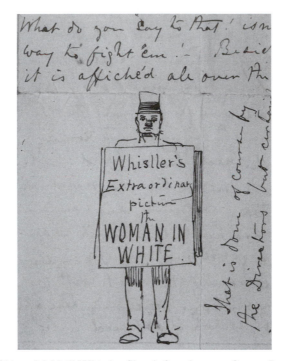

14–5. James Abbott McNeill Whistler, Sketch from letter to George Lucas, 26 June [1862]. Paper and ink. Gift of John F. Kraushaar, 1925.539. Wadsworth Athenaeum, Hartford, CT.

been born in St. Petersburg[25]—but we need not think he was lying about the original intentions of his painting in order to read his letter with skepticism. Even had a representative of the gallery not immediately protested that Whistler was "well aware of his picture being advertised as 'The Woman in White,' and was pleased with the name," the evidence of his own pen condemns him. In a letter to a friend that same summer, the artist reveled in the publicity campaign that the gallery had mounted, and gleefully reported how posters announcing "Whistler's Extraordinary picture the woman in white" were turning up all over London. "This is done of course by the Directors," he added, "but certainly it is waging an open war with the Academy, eh?"[26] A drawing scrawled in the margin of the letter visually punctuates this verbal record of Whistler's complicity (fig. 14–5).

"Not even the popularity of Dickens should be invoked to lend an adventitious aid to art of another kind from his," Whistler might announce sixteen years later, but in publicizing his first major picture, he seems to have been more than ready to call on the popularity of Collins.[27] Nor was this the last

time when the painting would appear under such auspices. Having been rejected by the Paris Salon the following year, just as it had been by the Royal Academy, the picture made its French debut at the Salon des Refusés of 1863 as *La dame blanche*—the title of a popular opera by Adrien Boieldieu and Eugène Scribe that had recently received its thousandth performance. As Tsui notes, the persistent tendency of Parisian viewers, including Courbet himself, to see the figure as an "apparition" may well have had something to do with the ghostly status of its apparent namesake in Boieldieu's opera.[28]

Whistler's readiness to invite such associations was always greater than he pretended. "Without baptism," as he ironically observed in the 1878 interview, "there is no market!"[29] Taken in context, his wicked summary of his friends' advice seems directed at the naming of pictures after persons like "Trotty Veck"—or "the Painter's Mother," for that matter—but as so often with Whistler, the remark invites other readings. Without baptism of some sort, after all, a modern economy in pictures would be almost impossible.[30] Perhaps a face-to-face purchase might proceed with the painting alone; but transactions at a distance would surely suffer without some brief way of referring to the object in question, and so, too, would the participants' record keeping. Certainly advertising, as Whistler knew very well, depends heavily on titles; and he never hesitated to exploit his own choices accordingly. Tsui argues persuasively that the early titles of *The White Girl* served to incite a narrative interest that the work itself then proceeded to frustrate—a bait and switch by which the artist managed to "assert . . . the superiority of his work to the public's vision even while attracting public notice." The fact that he always called the picture *The White Girl* or *La fille blanche* in his private correspondence suggests to her that he conceived of different kinds of titles, depending on his audience, and that he would remain committed to the idea of an art world hopelessly divided between popular taste and the aesthetic ideal on which he prided himself. But Whistler's lifelong "quest to receive the paradoxical modern honours of public incomprehension," as Tsui nicely puts it, is only half the story; and the musical nomenclature that he first adopted with his *Symphony in White, No. III* was not merely a further invitation to bafflement.[31] While there is no doubt that he would continue to market himself as an artist whose very failure to be understood was a sign of his achievement, he would also engage in a relentless campaign to teach the public to see differently. Nothing was more central to that campaign—or a more effective advertisement of the Whistler brand—than the capsule instructions he adopted as titles.

In 1881 the French journalist and art critic Théodore Duret published an article on Whistler that served as both an enthusiastic endorsement of the

painter's work and a brief history of its development. The piece represented Whistler's career to date as a steady progression from the figurative art of *The White Girl* to what it tellingly termed "a sort of abstraction" reminiscent of Wagnerian harmony. By this account, the painter's titles had evolved systematically with his art. Though even *The White Girl* "might have been called an arrangement in white," Duret noted, "no subtitle or special designation as yet drew attention to the combination of colors." But in proportion as the artist continued to paint, "his reflection and judgment on his work develop[ed]," and he began to identify such tonal arrangements in his titles. As Duret told it, Whistler first confined such language to the subtitle, implicitly recognizing the difficulty of rhetorically subordinating the human figure to a canvas it dominated: hence "Portrait of My Mother—Arrangement in Black and Grey" and the identically subtitled portrait of Thomas Carlyle. The next step was to abandon the human form for a decorative scheme whose principal motif was the plumage of a bird—a move that correspondingly freed the artist to reverse the order of his title and call the design "Harmony in Blue and Gold: The Peacock Room." Then "he went still further" and no longer identified the motif at all: "absolutely suppressing any kind of title other than that drawn from the arrangement of colors." Among such works, Duret instanced a "Harmony in Grey and Peach Color," a "Symphony in Blue and Rose," and a "Variations in Blue and Green." Since even many of the works so designated still offered a recognizable figure or landscape, there remained, as the critic saw it, a final step in the process. This was the "Nocturnes"—canvases "repeating the same effects with variants" and differentiated from one another simply by numbers. With these paintings, in which the motif itself is "of no importance," Whistler had reached what Duret termed "the very limit of figurative painting. One step more, and there would be nothing on the canvas but a uniform blot, incapable of saying anything to the eye and to the mind."[32]

Despite the slightly ominous tone of that last remark, Duret clearly cast this narrative as one of progress. Having already written an important history of the impressionists, he would soon incorporate the Whistler piece in a volume entitled *Critique d'avant-garde* (1885)—a term that he was among the first to associate with cutting-edge art.[33] Indeed, so intent was he on articulating the logic of Whistler's development that he significantly smoothed over and rationalized the artist's titling practice, which was far more erratic than he implied. The idea of a subtitle that moved to first place as Whistler turned from portraiture to decoration was a historical fiction: *Arrangement in Grey and Black: Portrait of the Painter's Mother* first appeared as such in 1872— five years before the artist advertised his *Harmony in Blue and Gold: The Pea-*

cock Room.[34] Nor did Whistler arrive only gradually at the practice of suppressing the identity of the motif for a musical title alone: as we have seen, the *Symphony in White, No. III* had been publicly exhibited with that inscription as early as 1867, a full decade before the doubly titled *Peacock Room*. Duret, who had met Whistler through Manet in 1880, seems to have conferred with his subject more than once while working on the article, and it is quite possible that the artist himself contributed to this revisionary narrative. He certainly appreciated the results. "I have never been so thoroughly understood and explained," he wrote to the author when the piece first appeared. "'I am very pleased with myself'!!" As for the book: "what a perfect title—L'Avant Garde!"[35]

Some rearrangement of the facts was always compatible with the dissemination of what Whistler termed his "theory of painting," and Duret had clearly gotten that theory right.[36] To some extent, in fact, the confusions over which canvas had been called what and when came with the territory: precisely because Whistler's titles were meant to evoke recurrent formal patterns rather than to identify particular motifs, they never served very well as a means of discriminating one canvas from another. Duret referred to the numbers that minimally distinguished among the *Nocturnes*, but speaking on the witness stand at the Ruskin trial, the artist himself emphasized the collective title that invited viewers to recognize the group: "Among my works are some night pieces, and I have chosen the word 'nocturne' because it generalizes and simplifies the whole set of them."[37] He produced a related effect by adapting his musical nomenclature to designate not just individual works but entire settings, as when he publicized his redecoration of Frederick Leyland's dining room by distributing a leaflet to the press that entitled the whole a *Harmony in Blue and Gold*, or began to install and advertise exhibitions of his work by their color schemes: *Arrangement in White and Yellow* for a show of etchings in 1883; *Arrangement in Flesh Colour and Grey* for an exhibit of oils, pastels, and watercolors the following year. The yellows and whites on the former occasion even extended to the catalogue-seller, a figure described in one press account as "habited in the tints of a poached egg."[38]

Whistler's titles certainly drew their share of resistance and mockery. Critics routinely dismissed them as eccentric or pretentious. "Such works have interest if presented as what they are, mere tone studies," one allowed, but "without the pretension implied in peculiar names and frames."[39] Another complained of "those grimly-satirical 'arrangements' that have so often disarranged the thoughts of unprepared spectators," before going on to inquire facetiously: "For if music may be made tributary to painting, why not rhetoric, cookery, and perfumery as well?"[40] Reviewing an exhibit at the Grosvenor

Gallery in 1878, the critic for the *Times* likewise remarked with irony on two of Whistler's "vaporous full lengths . . . which it pleases him to call 'arrangements' in blue and green, and white and black, as if the colour of the dress imported more than the face; and as if young ladies had no right to feel aggrieved at being converted into 'arrangements.'"[41] The *Examiner* that same year was still more dismissive of these "strangely-named examples of paint-splashing and scraping": "A musician is not elevated in his art by being called a tone-poet, nor is a picture improved in value when it is termed a 'Harmony in Blue,' a 'Symphony in Red,' or a 'Polka-Mazurka in Tartan Plaid.'"[42]

The titles were easy to parody, and skeptical commentators took full advantage of the fact. The opposing attorney at the Ruskin trial elicited laughter from the audience by postulating a "'Moonlight in E Minor' or a 'Chiaroscuro in Four Flats.'"[43] The satirists at *Punch*, who made Whistler a frequent target, produced "A Gruesomeness in Grey" and "An Arrangement in 'Fiddle-de-dee'"—this last a cartoon by Linley Sambourne that managed to send up the artist's musical analogies and women's fashion simultaneously (fig. 14–6).[44] The close of the Ruskin trial—at which Whistler was awarded a derisory one farthing in damages—prompted a rash of satirical commentary, including "A Derangement after Whistler" from a journal called *Funny Folks* and a witty cartoon by Alfred Bryan entitled *Mr. J. Whistler: An Arrangement in Done-Brown*, in which the artist is shown painting a record of his damages onto a murky canvas (fig. 14–7), presumably the *Arrangement in Brown* that had been among the paintings subpoenaed by the court.[45] The *Funny Folks* "Derangement" spun out further variations on the theme, from a "Diurne in Rose Madder" to a "Pizzicato in Pea Green."[46] Indeed, the very fact that words travel more readily than paintings meant that Whistler's idiosyncratic nomenclature was being similarly mocked in his native land before all but a handful of the works themselves had crossed the Atlantic. So one American critic remarked of a painting by Homer D. Martin in 1879, for example, that it "might, perhaps, have been more opportunely termed a symphony in pea green, raw umber, and white."[47]

Walter Hamilton, who published the first general guide to British aestheticism in 1882, thought the "eccentric affectation" of Whistler's titles "brought down upon him more ridicule than all the adverse opinions of the critics would have done."[48] Perhaps Hamilton was right. Yet Whistler's reception was by no means as uniformly hostile as the artist himself liked to pretend, and among all the ridicule there was also considerable testimony to the effectiveness of his titles' instructions for viewing. As early as the *Symphony in White, No. III*, Catherine Goebel has shown, British reviewers responded to Whistler's title in terms that the painter himself could hardly

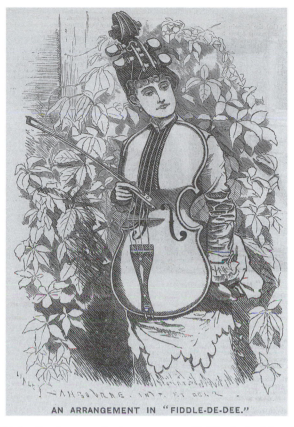

AN ARRANGEMENT IN "FIDDLE-DE-DEE."

14–6. Edward Linley Sambourne, *An Arrangement in "Fiddle-de-dee," from Punch, Or the London Charivari*, no. 73 (1877). Wood engraving. Yale Center for British Art, Paul Mellon Collection.

have faulted.[49] Thus the *Athenaeum*, for instance, pronounced it "clearly the duty of a painter to get himself understood," while articulating with some precision how Whistler had managed to do so:

> [T]his artist calls his beautiful study in grades of white, pale rose tints, and grey, *Symphony in White, No. 3* . . . and, by borrowing a musical phrase, doubtless casts reflected light upon former studies or "symphonies" of the same kind. . . . there can be nothing but thanks due to a painter who endeavours by any means to show what he really aims at, and to get observers to understand that he produces pictures for the sake of ineffable Art itself, not as mere illustrations of "subjects," or the previous conceptions of other minds. We cannot define the hues of Mr.

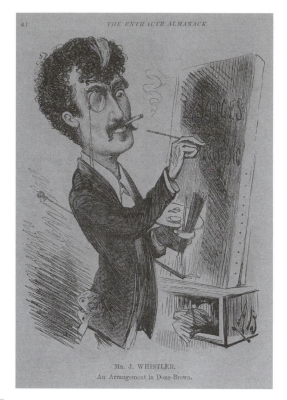

14–7. Alfred Bryan, *Mr. J. Whistler: An Arrangement in Done-Brown*, from *The Entr'acte and Limelight Almanack* (1879). Woodcut engraving. Courtesy, University of Pennsylvania Library.

Whistler's "symphony," and so must limit our notice here to thanks for their beauty, wealth, and melodious combining.[50]

The *Illustrated London News* likewise took the title to indicate that "the artist's primary aim is colour" and that "in favour of this quality, the painter proposes to attain abstract art, as exclusively addressed to the eye as a symphony independent of words is addressed to the ear."[51]

The same critic, who went on to remark the picture's "beautiful chromatic harmonies of whites and greys," also felt compelled to protest the limits of the titular analogy, arguing that Whistler's conception of art threatened to deprive painting of "means . . . for reaching the mind and heart" that were not available to music.[52] But writers need not always endorse the titles' formalism, after all, in order to help disseminate it. Even Tom Taylor, the critic for the *Times* whose disparaging comments on some "Arrangements" I have al-

ready quoted—and who would follow them up later that year by testifying for the defense at the Ruskin trial—did his part to pass on the artist's teaching. In a remarkably sympathetic review of Whistler's contributions to an exhibit at the Dudley Gallery in 1871, Taylor explained how the paintings in question, a *Variations in Violet and Green* and a *Harmony in Blue-Green—Moonlight,*

> are illustrations of the theory, not confined to this painter, but most conspicuously and ably worked out by him, that painting is so closely akin to music that the colours of the one may and should be used, like the ordered sounds of the other, as means and influences of vague emotion; that painting should not aim at expressing dramatic emotions, depicting incidents of history, or recording facts of nature, but should be content with moulding our moods and stirring our imaginations, by subtle combinations of colour, through which all that painting has to say to us can be said, and beyond which painting has no valuable or true speech whatever.[53]

That this *Harmony in Blue-Green* would resurface in London eight years later as a *Nocturne* (plate 11) is the kind of detail that poses a constant challenge to Whistler's cataloguers, but does little to alter what the artist and critic alike called his "theory." (The change in color designation followed soon thereafter.)[54] The titles did their work less by specifying the character of a particular image than by arguing for a way of looking, and there is abundant evidence that the argument had its impact. As the critic for the *Art-Journal* summarized the lesson of those titles in 1874: "They assert ... that a picture, whatever its subject, must make its appeal to the eye.... A picture should, before all things, be a beautiful scheme and design, both of lines and colour; and unless these qualities are secured, it is of very little consequence what text the painter chooses to illustrate."[55]

The German painter Otto Scholderer may have been exaggerating when he reported from London in 1876 that "harmonies, symphonies, à la Whistler are all the rage at the moment" and "every imbecile talks about harmonies, colors, symphonies in white or other colors," but he was also testifying to a genuine phenomenon.[56] So thoroughly did Whistler's titular idiom seep into popular consciousness that it could be adopted for ends far removed from its own—as when an anonymous author produced "An Aesthetic Valentine (*A la* Whistler)" for a journal called *Moonshine* in February of 1888, whose brief narrative of an impecunious suitor and his successful courtship offered six jokey variations on the theme, including a prospective father-in-

law who "was a 'harmony in gold,' / When prospering in the city," and a convenient aunt who "Died, with 'arrangements black and white,' / Which suited me completely."[57] Though Whistler would continue to represent himself as an embattled outsider—going so far as to suppress the favorable remarks of his critics when he reprinted extracts from their reviews in his one-man catalogues and *The Gentle Art of Making Enemies*—even that self-representation may have had the paradoxical effect of increasing his impact, not just by surrounding him with the buzz of scandal but by so exaggerating the hostility of his reception that viewers were compelled to distance themselves from such "drivel."[58]

What Whistler could not manage to do, in the end, was simply to bypass language altogether. "Let work, then, be received in silence," he announced in his first published commentary on the Ruskin trial; but it would hardly require an Oscar Wilde to register the paradox that Whistler himself never ceased speaking. The same piece invokes "art, that for ages has hewn its own history in marble, and written its own comments on canvas"—by which he presumably did not mean the sort of "comment" he had painted in the corner of a canvas when he first inscribed the title of his *Symphony in White, No. III* a decade earlier.[59] Nor did he mean the sort he would later issue when he published a transcript of the trial—artfully cut and edited to highlight his own performance—as an introduction to *The Gentle Art of Making Enemies*.[60] The author of that book, said Max Beerbohm, was "a born writer," and if that is a strange compliment for someone who professed himself at war with the pen, Beerbohm was nonetheless surely right to emphasize the stylistic panache with which Whistler conducted his campaign in print.[61] Whistler may have reached for musical analogies rather than literary ones in order to subordinate his art's subject matter to its formal arrangements, but few artists, then or since, have been more aggressively engaged in the business of titling images.

And despite his professions to the contrary, that business still entailed middlemen. Not only did Whistler depend on the press, including its more hostile members, to publish and circulate his titles, but his very names for pictorial autonomy owed far more to the language of others than he ever let on. "It would be beyond me to agree with the critics," he quipped on the witness stand;[62] yet the first person to call one of his works "a symphony" was not Whistler himself but a critic. The work at issue was the one he had originally advertised as *The Woman in White*, and the occasion of its musical baptism was a French review of its 1863 appearance in Paris, where it was then going by the name of *La dame blanche*. "The American artist has perhaps been wrong to strew the carpet on which his charming phantom treads with blue

tones," Paul Mantz wrote in the *Gazette des beaux-arts*: "there he is straying from his principle, and almost from his subject, which is none other than the symphony of white."[63] Nor was Mantz being particularly original in proposing this analogy. From Baudelaire and Gautier to Swinburne and Pater, comparisons among the arts were very much in the air at midcentury. By 1851 the trope was sufficiently commonplace to show up as an imaginary musician's "symphonie sur *l'influence du bleu dans les arts*" in Henry Murger's *Scènes de la bohême*. Gautier's own "Symphonie en blanc majeur" appeared in a collection of poems published in 1852, while Baudelaire's "Correspondances"—in which "perfumes, colors, and sounds answer each other"—dates from 1857.[64] Manet's future biographer, Antonin Proust, recalled walking with the artist near a Paris demolition site a few years later, when he paused to admire the vision of some workers posed against a white wall and appearing whiter still from the dust of its collapse: "'There you are,' he exclaimed, 'the Symphony in White Major, which Théophile Gautier speaks about.'"[65]

Mantz was not the only member of the public to adopt this musical language for Whistler's pictures in advance of the artist himself. As Catherine Goebel has shown, terms like "harmony," "arrangement," "capriccio"—or their French equivalents—appear repeatedly in early reviews of his work, several years before his *Two Little White Girls* officially became a *Symphony*.[66] And well after that moment, the two-way traffic between artist and beholder continued. Even a patron got into the act—and this despite Whistler's subsequent claim that "the period of the patron ha[d] utterly passed away."[67] It was Frederick Leyland—the wealthy Liverpool shipowner who would later commission the Peacock Room, and who happened also to be a dedicated pianist—who first suggested that Whistler call his night pieces "Nocturnes." "I can't thank you too much for the name 'Nocturne' as a title for my moonlights!" the artist wrote in reply, though he couldn't help adding, characteristically, "You have no idea what an irritation it proves to the critics and consequent pleasure to me."[68]

As we have already seen, such post hoc negotiation over a title is scarcely unusual in the modern art world. Even in an age of artistic authorship, many painters continue to invite—or at least tacitly accede to—the interventions of middlemen. Other famous paintings of the decade during which Whistler was working out his titling system likewise acquired their names from the critics. The same Salon des Refusés at which Whistler displayed his *Dame blanche* included a controversial painting by Manet that was listed in the catalogue as *Le bain* but is better known today as *Le déjeuner sur l'herbe* (1862–63)—a title apparently first recorded by the critic Ernest Chesneau in a book of the following year. (It is Chesneau, incidentally, who would later provide

the disapproving account of how Whistler tried to get his paintings identified by their musical titles at the Durand-Ruel gallery in 1873.) By the time that Manet reexhibited the canvas in 1867, it had become *Le déjeuner sur l'herbe*, just as Monet would similarly acquiesce when Thoré-Bürger turned his 1866 *Camille* into *La femme en robe verte*.[69] What distinguishes Whistler's practice from these and similar instances is not his reliance on others but his strenuous insistence that his was, in fact, an act of authorship. When an American newspaper reported that the *Symphony in White* and other titles had been casually suggested to him by one of his "boon companions," he immediately drafted a letter protesting the claim: "These titles ..., if 'poor things,' are 'mine own.'"[70]

There was a measure of truth in another letter's boastful allusion to "the whole system of arrangements and harmonies which I most certainly invented";[71] but only if one places the accent on "system," and understands by that term less a fully coherent and stable arrangement than an evolving, if relentlessly advertised, mode of classification.[72] From that perspective, Whistler's aggressive publicizing of his system over the last decades of the nineteenth century surely helped to prepare the public for the still greater formalism of the century to come. By insisting that viewers look to painting not for recognizable figures but for rhythmic patterns of color and tone, Whistler's titles made works like Piet Mondrian's *Composition 10 in Black and White* (1915) or Kazimir Malevich's *Suprematist Composition: White on White* (1918) more immediately comprehensible—easier to grasp, if not necessarily to like, than those whose verbal instructions appeared to contravene the evidence of the viewer's own eyes (fig. 14–8). While there remains a faint musical overtone in *Composition*, other such titles over the course of the twentieth century would do away with the analogy altogether: think of the numerous variants, for example, on the word *Construction*, or canvases whose titles defiantly announce their own medium, like Wassily Kandinsky's *Painting with White Border* of 1913, or Gerhard Richter's slightly more informative *Abstract Painting*—this last a title Richter has used repeatedly over the decades, distinguishing one version from another by the accompanying numbers.[73]

Yet as Kirk Varnedoe observes in his own aptly titled *Pictures of Nothing* (2006), "the 'abstractness' of abstraction" is difficult to enforce, and "almost as fast as artists can open blank slates, others hasten to inscribe something on them." The specific context for Varnedoe's remark is the way viewers and critics immediately began to characterize the minimal sculptures of Donald Judd, routinely referring to one untitled object as the "Letter Box," for example, or nicknaming others "The Harp" and "The Lifeboat."[74] The need to make sense of our visual experience is a powerful one, and locating a familiar

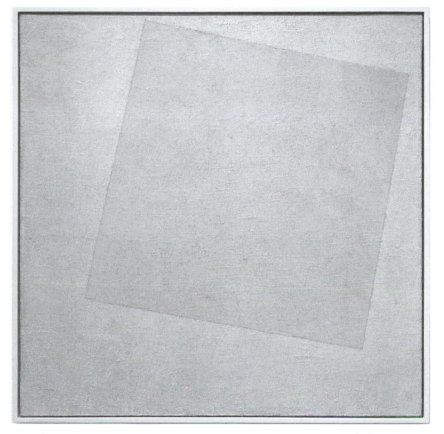

14–8. Kazimir Malevich, *Suprematist Composition: White on White* (1918). Oil on canvas. Museum of Modern Art, New York. Digital Image © The Museum of Modern Art/Licensed by SCALA/Art Resource, NY.

form in a work that appears to resist that effort can be oddly comforting. Varnedoe doesn't refer to the added challenge of conjuring up such works in the absence of visual reproduction, but that is clearly another factor in this game of associative retitling. According to his first biographers, Whistler himself took to providing little sketches for printed notices of his work, "as an aid to ... identification ... where his titles failed."[75] Naming a canvas for a recognizable image is an undeniable aid to memory.

In Whistler's case, of course, the painter had already supplied his viewers with enough representational cues to make such naming comparatively easy—even had he himself not continued to subtitle many of his pictures by the person or scene that inspired them. "Imagine a picture becoming known

as 'Whistler's Mother' if you were Whistler," Lee Krasner worried, as she contemplated the public's habit of substituting its own imprecise labels for the painter's.[76] The history of this particular painting's reappropriation as a sentimental icon—including its dramatic tour of the United States in the 1930s, with headlines reading "WHISTLER'S 'MOTHER' COMES HOME AGAIN," and its adoption as a postage stamp to commemorate Mother's Day—has been well told by others.[77] But it is not only the vulgar masses who ended up referring in this way to the artist's first *Arrangement in Grey and Black*. Whistler's first biographers approached his theories with reverence, but they routinely alluded to "the *Mother*" and called the second such *Arrangement* "the *Carlyle*."[78] Nor was it only paintings of the human form that were thus subject to rebaptism, though there are obvious reasons why portraits should be prime candidates. The artist went to law to defend the honor of a *Nocturne in Black and Gold* (see plate 4), but his biographers had a difficult time telling the story without repeatedly alluding to *The Falling Rocket*.[79]

By a process that I like to call "designatory drift," the title of any representation, however abstract, is similarly vulnerable. Indeed, even the titles of wholly nonrepresentational works are subject to a related rule, as when scholars and critics speak of "Malevich's *White on White*" rather than his *Suprematist Composition*, for example, or someone adds the parenthetical descriptor *Disc* to an untitled painting on aluminum by the contemporary American artist Robert Irwin.[80] The need to keep track of paintings and recall them does not always coincide with the artist's wish to direct how the viewer sees. In the privacy of his own letters Whistler, too, routinely referred to "the portrait"—or "picture"—of "my mother."[81] Titles, as he always knew, were for instructing others.

Like Whistler, René Magritte took the question of titles very seriously. Yet he, too, vehemently denied that his work was "literary." "If there exists a non-literary, and even antiliterary painting," he told a Flemish interviewer in 1962, "that's exactly what I try to create. Indeed, my painting expresses neither ideas nor sentiments. I leave that concern to writers." He was equally insistent that his work should not be construed as the illustration of a preexisting text. "'Illustration,'" as he put it in a letter of 1959, "is a word it is necessary to abolish."[1] What, then, is the use of words according to Magritte?

We may begin to answer this question by looking at the first of the paintings he chose to call just that: an image of 1928 entitled *L'usage de la parole* (plate 12). The lower half of the canvas shows two male profiles face-to-face against a flat dark ground, each supplied with a cartoon-like word bubble. Above their heads floats a blue sky with clouds, framed in a rectangle equal in size and shape to the banded rectangle below. The men have tentatively been identified as Magritte himself (on the right) and his fellow surrealist André Breton, and the apparently random words they are reciting—one says "the piano," the other, "the violet"—have suggested to informed commentators that they are playing a word-association game of the sort popular among surrealists at the time. (Though Magritte's relations with surrealism in general and Breton in particular would later be fraught, the artist was then working in Breton's circle in Paris.) The catalogue raisonné, which translates the title as *The Use of Speech*, reminds us that the surrealists borrowed such word associations from psychoanalysis.[2] But Magritte—whose lifelong hostility to psychoanalysis was among his principal differences with the French surrealists—was unlikely to have had any psychoanalytic uses in mind when he painted this particular word picture.[3]

Less has been said about the upper half of the canvas, which appears at first glance to be a window. Focus on its frame-like border, however, and es-

pecially on the placement of the artist's signature, and the open window turns into a painting-within-the-painting. Magritte would of course frequently exploit a related ambiguity—one of the best-known instances being the *Condition humaine* of 1933 that we have already seen (fig. 13–7). But unlike that work and a number of its variants, which allow us to see window and painting simultaneously, this *Usage de la parole* forces us to choose, if only for the moment, between them; and here I would like to suggest that we opt for the painting-within-the-painting. The fact that Magritte would go on to produce several works that closely resemble this imaginary canvas may help with the exercise (plate 13). So, too, will the fact that all the versions of such sky painting are enigmatically titled *La malédiction* (*The Curse*)—a phrase that scarcely bears a more obvious relation to the images it designates than would "The Piano" or "The Violet." Rather than a game of free association played beneath an open window, in other words, I propose that we think of the figures in this *Usage de la parole* as engaged in Magritte's kind of picture titling.

This scenario is less far-fetched than it may seem. Like the painting-within-the-painting, which would appear to have been completed before the figures began spinning out possible words to accompany it, Magritte's pictures almost always preceded their titles: the true painter, he insisted, thinks in images rather than language, and only "*après* que l'image est peinte, on peut penser à des rapports qu'elle aurait avec des idées ou des paroles" (*after the image is painted, one can think of the affinities it will have with ideas or words*).[4] The fact that more than one person is involved also accords with the practice of the artist, who often enlisted his friends and fellow surrealists in the business of "finding"—the term Magritte used repeatedly—an appropriate name for the image. David Sylvester estimates that of the artist's 700 titles (distributed among some 1,800 works), nearly half were supplied by other people. (At approximately 170, the poet Louis Scutenaire tops the list, which also includes, inter alia, Paul Éluard and Breton himself.)[5] Nor is the seeming arbitrariness of the titles being proposed in this scenario a barrier to the analogy. As I have already begun to suggest, the very gap between word and image in a Magritte title is as likely to puzzle the casual viewer as to enlighten her. There are no works called "Le Piano" or "La Violette" in the artist's oeuvre, but there is one called *Le chant de la violette* (*The Song of the Violet*), whose stony, bowler-hatted men in their petrified landscape could scarcely appear less musical or flower-like (fig. 15–1).

Two other paintings of 1928, also called *L'usage de la parole*, reduce the mystery of naming to a schematic abstraction. The speakers have disappeared, leaving a pair of handwritten words—in the version reproduced here, these are "miroir" and "corps de femme" (fig. 15–2)—linked by straight lines to the

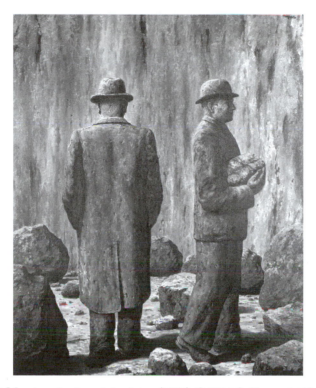

15–1. René Magritte, *Le chant de la violette* (1951). © 2014 C. Herscovici/Artists Rights Society (ARS), New York. Oil on canvas. Private collection. Banque d'Images, ADAGP/Art Resource, NY.

nebulous forms they appear to identify. (In the companion picture the words are "le vent" and "la Normandie.")[6] According to the catalogue raisonné, these works continue the game of word association without the players—an account that has some warrant in the obvious relation between each pair of words, though it fails to explain how speakers who might understandably associate a mirror with the body of a woman or the wind with Normandy would likewise connect a piano with a violet.[7] But *parole* is itself a capacious and flexible term, and Magritte's own usage elsewhere suggests that he had little interest in worrying the distinction between speech and writing.[8] The relation that did obsess him was that between words—typically, in fact, written words, even when they served to represent speech—and images.

All three versions of *L'usage de la parole* belong to a series of pictures first painted between 1927 and 1930, but re-created throughout his career, in which Magritte played with the relations between verbal and visual signs. The first of these, called *La clef des songes* or *The Key of Dreams*—a trans-

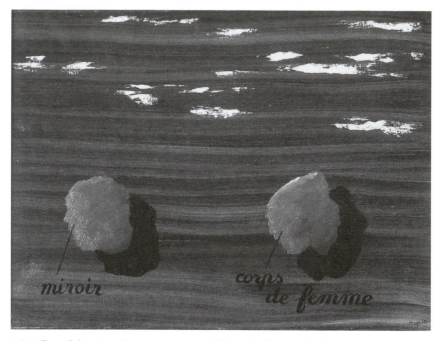

15–2. René Magritte, *L'usage de la parole* (6) (1928). © 2014 C. Herscovici/Artists Rights Society (ARS), New York. Oil on canvas. Banque d'Images, ADAGP/Art Resource, NY.

lation I prefer to the standard but Freudian-sounding "Interpretation" of Dreams—has aptly been compared to "a school reading primer gone wrong" (fig. 15–3).[9] Four panels, divided by illusionistic frames, show four ordinary objects accompanied by their labels, only one of which ("the sponge") conventionally corresponds to the image it names. Other versions of the painting vary the objects and words, or do away with the conventional correspondence altogether. If the function of a children's primer—or an illustrated dictionary like *Larousse*, from which many of the artist's familiar images have been shown to derive[10]—is to instruct readers in the conventional uses of language, then Magritte's *Key* seeks to unsettle that education.

Perhaps the most thoroughgoing of such Magrittean primers is a piece that appeared in a journal called *La révolution surréaliste* in the winter of 1929. Entitled "Les mots et les images," it has been called "virtually an instruction manual for the word-and-image paintings that appeared between 1927 and 1929," though whether it was meant as a summary of that work or a program remains unclear, since drafts of the piece go back to the first *Key* two years earlier.[11] The manual consists of a sequence of sketches, most of which com-

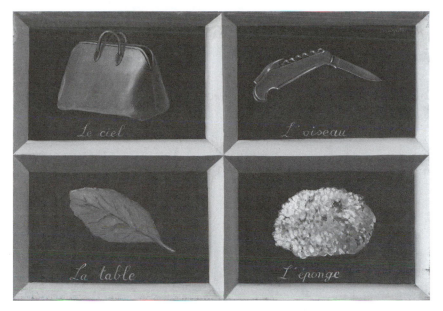

15–3. René Magritte, *La clef des songes* (1927). © 2014 C. Herscovici/Artists Rights Society (ARS), New York. Oil on canvas. Pinkothek der Moderne, Bayerische Staatsgemaeldesammlungen, Munich. bpk, Berlin/Art Resource, NY.

bine drawing and writing, accompanied by printed captions that spin out various permutations on the theme (fig. 15–4). Four amorphous shapes in the upper right-hand corner, each labeled "le soleil," demonstrate the principle implicit in the later versions of *L'usage de la parole*: "Any form whatsoever can replace the image of an object." A pair of seemingly identical house sketches in the second column—one labeled "the real object" and the other "the represented object"—wittily serves to illustrate the paradox advanced by *La trahison des images*: "Everything," says the deadpan caption: "serves to persuade us that there is little relation between an object and that which represents it." Another drawing in the right-hand column shows a horse, a painting of a horse, and a man speaking the word "horse"—the whole accompanied by the observation "An object never has the same function as its name or its image." The aphorism anticipates how Magritte later would gloss the implications of his "famous pipe" by remarking, "Can you stuff it, my pipe? No, surely, it's only a representation."[12] Like the paired houses, the horse sequence ostensibly illustrates the difference between a thing and its sign, even as it self-consciously depends on another sign to drive home the argument.

Magritte's interest in the arbitrary character of the sign has understandably prompted comparisons to Ferdinand de Saussure's *Cours de linguistique*

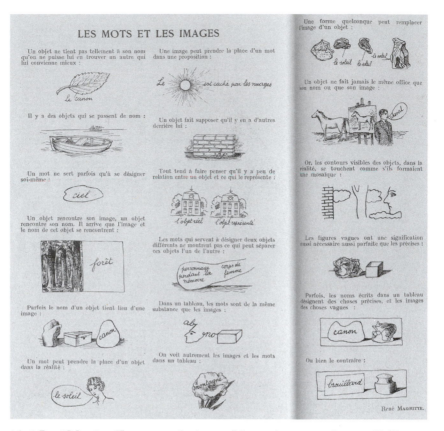

15–4. René Magritte, "Les mots et les images," *La révolution surréaliste*, no. 12 (December 1929). © ARS. Beinecke Rare Book and Manuscript Library, Yale University.

générale (1916), as well as to the contemporaneous language games of Ludwig Wittgenstein.[13] Though it is not clear whether he read either one, there is no doubt that he saw his own work, too, as a form of thinking. "L'art de peindre est un art de penser," he announced flatly: "The art of painting is an art of thinking."[14] "For me," he went so far as to declare on another occasion, "it's not a question of painting, but of thought!"[15] More than once he even suggested that he might just as well have expressed such thought with a pen as with the brush[16]—a position, of course, that would have struck Whistler as anathema. Yet words for Magritte always remained an adjunct to images; and when it came to the problem of titling his pictures, the author of "Les mots et les images" was most concerned with the first of its propositions: "An object doesn't so adhere to its name that one can't find it another that will suit it better." Whether face-to-face, as in *L'usage de la parole*, or by correspondence,

finding the best names for his pictures was an exacting business; and recognizing the potential arbitrariness of the sign was in no way a license to approach that work casually.

Nor did Magritte's deliberate cultivation of naming after the fact really amount to a relinquishment of authorship. The lawyer Harry Torczyner, who acted as his American agent in the last decade of his life, likens the face-to-face gatherings to the baptism of a newborn child, while making clear that the artist reserved the final decision for himself.[17] Sometimes he would propose a provisional title and ask a friend to come up with a better one; sometimes several correspondents would be queried at once, so that he might entertain a series of possibilities in order to arrive at the right formula. A painting eventually called *La clef de verre* (*The Glass Key*, 1959) seems to have gone through at least sixteen titles—and several rounds of letters—before acquiring its final name.[18] According to Sylvester, the backs of canvases frequently testify to such protracted deliberations, with canceled inscriptions and new titles added "sometimes long after the work was first shown or published."[19] No verbal detail, however small, seems to have escaped the artist's notice. A letter of 1959 tentatively advances "Le clair de lune de midi" ("The Moonlight of Noon") as "more precise" than "Un clair de lune à midi" ("A Moonlight at Noon"), while dismissing this solution on the grounds of the repeated "de"—an echo that "would not fail to disturb the attentive reader." (He was seeking a new title for a large version of the 1938 painting originally called *Bel canto*.)[20] He could be equally fussy about adhering to the precise wording once a title was settled. "The title of the picture in the Museum, if it is the one showing sleigh bells in the sky, is not 'La Voix du Vent' [The Voice of the Wind] but 'La Voix des Airs' [The Voice of the Airs]," Magritte wrote to Torcyzner in 1964: "I would appreciate your rectifying this stupid error. As for 'Le Portrait,' that is the exact title."[21] Two years later an interviewer for *Life* magazine translated his comments on the naming of a work called *The Masterpiece*: "As I always do, I worked very hard for this title. I'm very exigeant [*sic*] about titles."[22]

Unlike Whistler's titles, Magritte's never refer to the formal character of his art. With a few notable exceptions—a series of paintings called *Le modèle rouge* (*The Red Model*), for example, and another called *La race blanche* (*The White Race*)—even color words are conspicuous by their absence. Much to the frustration of some of his critics, Magritte professed himself virtually indifferent to his medium.[23] The artist's technique is of little interest, he contended, nor was anything to be gained by seeing a work in the original: a reproduction would do just as well.[24] (His own most influential encounter with a painting, Giorgio de Chirico's *The Song of Love* [1914], had come through a

black-and-white photograph.)[25] Magritte's disdain for the material basis of his art—he once compared it to the writer's ink[26]—accords with his idea of himself as a thinker as much as a painter. It also helps to explain his readiness to turn out copies of his work for the market, another practice that has sometimes troubled his commentators. Writers, after all, do not customarily worry about printing more than one copy of a manuscript; and throughout his working life, Magritte's closest friends were poets and writers, not other painters. They in turn essentially took him for a fellow poet who happened to work with images.[27]

As Didier Ottinger has shrewdly noted, Magritte's attitude toward his work looks both backward and forward simultaneously—at once recalling a time when artistic genius was identified more with invention than with mechanical skill and anticipating the development of conceptual art.[28] The affinity with conceptualism in particular has been a recurrent note in recent commentary on the artist.[29] But for all his valuing of thought over execution, Magritte himself continued to insist that his was not an art of "ideas"—a term he seems to have associated instead with allegory. ("It is certain that paintings which represent ideas, justice for example, don't move us," he wrote at one point.)[30] "Pensée" in his lexicon meant something closer to the mind's encounter with the mystery of things than it did to verbalizable thought; and a good title was one that intensified the effect of the image without pretending to explain it. "The title of a painting is an image made with words," he told an interviewer in 1959. "It combines with a painted image without wanting to satisfy any need to have ideas. The title and painting enrich and specify a way of thinking [*la pensée*] that delights in images whose meaning is unknown."[31]

Magritte's way with titles, in fact, was not really that different from his way with images. In both cases, he sought to take familiar signs and render them strange, so as to disrupt accustomed habits of seeing and thinking. In both cases, too, he spoke of the power to "surprise and enchant"—a power he identified with "poetry."[32] Just as the paintings create their defamiliarizing effects less by distorting conventional forms than by combining them in unexpected ways, so the titles typically consist of comparatively simple phrases whose capacity to "surprise and enchant" depends in turn on their association with the painting.[33] Sometimes, indeed, it is only the association of image and title that produces this characteristic effect, as in the several versions of *La malédiction*—canvases that apart from their titles serve perfectly to illustrate what Magritte meant when he referred to his "banal, academic" style of painting. (Elsewhere he spoke of his "style universel" and offered as an example his habit of using a clear blue to represent the sky, rather than seizing

15–5. René Magritte, *La leçon de politesse* (1957). © 2014 C. Herscovici/Artists Rights Society (ARS), New York. Oil on canvas. Private collection. Art Resource, NY.

the occasion to indulge his personal preferences for distinctive shades of blue and gray.)[34] At other times, the strange conjunction of ordinary forms on the canvas is doubled by the addition of a title that, like the forms depicted, would seem ordinary enough by itself. "To name the image of a tree 'Tree' is an error, a 'mistaken identity,'" the artist characteristically wrote to a friend in 1959, "since the image of a tree is surely not a tree. The image is distinct from what it shows."[35] But to give such a representation another kind of name—to call the painting of a rock and a tree, for example, *La leçon de politesse*, or *The Etiquette Lesson* (fig. 15–5)—was to do more than acknowledge that the image of a thing is not the thing itself. It was also to produce the kind of "mystery" that Magritte again and again declared the aim of his art. "What are the connections between the title and the subject of your pictures?" an interviewer inquired in 1962. To which the artist responded: "The title has the same connection with the painted figures as the figures have among themselves. The figures are brought together in an order that evokes mystery. The title is brought together with the painted image according to the same order."[36]

Magritte strenuously resisted attempts to interpret his pictures or to find symbols in them, and he appears to have chosen his titles accordingly. "Generally, the relationship of his title to his image is beyond explanation," David Sylvester says flatly; and as the editor of the five-volume catalogue raisonné he would have had ample opportunity to ponder the question.[37] The artist's

15–6. René Magritte, *La cascade* (1961). © 2014 C. Herscovici/Artists Rights Society (ARS), New York. Oil on canvas. Private collection. Banque d'Images, ADAGP/Art Resource, NY.

occasional glosses on his titles do little to dispel the impression that only co-terie knowledge could provide the link between word and image. Consider the picture called *La cascade*, or *The Waterfall* (fig. 15–6). A variant of the painting-within-the-painting, it depicts a canvas representing a bank of leafy trees, propped on an easel surrounded by what appears to be the very same foliage. According to its creator, it is "the description of an inspired thought," and "the title *The Waterfall* suggests that this inspired thought gushed forth like a waterfall."[38]

The relation between title and picture can be just as improbable when the title in question supposedly invokes the viewer's response rather than the art-ist's inspiration. A gouache of 1947 (the image exists in several versions) shows a large stone surrounded by grass and foliage and what appear to be the ruins of a column, with another fallen stone in the foreground. The cen-tral stone is inscribed "A N 1920370," as if it were perhaps the tombstone of an unknown person in some impossible future; and the whole is entitled *Le sourire*, or *The Smile*—a title that "is neither gratuitous nor arbitrary," Mag-

15–7. René Magritte, *Golconde* (1953). © 2014 C. Herscovici/Artists Rights Society (ARS), New York. Oil on canvas. Menil Collection, Houston, TX. Banque d'Images, ADAGP/Art Resource, NY.

ritte explained, since "the painting, because of what it evokes, makes the spectator smile and the title finds its justification."[39] Nor does a traceable allusion in a title necessarily make its meaning clearer. Even a viewer who knew that Golconda was an ancient Indian city famous for its diamonds would have difficulty in grasping its relevance to Magritte's painting of that title (fig. 15–7), with its replicating figures of bowler-hatted men suspended in the air above some anonymous urban buildings. "As for the title," said the artist: "Golconda was an Indian city of riches, something of a marvel. I think it is a marvel to travel through the sky on the earth."[40]

One would be tempted to find such explanations merely mischievous, were it not for the evidence that these were just the kind of links between image and title that Magritte articulated for himself. The history of a painting called, with marvelous irrelevance, *Les vacances de Hegel* (*Hegel's Holiday*) may provide a final example of the process (plate 14). This is a work that is unusually well documented, with three separate letters describing its conception.[41] The first two of these report on the painting soon after its completion

in the spring of 1958, and while their wording is somewhat different, both trace the same trajectory: a work that began with a glass of water ended in the imagined amusement of the nineteenth-century philosopher. Along the way, they also offer a glimpse of Magritte thinking his way through his characteristic art of juxtaposition, so as to arrive at one of those works Max Ernst memorably termed "collages painted entirely by hand."[42] Here's how Magritte told the story to the artist and critic Suzi Gablik:

> My latest painting began with the question: how to show a glass of water in a painting in such a way that it would not be indifferent? Or whimsical, or arbitrary, or weak—but, allow us to use the word, with genius? (Without false modesty.) I began by drawing many glasses of water, always with a linear mark on the glass. This line, after the 100th or 150th drawing, widened out and finally took the form of an umbrella. The umbrella was then put into the glass, and to conclude, underneath the glass. Which is the exact solution to the initial question: how to paint a glass of water with genius. I then thought that Hegel (another genius) would have been very sensitive to this object which has two opposing functions: at the same time not to admit any water (repelling it) and to admit it (containing it). He would have been delighted, I think, or amused (as on a vacation) and I call the painting *Hegel's Holiday*.[43]

Though the contemporaneous letter to the painter Maurice Rapin drops the allusions to "genius," it makes the same leap from the opposing (dialectical?) activities implied by the picture to the imagined amusement of Hegel and thence to the analogy with holiday making.[44]

According to the catalogue raisonné, the title of *Hegel's Holiday* was actually "found" by the poet Louis Scutenaire, but Magritte's failure to mention the fact in these letters seems less a matter of willful deception than a sign of how thoroughly he embraced his friend's language as his own.[45] So, too, does his subsequent decision to retain the title after having temporarily opted instead for "The Philosopher's Holiday" in order to avoid Hegel's potential association with Nazism. Rather than accept the view that would identify Hegel with "their tastes for gas-chambers, stupid racialist ideas and cannon-fire," he concluded, he would hold on to a different idea of life and the philosopher alike. "Hegel wrote enough fine and good things for those things to be remembered in the first place," he explained to his dealer in restoring the picture's original name; "the remainder, if there is a remainder, can be left to those people who have a taste for the mean and the ugly."[46] Despite its ad-

ventitious origins, the title had become too closely identified with the work in the artist's mind to be abandoned lightly. Yet without the documentary evidence of the letters, it seems safe to say, no spectator would have been able to reconstruct the links by which Magritte had arrived at the happy thought of associating his paradoxical image with a vacationing Hegel. If "a good title will guide the observer in his quest of how to construe the work," as one philosopher has it, and "a bad title . . . misleads," then most of Magritte's titles would fail the test—unless their very mysteriousness could be said to help the viewer grasp the effect at which all his art was aiming.[47]

There is another way, however, to think about the work performed by such inexplicable acts of baptism. Rather than guide the observer in construing the image, titles like Magritte's serve to forestall her inclination to *mis*construe it—to assimilate it to some more habitual mode of seeing or thinking. From such a perspective, what matters is less that viewers be able to intuit the associative logic that produced the title's "poetry" than that they be prevented from easily translating the picture into language of their own. Though Magritte's practice of enlisting others to help "find" his titles may look like an acquiescence in the sort of post hoc identification that has supplied the names of so many works in the European tradition, the result is quite the opposite: a coterie understanding of his titles that blocks the public's ability to continue the process. Call it the preemptive title: one that productively arrests the viewer before the baffling conjunction of word and image.

Magritte is hardly the only modern painter to exploit such titles, whose lineage extends well beyond the experiments of surrealism. But his early experience as a commercial artist would have heightened his alertness to the uses—and abuses—of the language that accompanied his images. For several years in the 1920s, and then intermittently throughout his career, Magritte supplemented his income by turning out posters, sheet-music covers, and magazine ads (fig. 15–8)—a practice that undoubtedly contributed to the readiness with which he incorporated words within the picture frame of his noncommercial art as well. His lifelong comfort with reproduction probably also owes something to this early experience, as does that "banal" facture of which he was happy to boast, with its bright areas of unmodulated color. In a persuasive study of this aspect of Magritte's career, Georges Roque has suggested that these very characteristics of his style help to account for the extraordinary degree to which his serious paintings have been co-opted in turn by later commercial artists, who continue to adapt his work for everything from book covers and record jackets to ads for cigarettes, alcohol, television sets, and banking services. Though Roque gives no statistics, his stunning demonstration of the omnipresence of Magritte's imagery in late twentieth-

15–8. René Magritte, Triple advertisement (1924). © 2014 C. Herscovici/Artists Rights Society (ARS), New York. Four-color print. Art Resource, NY.

century advertising makes it easy to credit his claim that no painter's work has been more thoroughly pillaged for such purposes.[48]

But it is also, Roque argues, because the paintings by themselves elude signification that they have so readily lent themselves to other uses. A striking image whose meaning cannot be easily verbalized is one ripe for repurposing. Suppress Magritte's title, inscribe another message, and—with a little tweaking of costume and gender mix—*Golconde* becomes a radio ad: "Each day," it proudly announces, "we have 9,300,000 listeners on our wave-length." With other paintings, no change of costume is even necessary: all it takes is

15–9. René Magritte, *Le modèle rouge* (1935). © 2014 C. Herscovici/Artists Rights Society (ARS), New York. Oil on canvas on cardboard. Musée national d'art moderne, Centre Georges Pompidou, Paris. © CNAC/MNAM/Dist. RMN-Grand Palais/Art Resource, NY.

a new set of words. In one of Roque's most compelling examples, the picture called *Le modèle rouge* or *The Red Model* (fig. 15–9) was converted into a poster for Canadian customs—its uncanny image of two boots mysteriously morphing into human feet now serving to drive home the inquiry "Are you accustomed to travel?" (Whatever your plans, the poster warned, "talk to Canada Customs first," since the rules had changed.) For Magritte, the painting demonstrated "how the most barbarous things are accepted, by force of habit, as entirely reasonable," but the conjunction of human foot and leather shoe that he sought to defamiliarize as "a monstrous custom" had become, ironically, the means to inculcate proper habits in those subject to a Customs Bureau.[49]

Roque is more concerned with the verbal appropriation of Magritte's images than with the language that originally accompanied them, though he does acknowledge at one point that a Magritte with no title at all would be still more vulnerable—its polysemy open to any interpretation or explication that a puzzled spectator chose to provide.[50] What I am calling the preemp-

tive title, on the other hand, is a way of blocking that impulse—a means of slowing down, if not checking altogether, the viewer's attempt to make verbal sense of the picture. To the best of my knowledge, Magritte never explained the particular chain of associations that had prompted him to call his shoe-and-foot painting *The Red Model*, but the viewer who pauses before that painting to contemplate its mystery will be in no danger of too quickly dissipating her sensation by a glance at the title. At the same time, the very fact that the image *has* a name—and an enigmatic one at that—will make her less quick to substitute a formula of her own. As Magritte himself once put it, his titles should "prevent" the viewer from placing his pictures in "a reassuring context." Rather than an "explication," they should provide a kind of shield—his phrase was "une protection supplémentaire"—that would "deter any attempt to reduce true poetry to a game without consequence." Another time he was equally firm, if more cryptic: "[My titles] are not keys," he declared, adding, "There are only false keys."[51] Whether the falsity was to be attributed to the artist who had provided the title or to the viewer who sought to interpret it, the moral in either case was the same: to take the names of his paintings as a guide to understanding them, Magritte insisted, was inevitably to go astray.

Not surprisingly, however, this was a point Magritte found himself forced to make again and again. Just as some critics continue to interpret his work psychoanalytically, despite his injunctions against the practice,[52] others continue to read for the connection between words and image. The human appetite for meaning is a powerful one, and few commentators on his work have proved able to resist the occasional impulse to make sense of a title. Commenting on the famous painting of a steam engine emerging from a fireplace that Magritte called *La durée poignardée* (*Time Transfixed*), Siegfried Gohr, for example, has recently observed that "anyone . . . who reads the title . . . and begins to reflect on the nature of time in such Magritte compositions, immediately faces the strange paradox of stasis and motion." Elsewhere Gohr concludes that the artist entitled his five vertically arranged fragments of a naked woman *L'évidence éternelle* (*The Eternally Obvious*) as an ironic allusion to "the trope of 'the naked truth'"—the point being that such an identification of the female nude was no longer possible for the modern artist.[53] In this case Gohr assumes a certain disjunction between the picture and its name, but to construe a title as ironic, of course, is still to take it as a key to the image.

Even writers theoretically committed to the arbitrariness of the signifier—and to Magritte's investment in that principle—nonetheless fall back, when the opportunity arises, on reading by the title. One scholar points to

15–10. René Magritte, *Le paysage fantôme* (1928). © 2014 C. Herscovici/Artists Rights Society (ARS), New York. Oil on canvas. Private collection. Banque d'Images, ADAGP/Art Resource, NY.

the word "montagne" written across a woman's face in the painting of 1928 called *Le paysage fantôme* (fig. 15–10) as an exemplary instance of the problematic relation between word and image. "Why then the choice of this signifier, and what does it indicate about the process of displacement in Magritte's work?" she asks. "To answer, one must consider the title." What the title tells her, needless to say, is that "this work may not be a portrait, but a landscape (*paysage*)."[54] Sometimes a mountain is not a mountain, in other words, but in order to demonstrate that principle, sometimes a landscape will have to be landscape. In a related move, another critic subtly analyzes the shifting reference of the deictic "ceci" in *Ceci n'est pas un pipe*, as it points alternatively to the painted image of the pipe, the picture as a whole, and its own status as linguistic placeholder. "The 'treachery of images' is not the mismatch or 'forgery' of the real in representation," she concludes, "but the underlying absence of the real in representation."[55] *La trahison des images*, by this account, proves an eminently decodable title.

And so, indeed, it is. For all his theorizing, Magritte was no more able than his critics to keep the arbitrariness of all his signifiers in play at once; and it may be no accident that a number of his philosophically more programmatic paintings carry titles that likewise serve to interpret the images they identify. A painting called *Tentative de l'impossible* (*Attempting the Impossible*) depicts the artist in the Pygmalion-like act of trying to bring a nude woman into existence by painting her; another, called *La clairvoyance*, shows him looking intently at a large egg while depicting with his brush the adult bird that will presumably emerge from it. The sequence of works known as *La condition humaine* may be titled somewhat more obliquely than *La trahison des images*, but, like that famous painting, they clearly question the border between representation and the real; and it is not hard to read their title as a generalizing commentary on the situation in which all viewers of representations inevitably find themselves (see fig. 13–7). Both *The Treachery of Images* and *Attempting the Impossible* have recently been adopted, for good reason, as the subtitles of books about Magritte, with the former also serving to gloss his continuing legacy for contemporary art.[56] And then, of course, there is *The Use of Words*—a title I have likewise adopted as a shorthand for the artist's practice more generally. Whether or not I am right that the first of the paintings to bear this title is meant to conjure up the whole problem of titling images, the title itself is surely a key to the picture.

[16 · JOHNS'S *NO* AND THE

PAINTED WORD]

In March 1954—several months before he began the painting that would officially inaugurate his career—Jasper Johns encountered the work of René Magritte at a New York gallery. The exhibit was subtitled, somewhat misleadingly, *Word vs. Image*, and it included some of the artist's best-known word pictures, *The Treachery of Images* prominently among them. Though Johns has said relatively little about the experience, the exhibit evidently made an impression. By the time that Magritte himself arrived on his only visit to the United States eleven years later, the American not only managed to meet his Belgian counterpart but to acquire a version of *The Key of Dreams*—the centerpiece of a small Magritte collection that at last count comprises some seven pictures, including two variations on *The Human Condition* as well.[1] Some commentators have even suggested that Johns is, in fact, Magritte's truest heir.[2] Yet if Johns learned from his predecessor, the lessons he absorbed would have been hard to detect in the work by which he first captured the attention of the art world in the late 1950s. Rather than studies in the arbitrariness of the sign, Johns's early work struck his contemporaries as startlingly literal.

From the perspective of modern art history, much of the impact of that work came from Johns's reintroduction of subject matter into a field that had hitherto been premised on its banishment—a feat he managed by painting objects and signs that were as flat as the canvas they occupied. His celebrated *Flag* (1954–55), for instance, seemed to be just that: not so much a representation of the US flag as a reproduction of the thing itself, down to the swatches of fabric (apparently a bed sheet) on which its encaustic, oil, and collage were deployed (fig. 16–1).[3] So, too, the various *Targets* that accompa-

16–1. Jasper Johns, *Flag* (1954–55) (dated on reverse, 1954). Encaustic, oil, and collage on fabric mounted on plywood, three panels. Museum of Modern Art, New York. Art © Jasper Johns/Licensed by VAGA, New York, NY. Digital Image © The Museum of Modern Art/Licensed by SCALA/Art Resource, NY.

nied versions of *Flag* at the artist's breakthrough show for the Leo Castelli Gallery in 1958. These were paintings—or objects—in which subject and work seemed to coincide, even their dimensions sometimes congruent with the things they depicted.[4] As Leo Steinberg famously quipped, "You can't smoke Magritte's painted pipe, but you could throw a dart at a Johns target, or use his painted alphabets for testing myopia."[5]

Though Steinberg did not say so, the titles by which Johns identified these works only heightened the literal effect. Magritte may have decreed that to name the image of a tree "Tree" was an error, but Johns apparently had no qualms about designating his flag *Flag*—the absence of any article intensifying the impression that object and referent were one and the same. (This is not a depiction of "a" flag or "the" flag, with the article seeming to refer to something outside the canvas, but the thing itself.) Among his other early works are paintings entitled *Book* (1957), *Newspaper* (1957), *Shade* (1959), and even *Canvas* (1956), this last a small canvas face down on a larger one, the whole painted in gray encaustic (fig. 16–2). According to Magritte, "An object doesn't so adhere to its name that one can't find it another that will suit it better."[6] But just as Johns has repeatedly proclaimed his preference for

16–2. Jasper Johns, *Canvas* (1956). Encaustic and collage on wood and canvas, 30 × 25″. Private collection. Art © Jasper Johns/Licensed by VAGA, New York, NY.

working with forms he didn't have to design—"things the mind already knows"—so he has seemed quite happy to take their ordinary names as given.[7] He is even capable of speaking as if those ordinary English words had some essential relation to the things they signified. "I have always loved it," he told an interviewer in 1977, "when works could be called what they really are."[8]

Of course, matters are not so simple, if only because the person who apparently held this Adamic view of language was also an avid reader of Wittgenstein—not to mention a collector of Magritte.[9] As Johns surely knew quite well, to call his flag *Flag* was to raise as many questions as it answered. "When you painted a flag, I wonder if you were strongly aware of the difference between the title 'Flag' and the picture itself titled *Flag*," the Japanese art critic Yoshiaki Tono asked in 1964, his point being that there are many kinds of flag, of which the Stars and Stripes is merely one. "While I was painting a flag, I was aware that it was not a flag that I was painting," Johns responded in part. "If I say that it was a flag and at the same time it was not a flag, I am

245

answering the question you have asked, am I not?"[10] It is not clear that Johns *was* answering Tono's question, but the issue he did go on to address was the one that had most occupied contemporary commentators: "Is it a flag, or is it a painting?" as the author of an exhibition catalogue had put it that same year.[11] After noting that the traditional red, white, and blue of his first *Flag* tended to prompt this conundrum as a version painted entirely in white tones had not, Johns continued: "It is the gray zone between these two extremes that I am interested in—the area [where it] is neither a flag nor a painting. It can be both and still be neither. You can have a certain view of a thing at one time and a different view of it at another. This phenomenon interests me."[12]

Calling a painted flag *Flag* or a canvas *Canvas*, in other words, can be a way not of foreclosing the difference between things and their signs but of opening it up—defamiliarizing ordinary objects and their names alike. Johns's redundant literalism has something of the same effect Magritte produces when he follows up his misaligned words and images in *The Key of Dreams* with a panel in which the conventional relations obtain: suddenly neither word nor image, nor the connection between them, looks quite right. (In the *Key* reproduced here—see fig. 15–3—the "correct" panel is the one with the sponge; in the English-language version that Johns would acquire in 1965, the corresponding panel shows a valise.) Unlike Magritte, however, Johns characteristically achieves this effect not by first disrupting the received relations between signs but by compounding them—inviting us to recognize that even the referent of the most common noun is less stable than we may think. It is, after all, perfectly acceptable in ordinary usage to say of the picture of a pipe, "That's a pipe," *The Treachery of Images* notwithstanding: Magritte's famous legend unsettles by articulating a distinction that usually goes without saying, while Johns's deadpan nouns oscillate between naming things and titling pictures.

Viewed in isolation, Johns's breakthrough work might seem that of a painter determined to defy the logocentrism of his culture. Having produced a canvas so wordless that it lacks even the artist's signature (unless one counts the bits of newsprint faintly visible beneath the paint), the creator of *Flag* makes his only concession to the regime of language its mockingly redundant title. Yet Johns is an artist almost as obsessed with words as he is with brushstrokes, and he had no sooner completed his iconic image than he began to produce a series of paintings whose titles would figure prominently within the very pictures they named. Far from being the antithesis of works like *Flag* or the equally mute *Canvas*, these paintings often seem to reduplicate their literalism.

Consider the work of 1961 that is called, simply, *No* (plate 15). Another painting covered in shades of gray encaustic like *Canvas*, it too is a collage; but while the earlier work affixes a second empty canvas to the first, *No* incorporates a very different kind of object—two metal letters suspended from a long wire attached to an eyehook. These are, of course, the "N" and "O" of the painting's title—letters that also appear on the surface of the canvas, as if imprinted by the metal forms pressing into the paint. Depending on how the canvas is lighted, the shadows of the dangling letters can produce yet a third "NO," hovering distinct from the other two. It is, as one early observer remarked, "a picture full of NO."[13]

But what is the status of this "NO"—or these NOs? By incorporating the letters of his title not just as a written inscription but as physical objects, Johns renders the word unmistakably material, even as he makes the act of viewing the picture and reading its title inseparable. This is not to say that we exhaust the painting by reading the title, only that for any viewer minimally literate in English—an important caveat in Johns's case, as Philip Fisher reminds us[14]—it is impossible to look at the canvas without silently spelling out its name. In this sense, at least, encountering *No* is very unlike that characteristic experience of the modern museum-goer who finds herself furtively glancing down at an adjacent label in order to locate herself verbally. At once the name of the painting and the principal object within it, *No* feels even more redundant a title than *Flag* or *Canvas*, both of which still translate a wordless phenomenon into language. This is a picture called *No* because it is a picture of "NO."

A painting once owned by Johns's former lover and collaborator, Robert Rauschenberg, may help to point up the difference between Magritte's practice and that of his American counterpart. Yet another of the surrealist's word pictures, it shows an empty, framed panel inscribed with the phrase "femme triste" (sad woman), placed against a wall of stones (fig. 16–3). Though the picture is called, ironically enough, *Le sens propre* (*The Literal Meaning*), the words within it bear no discernible relation, literal or otherwise, to the forms depicted. Nor do they echo in any way the words of the title, which remain, as almost always in Magritte, altogether distinct from the painting. The contrast with the use of language both within and without *No* could scarcely be sharper. Johns's preference for calling things "what they really are" extends not only to his practice of naming a canvas *Canvas* or a flag *Flag*, but to this wholly verbal kind of literalism.

Words have weight for Johns, though few of his works demonstrate that fact quite so literally as the hanging letters of *No*. Rather than a three-

16–3. René Magritte, *Le sens propre* (1929). © 2014 C. Herscovici/Artists Rights Society (ARS), New York. Oil on canvas. Private Collection. Banque d'images, ADAGP/ Art Resource, NY.

dimensional object appended to the canvas (as well, of course, as imprinted and shadowed within it), most of the titles Johns incorporates are lettered directly on the painting. Unlike Magritte's cursive inscriptions, they are typically printed or stenciled, as if to heighten the impression of "things the mind already knows": not the mark of a unique hand, but impersonal forms the artist chanced to discover. (Steinberg records an amusing exchange in which he attempts to learn whether Johns uses his typefaces because he likes them or because "that's how the stencils come," only to register that this is a distinction without a difference in his case: what Johns likes is "that they come that way.")[15] Not all these paintings give the title so prominent a role in the composition as does *No*, nor do they all represent its words without distortion. But all openly defy the convention by which the title of a modern painting is recorded on the verso of a canvas, to be reproduced elsewhere by someone other than the artist himself.

16–4. Jasper Johns, *Souvenir 2* (1964). Mixed media. Private Collection. Art © Jasper Johns/Licensed by VAGA, New York, NY. Photo © Christie's Images/Bridgeman Images.

Johns's occasional play with that convention only drives home how self-consciously he chooses to violate it. In both *According to What* and *Souvenir 2* (1964), for example, the title appears on the verso of another small canvas turned back-to-front on the larger one—the cursive inscription of "souvenir" proving a rare exception to the artist's preference for standardized typefaces (fig. 16-4). In the case of *Souvenir 2*, as Harry Cooper has noted, Johns "seal[s]" his act of reversal with a pun—"souvenir" literally meaning "to come from beneath."[16] (The physical "souvenir" in the picture is an inexpensive plate, decorated with the artist's photograph and stenciled names of the primary colors, that Johns had acquired as a tourist in Japan.) As these reversals of the canvas might also remind us, to bring a title forward spatially like this is perforce to bring it forward temporally as well: rather than Magritte's post hoc addition to the image, scrawled on the back of the canvas, Johns's title has become an integral part of the picture's making. It is tempting to say

that in such cases Johns does not so much title his artworks as make art of their titles.

That conceit is not so far-fetched as it may seem. Noting that "language, words, are very important to you," an interviewer once asked whether Johns had ever felt the desire to write. "Well . . . hasn't everyone?" the artist replied, before going on to say, in effect, that while he thought everyone would want to explain a feeling in words, he hadn't done it. The answer seems true enough—to the best of my knowledge, none of Johns's pictures "explain" his feelings verbally—yet like much of the artist's fencing with interviewers, it tells only half the story. "So you've thought about it," his questioner persisted, to which Johns responded: "Yes. Words are interesting. Painting isn't words, so you know that using words would mean making something else."[17] If this is a disavowal, it is a curious one, given the obvious contradiction with the speaker's practice. As Mark Rosenthal has shrewdly noted, what it suggests is not that Johns has forsworn the use of words but that he knows full well that he is "making something else"—that the composite works he creates are not simply, or purely, "painting."[18] The writer in Johns may not be given to explaining his feelings in words, but he likes to do things with them, just as the painter in him likes to do things with brushstrokes. An early entry in his sketchbooks appears to be a tentative list of items to be used in a project, probably the work that became *According to What.* "Lead section?" it begins: "bronze junk?" "glove?" "glass?" "ruler?" Two-thirds of the way down this list, right after "brush?" comes "title?"—a question like all the rest, but like the rest, too, a potential component of the picture.[19]

Johns began keeping such sketchbooks after he reviewed the first complete English translation of Marcel Duchamp's *Green Box*—itself a set of notes composed for the work known as the *Large Glass*, or *The Bride Stripped Bare by Her Bachelors, Even*—and despite the conventional term by which they are known, there are actually more words in these "sketch" books than pictures.[20] Together with Duchamp, Wittgenstein seems to have been one of their presiding influences, and Johns frequently meditates in their pages on the relations between language and painting. "The mind makes marks, language, measurement," he writes at one point. "There seems to be a sort of 'pressure area' 'underneath' . . . language which operates in such a way as to force the language to change," he observes at another. "I'm believing painting to be a language, or wishing language to be any sort of recognition," he notes parenthetically before continuing, "If one takes delight in that kind of changing process, one moves toward new recognitions (?), names, images." The implicit equivalence among sign systems—the apposition of "marks, language, measurement" in the first passage, or of "names, images" in the second—is

16–5. Jasper Johns, Sketchbook A, p. 53 (1964). Art © Jasper Johns/Licensed by VAGA, New York, NY.

telling, as is the evidence both in the sketchbooks and elsewhere that sometimes names do indeed precede images in Johns's practice.[21]

"For a painting called TUSSAUD OR BARRIER," an entry of 1964 begins, "see Larry Scull's legs (or perhaps the child of an artist) for a plaster cast." This seems to have been an early idea for the painting that would become *Watchman* (1964), whose eventual title, underlined and capitalized, appears beneath an annotated drawing for the work later that year.[22] (Johns later told an interviewer that the inspiration for the picture had come from a visit to Madame Tussaud's.)[23] Another entry of 1964, headed "ACCORDING TO WHAT or FOCUS" and followed by several annotated sketches of legs in a chair, clearly works out ideas for the painting that would later bear the first of these names.[24] Still another page begins with the query "No NO?" in the upper left-hand corner, only to respond with the word "souvenir" enclosed in a rectangle on the right, as the artist apparently settles on his title (fig. 16–5). Johns had evidently discovered that the Japanese for the possessive "of" sounds phoneti-

cally like the English "no," but rather than play with that fact in his title, as he seems to have been contemplating, he decided to stencil the word "no" beneath the souvenir plate he would attach to the canvas.[25] On the same trip to Japan, the artist apparently confessed to Yoshiaki Tono that all he had to show for a promised exhibit in New York was a list of titles. "I have no works or even their images yet," Tono quoted Johns as saying: "All I have done is name them."[26]

This is, clearly, a very different approach to the act of titling from Picasso's dismissal of the whole business, or even from Magritte's insistence that the right title can only be "found" after the picture itself has been completed. To the extent that titles come first for Johns, his practice might more nearly be said to resemble David's, who verbally proposed his *Oath* more than a year, after all, before he represented it on canvas. And sometimes Johns has indeed spoken as if a picture originated in language, telling an interviewer in 1980, for example, that the painting and prints he called *Usuyuki* acquired their name when "I came upon the word in something I was reading—and the word triggered my thinking." As Johns recalled it, Usuyuki was the name of a heroine in a Japanese play or novel that had to do with "the fleeting quality of beauty in the world," and when he was told that it meant "a little snow," he decided to make his pictures "using that title." Elsewhere he accounted for the title of *Racing Thoughts* by recalling a conversation with a psychologist at a dinner party, who happily supplied a name for his condition when he described how "bits of images, and bits of thoughts" would run disconnectedly through his head while he was trying to fall asleep.[27] Whether the idea for the picture originated in this exchange, or whether the title arrived after the work was underway, remains unclear, however.

Scholars often point out that among the distinctive properties of language, as opposed to images, is the capacity to negate. Whatever an image represents, its existence is an affirmative fact: "pictures," as Sol Worth memorably put it, "can't say ain't."[28] Only words can express that something is not the case—a rule that incidentally explains why Magritte must resort to writing in order to deny that his pipe picture is a pipe. Johns's *No* likewise plays with this rule, at once acknowledging and defying it.[29] *No* is a picture that does "say ain't," but it does so only by incorporating the verbal token of its negation directly in the canvas. Yet the artist who once apparently contemplated calling another painting "No no" would surely have been aware that his nay-saying picture can also be seen to negate its own negation. There are, at a minimum, two "NOs" in *No*—the dangling letters and the imprint on the canvas—though depending on how the picture is lit, the shadows produced by those dangling letters can either reverse this double negative or reinforce it.

According to Michael Crichton, whose book on Johns draws on interviews conducted over a period of several months in 1976, the artist once spoke of how he set out to work by deliberately choosing *not* to do what other people did. "When I could observe what others did, I tried to remove that from my work," Johns is quoted as saying: "My work became a constant negation of impulses." Yet elsewhere in the same book Crichton reports without comment the artist's characteristic exchange with an unnamed interlocutor: "'His work is a constant negation of impulses,' said a critic who has known him a long time. 'Wouldn't you say so, Jasper?' 'No,' Johns said, and laughed."[30] Whether or not his painted *No* was also meant to conjure up the English homonym "know," as some have speculated, Johns is clearly enough of a wordsmith to relish that possibility too.[31]

Johns is not the first artist to make a title an integral part of his painting, though what one critic calls "the taboo against front-titling" was certainly in full sway at the time of his early word pictures.[32] We have already seen Whistler briefly resort to such titling with his *Symphony in White, No. III*, and the inclusion of language on the canvas—or, more typically, its frame—was a frequent procedure among the Pre-Raphaelites, who were, of course, seeking to restore an artistic culture that antedated the Renaissance divorce of word and image. In a brief survey of the practice over the last century, Leo Hoek also mentions works by Paul Gauguin, Francis Picabia, Picasso (*Ma jolie*), and Duchamp.[33] Johns himself openly acknowledges the influence of the relatively obscure American still-life painter John F. Peto by adjoining the latter's name to his own after the title of *4 the News*, whose numerical pun Johns has clearly borrowed from the earlier artist's *The Cup We All Race 4* (figs. 16–6 and 16–7). A friend who noted the coincidental resemblance between this trompe d'oeil cup and a sculp-metal cup hanging from Johns's *Good Time Charley* of 1961 first brought the Peto to his attention; and Johns seems to have decided that the isolated position of the definite article on its frame anticipated his *The* as well, since *4 the News* duplicates the word in large capitals superimposed on smaller ones above its title in the lowest of its eponymous four panels. (The "news" in *4 the News* refers most immediately to a roll of newspaper wedged between the first panel and the second.)[34] But if Johns has precedent for such titular exercises, few artists have so concertedly—and so variously—experimented with their possibilities. And few have so self-consciously demonstrated how reading a title can become an integral part of looking at a picture.

Though commentators have occasionally suggested that the "visibility" of a painted word trumps its "legibility,"[35] Johns knows that matters are not so simple. As long as the word in question is legible in the ordinary sense, a

16–6. Jasper Johns, *4 the News* (1962). Encaustic and collage on canvas with objects, 65 × 50″. Kunstammlung Nordrhein-Westfalen, Düsseldorf. Art © Jasper Johns/Licensed by VAGA, New York, NY.

competent reader of the language will be forced to take in its meaning. Such understanding, as Steven Pinker has observed in another connection, is automatic: "once a word is seen or heard we are incapable of treating it as a squiggle or noise but reflexively look it up in memory and respond to its meaning, including its connotation."[36] Pinker's immediate concern is the experience of hearing taboo words, but his principal evidence for the effect is a visual experiment that bears very directly on Johns's paintings: the so-called Stroop test, named after its inventor, in which subjects are exposed to a series of color words, some of them printed in an ink different from the color they name, and tested for the speed with which they can identify the color of the ink. Not surprisingly, perhaps, it takes longer to do this when the meaning of the word and its color conflict. And it is harder to identify the color of the ink in such cases than it is to read the word itself: a person who sees the word "red" printed in blue, for example, will respond more quickly if she is asked to read

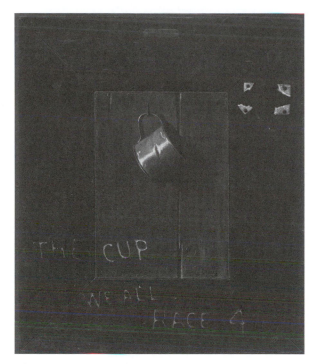

16–7. John Frederick Peto, *The Cup We All Race 4* (1905). Oil on canvas and wood, 25½ × 21½″ (64.8 × 54.6 cm); 32 3/8 × 28 3/8 × 2½″ (82.2 × 72.1 × 6.4 cm) framed dimensions. Gift of Mr. and Mrs. John D. Rockefeller 3rd. 1979.7.80. Fine Art Museums of San Francisco.

for the red than if she is asked to identify the blue.[37] Whether this necessarily means that reading is faster than perceiving a color, or only than naming it, is not clear. But what the phenomenon unmistakably does demonstrate is the speed with which the written word communicates to a literate viewer, as well as the virtual impossibility of canceling out the reading habit once we have acquired it.[38]

There is no evidence that Johns knew of the Stroop test when he began painting color words, though he later adopted motifs from other studies of perception he encountered in scientific journals.[39] But the artist's fascination with the difference between reading colors and seeing them has been evident at least since 1959, when he chose to play flamboyantly with such differences in *False Start* (plate 16). In that painting and many since, Johns not only stencils words in colors different from those they name, but layers them over patches of color partly distinct from both—as when a yellow-lettered "RED" in the mid-upper left of *False Start* appears on a patch of blue, or the white-

lettered "ORANGE" below it figures on a ground predominantly red. Yet even to articulate these facts is to distort the complicated effects of the painting—not just because Johns sometimes varies the pattern and gives us, for example, a blue-lettered "BLUE" in the lower left or a red "RED" far upper right, but because the presence of the words paradoxically helps us to see that virtually no area of the canvas is one color only, and that the conflict between word and paint is never as absolute as it first appears. Where exactly *is* red in the canvas—the color, not the word—and where does it end and other colors begin?[40] Would it be accurate to say of the upper left-hand corner that the word "GRAY" is lettered in red and orange on a field of yellow, red, and blue; or is that almost gray itself that has begun to emerge from the mixing of these primaries? The stenciled words divide up the spectrum in ways that the brushwork refuses to do, and Johns clearly invites us to register that tension. As he later commented on such experiments to David Sylvester: "I liked it that the words had a meaning. . . . I liked it that the meaning of the words either denied or coincided in the coloured paintings, or reaffirmed the actual experience of the colour sensation. Those paintings to me were an accomplishment in ambiguity that previous paintings had not reached." Once the artist has completed a picture, Johns had previously observed to Sylvester, he shares with the viewer in the work of giving meaning by looking; and it was as such a viewer, he emphasized, that he was now speaking.[41]

The color words of *False Start* are not its title, which in this case makes no appearance on the canvas. But the "questioning of visual, mental and verbal focus and order" that Johns celebrated in his early review of Duchamp bears equally on the paintings that do incorporate their titles, which likewise strive to keep both their languages in play.[42] Johns is as sensitive as any modern artist to the danger that a verbal formula will prematurely short-circuit the viewer's experience. In an interview of 1994 he relays a charming anecdote about a woman "sitting in a room looking at a [László] Moholy-Nagy . . . [and] not able to take her eyes off it."

> She kept turning to it. Finally, she stood up, walked over to the mantle, and looked and read the title, "Oh *Space Modulator*, that's what it is!" And then she sat down and never looked at it again. There is something like that in all of us, I think, that wants "space modulator," whatever it is you can say that will satisfy our curiosity.[43]

Yet rather than defy such reliance on a title by refusing to supply one—insisting, after the fashion of Picasso, that his is a purely visual, not semantic, art—Johns chooses to take charge of the process by slowing down the acts of read-

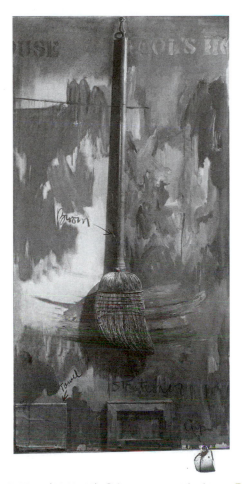

16–8. Jasper Johns, *Fool's House* (1961–62). Oil on canvas with objects. Private Collection. Art © Jasper Johns/Licensed by VAGA, New York, NY. Bridgeman Images.

ing and seeing alike.[44] Even as he makes pictures that include the words of their titles, he also treats those words as objects to be split apart, partly effaced, or otherwise manipulated.

Sometimes Johns breaks up a title so as to compel the viewer mentally to reassemble it: note how the title of *Fool's House*, for example, stops short at the right edge of the canvas only to continue at the left, as if the painting were designed to roll up like a scroll (fig. 16–8). A related split characterizes the title of *Racing Thoughts*, though in this case the imaginary cylinder would comprise only the right-hand panel of the canvas.[45] The title of *Voice 2* (1971) sprawls unevenly—and noisily—across the three separate panels of the can-

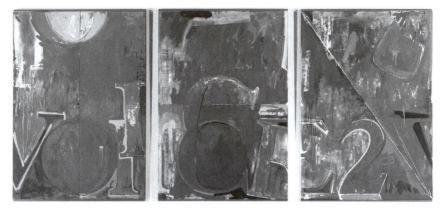

16–9. Jasper Johns, *Voice 2* (1971). Oil and collage on canvas (3 panels), 72″ × 50″ each panel; 72″ × 162″ overall (6″ between each panel). Kunstmuseum, Basel. Art © Jasper Johns/Licensed by VAGA, New York, NY.

vas, its individual letters splintering and doubling (fig. 16–9). Alternatively, Johns slows down the reading process in much the way he did with the color words in *False Start*. John Yau has noted, for example, how the varying color and adjacent brushwork of the individual letters in the title of *Device* (1961–62) compel us to "keep adjusting our focus, at least in our mind's eye," as we read—an effect by which "the acts of reading and looking," in Yau's acute description, "are conflated, one constantly being inflected by the other."[46] At other times, especially in predominantly gray works such as the earlier *Voice* of 1964–67, the letters of a title may be stenciled so quietly on a like-colored ground as to be difficult to discern in reproduction. (Though Johns moved the title of the first *Voice* from its initial position when he partly repainted the work in 1967, "a ghost of the original" remains still more faintly visible along the bottom edge of the canvas.)[47] Johns also likes to break up a title by interleaving its characters with those of his name and the painting's date. Sometimes he impedes our reading yet further by reversing some characters, as he did when he wove the name of the dancer Merce Cunningham into the reversed letters of the title in one version of *Dancers on a Plane* (1980–81; fig. 16–10), or teasingly hinted at a mirror effect by weaving the reversed characters of the date and his own name into the title of *Mirror's Edge*.

"After the first *Voice*, I suppose there was something left over, some kind of anxiety, some question about the use of the word in the first painting," Johns told an interviewer in 1978. "Perhaps its smallness in relation to the size of the painting led me to use the word in another way, to make it big, to distort it, bend it about a bit, split it up."[48] In a sketchbook note of the previ-

16–10. Jasper Johns, *Dancers on a Plane* (1980–81). Oil on canvas. Tate, London. Art © Jasper Johns/Licensed by VAGA, New York, NY. Tate, London/Art Resource, NY.

ous decade he had exhorted himself to "shake (shift) parts of some of the letters in VOICE (2)," before going on to add somewhat cryptically: "A not complete unit or a new unit. The elements in the 3 parts should neither fit nor not fit together."[49] As the note implies, the effect of such shaking and shifting is both to disrupt—or at least to delay—the viewer's comprehension of one semantic unit and to encourage the discovery of new ones. So commentators remark how the word "USE" emerges from the truncated title of *Fool's House*, for example (see fig. 16–8), or "OUGHT" from *Racing Thoughts*, as they in turn put these discoveries to the work of further interpretation. For one critic, the various visual systems by which Johns organizes the latter painting serve as "a plethora of provisional 'oughts,'" while another hears a homophonic pun on "aught"—the fragmented title simultaneously evoking artistic responsibility and the "nothingness" that by this account continually haunts Johns's oeuvre.[50] In her influential account of Johns's work, Roberta Bernstein likewise called attention to the new semantic units that could emerge from his painted words. She herself glossed the mood of *Voice* by

finding "ice" in its title and reported that she had once seen the artist rear-range the panels of *Voice 2* "so that the central letters in each spelled out the exclamation: 'O 2 C' (i.e., 'oh, to see')."[51]

According to Bernstein, Johns specified that the panels of *Voice 2* could be combined in any order.[52] Even the customary arrangement, however, charac-teristically experiments with the limits of painting (see fig. 16–9). By prompt-ing us to spell out the title across the gaps that fragment it, Johns not only elicits our active participation in the work but potentially renders its voice articulate—an addition of sound to pictorial visibility that has tempted him ever since he began exhibiting his work in the mid-1950s. Unlike his early *Construction with Toy Piano* (1954), with its functioning keys, or the working music box attached to the back of *Tango* (1955), this canvas relies only on the viewer's capacity to read in order to activate its sound, whose voicing will on most occasions remain virtual rather than literal.[53] No incitement to touch or play *Voice 2* violates the conventions of the modern museum, yet it, too, poses an implicit challenge to time-honored assumptions about Johns's medium. "One can portray 'voice' (as name, the word as object), but one cannot paint voice," Jeffrey Weiss has observed of the first canvas with that title: "under the condition of shunning statement, *Voice* merely identifies the medium it can-not hold."[54] By breaking up the verbal "object" in *Voice 2*, Johns comes close to defying that rule, as if he could thereby realize the ancient dream of making the mute picture "speak." Just as *No* flirts with the impossibility of pictorial negation, so *Voice 2* turns the title of the painting into a vehicle for question-ing the nature of painting itself.

No dates from 1961. *Voice 2* was completed a decade later—by which time the art world was growing accustomed to seeing words framed on gallery walls. Indeed, ever since the advent of so-called conceptualism in the late 1960s, painting-like objects composed wholly of printed letters have often hung cheek by jowl with actual paintings, as if to demonstrate the inescap-ably verbal context in which even the most purely nonverbal art inevitably finds itself.[55] Garrett Stewart, who terms such objects "lexigraphs," singles out Joseph Kosuth's self-consciously titled series *Titled (Art as Idea as Idea)*, each of which consists of a photographically enlarged dictionary entry. In Stewart's example, the word at issue is "red"—a pun on the act of reading that here substitutes for the perception of the primary color (fig. 16–11).[56] Others in the series include "meaning," "symbol," "painting," and "art" itself. Asked what he expected viewers to do with such a work now that it was "up on the wall," Kosuth replied, "They are supposed to read it, that's all."[57] His near contemporary Jenny Holzer told an interviewer in 1986 of her own conver-sion from painting to writing when a fascination with scientific and other

16–11. Joseph Kosuth (b. 1945), *Titled (Art as Idea as Idea)* [*red*] (1967). © Joseph Kosuth/Artists Rights Society (ARS), New York. Photographic enlargement mounted on board. Image: 48 × 48″ (121.9 × 121.9 cm). Whitney Museum of American Art, New York; gift of Peter M. Brant 74.108. Digital Image © Whitney Museum of American Art.

16–12. Jenny Holzer, *Truisms* (1994). © 2014 Jenny Holzer, member Artists Rights Society (ARS), New York. Postcard series of screenprints on balsa wood. Museum of Modern Art, New York. Digital Image © The Museum of Modern Art/ Licensed by SCALA/Art Resource, NY.

diagrams prompted the realization that she was "finally . . . more interested in the captions than the drawings. The captions," she continued, "told you everything in a clean, pure way"—the implication being that they rendered the drawings superfluous. The result in Holzer's case amounted to work that was, in effect, all caption (fig. 16–12).[58]

The advent of such work might well seem the end point of this history. In practice, of course, things are not so simple, if only because there remains a difference between the texts recorded in these works and the collective titles by which they are officially identified—the Holzer reproduced here comes from a series called *Truisms*—and because this difference returns us in some ways to the problem with which we began, that of the tension between title and legend in Magritte's *La trahison des images*. As with Magritte, commentators on these works seem uncertain whether to refer to them by their official titles or by the words they record, and the problem is in no way simplified by the absence of anything like Magritte's painted pipe from the works themselves. When Kosuth spoke of making the "middleman unnecessary," he was imagining an art that would eliminate the need for critics, but working with words is hardly a way of forestalling others' words, as a moment's thought about the fate of literature would have reminded him; and even mundane decisions as to how to identify one of his photographs on a museum wall or in a catalogue require the intervention of middlemen.[59] The problem of titling—along with the act of interpretation it entails—does not necessarily disappear with the arrival of a text-based conceptualism.

For the purposes of the present book, however, the more immediate question may be whether such art should be seen as painting in the first place. If I choose instead to end with Jasper Johns, that is because his work retains a tension between the visual and the verbal that more purely text-based performances threaten to eliminate. Despite their common debt to Duchamp, Johns would never proclaim, as did an influential commentator in 1969, that "painting is obsolete."[60] Nor does his delight in verbal games of all sorts mean that he is engaged, as one critic has it, in "an anti-visual discourse."[61] Unlike those who allied themselves unequivocally with Duchamp's privileging of conceptual over "retinal" art, Johns continued to insist that it mattered how things looked. "My idea has always been that in painting the way ideas are conveyed is through the way it looks and I see no way to avoid that," he told an interviewer in 1965, "and I don't think Duchamp can either."[62] Rather than declare, like Kosuth, that the viewer of his verbal art should "read it, that's all," Johns tries to make the work of reading almost as painstaking as that of looking. His *Voice 2* may flirt with the possibility of a speaking picture, but it does so as much by impeding the viewer's perception of the word as by enabling it. "Avoid the idea of a puzzle which could be solved," he exhorted himself in planning the picture: "Remove the signs of 'thought.' It is not the 'thought' which needs showing."[63] Talking with David Sylvester a few years earlier, he had famously invoked his need to keep painting "in a state of 'shunning statement'"—a state that included, by this account, the very articu-

lation of the principle itself. "In other words, if your painting says something that could be pinned down, what it says is that nothing can be pinned down, that nothing is pure, that nothing is simple," Sylvester ventured, to which Johns replied: "I don't like saying that it says that. I would like it to be that."[64] This is not the artistic creed of one who titles his paintings in the hope of translating them into words.

Yet Johns is also an aggressive author of titles, one whose commitment to finding words for his paintings often extends, as we have seen, to making those words a part of the objects themselves. Though he is perfectly capable of contradicting himself when he chooses, the contradiction in this case may be less than it seems. "I think titles help in referring to pictures," he said in the same interview that told of the woman who stopped looking at the *Space Modulator* once she knew what it was called;[65] and a title that is part of the work itself is the surest means of forestalling others' impulse to short-circuit its meaning by labeling it. The meaning of *No* may be ambiguous and open-ended, but the ambiguity is the author's—and few titles seem more likely to stick.

ACKNOWLEDGMENTS

Studying the history of picture titles makes one acutely aware that no work enters the public sphere without the collaboration of others. The generous offer of a Walter Hines Page Fellowship from the National Humanities Center in the spring of 2009 granted me the good fortune to have an exceptional set of collaborators when this project was in its very earliest stages. I am especially grateful to the members of the working group on titles—Nicholas Bock, Jessica Brantley, Katherine Starkey, and Christian Thoreau—for spirited conversation on matters ranging from medieval *tituli* to nineteenth-century relations between words and music. The Center's staff made books and articles from as far away as the Getty appear on my desk as if by magic and helped to rescue me from an otherwise disastrous computer crash. Thanks in particular to Josiah Drewry for enthusiastically following up on library requests, to Joel Elliott for technical assistance, and above all to Kent Mullikin, whose invitation to deliver a joint talk on titles with Nicholas Bock gave me an opportunity to try out some ideas for this book with a larger audience.

An invitation from John Plotz and Leah Price to speak at the Victorian Literature and Culture Seminar of the Harvard Humanities Center later that spring prompted me to start writing and provided some lively interlocutors for a conversation about Whistler. Toward the close of the project, Martin Hägglund organized a discussion of several chapters of the manuscript among colleagues in the Humanities Program at Yale: in addition to Martin himself, I would like to thank Joshua Billings, Howard Bloch, Francesco Casetti, Emily Greenwood, and Anthony Kronman for their stimulating responses. My thinking about titles has also been energized by audiences at the North American Victorian Studies Association, the Nineteenth-Century Seminar in the History of Art at Yale, and the College Art Association, where I am grateful to Anne Helmreich and Francesco Freddolini for including me in their panel on the history of catalogues.

While we were still at the Humanities Center, Robert DuPlessis helped me to decode the colloquial French of a Daumier caption and introduced me to the resources of ARTFL. More recently, Thomas Kavanagh and Leah Price have come to my aid with more than one knotty translation problem. I owe a particular debt to Tom, who cheerfully interrupted his own work to attend to mine with a frequency I am embarrassed to recall.

One of the pleasures of working on this book has been talking it over with Alison MacKeen, whose responsiveness and enthusiasm for the project kept me going. Anne Savarese ably took over from Alison at the Press and shepherded the book through its later stages with friendliness and efficiency. I couldn't have had a better copyeditor than Lauren Lepow, who also did a splendid job of overseeing the book's production, while Dimitri Karetnikov brought his keen eye to the illustrations. Langdon Hammer first directed me to the titles of Jasper Johns. To Yoon Sun Lee belongs the credit of coming up with a mischievous title of her own, which I shamelessly lifted for the prologue. David McKitterick at Cambridge, Mark Pomeroy at the Royal Academy, and Ian Warrell at the Tate graciously responded to queries from a stranger. Both my work and that of my excellent research assistants—Michaela Bronstein, Jordan Brower, and Margaret Deli—has been immeasurably aided by the visual and verbal resources of the Yale collections. I am grateful to the staff of the Beinecke Rare Book and Manuscript Library, the Center for British Art, the Haas Arts Library, the Lewis Walpole Library, and the Sterling Memorial Library, as well as that of the Thomas J. Watson Library at the Metropolitan Museum of Art. At the last minute, Elizabeth Fairman generously came to my rescue and tracked down an elusive catalogue among the rare books and manuscripts at the Center for British Art. For various forms of advice and encouragement over the years, I also want to thank Emily Bakemeier, Cora Bernard, David Bromwich, Edward Cooke, Jr., Gillian Forrester, Deborah Friedell, Matthew Hargraves, David Joselit, Elizabeth Mansfield, Stefanie Markovits, Zoe Mercer-Golden, Herbert Morris, Robert Nelson, Annabel Patterson, Linda Peterson, Steven Pincus, Margaret Powell, Leah Price, David Quint, Cynthia Roman, Jonah Siegel, Fred Strebeigh, Alicia Weisberg-Roberts, and the late Jon Imber.

The anonymous readers at Princeton University Press helped to make this a shapelier book and, I hope, a more appealing one. Its production was greatly assisted by the resources of the Provost's Office and by the generous support of the Department of the History of Art Publications Fund at Yale. Versions of the prologue, chapter 8 (as well as some paragraphs from chapter 14), and chapter 12 first appeared in the *Yale Review*, *Raritan*, and *Victorian Studies*; and I thank the editors of those journals for permission to reprint them here.

This book is dedicated to Alexander Welsh, who first taught me the difference a good title could make. I owe more than I can say to his love and example—even if he were not the real artist in the house.

NOTES

PROLOGUE

1. David Sylvester, ed., *René Magritte: Catalogue Raisonné*, 5 vols. (London: Philip Wilson, 1992–97), 1:331. Cf. Michel Foucault, *This Is Not a Pipe*, trans. James Harkness (Berkeley: University of California Press, 1983), plate 3.

2. In addition to the versions mentioned below, Sylvester records eight other variations on the image. Five of these are gouaches painted in the 1950s that apparently have no title inscribed on the back, but whose close resemblance to the first oil leads Sylvester to call them also by that name; a sixth gouache from the same period, painted on brown paper and inscribed on the back "affiche pour une vitrine," is catalogued by Sylvester as "[Poster for a shop window]." A significant variant of the original, in which an image of that painting appears together with a large painted pipe looming above it, was produced in oil in 1966 and labeled on the back *Les deux mystères* ("The Two Mysteries"). There is also a gouache of 1964—produced, Magritte wrote, because it was "desirable that such an item should be present in as many 'households' as possible"—that is labeled verso, *L'air et la chanson* ("The Tune and also the Words," in Sylvester's translation). See *René Magritte: Catalogue Raisonné*, 3:428–29; 4:140, 156, 157, 172, 218, 277; 5:98.

3. Anne Ferry, *The Title to the Poem* (Stanford, CA: Stanford University Press, 1996), 2.

4. Sylvester, *René Magritte: Catalogue Raisonné*, 1:331–32; 2:198.

5. A further complication is introduced by a footnote to the French edition of Foucault's book, in which the author claims to have received from Magritte a reproduction of a painting he calls "Ceci n'est pas un pipe," on the back of which the artist had written, "Le titre ne contredit pas le dessin; il affirme autrement" (The title does not contradict the design; it affirms it in a different way). If this is indeed an accurate transcription, then at some point in the painting's history, Magritte, too, was capable of identifying its legend with its title. See Michel Foucault, *Ceci n'est pas un pipe: Deux lettres et quatre dessins de René Magritte* (Montpellier: Fata Morgana, 1973), 91. The note does not, however, appear in the English translation of Foucault's work published a decade later.

6. Mitchell has articulated this position in a number of places. See especially W.J.T. Mitchell, *Iconology: Image, Text, Ideology* (1986; rpt. Chicago: University of Chicago Press, 1987), 1–52; and Mitchell, *Picture Theory: Essays on Verbal and Visual Representation* (1994; rpt. Chicago: University of Chicago Press, 1995), 1–107.

7. For the argument that the incorporation of a painting's name into the work itself represents "the fulfillment of a certain logic of development which is inscribed in the history of Western painting," see Stephen Bann, "The Mythical Conception Is the Name: Titles and Names in Modern and Post-Modern Painting," *Word & Image* 1 (1985): 176–90. (Quotation from p. 177.)

8. The phrase is from a much-quoted passage by Rosalind E. Krauss that invokes "modern art's will to silence, its hostility to literature, to narrative, to discourse" (*The Originality of the Avant-Garde and Other Modernist Myths* [Cambridge, MA: MIT Press, 1985], 9).

9. Tom Wolfe, *The Painted Word* (1975; rpt. New York: Bantam, 1987). For more sophisticated versions of this argument, see especially Mitchell, *Picture Theory*, 213–39; and James A. W. Heffernan, *Cultivating Picturacy: Visual Art and Verbal Interventions* (Waco, TX: Baylor University Press, 2006), 39–68.

10. Philip Fisher, *Making and Effacing Art: Modern American Art in a Culture of Museums* (1991; rpt. Cambridge, MA: Harvard University Press, 1997), 91.

11. Norman Bryson, *Word and Image: French Painting of the Ancien Régime* (Cambridge: Cambridge University Press, 1981), 5.

12. In addition to works cited elsewhere, see Christian Moncelet, *Essai sur le titre en littérature et dans les arts* (Le Cendre: Éditions BOF, 1972); John Hollander, "'Haddocks' Eyes': A Note on the Theory of Titles," in *Vision and Resonance: Two Senses of Poetic Form*, 2nd ed. (New Haven, CT: Yale University Press, 1975), 212–26; Steven G. Kellman, "Dropping Names: The Poetics of Titles," *Criticism* 17 (1975): 152–67; Jacques Derrida, "Title (To Be Specified)," trans. Tom Conley, *SubStance* 10, no. 2 (1981): 5–22; and Laurence Lerner, "Titles and Timelessness," in *Reconstructing Literature*, ed. Lerner (Oxford: Basil Blackwell, 1983), 179–204. For discussions that limit themselves to literary titles only, see also Harry Levin, "The Title as a Literary Genre," *Modern Language Review* 72, no. 4 (1977), xxiii–xxxvi; Alastair Fowler, *Kinds of Literature: An Introduction to the Theory of Genres and Modes* (Cambridge, MA: Harvard University Press, 1982), 92–98; and S. J. Wilsmore, "The Role of Titles in Identifying Literary Works," *Journal of Aesthetics and Art Criticism* 45 (1987): 403–8.

13. John Fisher, "Entitling," *Critical Inquiry* 11 (1984): 288, 290, 291, 289, 292. For a related critique of Fisher's argument from the perspective of visual modernism, see John C. Welchman, *Invisible Colors: A Visual History of Titles* (New Haven, CT: Yale University Press, 1997), 15–17.

14. Jerrold Levinson, "Titles," *Journal of Aesthetics and Art Criticism* 44 (1985): 33. Hazard Adams, who explicitly credits Levinson, shares this position. Unlike the latter, however, he acknowledges the element of chance and even arbitrariness that may enter into the process, as well as the potential contribution of others: "I mean the [title] we think the author chose, agreed to, was talked into accepting, tacitly accepted, or hit upon" ("Titles, Titling, and Entitlement To," *Journal of Aesthetics and Art Criticism* 46 [1987]: 9–10, 12). Approaching the question from the perspective of English book history, Eleanor F. Shevlin suggests that the "semantic slippage" between a title in its legal and its aesthetic sense was encouraged by the practice of recording textual titles in the register book of the Stationers' Company as a means of claiming legal property in the works they named—what the act of 1710 significantly termed "the Title to the Copy of such Book or Books" ("'To Reconcile *Book* and *Title*, and Make 'Em Kin to One Another': The Evolution of the Title's Contractual Functions," *Book History* 2 [1999]: 59).

15. Colin Symes, "You Can't Judge a Book by Its Cover: The Aesthetics of Titles and Other Epitextual Devices," *Journal of Aesthetic Education* 26, no. 3 (1992): 20.

16. This practice has often been discussed in connection with the surrealists. For a brief treatment in relation to Magritte, see David Sylvester, *Magritte* (Brussels: Merca-

torfonds: 2009), 173–74. This is a revised and enlarged edition of Sylvester's 1992 *Magritte: The Silence of the World*.

17. Ferry, *Title to the Poem*, 10.

18. Ibid., 17.

19. See Elizabeth L. Eisenstein, *The Printing Press as an Agent of Change: Communications and Cultural Transformations in Early Modern Europe* (1979; 1 vol. ed., Cambridge: Cambridge University Press, 1982): "Most studies of printing have, quite rightly, singled out the regular provision of title pages as the most significant new feature associated with the printed book format" (106). On the origins and early development of the title page in the last quarter of the fifteenth century, see Margaret M. Smith, *The Title-Page: Its Early Development, 1460–1510* (London: British Library, 2000).

20. Though it is often hard to determine who was responsible for book titles in the first centuries of print, Shevlin cites an authorial complaint of 1625 about the "foolish titles" with which booksellers try to make their works "saleable" in order to argue that the commercial interests of publishers initially trumped the intellectual or aesthetic aims of writers. Only in the last decades of the seventeenth century, she suggests, did the titles of English books begin to be regarded as the author's province ("'To Reconcile Book and Title,'" 53, 57).

21. The Berlin Royal Gallery, which opened in 1830 under the direction of G. F. Waagen, appears to have been an exception. Testifying in 1835 before a parliamentary committee concerned with the founding of the National Gallery in London, Waagen reported that his institution offered not only a catalogue raisonné and a short catalogue for visitors but a "little paper" on the wall with the name of the artist and "subject of each picture, and the date, arranged under the head of the school." Though the committee recommended following this practice at the National Gallery, its proposal does not seem to have been adopted. See Gregory Martin, "The Founding of the National Gallery in London," *Connoisseur* 187, no. 753 (November 1972): 205, and no. 754 (December 1972): 278.

22. Mary-Anne Staniszewski, *The Power of Display: A History of Exhibition Installations at the Museum of Modern Art* (Cambridge, MA: MIT Press, 1998), 62–70. Like others, Staniszewski credits Alfred H. Barr, Jr., MoMA's influential first director, with radically changing how modern pictures are displayed. Though Barr's opening show at the museum in 1929 had already dispensed with the practice of hanging pictures above one another known as "skying," the didactic wall labels for which he became famous apparently didn't become standard practice until the mid-1930s (62). For the earlier experiments at the Grosvenor, opened by Sir Coutts and Lady Lindsay in 1877, see Colleen Denney, "The Grosvenor Gallery as Palace of Art: An Exhibition Model," in *The Grosvenor Gallery: A Palace of Art in Victorian England*, ed. Susan P. Casteras and Denney (New Haven, CT: Yale University Press, 1996), esp. 21–24.

23. By saying that our temporal experience of paintings is not conventionally structured, I don't mean to deny our inclination to "read" them in the direction that we are accustomed to reading texts (so that readers of English, for example, ordinarily scan an image from left to right) or to question an artist's capacity to influence the order in which our eyes travel through a picture. But unlike our reading of verbal works, our viewing of pictures is not constrained by such sequences.

24. Peter Campbell, "At the National Gallery: Picasso's Borrowings," *London Review of Books* 31, no. 6 (2009): 36.

25. This is essentially the premise of Welchman, *Invisible Colors*, as well as of Leo H. Hoek, *Titres, toiles et critique d'art: Déterminants institutionnels du discours sur l'art au dix-neuvième siècle en France* (Amsterdam: Rodopi, 2001), though the latter does begin with a useful survey of titling at the French Academy in earlier periods. While I do not find the theoretical framework of either study particularly helpful, I am indebted to both books for the seriousness with which they approach the subject, and for many valuable leads in the material.

26. I quote from Arthur C. Danto's review of Welchman's *Invisible Colors* in *Artforum International* 36, no. 3 (1997): 14.

27. Hoek, *Titres*, 137, 352. At other points Hoek contrasts modernist titles with what he calls "the traditional narrative title," by which he presumably means the titles of academic history painting (157, 352).

28. During Whistler's lifetime the painting was exhibited under several variants of this formula, including *Arrangement in Black (Portrait of the Artist's Mother)* and *Portrait of the Artist's Mother* (with no "arrangement" in the title at all). There is, however, at least one exception to the rule: in 1883 it was apparently shown at the Paris Salon as *Portrait de ma mère*. See Andrew McLaren Young, Margaret MacDonald, Robin Spencer, with the assistance of Hamish Miles, *The Paintings of James McNeill Whistler*, 2 vols. (New Haven, CT: Yale University Press, 1980), 1:60.

29. C. S. Matheson, "'A Shilling Well Laid Out': The Royal Academy's Early Public," in *Art on the Line: The Royal Academy Exhibitions at Somerset House, 1780–1836*, ed. David H. Solkin (New Haven, CT: Yale University Press, 2001), 48.

30. Bryson, *Word and Image*, 5.

CHAPTER 1 Before Titles

1. For *Untitled* as a kind of direction or instruction, see Arthur C. Danto, *The Transfiguration of the Commonplace: A Philosophy of Art* (Cambridge, MA: Harvard University Press, 1981), 2–3; and E. H. Gombrich, "Image and Word in Twentieth-Century Art," *Word & Image* 1 (1985): 225. For more general remarks on the inescapably verbal context to which *Untitled* pays tribute, see Adams, "Titles, Titling, and Entitlement To," 13; Mary Price, *The Photograph: A Strange, Confined Space* (Stanford, CA: Stanford University Press, 1994), 71; and Hoek, *Titres*, 182.

2. Gombrich, "Image and Word," 216.

3. This is not to say that all Italian art before the eighteenth century was commissioned. Recent research has identified a considerable market for paintings purchased directly on the street or from dealers in seventeenth-century Rome, as well as a nascent retail market for work produced on spec as early as the second half of the fifteenth century in Florence. See Neil De Marchi and Hans J. Van Miegroet, "The History of Art Markets," in *Handbook of the Economics of Art and Culture*, vol. 1, ed. Victor A. Ginsburgh and David Throsby (Amsterdam: Elsevier North-Holland, 2006), 103, 108.

4. Bernard Berenson, *Aesthetics and History in the Visual Arts* (New York: Pantheon, 1948), 232. I owe this quotation to Creighton E. Gilbert, "What Did the Renaissance Patron Buy?" *Renaissance Quarterly* 51 (1998): 392.

5. Dale Kent, *Cosimo de' Medici and the Florentine Renaissance: The Patron's Oeuvre* (New Haven, CT: Yale University Press, 2000), 5, 331–32, 39ff.

6. Michelle O'Malley, *The Business of Art: Contracts and the Commissioning Process in Renaissance Italy* (New Haven, CT: Yale University Press, 2005), 8–9, 12, 171–96. O'Malley's contracts cover the period from 1285 to the 1530s.

7. As quoted by Charles Hope, "Artists, Patrons, and Advisers in the Italian Renaissance," in *Patronage in the Renaissance*, ed. Guy Fitch Lytle and Stephen Orgel (Princeton, NJ: Princeton University Press, 1981), 316. On this episode, see also Gilbert, "What Did the Renaissance Patron Buy?" 427.

8. Hope, "Artists, Patrons, and Advisers," 293; Gilbert, "What Did the Renaissance Patron Buy?" 433. Isabella's elaborate instructions to Perugino are often cited as evidence of the patron's dominant role in subject making, but as Hope points out, even Isabella herself was inconsistent on this score: two years earlier she had invited Leonardo da Vinci to choose his own subject in an effort to persuade him to paint for her (310); and when Giovanni Bellini declined to accept her instructions for some work in 1506, she professed herself "content to leave the subject to his judgment, so long as he paints some ancient story or fable or shows something of his own invention representing an antique subject with a beautiful meaning" (309).

9. Francis Haskell, *Patrons and Painters: A Study in the Relations between Italian Art and Society in the Age of the Baroque* (1980; rev. ed. New Haven, CT: Yale University Press, 1998), 10.

10. O'Malley, *The Business of Art*, 253. As Kent observes of Cosimo's Florence, "Nowadays scholars must painstakingly reconstruct the repertoire of symbols and forms, both Christian and classical, which was familiar and immediately recognizable to a fifteenth-century audience" (*Cosimo de' Medici*, 21).

11. Haskell, *Patrons and Painters*, 256.

12. As translated and quoted by Hope, "Artists, Patrons, and Advisers," 334–35.

13. Haskell, *Patrons and Painters*, 227.

14. O'Malley, *The Business of Art*, 253.

15. See John C. O'Neal, "Nature's Culture in Du Bos's *Réflexions sur la poésie et sur la peinture*," in *Art and Culture in the Eighteenth Century: New Dimensions and Multiple Perspectives*, ed. Elise Goodman (Newark: University of Delaware Press, 2001), 17–18.

16. Abbé [Jean-Baptiste] Du Bos, *Réflexions critiques sur la poésie et sur la peinture* (Paris: École nationale supérieure des beaux-arts, 1993), 36. The *Réflexions* also appeared in England within the author's lifetime as *Critical Reflections on Poetry, Painting and Music . . .*, trans. Thomas Nugent, 3 vols. (London, 1748).

17. Du Bos, *Réflexions critiques*, 30, 36, 37, 36.

18. Ibid., 30.

19. Ibid., 30–31.

20. Gombrich, "Image and Word," 216. Though I have found this essay immensely helpful, I obviously disagree with its central premise: that "only in the twentieth century" did "the relation between images and words, between works of art and their captions or titles . . . become a problem" (213).

21. Meyer Schapiro, *Words, Script, and Pictures: Semiotics of Visual Language* (New York: George Braziller, 1996), 183–84. For a helpful overview of pictorial inscriptions, see Mieczysław Wallis, "Inscriptions in Paintings," trans. Olgierd Wojtasiewicz, *Semi-*

otica 9 (1973): 1–28. On the emblem tradition, see John Manning, *The Emblem* (London: Reaktion, 2002).

CHAPTER 2 Dealers and Notaries

1. For selected studies, see the essays gathered in Michael North and David Ormrod, eds., *Art Markets in Europe, 1400–1800* (Aldershot, UK: Ashgate, 1998). For a recent overview, see also De Marchi and Van Miegroet, "History of Art Markets," 69–122.

2. Haskell, *Patrons and Painters*, esp. 3–14; Volker Reinhardt, "The Roman Art Market in the Sixteenth and Seventeenth Centuries," in North and Ormrod, *Art Markets in Europe*, 83; Rudolf and Margot Wittkower, *Born under Saturn: The Character and Conduct of Artists: A Documented History from Antiquity to the French Revolution* (New York: Random House, 1963), 19; Gilbert, "What Did the Renaissance Patron Buy?" 407–8.

3. Gilbert, "What Did the Renaissance Patron Buy?" 407.

4. Wittkower, *Born under Saturn*, 19–22. For a detailed study of the phenomenon, see John Michael Montias, *Le marché de l'art aux Pays-Bas (XVᵉ–XVIIᵉ siècles)* (Paris: Flammarion: 1996). Cf. also Michael North, *Art and Commerce in the Dutch Golden Age*, trans. Catherine Hill (New Haven, CT: Yale University Press, 1997), esp. 82–105.

5. Montias, *Le marché de l'art*, 45–46; Larry Silver, *Peasant Scenes and Landscapes: The Rise of Pictorial Genres in the Antwerp Art Market* (Philadelphia: University of Pennsylvania Press, 2006), 1.

6. Niels von Holst, *Creators, Collectors, and Connoisseurs: The Anatomy of Artistic Taste from Antiquity to the Present Day* (New York: G. P. Putnam's Sons, 1967), 75.

7. Arthur Danto, "The Artworld," *Journal of Philosophy* 61 (1964): 580, 584.

8. Howard S. Becker, *Art Worlds* (Berkeley: University of California Press, 1982), x, 198.

9. Danto, "Artworld," 577–79. Danto later elaborates this argument in *The Transfiguration of the Commonplace*, where he contends that "it is analytical to the concept of an artwork that there has to be an interpretation" (124), and implies that different interpretations therefore constitute different works of art.

10. There is some evidence that Danto is committed to a theory of intention which makes after-the-fact titles problematic. I will return to this question when I take up his reading of Pieter Bruegel's *Landscape with the Fall of Icarus* later in the book.

11. This list forms part of the estate inventory of Dirck Claesz. van der Minne (d. 20 July 1657), as given by John Michael Montias, *Vermeer and His Milieu: A Web of Social History* (Princeton, NJ: Princeton University Press, 1989), 312 (appendix B, no. 270). The dead man was a master felt-maker and hat merchant, as well as a stepbrother of Vermeer's father (10–11, 63). Here as elsewhere, I am greatly indebted to Montias's patient work in the archives.

12. As Nelson Goodman might argue, even the ability to identify a picture of a musician depends on learning certain codes—from the local costumes and instruments of music making to the convention by which a particular arrangement of pigments on a two-dimensional surface is understood to represent the human figure. See Goodman, *Languages of Art: An Approach to a Theory of Symbols*, 2nd ed. (Indianapolis: Hackett, 1976), esp. 3–43. Though Goodman would contend that the sort of pictorial realism developed in the seventeenth-century Netherlands is as thoroughly conventional as any

other sign system, my own position here is closer to Gombrich's: "If we grade the so-called conventions of the visual image according to the relative ease or difficulty with which they can be learned, the problem shifts on to a very different plane." As Gombrich argues, we appear to be biologically programmed so that we respond more easily to some configurations than others—among which he includes the shape of the human body. Even animals, he notes, respond to objects outlined on a two-dimensional surface, despite the fact that outlines are, strictly speaking, unnatural; and "what else is a decoy duck or the angler's bait than an image securing the reaction of another creature?" See E. H. Gombrich, "Image and Code: Scope and Limits of Conventionalism in Pictorial Representation," in *Image and Code*, ed. Wendy Steiner (Ann Arbor: University of Michigan Press, 1981), 11–42; quotations from 17, 20.

13. For a detailed account of this world (whose population numbered only about twenty-five thousand at midcentury), see Montias, *Vermeer and His Milieu*.

14. Silver, *Peasant Scenes and Landscapes*, 2. By emphasizing how the pictorial experiments of the Netherlands gradually evolved into what we now recognize as the genre of landscape, Silver partly seeks to counter an earlier argument by Gombrich that appeared to privilege Italian theory over Northern practice. Claiming that "it is in Venice, not in Antwerp, that the term 'a landscape' is first applied to any individual painting," Gombrich contended that the genre developed only when Renaissance Italy articulated a demand for such painting—a demand he in turn identified with the revival of an idea of "pure" landscape already implicit in Pliny. "To put it as concretely as possible," Gombrich wrote, "how could anyone demand landscape paintings unless the concept and even the word existed?" (E. H. Gombrich, "The Renaissance Theory of Art and the Rise of Landscape," in *Norm and Form: Studies in the Art of the Renaissance* [London: Phaidon, 1966], 109). In placing a welcome emphasis on Northern developments, Silver occasionally seems to imply that visual innovations altogether preceded verbal formulae; but in citing evidence that the word for landscape appeared in a contract drawn up in Haarlem more than a quarter century before the instance reported by Gombrich, he instead suggests how genres are constituted by a reciprocal relation between word and image—a relation whose origins prove impossible to trace (*Peasant Scenes and Landscapes*, 249n5). On the other side of the dispute, even Gombrich acknowledges that landscape "in some form" already existed in Northern painting and that the Italian idea was rather "a frame" into which such works could be fit ("Renaissance Theory of Art," 114).

15. Compare Montias's observation about the Delft archives: "I suspect (but cannot prove by any concrete examples) that many paintings painted in the 1610s or 1620s were first recorded in inventories as 'a Tobias' or 'Burning of Troy' and were later called 'a landscape' or 'a conflagration.'" (The journey of the biblical Tobias, usually accompanied by the angel Raphael, was a frequent subject of seventeenth-century painting.) If this is true, he goes on note, the inventories document not just changing fashions in subject matter, but shifts in perception. See John Michael Montias, *Artists and Artisans in Delft: A Socio-Economic Study of the Seventeenth Century* (Princeton, NJ: Princeton University Press, 1982), 244.

16. Simon Schama, *The Embarrassment of Riches: An Interpretation of Dutch Culture in the Golden Age* (1987; rpt. New York: Vintage, 1997), 318.

17. Montias, *Le marché de l'art*, 30–32. Compare Haskell's markedly different account of the economic climate for art in seventeenth-century Italy. While the role of dealers,

foreign travelers, and other intermediaries increased over the course of the century, Italian artists "usually disliked the freedom of working for unknown admirers, and with a few notable exceptions exhibitions were assumed to be the last resort of the unemployed" (*Patrons and Painters*, 6).

18. Montias, *Artists and Artisans in Delft*, 271, 192–93.

19. Montias argues that the repetitiveness of generic formulae yielded "economies of scale" and that it was typically fast workers who chose to proceed in this way; those who painted more laboriously, by contrast, preferred working to order (*Le marché de l'art*, 34–35). See also Silver, *Peasant Scenes and Landscapes*, who compares such generic specialization to the establishment of a "brand name" (xiv).

20. It is also to the sheer volume of the Netherlandish art market in this period that we owe our habit of referring to the individual oil or watercolor as an "easel" painting. Though the practice of resting an independent panel on a physical support long antedated the Dutch Golden Age, it was only when mobile images began to be bought and sold on a large scale that a Dutch word originally meaning donkey—*ezel* or *esel*—began to be used in this transferred sense and swiftly acquired cognates in both English and German as well. For a helpful summary of this history, see Amy Powell, "Painting as Blur: Landscapes in Paintings of the Dutch Interior," *Oxford Art Journal* 32 (2010): 145–47.

21. John Michael Montias, "How Notaries and Other Scribes Recorded Works of Art in Seventeenth-Century Sales and Inventories," *Simiolus: Netherlands Quarterly for the History of Art* 30 (2003): 217–35; quotation from 235.

22. Interview with Giorgio Morandi, in Edouard Roditi, *Dialogues: Conversations with European Artists at Mid-Century* (San Francisco: Bedford Arts, 1990), 106–7. Conducted in Italian in 1958, the interview was translated into English by Roditi and subsequently corrected by Morandi from an Italian translation of Roditi's transcript.

23. See Paul Crenshaw, *Rembrandt's Bankruptcy: The Artist, His Patrons, and the Art World in Seventeenth-Century Netherlands* (Cambridge: Cambridge University Press, 2006).

24. Montias, *Artists and Artisans in Delft*, 58, 221–22; Zirka Zaremba Filipczak, *Picturing Art in Antwerp, 1550–1750* (Princeton, NJ: Princeton University Press, 1987), 65. Montias reports that this began to change in the 1640s and 1650s, when a growing emphasis on painting as art rather than craft made the practice of attribution more common (227).

25. Montias, *Artist and Artisans in Delft*, 221–22; Montias, "How Notaries and Other Scribes Recorded Works of Art," 218–19. According to the latter work, the most detailed descriptions of individual items appear in the inventories of insolvent debtors, presumably to protect the financial interests of their creditors (219).

26. John Michael Montias, "Art Dealers in the Seventeenth-Century Netherlands," *Simiolus: Netherlands Quarterly for the History of Art* 18 (1988): 244–56. Surviving correspondence between dealers in France and Spain and their counterparts in Antwerp indicates that the former sometimes ordered up particular kinds of subjects to suit local markets; and to that degree, at least, they indirectly commissioned work as well as circulated it. Presumably neighborhood dealers could also exert this kind of influence on an artist's production. See John Michael Montias, "The Sovereign Consumer: The Adaptation of Works of Art to Demand in the Netherlands in the Early Modern Period," in

Artists—Dealers—Consumers: On the Social World of Art, ed. Ton Bevers (Verloren: Hilversum, 1994), esp. 68–73.

CHAPTER 3 Early Cataloguers

1. The pioneering work on the Dutch inventories is Abraham Bredius, *Künstlerinventare: Urkunden zur Geschichte der Holländischen Kunst des XVI^ten, XVII^ten, und XVIII^ten Jahrhunderts*, 8 vols. (The Hague: Martinus Nijhoff, 1915–22).

2. For a brief account of the Dutch auction catalogues, see the introduction to Burton B. Fredericksen et al., *Corpus of Paintings Sold in the Netherlands during the Nineteenth Century, 1801–1810* (Los Angeles: The Provenance Index of the Getty Information Institute, 1998), ix.

3. For dates and other information about the early auction catalogues, I have drawn on the online database known as SCIPIO.

4. Although Paris and London dominated the international market, the Dutch remained active locally, buying and selling art produced almost exclusively within the borders of the Netherlands (Fredericksen, *Corpus of Paintings*, ix). Especially in the latter half of the century, the Germans also began to make their own contributions to the art of the catalogue. Goethe, who enjoyed frequenting auctions, was a serious collector of such documents (Thomas Ketelsen, "Art Auctions in Germany during the Eighteenth Century," in North and Ormrod, *Art Markets in Europe*, 144–45).

5. Richard Wrigley, *The Origins of French Art Criticism: From the Ancien Régime to the Restoration* (Oxford: Clarendon, 1993), 78, 159. From midcentury to the 1780s, according to Wrigley, sales of the *livret* more than doubled.

6. Unlike the French, the Royal Academicians always charged admission to their exhibits. After 1798, they also levied an additional charge for the catalogue, rather than including it in the price of entry. See Sidney C. Hutchinson, *The History of the Royal Academy, 1768–1986* (London: Robert Royce, 1986), 57.

7. Francis Haskell, *The Ephemeral Museum: Old Master Paintings and the Rise of the Art Exhibition* (New Haven, CT: Yale University Press, 2000), 12–14.

8. Wolfgang Prohaska, *Kunsthistorisches Museum, Vienna: The Paintings* [trans. Judith Hayward] ([Munich]: C. H. Beck, 1997), 12.

9. Carol Duncan and Alan Wallach, "The Universal Survey Museum," *Art History* 3 (1980): 455; and Andrew McClellan, *Inventing the Louvre: Art, Politics, and the Origins of the Modern Museum in Eighteenth-Century Paris* (Cambridge: Cambridge University Press, 1994), 79–80.

10. For the relevant history, see Yveline Cantarel-Besson, *La naissance du musée du Louvre: La politique muséologique sous la Révolution d'après les archives des musées nationaux*, 2 vols. (Paris: Éditions de la Réunion des musées nationaux, 1981); and McClellan, *Inventing the Louvre*. For the catalogue itself, see Marie-Martine Dubreuil, "Le catalogue du Muséum français (Louvre) en 1793," *Bulletin de la Société de l'histoire de l'art français* (2001): 125–65.

11. Fredericksen, *Corpus of Paintings*, x.

12. On the history of the Salon public, particularly as it challenged an earlier conception of elite culture, see Thomas E. Crow, *Painters and Public Life in Eighteenth-Century Paris* (New Haven, CT: Yale University Press, 1985), esp. 1–22 and 104–33.

13. Burton B. Fredericksen et al., *The Index of Paintings Sold in the British Isles during the Nineteenth Century, 1801–1805 / The Provenance Index of the Getty Art History Information Program* (Santa Barbara, CA: ABC-Clio, 1988), xiv.

14. Franco Moretti, "Style, Inc. Reflections on Seven Thousand Titles (British Novels, 1740–1850)," *Critical Inquiry* 36 (2009): 134–58. Moretti, who focuses exclusively on the British case, attributes this process to the crowding of the market for new novels, with long titles taking up unnecessary space in advertisements and the catalogues of circulating libraries. In his crisp formula, "The market expands, and titles contract" (141). But by calling attention to the fact that even before the genre took off in the nineteenth century, some notable French novels tended to have comparatively short titles, Katie Trumpener alerts us to the possibility that other conventions may also be in play. See her "Paratext and Genre System: A Response to Franco Moretti," in the same issue, esp. 167–69. Cf. also Gérard Genette, who remarks the general tendency of titles to shrink over time—he calls it "title drift"—in "Structure and Functions of the Title in Literature," *Critical Inquiry* 14 (1988): 703–5.

15. I draw this account of how the reference of proper names is perpetuated from Saul A. Kripke, *Naming and Necessity,* rev. ed. (Cambridge, MA: Harvard University Press, 1980), esp. 91–92 and 96–97.

CHAPTER 4 Academies

1. "Séance du 21 floréal" [10 mai 1796], as reproduced in Cantarel-Besson, *La naissance du musée du Louvre,* 2:66. For the formation of the Conservatoire and the history of the temporary exhibition in the Salon, see McClellan, *Inventing the Louvre,* 104–8, 126–27.

2. *Collection des livrets des anciennes expositions depuis 1673 jusqu'en 1800* [ed. Jules Joseph Guiffrey] (Paris: Liepmannssohn et Dufour, 1869–72), no. 18 (1755): 10.

3. Ibid., no. 7 (1740): 10.

4. Crow, *Painters and Public Life,* 16–17.

5. J[ules] J[oseph] Guiffrey, *Table générale des artistes ayant exposé aux salons du xviii^e siècle, suivie d'une table de la bibliographie des salons, précédée de notes sur les anciennes expositions et d'une liste raisonnée des salons de 1801 à 1873* (Paris: J. Baur, 1873), xviii. The *livret* itself makes no mention of such an experiment.

6. *Procès-verbaux de l'Académie royale de peinture et de sculpture, 1648–1793,* ed. Anatole de Montaiglon, 10 vols. (Paris: Société de l'histoire de l'art français, 1875–92), 6:257–59. The subject was also taken up again at a subsequent meeting several months later (6:277). Coypel did note that he had attached cartouches with appropriate inscriptions to some pictures painted for the king, without anyone's being the worse for it.

7. Guiffrey, *Table génerale des artistes,* xviii.

8. *Collection des livrets,* no. 11 (1745): 5. Cf. Wrigley, who cites a parody of 1783 that purports to come from a viewer outraged because pictures that he had first read about in the *livret* never actually appeared in the Salon itself (*Origins of French Art Criticism,* 56n108).

9. The authors of some eighteenth-century *livrets* are identified at the close of the volumes, but the practice is erratic. According to Robert W. Berger, the text of the *livret* was also reviewed before publication by the director of buildings, who "actively inspected" the works themselves and had the authority to reject any that might provoke

scandal. See Berger, *Public Access to Art in Paris: A Documentary History from the Middle Ages to 1800* (University Park: Pennsylvania State University Press, 1999), 166.

10. *Collection des livrets*, no. 17 (1753): 21.

11. Ibid., no. 15 (1750): 19.

12. *Procès-verbaux de l'Académie royale*, 1:4, 234.

13. Ibid., 2:212–13.

14. Ibid., 2:301, 304, 306.

15. The result in Watteau's case was the painting now generally known as *The Embar-kation for Cythera*, a work whose precise subject continues to be a matter of controversy. The published minutes say only that the piece represents "une feste galante," but the work's nineteenth-century editor reports that this replaces an earlier phrase in which the painting was said to represent "*le Pèlerinage à l'isle de Cythère*" (*Procès-verbaux de l'Académie royale*, 4:252). Since it is not clear when the earlier phrase was blotted out, the question of just how the painting was originally understood—and by whom—is unfortunately not settled by this record.

16. This new rule does not speak of titling as such, but rather requires artists who fail to submit notice of their works in advance to put "leurs noms, la note et l'explication au bas desdits ouvrages." Presumably "la note et l'explication" would take the form of the announcement that would otherwise have been submitted ahead of time. *Procès-verbaux de l'Académie royale*, 10 (1790): 60.

17. For a brief account of the relevant history, see Gérard-Georges Lemaire, *Histoire du Salon de peinture* (Paris: Klincksiek, 2004), 67–80.

18. *Collection des livrets*, no. 39 (1796): 9–10.

19. Ibid., no. 40 (1798): 9–10.

20. *True Briton*, 3 March 1798. For the earlier language, see, e.g., the classified ad in the *Public Advertiser*, 17 March 1769. As best I can tell from the online database of eighteenth-century British newspapers in the Burney Collection, the advertisement for 1798 is the first to record the new wording. I wish to thank Mark Pomeroy, the present archivist of the Royal Academy, for directing me to this evidence.

21. In 1684 members of the French Academy, who had hitherto refrained from ex-hibiting their works for sale "in order to elevate themselves above the *Maistrise* [paint-er's guild]," briefly agreed to lift the restrictions, provided a would-be exhibitor first re-quested formal permission from the group as a whole (*Procès-verbaux de l'Académie royale*, 2:292). One such permission was in fact granted at the next meeting, only to be rescinded together with the entire decision three years later (2:293, 351).

22. "Notice to Exhibitors," *The Exhibition of the Royal Academy of Arts* (London: Wil-liam Clowes and Sons, 1875), 3; (1885), 2. The arrangers of the 1819 exhibit were the first to include such a notice at the head of the catalogue, rather than simply publishing it in the newspapers.

CHAPTER 5 Printmakers

1. *Procès-verbaux de l'Académie royale*, 5 (1737): 222.

2. For a useful summary of engraving's early history in the Académie, see Susanne Anderson-Riedel, *Creativity and Reproduction: Nineteenth Century Engraving and the Academy* (Newcastle Upon Tyne: Cambridge Scholars Publishing, 2010), 1–9. Despite their official acceptance as academicians in 1655, Anderson-Riedel argues, engravers

were not fully recognized as the peers of painters and sculptors until the nineteenth century.

3. *Procès-verbaux de l'Académie royale*, 5:267, 290.

4. See *Collection des livrets*, no. 26 (1771): 47; no. 29 (1777): 49; no. 39 (1796): 46.

5. *Procès-verbaux de l'Académie royale*, 5:337.

6. If one focuses less on the word *titre* than on the habit of recording prints by the language inscribed on them, then the practice began at least two years earlier, when the secretary started characterizing some images as "appelé" (called) one thing or another. See *Procès-verbaux de l'Académie royale*, 5:157–58, 168, 175, 177, 192–93.

7. Mitchell, *Picture Theory*, 89n9.

8. David Landau and Peter Parshall, *The Renaissance Print, 1470–1550* (New Haven, CT: Yale University Press, 1994), 165–66. I am also indebted to Rebecca Zorach and Elizabeth Rodini, et al., *Paper Museums: The Reproductive Print in Europe, 1500–1800* (Chicago: David and Alfred Smart Museum of Art, 2005); and for the French case in particular, to Anne L. Schroder, "Genre Prints in Eighteenth-Century France: Production, Market, and Audience," in Richard Rand et al., *Intimate Encounters: Love and Domesticity in Eighteenth-Century France* (Hanover, NH: Hood Museum of Art; Princeton, NJ: Princeton University Press, 1997), 69–86; and Margaret Morgan Grasselli et al., *Colorful Impressions: The Printmaking Revolution in Eighteenth-Century France* (Washington, DC: National Gallery of Art, 2003).

9. Landau and Parshall, *The Renaissance Print*, 166.

10. Nadine M. Orenstein, "Images to Print: Pieter Bruegel's Engagement with Printmaking," in Orenstein et al., *Pieter Bruegel the Elder: Drawings and Prints* (New York: Metropolitan Museum of Art; New Haven, CT: Yale University Press, 2001), 49.

11. Pierre Casselle, *Le commerce des estampes à Paris dans la seconde moitié du 18ème siècle* (Paris: École nationale des Chartes, 1976), 117–19.

12. J[ean] G[eorges] Wille, *Mémoires et journal de J.-G. Wille, graveur du roi, publiés d'après les manuscrits autographes de la Bibliothèque impériale par Georges Duplessis, avec un préface par Edmond et Jules de Goncourt*, 2 vols. (Paris: Jules Renouard, 1857), 1:171–72, 176, 199–200, 347–48, 410, 138, 353, 320.

13. Johann Wolfgang von Goethe, *Elective Affinities*, trans. Elizabeth Mayer and Louise Bogan (South Bend, IN: Gateway Editions, 1963), 187.

14. Wille, *Mémoires*, 1:352, 356, 413, 417.

15. Alexandra M. Korey, "Creativity, Authenticity, and the Copy in Early Print Culture," in Zorach, Rodini, et al., *Paper Museums*, 39.

16. Denis Diderot, "Salon de 1767," in Denis Diderot, *Salons*, ed. Jean Seznec and Jean Adhémar, 4 vols. (Oxford: Clarendon, 1957–67), 3:332.

17. Inge Reist, "The Fate of the Palais Royal Collection: 1791–1800," in *La circulation des oeuvres d'art / The Circulation of Works of Art in the Revolutionary Era, 1789–1848*, ed. Roberta Panzanelli and Monica Preti-Hamard (Rennes: Presses Universitaires de Rennes; Paris: Institut d'histoire de l'art; Los Angeles: Getty Research Institute, 2007), 36.

18. Timothy Clayton, *The English Print, 1688–1802* (New Haven, CT: Yale University Press, 1997), xi–xii, 261–62. Quotation is from the *European Magazine* 21 (1792), as cited by Clayton (262).

19. I except for the moment the occasional practice of effacing the inscription on a print in order to pass it off as an early proof, issued before letters were added and hence

more valuable. For more on the cultural capital associated with such prints, see chapter 9 below.

20. Cf. Shevlin, who calls attention to a related phenomenon in book publishing by noting "the title's ability to circulate without its text in tow" ("'To Reconcile *Book* and *Title*,'" 48).

21. Such announcements became a regular feature of the *Mercure* with the introduction of a separate section, "Prints Newly Engraved," in April 1728, though occasional notices of specific projects had appeared earlier. See Benedict Leca, "An Art Book and Its Viewers: The 'Recueil Crozat' and the Uses of Reproductive Engraving," *Eighteenth-Century Studies* 38 (2005): 637.

22. Clayton, *The English Print*, 119–21, 172.

23. Casselle, *Le commerce des estampes*, 129–36. Casselle limits his study to titles he categorizes as "genres et moeurs" and "mythologie" (132)—comprising between them 40 percent of the prints advertised in the *Journal de la Librairie* for the period.

24. Ibid., 136, 262.

25. Du Bos, *Réflexions critiques*, 31.

26. M. [Pierre-Charles] Lévesque, "Inscription," in M. [Claude-Henri] Watelet and M. Lévesque, *Dictionnaire des arts de peinture, sculpture et gravure*, 5 vols. (Paris: L. F. Prault, 1792), 3:160, 161. I am grateful to Clayton, *The English Print*, 247, for directing me to this passage.

27. See Marianne Roland Michel, *Chardin* [trans. Eithne McCarthy] (London: Thames and Hudson, 1996), 238–43. For an influential account of the painter's work that relies heavily on the evidence of the prints, see Ella Snoep-Reitsma, "Chardin and the Bourgeois Ideals of His Time," *Nederlands Kunsthistorisch Jaarboek* 24 (1973): 147–243. Among those who partly resist her conclusions are Michael Fried, *Absorption and Theatricality: Painting and Beholder in the Age of Diderot* (Berkeley: University of California Press, 1980), 197n102; Michel, *Chardin*, 242–43; and Crow, *Painters and Public Life*, who aptly contrasts the "reticence" of the paintings with the "relentless textualization" of the prints (137).

28. *Collection des livrets*, no. 5 (1738): 29.

29. See Anthony Griffiths, "Greuze et ses graveurs," *Nouvelles de l'estampe* 52/53 (1980): 9–11; and Françoise Arquié-Bruley, "Documents notariés inédits sur Greuze," *Bulletin de la Société de l'histoire de l'art français 1981* (1983): esp. 126–28, 137–39. See also Schroder, "Genre Prints," 77–78.

30. *Collection des livrets*, no. 23 (1765): 26.

31. Robert L. S. Cowley, "Hogarth's Titles in His Progresses and Other Picture Series," *Notes and Queries* 30 (1983): 46; and Judy Egerton, *Hogarth's Marriage A-la-Mode* (London: National Gallery Publications, 1997), 13, 30. There is a partial exception for the prints of *A Rake's Progress* (1735), which carry neither the series title nor individual ones but are instead bordered with verse commentaries by the Rev. Dr. John Hoadly.

32. For the text of the ads, see Ronald Paulson, *Hogarth: His Life, Art, and Times*, 2 vols. (New Haven, CT: Yale University Press, 1971), 1:465.

33. See Cowley, "Hogarth's Titles," 48; and Egerton, *Hogarth's Marriage A-la-Mode*, 13. As Cowley notes, Hogarth himself does not specify that the doctor in the third plate of *Marriage A-La-Mode* is "a quack" (47).

34. William Hogarth, *The Analysis of Beauty, with the rejected passages from the manuscript drafts and autobiographical notes*, ed. Joseph Burke (Oxford: Clarendon, 1955), 209.

CHAPTER 6 Curators, Critics, Friends—and More Dealers

1. On manuscript titles, see Ferry, *Title to the Poem*, 11–12.

2. See the entry for "A Man in Armour," in Christopher Brown et al., *Rembrandt: The Master and His Workshop: Paintings* (New Haven, CT: Yale University Press, 1991), 258–61.

3. John Smith, *A Catalogue Raisonné of the Works of the Most Eminent Dutch, Flemish, and French Painters . . .* , 9 vols. (London: Smith and Son, 1829–42), 7:113, 144–45.

4. For some brief if apt remarks on the subject, including the problem of *The Jewish Bride*, see Svetlana Alpers, *Rembrandt's Enterprise: The Studio and the Market* (1988; rpt. Chicago: University of Chicago Press, 1990), 5–8.

5. Smith, *Catalogue Raisonné*, 4:118, 117; 1:32–34. In the case of the *Paternal Instruction*, however, Smith puzzlingly invokes a mezzotint by Vaillant, while alluding to a variant of the image supposedly engraved by Wille as *L'instruction maternelle* (4:117). For Smith's naming of *Curiosity*, see Walter Liedtke, *Dutch Paintings in the Metropolitan Museum of Art*, 2 vols. (New York: Metropolitan Museum of Art, 2007), 1:76.

6. See the entry for the painting on the Louvre website (http://www.louvre.fr/oeuvre-notices/la-malade-dit-traditionnellement-la-femme-hydropique).

7. W. Bürger [Théophile Thoré], *Musées de la Hollande*, 2 vols. (Paris: Jules Renouard, 1858–60), 1:16, 13, 16. For some subsequent allusions to *La ronde de nuit*, see 1:33, 38, 45, 198, 201, 206, 317; 2:3, 169.

8. See Dubreuil, "Catalogue du Muséum français," 143; and Frédéric Villot, *Notice des tableaux exposés dans les galeries du musée impérial du Louvre, 2ᵉ partie: Écoles allemande, flamande et hollandaise*, 8th ed. (Paris: Charles de Mourgues Frères, 1859), 215. For more on the implications of this secularized title, see Ruth Bernard Yeazell, *Art of the Everyday: Dutch Painting and the Realist Novel* (Princeton, NJ: Princeton University Press, 2008), 19–22.

9. Holst, *Creators, Collectors, and Connoisseurs*, 206.

10. *Notice des tableaux exposés dans le Musée royal* (Paris: Vinchon, 1838), 26, 28–29.

11. Henry G. Clarke, *The National Gallery, Its Pictures and Their Painters: A Hand-Book Guide for Visitors* (London: H. G. Clarke, [1848?]), n.p.

12. As quoted in Pieter van Thiel's entry on "Flora," in Brown et al., *Rembrandt*, 188.

13. Elizabeth A. Pergam, *The Manchester Art Treasures Exhibition of 1857: Entrepreneurs, Connoisseurs and the Public* (Surry, UK: Ashgate, 2011), 275.

14. Van Thiel, "Flora," 190.

15. I owe this observation to Cynthia E. Roman, curator of prints, drawings, and paintings at the Lewis Walpole Library, Yale University.

16. Van Thiel, "Flora," 190–91.

17. J. Bruyn et al., *A Corpus of Rembrandt Paintings*, trans. D. Cook-Radmore, 5 vols. (The Hague: Martinus Nijhoff, 1982–2011), 3:401.

18. Van Thiel, "Flora," 190.

19. Harrison C. White and Cynthia A. White, *Canvases and Careers: Institutional Change in the French Painting World* (New York: John Wiley & Sons, 1965). As the Whites argue, this system placed a still greater emphasis on the portable easel painting, since the growing body of middle-class consumers sought an affordable substitute for the "too-expensive floor-to-ceiling canvases in a luxury mansion" (10). For a partial critique of the Whites' argument, which emphasizes the continued power of the Salon

until the last quarter of the century, see David W. Galenson and Robert Jensen, "Careers and Canvases: The Rise of the Market for Modern Art in the Nineteenth Century," National Bureau of Economic Research Working Paper no. 9123 (2002). Galenson and Jensen contend that the Salon monopoly was broken not so much by individual dealers, who were more apt to follow the market than create it, as by groups of artists exhibiting collectively on the model of the impressionists.

20. Ambroise Vollard, *Souvenirs d'un marchand de tableaux* (Paris: Albin Michel, 1937), 47–48. All ellipses in original.

21. Ibid., 45.

22. For this history, see Ruth Butler, *Hidden in the Shadow of the Master: The Model-Wives of Cézanne, Monet, and Rodin* (New Haven: Yale University Press, 2008), 114–18. My treatment of this episode is partly drawn from my review of Butler's book in the *London Review of Books* 30, no. 20 (23 October 2008), 25–26.

23. W. Bürger [Théophile Thoré], *Salons de W. Bürger, 1861 à 1868*, 2 vols. (Paris: Jules Renouard, 1870), 2:286.

24. As quoted by Butler, *Hidden in the Shadow*, 118.

25. Mary Louise Krumrine et al., *Paul Cézanne: The Bathers* (Basel: Museum of Fine Arts/ Eidolon, 1989), 254n1; and John Rewald, *Cézanne: A Biography* (New York: Abrams, 1986), 45. I owe these citations to Welchman, *Invisible Colors*, 389n2, 147.

26. Pierre Daix et al., *Picasso: The Cubist Years, 1907–1916: A Catalogue Raisonné of the Paintings and Related Works*, trans. Dorothy S. Blair (Boston: New York Graphic Society, 1979), 90, 131, 353.

27. Francis Valentine O'Connor and Eugene Victor Thaw, eds., *Jackson Pollock: A Catalogue Raisonné of Paintings, Drawings, and Other Works*, 4 vols. (New Haven, CT: Yale University Press, 1978), 1:ix, 92. For the anecdote about *Pasiphaë*, see William Rubin, "Pollock as Jungian Illustrator: The Limits of Psychological Criticism," *Art in America* 67, no. 8 (December 1979): 74. See also Welchman, *Invisible Colors*, 407n8.

28. Pablo Picasso, *Picasso on Art: A Selection of Views*, ed. Dore Ashton (New York: Viking, 1972), 97, 153. The phrasing of the first quotation is that of his interviewer, Jaime Sabartés (trans. Angel Flores); the second comes from a 1957 biography by Antonina Vallentin.

29. For a detailed account of the title's history, see William Rubin, "The Genesis of *Les Demoiselles d'Avignon*," in Rubin et al., *Les Demoiselles d'Avignon* (New York: The Museum of Modern Art, 1994), 17–19. This history is further complicated by the fact that the artist's friends, including Salmon himself, first referred jokingly to the picture as "Le Bordel philosophique"—a title that probably originated with Guillaume Apollinaire in allusion to the marquis de Sade's *La philosophie dans le boudoir*. Even after Salmon substituted the public title, "Avignon" may still have evoked a brothel for those in the know, though stories differ as to whether the brothel in question was in the city itself or on an Avignon street in Barcelona. As Rubin notes, "brothels were apparently not uncommon on streets named after Avignon in other large European towns": in the early twentieth century, "andare agli avignonesi" seems to have been Roman slang for going to a brothel (19). Rubin also reports that Picasso once called the painting "Les Filles d'Avignon" and that he continued to refer to the figures in the picture as "filles"—girls—rather than the more polite "demoiselles"—young ladies (18). See also Welchman, *Invisible Colors*, 154–61.

CHAPTER 7 Reading by the Title

1. See, e.g., Danto, *Transfiguration of the Commonplace*: "A title is more than a name; frequently it is a direction for interpretation or reading" (3).

2. For one such objection to the tendency "to turn the visual arts into a 'language' whose grammar and syntax must be 'read,'" see Barbara Maria Stafford, *Artful Science: Enlightenment Entertainment and the Eclipse of Visual Education* (1994; rpt. Cambridge, MA: MIT Press, 1999), 287.

3. Shevlin, "'To Reconcile *Book* and *Title*,'" 67–68. Shevlin focuses on books, but a quick check of government websites in the United States and the United Kingdom confirms that the rule extends to the titles of visual works as well.

4. Kripke, *Naming and Necessity*. In a preface to the 1980 edition, Kripke briefly acknowledges the problem that two or more people may share the same name but argues that it makes no difference to the ordinary use of names as rigid designators (7–15).

5. Guillaume Apollinaire, *The Cubist Painters*, trans. Peter Read (Berkeley: University of California Press, 2004), 11.

6. *Collection des livrets*, no. 4 (1737): 18.

7. For the advertisement, see *Mercure de France*, January 1745, 152.

8. *Collection des livrets*, no. 17 (1753): 21.

9. I quote from Michael Fried's translation of Laugier's remarks in *Absorption and Theatricality*, 11; see also 52–53.

10. Mark Ledbury, *Sedaine, Greuze and the Boundaries of Genre* (Oxford: Voltaire Foundation, 2000), 46–47.

11. Michel, *Chardin*, 198.

12. *Collection des livrets*, no. 17 (1753): 29.

13. *Mercure de France*, March 1755, 152.

14. Anne Leclair, "Les deux *Philosophes* de Rembrandt: Un passion de collectionneurs," *La revue des musées de France, revue du Louvre*, no. 5 (2006): 38, 42; and Bruyn et al., *Corpus of Rembrandt Paintings*, 2:644, which also records a partial list of other engravers on 643–44. Not all of the prints I have seen include a title, but those that do either follow Surugue or adapt him slightly—e.g., an undated English print by Richard Houston (1721?–75) that translates *Un philosophe en méditation* as "The Philosopher in Deep Study."

15. See Dubreuil, "Catalogue du Muséum français," 134; and Villot, *Notice des tableaux*, 214–15.

16. Aloysius [Louis] Bertrand, *Gaspard de la nuit: Fantaisies à la manière de Rembrandt et de Callot*, in Bertrand, *Oeuvres complètes*, ed. Helen Hart Poggenburg (Paris: Honoré Champion, 2000), 105. *Gaspard* was written around 1830 but not published until 1842, a year after the author's death.

17. Théophile Gautier, "Faust de Goethe," in *L'art moderne* (Paris: Michel Lévy Frères, 1856), 207. The review is part of an essay on the theater at Munich first published in 1854.

18. Théophile Gautier, *Guide de l'amateur au Musée du Louvre, suivi de la vie et les oeuvres de quelques peintres* (Paris: G. Charpentier, 1882), 123–24.

19. Aldous Huxley, *Heaven and Hell* (1956), in *The Doors of Perception and Heaven and Hell* (New York: Harper & Row, 1963), 119.

20. Jean Marie Clarke, "Le *Philosophe en méditation* du Louvre: Un tableau signé

'RHL van Rijn' et daté '1632,'" *Revue du Louvre: La revue des musées de France* 40, no. 3 (1990): 194, 199n24; and Bruyn et al., *Corpus of Rembrandt Paintings*, 2:638–44.

21. Bruyn et al., *Corpus of Rembrandt Paintings*, 2:642.

22. Ibid., 641.

23. Clarke, "*Philosophe en méditation*," 191–200. See also Clarke's further comments on the painting at http://www.rembrandt-signature-file.com.

24. Bruyn et al., *Corpus of Rembrandt Paintings*, 2:642, 644; and Clarke, "*Philosophe en méditation*," 197–98.

25. Clarke, "*Philosophe en méditation*," 198, 194.

26. Bruyn et al., *Corpus of Rembrandt Paintings*, 5:196. The author of this reattribution, which suggests that we think of the painting as "art for art's sake," is the general editor of the final volume, Ernst van de Wetering.

27. See http://tsftmol.blogspot.com/2009/01/philosopher-in-meditation.html; and Christopher Braider, *Refiguring the Real: Picture and Modernity in Word and Image, 1400–1700* (Princeton, NJ: Princeton University Press, 1993), 211.

28. Goethe, *Elective Affinities*, 187.

29. George Eliot, "Recollections of Berlin 1854–55," in *The Journals of George Eliot*, ed. Margaret Harris and Judith Johnston (Cambridge: Cambridge University Press, 1998), 251.

30. See Alison McNeil Kettering's entry on the painting in *Gerard ter Borch*, ed. Arthur K. Wheelock, Jr. (Washington, DC: National Gallery of Art, 2004), 114–16 and 204n3.

31. *Collection des livrets*, no. 24 (1767): 41.

32. See Pierre Rosenberg et al., *Chardin, 1699–1779* (Paris: Éditions de la Réunion des musées nationaux, 1979), 212; and Michel, *Chardin*, 118.

33. Vollard, *Souvenirs*, 143.

34. Ibid., 143–44.

35. For a detailed analysis of these works and their development, see Krumrine et al., *Paul Cézanne: The Bathers*.

36. Meyer Schapiro, "The Apples of Cézanne: An Essay on the Meaning of Still-life" (1968), in *Modern Art: 19th and 20th Centuries* (1978; rpt. New York: George Braziller, 1979), 1–38.

37. Theodore Reff, "Cézanne, Flaubert, St. Anthony, and the Queen of Sheba," *Art Bulletin* 44 (1962): 118.

38. Eugène Fromentin, *Les maîtres d'autrefois* (1876), in *Oeuvres complètes*, ed. Guy Sagnes, Bibliothèque de la Pléiade (Paris: Gallimard, 1984), 669.

39. See Reff, "Cézanne, Flaubert," 113–25.

40. Rubin, "Pollock as Jungian Illustrator," 73; William Rubin, "Notes on Masson and Pollock," *Arts* 34, no. 2 (1959): 42; Rubin, "Pollock as Jungian Illustrator," 73–74.

41. Rubin, "Pollock as Jungian Illustrator," 74, 72.

42. Frank O'Hara, *Jackson Pollock* (New York: George Braziller, 1959), 19.

43. Rubin, "Pollock as Jungian Illustrator," 74.

CHAPTER 8　The Power of a Name

1. Danto, *Transfiguration of the Commonplace*, 119.

2. Ibid., 115.

3. The count of poems inspired by the painting comes from Robert D. Denham, *Poets on Paintings: A Bibliography* (Jefferson, NC: McFarland, 2010), 3.

4. Danto, *Transfiguration of the Commonplace*, 115–120.

5. Among the many commentators on the painting and the poetic tradition it inspired, only James A. W. Heffernan, to the best of my knowledge, registers this crucial fact about the picture's title. See his fine discussion of the Auden poem in *Museum of Words: The Poetics of Ekphrasis from Homer to Ashbery* (Chicago: University of Chicago Press, 1993), 146–52.

6. For quotations from the relevant correspondence, see Christina Currie and Dominique Allart, *The Brueg(H)el Phenomenon: Paintings by Pieter Bruegel the Elder and Pieter Brueghel the Younger, with a Special Focus on Technique and Copying Practice*, 3 vols. (Brussels: Royal Institute for Cultural Heritage, 2012), 3:846.

7. H[ippolyte] Fierens-Gevaert, *La peinture au Musée ancien de Bruxelles: Guide historique et critique* (Brussels: G. van Oest, 1913), 93; cf. plate 47. In 1922 a more official publication by the same author, then the chief curator of the museum, listed the painting as *Paysage avec la Chute d'Icare*. See Fierens-Gevaert, *Le Musée royal des beaux-arts de Belgique: Notice historique* (Brussels: M. Weissenbruch, 1922), 41.

8. I draw here on the following: Philippe Roberts-Jones, *Bruegel: La chute d'Icare* (Fribourg: Office du Livre, [1974]); Robert H. Marijnissen et al., *Bruegel: Tout l'oeuvre peint et dessiné* (Paris: Albin Michel, 1988), 378; Pierre Francastel, *Bruegel* (Paris: Hazen, 1995), 92–101; Philippe and Françoise Roberts-Jones, *Pierre Bruegel l'ancien* (Paris: Flammarion, 1997), 286–93; and Manfred Sellink, *Bruegel: The Complete Paintings, Drawings, and Prints* (Ghent: Ludion, 2007), 271. Inventory quotations are from Roberts-Jones, *Bruegel: La chute d'Icare*, 57. On the prints in particular, see also Orenstein et al., *Pieter Bruegel the Elder: Drawings and Prints*, 49, 216–18.

9. Ovid, *Metamorphoses*, trans. A. D. Melville, introduction and notes by E. J. Kenney (1986; rpt. Oxford: Oxford University Press, 1998), 177–78. The passage is bk. 8, lines 216–19.

10. Roberts-Jones, *Bruegel: La chute d'Icare*, 34, and *Pierre Bruegel l'ancien*, 291–92. Cf. also Ethan Matt Kavaler, *Pieter Bruegel: Parables of Order and Enterprise* (Cambridge: Cambridge University Press, 1999), 60.

11. Hoek, *Titres*, 39. Hoek, who refers simply to "*La Chute d'Icare*," calls it "doubtless the best-known example of a title that imperatively directs the reading of the painting" (38). Like Danto, however, he fails to register that the title in question is not the painter's.

12. Émile Verhaeren, "La vie flamande," *Journal de l'Université des annales*, 15 December 1913, 55.

13. W[ystan] H[ugh] Auden, "Musée des Beaux Arts," in *Collected Poems / W. H. Auden*, ed. Edward Mendelson, rev. ed. (London: Faber and Faber, 1994), 179.

14. For a reading very close to my own here, see Heffernan, *Museum of Words*, 148–52.

15. Auden, "Letter to Lord Byron," in *Collected Poems*, 100. I owe the use of these lines in this connection to J. D. McClatchy, *Poets on Painters: Essays on the Art of Painting by Twentieth-Century Poets*, ed. McClatchy (Berkeley: University of California Press, 1988), 127.

16. William Carlos Williams, "Paterson" (1927), in *The Collected Poems of William*

Carlos Williams, ed. A. Walton Litz and Christopher McGowan, 2 vols. (New York: New Directions, 1986–88), 1:263–64.

17. Stephen Cheeke, *Writing for Art: The Aesthetics of Ekphrasis* (Manchester: Manchester University Press, 2008), 114.

18. Williams, "Landscape with the Fall of Icarus," in *Collected Poems* 2:385–86.

19. Cheeke, *Writing for Art*, 109–110. On the shape of the poem, see also Irene R. Fairley, "On Reading Poems: Visual & Verbal Icons in William Carlos Williams' 'Landscape with the Fall of Icarus,'" *Studies in 20th Century Literature* 6 (1981–82): 67–97.

20. Cf. James V. Mirollo, "Bruegel's *Fall of Icarus* and the Poets," in *The Eye of the Poet: Studies in the Reciprocity of the Visual and Literary Arts from the Renaissance to the Present*, ed. Amy Golahny (Lewisburg, PA: Bucknell University Press, 1996), 145.

21. Robert Baldwin, "Peasant Imagery and Bruegel's 'Fall of Icarus,'" *Konsthistorisk Tidskrift* 55 (1986): 101–14; Ethan Matt Kavaler, "Pieter Bruegel's *Fall of Icarus* and the Noble Peasant," *Jaarboek van het Koninklijk Museum voor Schone Kunsten Antwerpen*, 1986, 83–98; and Kavaler, *Pieter Bruegel: Parables of Order and Enterprise*, 57–76. On Bruegel's attentiveness to the dignity of peasant labor more generally, see also Silver, *Peasant Scenes and Landscapes*, esp. 112–32. Recent evidence from infrared reflectography suggests that the indistinct motif in the bushes is probably not a corpse at all but a "'vulgar detail'... of the sort that certain sixteenth-century Flemish painters introduced in their compositions"—in this case, a defecating figure (Currie and Allart, *Brueg(H)el Phenomenon*, 3:854).

22. Ovid, *Sorrows of an Exile: Tristia*, trans. A. D. Melville, with an introduction and notes by E. J. Kenney (Oxford: Clarendon, 1992), 49. The passage is bk. 3, sec. 4a, lines 25–26.

23. Kavaler, *Pieter Bruegel: Parables of Order and Enterprise*, 76.

24. Lyckle de Vries, "Bruegel's *Fall of Icarus*: Ovid or Solomon?" *Simiolus: Netherlands Quarterly for the History of Art* 30 (2003): 18, 8–10, 17–18.

25. Ibid., 18.

26. Mirollo, "Bruegel's *Fall of Icarus* and the Poets," 131. Mirollo also argues that the *Aeneid* should be included among the painter's textual sources, since it is in Virgil's treatment of the myth in book 6 that the themes of "misreading, image envy, and verbal appropriation of the visual" are first adumbrated (140).

27. Dannie Abse, "Brueghel in Naples," *Poetry Review* 79, no. 2 (1989): 26. I am grateful to Elizabeth Bergmann Loizeaux, *Twentieth-Century Poetry and the Visual Arts* (Cambridge: Cambridge University Press, 2008), 77–78, for calling this poem to my attention.

28. Kavaler, *Pieter Bruegel: Parables of Order and Enterprise*, 59. For useful summaries of the debates over attribution, see also Marijnissen et al., *Bruegel: Tout l'oeuvre peint et dessiné*, 378; and Sellink, *Bruegel: The Complete Paintings, Drawings, and Prints*, 271.

29. Currie and Allart, *Brueg(H)el Phenomenon*, 3:844–75.

30. This was essentially the interpretation offered by the Roberts-Joneses, who contended that the presence of Daedalus would detract from the painting's critique of Icarus, as well as render it less plausible that his fall passed unperceived. Rather than a "classic illustration of the myth," Bruegel, by this account, sought "an evocation more profound and humane in its moral." As for the sun's position on the horizon: "illogical

as it seems by comparison to the posthumous version" (i.e., the copy in the Musée van Buuren), it "possesses an evocative intensity that the other lacks in its too obvious relation of cause and effect" (*Pierre Bruegel l'ancien*, 291).

31. Jacques Foucart, "'Bruegeliana' à propos de l'exposition de Bruxelles (1980)," *Revue de l'art*, no. 51 (1981): 62. For Williams's reliance on reproductions, see the editorial note in *Collected Poems*, 2:504.

CHAPTER 9 Many Can Read Print

1. Mark Twain, *Life on the Mississippi* (1883), in *Mark Twain: Mississippi Writings*, ed. Guy Cardwell (New York: Library of America, 1982), 488.

2. Nathaniel Hawthorne, *The French and Italian Notebooks*, ed. Thomas Woodson (Columbus: Ohio State University Press, 1980), 92. The entry is dated from Rome on 20 February 1858.

3. For an early debunking, see M[oses] F[oster] Sweetser, *Guido Reni* (Boston: Houghton, Osgood, 1878), 34–41.

4. W. Bürger [Théophile Thoré], *Salons de T. Thoré: 1844, 1845, 1847, 1848*, 2nd ed. (Paris: Jules Renouard, 1870), 113. "Painting doesn't measure its worth by the sum of *écus* it brings in," the critique continues. "Let's not allow financiers to make the law in the arts."

5. Charles Baudelaire, "Quelques caricaturistes français" (1857), in *Oeuvres complètes*, ed. Claude Pichois, 2 vols., Bibliothèque de la Pléiade (Paris: Gallimard, 1976), 2:556.

6. The immediate source of Olympia's name was presumably a poem by Zacharie Astruc, "La fille des îles," whose opening stanza appeared under the title in the *livret* when the painting was first exhibited at the Salon of 1865. (The poem, which was dedicated to Manet, begins with Olympia's awakening as "the spring enters in the arms of a sweet black messenger.") "Olympe" was also among the pseudonyms adopted by high-class prostitutes that Alexandre Parent-Duchâtelet had catalogued in his influential study of the profession in Paris, first published in 1836. See Phyllis A. Floyd, "The Puzzle of *Olympia*," *Nineteenth-Century Art Worldwide: A Journal of Nineteenth-Century Visual Culture* 3 (2004): http://www.19thc-artworldwide.org/spring04/70-spring04/spring04article/285-the-puzzle-of-olympia.

7. Baudelaire, "Quelques caricaturistes français," 556.

8. These prints are also composite in another sense, since the evidence suggests that the writing of Daumier's captions was typically farmed out to another hand. See Jean Adhémar, *Honoré Daumier* (Paris: Pierre Tisné, 1954), 27–28; and Richard Terdiman, *Discourse/Counter-Discourse: The Theory and Practice of Symbolic Resistance in Nineteenth-Century France* (Ithaca, NY: Cornell University Press, 1985), 180–84.

9. On the relation between word and image before the modern period, I am particularly indebted to Michael Camille, "Seeing and Reading: Some Visual Implications of Medieval Literacy and Illiteracy," *Art History* 8 (1985): 26–49; Lawrence G. Duggan, "Was Art Really the 'Book of the Illiterate'?" *Word & Image* 5 (1989): 227–51; Celia M. Chazelle, "Pictures, Books, and the Illiterate: Pope Gregory I's Letters to Serenus of Marseilles," *Word & Image* 6 (1990): 138–53; and Lina Bolzoni, *The Web of Images: Vernacular Preaching from Its Origins to St Bernardino da Siena*, trans. Carole Preston and

Lisa Chien (Aldershot, UK: Ashgate, 2004). Camille, Duggan, and Chazelle offer instructive critiques of Gregory's dictum, as well as abundant evidence of its continued circulation over the centuries.

10. For a representative statement of the distinction between natural and conventional signs, see the abbé Du Bos: "The signs that painting employs to address us are not arbitrary and constructed [*institués*] signs like the words poetry uses. Painting employs natural signs whose force does not depend on education. . . . Thus the objects that pictures present to us, acting as natural signs, must act more swiftly. The impression that they make on us must be stronger and more sudden than that which verse can make" (*Réflexions critiques*, 133–34). For a particularly helpful discussion of the problems such distinctions raise, see Mitchell, *Iconology*, 75–94. Mitchell himself, however, does not always clearly distinguish between speaking and reading when he sets out to argue that languages are "no less natural than images" (85).

11. Contradictions, of course, abounded; and the old idea that images were more accessible than the written word did not simply disappear with the advent of mass literacy. In mid-nineteenth-century France, for example, a police minister warned against the seditious potential of caricature by calling it "a translation which everyone can understand," unlike a page in a book, which "requires some time to read and a certain degree of intelligence." Cited by Jonathan Gilmore, "Censorship, Autonomy, and Artistic Form," in *Art History, Aesthetics, Visual Studies*, ed. Michael Ann Holly and Keith Moxey (Williamstown, MA: Sterling and Francine Clark Art Institute, 2002), 116.

12. For a lively account of the challenges, see Leah Price, "Reading: The State of the Discipline," *Book History* 7 (2004): 303–20.

13. R[obert] A[llen] Houston, *Literacy in Early Modern Europe: Culture and Education, 1500–1800* (1988; rpt. London: Longman, 1992) provides a useful overview. Though Houston estimates that by 1800 "countries like England, Scotland, the Scandinavian cluster, Germany and north-eastern France could, in their own ways, boast *mass literacy*" (150), others would reserve that designation for the turn of the twentieth century. See, e.g., Reinhard Wittmann, "Was There a Reading Revolution at the End of the Eighteenth Century?" and Martyn Lyons, "New Readers in the Nineteenth Century: Women, Children, Workers," in *A History of Reading in the West*, ed. Guglielmo Cavallo and Roger Chartier, trans. Lydia G. Cochrane (Cambridge: Polity, 1999), 284–344; and David Vincent, *The Rise of Mass Literacy: Reading and Writing in Modern Europe* (Cambridge: Polity, 2000), esp. 1–26. Even Wittmann, however, remarks "a dramatic *relative* increase in the number of readers" in central Europe over the course of the eighteenth century (288).

14. As quoted in Wittmann, "Was There a Reading Revolution," 285. For Britain, see also Stephen Colclough and David Vincent, "Reading," in *The Cambridge History of the Book in Britain, 1830–1914*, ed. David McKitterick (Cambridge: Cambridge University Press, 2009), 281–323: "By the early nineteenth century England and Wales had become societies in which the capacity to decode print was a commonplace" (284–85).

15. [Henri-Gabriel Duchesne and Pierre-Joseph Macquer], *Manuel du naturaliste: Ouvrage dédié à M. de Buffon* . . . (Paris: G. Desprez, 1771), viii. I am grateful to Barbara Stafford for directing me to this work (*Artful Science*, 266).

16. "Beaux-arts: Sur le Muséum des arts de Paris," *La décade philosophique, littéraire et politique; par une société de Républicains* 4, no. 28 (1795): 213–14, 215.

17. Martin, "Founding of the National Gallery," 205, 279; Carmen Stonge, "Making Private Collections Public: Gustav Friedrich Waagen and the Royal Museum in Berlin," *Journal of the History of Collections* 10 (1998): 67–69; and Christopher Whitehead, *The Public Art Museum in Nineteenth-Century Britain: The Development of the National Gallery* (Aldershot, UK: Ashgate, 2005), 151–53.

18. At the National Gallery in London, for example, a single-row display was not achieved until 1887, though the Gallery's first keeper, Charles Lock Eastlake, had begun advocating for it in the 1840s. See Charlotte Klonk, "Mounting Vision: Charles Eastlake and the National Gallery in London," *Art Bulletin* 82 (2000): 331–47.

19. G[eorge] Brown Goode, "The Museums of the Future" (Washington, DC: Government Printing Office, 1891), 427, 433.

20. Some measure of this change in France is evident via a sampling of the number of entries recorded in modern bibliographies of Salon criticism from the period 1699–1870: 1699 (3); 1750 (12); 1800 (54); 1835 (100); 1870 (138). This development is not wholly linear—there are only 73 entries recorded for 1850–51, for example, while the largest number (162) appears in 1863—but the general pattern is clear. See Neil McWilliam et al., *A Bibliography of Salon Criticism in Paris from the Ancien Régime to the Restoration, 1699–1827,* and McWilliam, *A Bibliography of Salon Criticism in Paris from the July Monarchy to the Second Republic, 1831–1851* (Cambridge: Cambridge University Press, 1991); and Christopher Parsons and Martha Ward, *A Bibliography of Salon Criticism in Second Empire Paris* (Cambridge: Cambridge University Press, 1986). In Britain the growth of such writing seems to have come a bit later, but to have been still more dramatic. According to Richard Altick, *Paintings from Books: Art and Literature in Britain, 1760–1900* (Columbus: Ohio University Press, 1985), there were some 20 journalists at the private press view for the Royal Academy in 1848; by 1892, there were at least 300 (197). In *The Literate Eye: Victorian Art Writing and Modernist Aesthetics* (New York: Oxford University Press, 2009), Rachel Teukolsky notes that the *Art-Journal,* founded in 1839 with a circulation of 700, had acquired 25,000 readers by 1851 (13).

21. See Francis Haskell, *The Painful Birth of the Art Book* (1987; rpt. New York: Thames & Hudson, 1988); and Leca, "An Art Book and Its Viewers."

22. Though some inexpensive guides to the National Gallery in London began to offer illustrations (from steel engravings) as early as the 1830s, the official catalogue of 1855, which sold for a penny, included only artists' names, dates, and picture titles. See Giles Waterfield, "The Origins of the Early Picture Gallery Catalogue in Europe, and Its Manifestation in Victorian Britain," in *Art in Museums,* ed. Susan Pearce (London: Athlone, 1995), esp. 56–64. For a helpful survey of technological developments in visual reproduction over the course of the century, see Michael Twyman, "The Illustration Revolution," in McKitterick, *Cambridge History of the Book in Britain, 1830–1914,* 117–43.

23. Haskell, *Ephemeral Museum,* 96. Haskell refers to Berenson's *Venetian Painters of the Italian Renaissance* of 1894, but the pattern continued with his 1896 book on the Florentine painters as well; and even volumes published in the first decade of the twentieth century had only a frontispiece.

24. Bürger, *Musées de la Hollande,* 1:16.

25. John Constable to C. R. Leslie, 20 January 1834, in *John Constable's Correspon-*

dence, ed. R. B. Beckett, 6 vols. (London: Suffolk Records Society, 1962–68), 3:108. I owe this reference to Heffernan, *Cultivating Picturacy*, 142.

26. For Leonardo, see *Leonardo on Painting*, ed. Martin Kemp, selected and trans. Martin Kemp and Margaret Walker (1989; rpt. New Haven, CT: Yale University Press, 2001), 23. Similar claims were advanced by Giovanni Battista Armenini (1586) and Federico Zuccaro (1607), among others. See Duggan, "Was Art Really the 'Book of the Illiterate'?" 236; and Mirollo, "Bruegel's *Fall of Icarus* and the Poets," 138.

27. T[homas] C[oglan] Horsfall, "Painting and Popular Culture," *Fraser's Magazine* 101 (1880); rpt. in *Victorian Painting: Essays and Reviews*, ed. John Charles Olmsted, 3 vols. (New York: Garland, 1980–85), 3:609. Horsfall's assumptions about the relative accessibility of poetry and painting were not always consistent, however. A few years earlier, he had argued for the establishment of an art museum in Manchester on the grounds that people learned best from pictures, which "can be read by many men who can read no written words." See Horsfall, "An Art Museum for Manchester," in *The Art Museum, Manchester* (Manchester: A. Ireland and Co., 1878), 7.

28. P[eter] T[aylor] Forsyth, *Religion in Recent Art: Being Expository Lectures on Rossetti, Burne Jones, Watts, Holman Hunt, and Wagner* (Manchester: Abel Heywood & Son, 1889), 17.

29. Horsfall, "Painting and Popular Culture," 613. For a thorough survey of the literary tradition in British painting, see Altick, *Paintings from Books*.

30. George Moore, "The Failure of the Nineteenth Century," in *Modern Painting* (London: Walter Scott, 1893), 52.

31. Philippe Junod, "Du péché de littérature chez les peintres: Origine et portée d'un débat," *Annales d'histoire de l'art et d'archéologie de l'Université libre de Bruxelles* 16 (1994): 109–27. Junod makes the interesting observation that even when the symbolists reacted against various forms of realism and positivism by invoking ideas generally associated with the literary, they continued to use "littérature" pejoratively, while adopting "poésie" and its variants as terms of praise (119). Though he does not say so explicitly, it is as if they chose to reserve the anathematized term for fiction and other popular writing, while still drawing on the prestige of more inaccessible genres.

32. Charles Baudelaire, "Salon de 1845," in *Oeuvres complètes*, 2:384. A helpful note indicates that "le père" in the poem reproduced in fig. 2–22 is a typographical error for "l'espère" (1278).

33. Baudelaire, "Salon de 1846," in *Oeuvres complètes*, 2:476.

34. Casselle, *Commerce des estampes*, 68; Clayton, *The English Print*, 229.

35. Wille, *Mémoires*, 1:496.

36. Antony Griffiths, *Prints and Printmaking: An Introduction to the History and Techniques* (Berkeley: University of California Press, 1996), 140.

37. Though the idiom first appears in the minutes of the artistic Académie in 1783 (a decade after it surfaces in Wille's unpublished journal), it does not enter the dictionary of the Académie française until the sixth edition, published in 1835. Both *Petit Robert* and *Le trésor de la langue française informatisé* also date the phrase to the 1820s and 1830s. For the reference in the minutes, see *Procès-verbaux de l'Académie royale*, 9:141.

38. Baudelaire, "Salon de 1859," in *Oeuvres complètes*, 2: 614. Cf. Welchman, *Invisible Colors*, 3–7.

39. Émile Zola, "Lettres de Paris" (1875) and "Après une promenade au Salon"

(1881), in *Mon Salon, Manet, Écrits d'art*, ed. Antoinette Ehrard (Paris: Garnier-Flammarion, 1970), 233, 356.

40. Henry James, "Picture Season in London" (1877), rpt. in James, *The Painter's Eye: Notes and Essays on the Pictorial Arts*, ed. John L. Sweeney (1956; rpt. Madison: University of Wisconsin Press, 1989), 148.

41. James Abbott McNeill Whistler, *The Gentle Art of Making Enemies* (Elibron Classics, 2006), 126–27, 25. This is an unabridged facsimile of the 3rd edition, published in London by William Heinemann in 1904.

42. Clement Greenberg, "Towards a Newer Laocoon," *Partisan Review* 7 (1940): 307, 296. For a detailed critique of Greenberg's "unyielding 'Laocoönism'" and its consequences for picture titles, see Welchman, *Invisible Colors*, 286–94, 299–300.

43. Whistler, *Gentle Art*, 127, 126.

44. Wassily Kandinsky, *Concerning the Spiritual in Art and Painting in Particular* (1912), trans. Michael Sadleir et al. (1947; rpt. New York: Wittenborn, 1955), 25; Roland Barthes, "The Wisdom of Art" (1979), in *The Responsibility of Forms: Critical Essays on Music, Art, and Representation*, trans. Richard Howard (1985; rpt. Berkeley: University of California Press, 1991), 184.

CHAPTER 10 Reading against the Title

1. Cf. Wrigley, *Origins of French Art Criticism*: "the most damning reaction to a work of art was a professed inability to grasp the subject even *after* consulting the *livret*" (56).

2. *Collection des livrets*, no. 12 (1746): 15.

3. [Étienne La Font de Saint-Yenne], *Réflexions sur quelques causes de l'état présent de la peinture en France, avec un examen des principaux ouvrages exposés au Louvre le mois d'août 1746* (The Hague: Jean Neaulme, 1747), 75.

4. Crow, *Painters and Public Life*, 7.

5. *Collection des livrets*, no. 17 (1753): 21.

6. [Jean-Bernard, abbé Le Blanc], *Observations sur les ouvrages de MM. de l'Académie de peinture et de sculpture, exposés au Sallon du Louvre, en l'année 1753 . . .* (Paris, 1753), 21–22.

7. Ibid., 5.

8. Thomas Crow, "Diderot's *Salons:* Public Art and the Mind of the Private Critic," in *Diderot on Art*, ed. and trans. John Goodman, 2 vols. (New Haven, CT: Yale University Press, 1995), ix–xix. Published posthumously beginning in 1795, Diderot's *Salons* exerted a strong influence on French art criticism in the nineteenth century.

9. Diderot, *Salons*, 1:65, 200; 2:78, 82–83, 161–62, 164; 3:84, 86, 90–91, 101. I have omitted paragraph breaks within individual extracts. Apart from the entry on *The Encounter of Psyche and the Fisherman*, all ellipses are mine.

10. *Collection des livrets*, no. 23 (1765): 16; Diderot, *Salons*, 2:106.

11. Diderot, *Salons*, 2:162–63.

12. An entry on two paintings by Phillipe-Jacques Loutherbourg at the Salon of 1765—*Des voleurs attaquant des voyageurs dans une gorge de montagnes* and *Les mêmes voleurs pris et conduits par des cavaliers*—begins, "There's nothing to add to the titles [*titres*]; they say everything." Despite the disclaimer, Diderot predictably does have something to add, and the entry continues with a brief description, as well as a passage of direct address to the painter. Two years earlier, he had also used the verb *intituler* when

suggesting that Greuze's *Piété filiale* would be better titled *De la récompense de la bonne éducation donnée.* See Diderot, *Salons*, 2:170; 1:233.

13. For some other examples in this vein, see Hoek, *Titres*, 97–101.

14. "The Royal Academy: The Seventy-first Exhibition, 1839," *Art-Union* 1, no. 4 (May 1839): 68.

15. John Ruskin, *Academy Notes* (1855), in *The Works of John Ruskin*, ed. E. T. Cook and Alexander Wedderburn, 39 vols. (London: George Allen, 1903–12), 14:14.

16. "The Exhibition of the New Society of Painters in Water Colours," *Art-Journal* 18 (June 1856): 180.

17. "Fine Arts: Royal Academy," *Athenaeum*, 9 May 1863, 622.

18. James, "On Some Pictures Lately Exhibited" (1875), in *Painter's Eye*, 95.

19. Juliet was particularly apt to provoke such responses. As Altick observes: "No other heroine in literary art was more critically examined to be sure the painter's portrayal was faithful to the poet's intention—or, what amounted to much the same thing, to the spectator's idea of what she should look like" (*Paintings from Books*, 294–95).

20. For a lively account of contemporary reactions to the paintings, see Justine de Young, "'Housewife or Harlot': Art, Fashion, and Morality in the Paris Salon of 1868," in *Cultures of Femininity in Modern Fashion*, ed. Ilya Parkins and Elizabeth M. Sheehan (Durham: University of New Hampshire Press, 2011), 124–46.

21. J[ules]-J[oseph] Guiffrey, "Le Salon de Paris," *Journal des beaux-arts et de la littérature*, 15 June 1868, 86.

22. Bürger, *Salons . . . 1861 à 1868*, 2:464–65.

23. Zola, "Lettres de Paris: Deux expositions d'art en mai" (1876) and "Le Naturalisme au Salon" (1880), in *Mon Salon*, 258–59, 346, 258–59. I am grateful to Leo Hoek for directing me to these passages (*Titres*, 99–100).

24. Arsène Houssaye, "Salon de 1845: M. Eugène Delacroix," *L'artiste*, 4th ser., 3 (1845): 210. The present label for the painting at the Musée Delacroix implicitly acknowledges Houssaye's bafflement: "If it were not the title given by the painter himself in the Salon *livret*," the label reads, "nothing would enable the identification of the saint."

25. George P. Landow, *William Holman Hunt and Typological Symbolism* (New Haven, CT: Yale University Press, 1979), 104–5.

26. "Fine Arts: Royal Academy," *Athenaeum*, 10 May 1865, 589.

27. "Exhibitions—Royal Academy and British Institution," *Blackwood's Edinburgh Magazine* 50 (1841): 342.

28. "Fine Arts: Royal Academy Exhibition," *Times*, 6 May 1836, 3.

29. [W. H. Leeds], "The Somerset House Annual," *Fraser's Magazine* 12 (1835): 55.

30. [Edward Chatfield], "Poetic Painting and Sculpture," *New Monthly Magazine* 55 (1839): 201.

31. "The Royal Academy: The Seventy-Sixth Exhibition," *Art-Union*, no. 67 (1 June 1844): 162, 154.

32. Linda Merrill, *A Pot of Paint: Aesthetics on Trial in "Whistler v Ruskin"* (Washington, DC: Smithsonian Institution Press, 1992), 145. The quotations come from a transcript of the trial as reconstructed by Merrill from notes taken by a court clerk and contemporary press accounts.

33. Whistler, *Gentle Art*, 44–45 (ellipses in original).

CHAPTER 11 The Force of David's *Oath*

1. "Courbet's 'Profession de Foi' at the Antwerp Congress," in Paul B. Crapo, "Disjuncture on the Left: Proudhon, Courbet and the Antwerp Congress of 1861," *Art History* 14 (1991): 85. Crapo reprints Courbet's speech to this congress as it originally appeared in the *Précurseur d'Anvers* of 22 August 1861; Courbet's boast to his father concerns the *Courrier du dimanche*, which reprinted his remarks on 1 September. See *Letters of Gustave Courbet*, ed. and trans. Petra ten-Doesschate Chu (Chicago: University of Chicago Press, 1992), 201.

2. In 2012 the rules required two labels—a self-adhesive one "firmly fixed" to the back of the work and a tie-on attached by string so that it hung over the front. Though the instructions no longer explicitly warned lest labels be "interchanged and attached to the wrong Works," as they did in 1965, the repeated emphasis on the need to make sure that labels, entry numbers, and works all corresponded still bespoke the same anxiety. I quote from the Academy's websites for the exhibits of 2012 and 2014 and from "Notice to Artists, 1965," *Summer Exhibition* (London: Royal Academy of Arts, 1965), 6.

3. Picasso, *Picasso on Art*, 97. For the sources of these quotations, see chap. 6, n28.

4. O'Connor and Thaw, *Jackson Pollock: A Catalogue Raisonné*, 4:247.

5. "Unframed Space," *New Yorker*, 5 August 1950, 16.

6. John Bernard Myers, "Naming Pictures: Conversations between Lee Krasner and John Bernard Myers," *Artforum* 23 (November 1984): 69, 71.

7. Fisher, *Making and Effacing Art*, 91.

8. For a useful summary of this history, see David Anfam, "Clyfford Still's Art: Between the Quick and the Dead," in *Clyfford Still: Paintings 1944–1960*, ed. James T. Demetrion (Washington, DC: Smithsonian Institution, 2001), 17–19; also the chronology in the same volume (162–65).

9. Welchman, *Invisible Colors*, 114. Welchman begins his book with the impressionists, which partly explains his curious claim about Signac. But even within that restricted purview, Whistler turns out to have anticipated his fellow artist by more than a decade.

10. Paul Gardner, "Do Titles Really Matter?" *Art News* 91, no. 2 (1992): 92. Gardner is quoting Ivan Karp, who worked for Castelli at the time. (No date is given for the incident.) The Warhol anecdote notwithstanding, virtually all the living artists Gardner surveys affirm the importance of titling. "The notion that a painting doesn't need a title is musty today," says Richard Artschwager (95).

11. From an interview with Roland Topor, in Françoise Armengaud, *Titres: Entretiens avec Alechinsky, Arman, Appel, César, Marie-Elisabeth Collet, Corneille, Dolla, Hajdu, Hartung, Helman, Herold, Jenkins, Le Gac, Masson, Philippe, Pol Bury, Pons, Sosno, Soulages, Topor, Anita Tullio, Verdet* (Paris: Meridiens Klincksieck, 1988), 115.

12. *Collection des livrets*, no. 33 (1785): 30; Antoine Schnapper and Arlette Sérullaz, *Jacques-Louis David, 1748–1825* ([Paris]: Réunion des musées nationaux, 1989), 167.

13. All quoted material dates from 1785 and can be found in vol. 14 of the *Collection Deloynes*, cited here by item number in parentheses: anonymous poem in manuscript, inserted into copy of the *Explication des peintures* opposite the entry for David's painting (no. 324); *L'année littéraire*, 776 (no. 349); *Mercure de France*, 758–59 (no. 348); *Observations sur le Sallon de 1785, extraites du Journal général de France*, 5 (no. 339); *Supplément du peintre anglais au Salon*, 2 (no. 328); *Avis important d'une femme sur le Sallon*

de 1785, 29, 31 (no. 344). The entries for *L'année littéraire* and the *Mercure de France* are recorded in manuscript.

14. Thomas Crow, "The *Oath of the Horatii* in 1785: Painting and Pre-Revolutionary Radicalism in France," *Art History* 1 (1978): 424–71. For some skeptical responses to Crow's account, see Académie de France à Rome, *David et Rome* (Rome: De Luca Editore, 1981), 137; and Schnapper and Sérullaz, *Jacques-Louis David*, 167.

15. Letter of 16 April 1789, in Hugues-Adrien Joly, *Lettres à Karl-Heinrich von Heinecken, 1772–1789*, ed. W. McAllister Johnson (Paris: Bibliothèque nationale, 1988), 158.

16. Louis Hautecoeur, *Louis David* (Paris: La table ronde, [1954]), 82–84.

17. Livy, *The Rise of Rome: Books 1–5*, trans. T. J. Luce (Oxford: Oxford World's Classics, 1998), 32, 33. The entire narrative can be found in bk. 1, chaps. 22–26.

18. Alexandre Péron, *Examen du tableau des Horaces* (Paris: Ducessois, 1839), 28. (Sedaine, in whose household the artist lived for a number of years, was David's godfather.)

19. Schnapper and Sérullaz, *Jacques-Louis David*, 162–71. On the list of proposals for the 1783 Salon, see also Barthelemy Jobert, "The 'Travaux d'encouragement': An Aspect of Official Arts Policy in France under Louis XVI," trans. Richard Wrigley, *Oxford Art Journal* 10 (1987): 6–7. On the various preparatory sketches and their dating, see also Pierre Rosenberg and Louis-Antoine Prat, *Jacques-Louis David, 1748–1825: Catalogue raisonné des dessins*, 2 vols. (Milan: Leonardo Arte, 2002), 67–70; and [Marion Diez, ed.], *Jacques-Louis David, 1748–1825* (Paris: Nicolas Chaudun, 2005), 74–81.

20. "I would like to know in which authors M. David has found that the old Horatius took the swords of his three sons to make them swear over," a hostile critic demanded when the painting was reexhibited at the Salon of 1791: "I know of none who mention this fact." See [Phillipe Chery], *Lettres analitiques, critiques et philosophiques, sur les tableaux du Sallon* (Paris, 1791), 54, in *Collection Deloynes* 17, no. 441.

21. *Collection des livrets*, no. 33 (1785): 12.

22. Robert Rosenblum, *Transformations in Late Eighteenth Century Art* (1967; rpt. Princeton, NJ: Princeton University Press, 1974), 70.

23. Joan B. Landes, *Women and the Public Sphere in the Age of the French Revolution* (Ithaca, NY: Cornell University Press, 1988), 152.

24. Edgar Wind, "The Sources of David's *Horaces*," *Journal of the Courtauld and Warburg Institutes* 4 (1941): 124–38. Cf. Anita Brookner, *Jacques-Louis David* (1980; rpt. London: Thames and Hudson, 1987), 71–73. Brookner also notes that a contemporary observer who did see the ballet and complained in detail of the mise-en-scène later commented on David's painting without registering any link (73). For Noverre's battlefield oath, which can already be found in Livy and Dionysius of Halicarnassus, see [Jean Georges] Noverre, *Les Horaces, ballet-tragique . . .* (Paris: Delormel, 1777), 17.

25. Robert Rosenblum, "Gavin Hamilton's 'Brutus' and Its Aftermath," *Burlington Magazine* 103 (1961): 16, 12.

26. *La mort de Cesar, tragédie de M. Voltaire . . .* (Amsterdam, 1735), 24, 25. I owe this connection to Voltaire to Brookner, *Jacques-Louis David*, 78–79.

27. Albert Boime, "Les thèmes du *Serment*: David et la franc-maçonnerie," in *David contre David: Actes du colloque organisé au musée du Louvre par le service culturel du 6 au 10 décembre 1989*, ed. Régis Michel, 2 vols. (Paris: La documentation française, 1993), 1:259–91.

28. *Procès-verbaux de l'Académie royale*, 9:166.

29. See *Memorie per le belle arti* 1 (1785): 138.

30. For more on David's departure from literary sources, see Dorothy Johnson, *Jacques-Louis David: Art in Metamorphosis* (Princeton, NJ: Princeton University Press, 1993), esp. 52–58.

31. Udolpho van de Sandt, "David pour David: 'Jamais on ne me fera rien faire au détriment de ma gloire,'" in Michel, *David contre David*, 1:115–40. My account of David's canny career management in this and subsequent paragraphs is particularly indebted to de Sandt's stimulating article.

32. *Avis important d'une femme*, 29 (*Collection Deloynes* 14, no. 344).

33. Académie de France à Rome, *David et Rome*, 136. On the shift toward artists' proposing their own subjects for these commissions, see Jobert, "'Travaux d'encouragement,'" 7–8.

34. To the marquis de Bièvre, 8 August 1785, in *Documents complémentaires au catalogue de l'oeuvre de Louis David*, ed. Daniel Wildenstein and Guy Wildenstein ([Paris]: Fondation Wildenstein, [1973]), 19.

35. Jobert, "'Travaux d'encouragement,'" 9.

36. Brookner, *Jacques-Louis David*, 63.

37. Hautecoeur, *Louis David*, 73–77; see also Crow, *Painters and Public Life*, 232–33.

38. D. and G. Wildenstein, *Documents complémentaires*, 19.

39. J. H. Wilhelm Tischbein, *Aus meinem Leben*, ed. Carl G. W. Schiller, 2 vols. (Brunswick: Schwetschke und Sohn, 1861), 2:57.

40. D. and G. Wildenstein, *Documents complémentaires*, 19.

41. Tischbein, *Aus meinem Leben*, 2:58.

42. [J. H. Wilhelm Tischbein], "Briefe aus Rom, über neue Kunstwerke jetztlebender Künstler," *Der teutsche Merkur*, February 1786, 183–84.

43. Schnapper and Sérullaz, *Jacques-Louis David*, 162. On the "atelier des Horaces," see also E[tiénne]-J[ean] Delécluze, *Louis David, son école et son temps: Souvenirs* (Paris: Didier, 1855), 1–44.

44. Crow, *Painters and Public Life*, 232; Dorothy Johnson, "Jacques-Louis David, Artist and Teacher: An Introduction," in *Jacques-Louis David: New Perspectives*, ed. Johnson (Newark: University of Delaware Press, 2006), 38–39. See also Antoine Schnapper, "David et l'argent," in Michel, *David contre David*, 2:916–18.

45. Brookner, *Jacques-Louis David*, 50.

46. Johnson, *Jacques-Louis David*, esp. 86–88, 106–8.

47. Luc de Nanteuil, *Jacques-Louis David* (New York: Abrams, 1985), 90.

48. Jacques Lebrun, "Discours prononcé à l'occasion de la plantation de l'Arbre de la liberté," in *Aux armes et aux arts! Peinture, sculpture, architecture, gravure: Journal de la Société républicaine des arts . . .*, ed. [Athanase] Détournelle (Paris, [1794]), 190.

49. See, e.g., Landes, *Women and the Public Sphere*, 154.

50. See, e.g., *Diario ordinario*, 20 August 1785, which described the brothers as swearing "di combattere per la Patria" (D. and G. Wildenstein, *Documents complémentaires*, 19); or the *Memorie per le belle arti* for September 1785, which had them vowing, "o di vincere, o di morire." The latter, it should be said, also referred to their defense of "la Romana libertà" against the three Curatii (136). For another version of the vow to conquer or die, see C[harles] P[aul] Landon, *Annales du musée et de l'école moderne des beaux-arts . . .*, vol. 7 (Paris: C. P. Landon, 1803), 129. In 1839 Alexandre Péron more specifi-

cally imagined the second son addressing his elder brother: "Avec toi Rome est sauvée: si nous mourons, à toi l'honneur de la victoire!" (*Examen du tableau des Horaces*, 6).

51. *Troisième promenade de Critès au Sallon* . . . (London, 1785), 34, 36 (*Collection Deloynes* 14, no. 335). For the identification of this pamphlet with the radical journalist and future Girondist Antoine Gorsas, see Crow, *Painters and Public Life*, 215.

52. See *Collection des livrets*, no. 33 (1785): entry nos. 4, 7, 67–69, 110, 178, 185.

53. Crow, *Painters and Public Life*, 227. Cf. Albert Boime, who also focuses on a particular group of "initiates"—in his case, the Freemasons—while nonetheless arguing for David's ability to address different publics simultaneously ("Les thèmes du *Serment*," 280).

54. Landes, *Women and the Public Sphere*, 155.

55. *Dictionnaire de l'Académie française*, 1st ed. (Paris, 1694), s.v. "serment"; *Procès-verbaux de l'Académie royale*, 1:11, 102.

56. Juliette Trey and Antoine de Baecque, *Le serment du jeu de paume: Quand David réécrit l'histoire* (Versailles: Artlys, 2008), 12.

57. Philippe Bordes, *Le serment du jeu de paume de Jacques-Louis David: Le peintre, son milieu et son temps de 1789 à 1792* (Paris: Réunion des musées nationaux, 1983), 30; Trey and de Baecque, *Le serment du jeu de paume*, 16–17.

58. André Chénier, *Le jeu de paume: À Louis David, peintre* (Paris: Bluet, 1791), 5–6, 9.

59. Trey and de Baecque, *Le serment du jeu de paume*, 18.

60. Ibid., 30–33; Crow, *Painters and Public Life*, 258. It was not until 1822 that David, then exiled in Brussels, finally succeeded in publishing an engraving based on his drawing, followed the next year by a key identifying fifty of its figures (Trey and de Baecque, *Le serment du jeu de paume*, 36).

61. David Lloyd Dowd, *Pageant-Master of the Republic: Jacques-Louis David and the French Revolution* (Lincoln: University of Nebraska Press, 1948), 123. On David's stage-managing of revolutionary festivals, see also Warren Roberts, *Jacques-Louis David and Jean-Louis Prieur, Revolutionary Artists: The Public, the Populace, and Images of the French Revolution* (Albany: State University of New York Press, 2000), 269–311.

62. Wind, "The Sources of David's *Horaces*," 133–35. Apparently warned of the plot in advance, the police managed to round up the conspirators without disrupting the opera.

63. D. and G. Wildenstein, *Documents complémentaires*, 171.

64. Dorothy Johnson, "David and Napoleonic Painting," in Johnson, *Jacques-Louis David: New Perspectives*, 139–40.

65. D. and G. Wildenstein, *Documents complémentaires*, 56; Philippe Bordes, *Jacques-Louis David: Empire to Exile* (New Haven, CT: Yale University Press, 2005), 53.

CHAPTER 12 Turner's Poetic *Fallacies*

1. Jan Piggott, "Poetry and Turner," in *The Oxford Companion to J.M.W. Turner*, ed. Evelyn Joll, Martin Butlin, and Luke Herrmann (Oxford: Oxford University Press, 2001), 229.

2. To James Holworthy [21 November 1817], in *Collected Correspondence of J.M.W. Turner*, ed. John Gage (Oxford: Clarendon, 1980), 71. Barry's words are recorded in *The Works of James Barry*, 2 vols. (London: T. Cadell and W. Davies, 1809), 1:555.

3. Kathleen Nicholson, "Turner's 'Appulia in Search of Appulus' and the Dialectics

of Landscape Tradition," *Burlington Magazine* 122 (1980): 679. The discussion that follows is particularly indebted to Nicholson's work on this painting.

4. In addition to Nicholson, see, e.g., Martin Butlin and Evelyn Joll, *The Paintings of J.M.W. Turner*, rev. ed., 2 vols. (New Haven, CT: Yale University Press, 1984), 1:92; Barry Venning, *Turner* (2003; rpt. London: Phaidon, 2004), 129–30.

5. Nicholson attributes the discovery to William Chubb ("Turner's 'Appulia,'" 684n27).

6. Gerald Finley, *Angel in the Sun: Turner's Vision of History* (Montreal: McGill-Queen's University Press, 1999), 216n34.

7. For a useful summary of this tradition, see Ann Bermingham, "Landscape-O-Rama: The Exhibition Landscape at Somerset House and the Rise of Popular Landscape Entertainments," in Solkin, *Art on the Line*, 136–38.

8. See Ruskin's letter to Mrs. John Simon [28 November 1857], in *Works*, 36:270.

9. For related observations on this picture, see Heffernan, *Cultivating Picturacy*, 119. Though Heffernan focuses on the artist's poetry rather than his titles as such, his fine account of the relations between word and image in Turner's work has significant points of contact with my own.

10. Butlin and Joll, *Paintings of J.M.W. Turner*, 1:48.

11. Venning, *Turner*, 22–23, 296–97, 71, 171; James Hamilton, *Turner: A Life* (London: Hodder and Stoughton, 1997), 193, 92, 120–22, 171–72, 275.

12. The complicated history of the Turner Bequest is beyond the scope of the present project, but among the terms of the will was the stipulation that two paintings, *Dido building Carthage; or the Rise of the Carthaginian Empire* (1815) and *Sun Rising through Vapour; Fishermen cleaning and selling Fish* (1807) hang next to the Claudes that had inspired him, as they do today at the National Gallery. (The Claudes are *Seaport with the Embarkation of the Queen of Sheba* and *Landscape with the Marriage of Isaac and Rebekah*.) The artist's hope for a single space devoted to his work was only partly realized, however, with the opening of what is now known as the Clore Gallery for the Turner Bequest at Tate Britain in 1987, since the nation's collection of Turners is still divided between the two museums.

13. Venning, *Turner*, 44–46.

14. Hamilton, *Turner*, 52.

15. The count is Heffernan's. See *Cultivating Picturacy*, 117, 125.

16. George Walter Thornbury, *The Life of J.M.W. Turner, R.A.*, 2 vols. (London: Hurst and Blackett, 1862), 2:88.

17. Lynn R. Matteson, "The Poetics and Politics of Alpine Passage: Turner's *Snowstorm: Hannibal and His Army Crossing the Alps*," *Art Bulletin* 62 (1980): 385–98; quotation on 391. Gisborne's poem is *Walks in a Forest*, first published in 1794; Gray's list comes from an edition of his *Poems* compiled by William Mason that appeared in 1775.

18. Butlin and Joll, *Paintings of J.M.W. Turner*, 1:89.

19. Elizabeth Rigby, diary entry of 20 May 1846, in *Journals and Correspondence of Lady Eastlake*, ed. Charles Eastlake Smith, 2 vols. (London: John Murray, 1895), 1:188.

20. Hamilton, *Turner*, 304–6.

21. See, e.g., Kathleen Nicholson, *Turner's Classical Landscapes: Myth and Meaning* (Princeton, NJ: Princeton University Press, 1990), 101; and Finley, *Angel in the Sun*, 101.

22. Hoek, *Titres*, 137, 352. Cf. also Armengaud, *Titres*, 16–18, 333.

23. "Fine Arts: Exhibition at the Gallery of the British Institution," *Literary Gazette, and Journal of the Belles Lettres, Arts, Sciences, etc.*, 4 February 1837, 74.

24. Ibid.

25. John Gage, *Color in Turner: Poetry and Truth* (New York: Praeger, 1969), 143.

26. Butlin and Joll, *Paintings of J.M.W. Turner*, 1:173.

27. Edmund Burke, *A Philosophical Enquiry into the Origin of Our Ideas of the Sublime and Beautiful*, 2nd ed. (London: Dodsley, 1759), 146. The relevance of the passage is noted by Finley, *Angel in the Sun*, 224n19.

28. Nicholson, *Turner's Classical Landscapes*, 114.

29. As reproduced in Finley, *Angel in the Sun*, 213, from a typescript copy of the Sir Daniel Wilson Journal at the University of Toronto. The entry is dated 25 May 1889.

30. For one account that seeks to reconcile them, see Eric Shanes, *Turner's Human Landscape* (London: Heinemann, 1990), 133–35.

31. Adams, "Titles, Titling, and Entitlement To," 14.

32. Venning, *Turner*, 197. For a general argument about the importance of such narrative decoding in Turner, see also Shanes, *Turner's Human Landscape*.

33. Ruskin, "Notes on the Turner Gallery at Malborough House, 1856" (1857), in *Works*, 13:161.

34. Butlin and Joll, *Paintings of J.M.W. Turner*, 1:146, 151, 247.

35. James A. W. Heffernan, *The Re-Creation of Landscape: A Study of Wordsworth, Coleridge, Constable, and Turner* (Hanover, NH: University Press of New England, 1984), 47–49; the quotation (on 47) comes from a Turner manuscript in the Tate (TMS BB 22v).

36. Andrew Wilton, *Painting and Poetry: Turner's Verse Book and His Work of 1804–1812* (London: Tate, 1990), 62. For "Fallacious Hope" in particular, see also Jerrold Ziff, "John Langhorne and Turner's 'Fallacies of Hope,'" *Journal of the Warburg and Courtauld Institutes* 27 (1964): 340–42.

37. Wilton, *Painting and Poetry*, 64.

38. Heffernan, *Cultivating Picturacy*, 130.

39. Butlin and Joll, *Paintings of J.M.W. Turner*, 1:263–64. There has long been confusion about which of two similarly titled pairs Turner actually exhibited in 1845. I wish to thank Ian Warrell, formerly curator at the Tate, for directing me to the correct image.

40. "Punch's Lounge at the Exhibition of the Royal Academy," *Punch* 8 (1845): 236.

41. Odilon Redon, *À soi-même: Journal 1867–1915: Notes sur la vie, l'art et les artistes* ([Paris]: José Corti, 1989), 26–27. I am grateful to Welchman for directing me to this passage (*Invisible Colors*, 92).

42. Cf. Heffernan, who also notes that one of these pictures "represents an event that Turner simply imagined: Aeneas and Dido visit the tomb of her late husband, while 'the sun went down in wrath at such deceit'" (*Cultivating Picturacy*, 129).

43. The confusion arose from a transcription error by Turner's first biographer, Walter Thornbury, in 1877 that has since been perpetuated in many subsequent accounts. See Adele M. Holcomb and C. R. Leslie, "'Indistinctness is my fault': A Letter about Turner from C. R. Leslie to James Lenox," *Burlington Magazine* 114 (1972): 557–58. Despite Holcomb's debunking, a quick check of the Internet reveals that the erroneous quotation still outnumbers the corrected version by roughly four to one.

44. On Twombly's affinities with Turner, see Venning, *Turner*, 326–28.

45. Barthes, "Wisdom of Art," 184.

CHAPTER 13 Courbet's *Studio* as Manifesto

1. To Alfred Bruyas [November–December 1854], in *Letters of Gustave Courbet*, 129.

2. To Champfleury [November–December 1854], ibid., 131.

3. Ibid., 131–32.

4. Though scholars had quoted it earlier, the letter to Champfleury was first published in full in the catalogue of a major retrospective commemorating the centenary of the artist's death: Hélène Toussaint et al., *Gustave Courbet, 1819–1877* (Paris: Éditions des musées nationaux, 1977), 246–47.

5. To his family [April–May 1846], in *Letters of Gustave Courbet*, 64.

6. For particularly shrewd accounts of Courbet's maneuvering during this period, see Patricia Mainardi, *Art and Politics of the Second Empire: The Universal Expositions of 1855 and 1867* (New Haven, CT: Yale University Press, 1987), 57–61; and Ségolène Le Men, *Courbet*, trans. Deke Dusinberre et al. (New York: Abbeville Press, 2008), 184–91.

7. Alan Bowness, introduction to Toussaint et al., *Gustave Courbet*, 18.

8. I quote from the statement as it is reproduced in Gustave Courbet, *Écrits, propos, lettres et témoignages*, ed. Roger Bruyeron (Paris: Hermann, 2011), 51–52.

9. The possibility is suggested by a letter in which Courbet anticipates that Champfleury will produce "an annotated catalog" for the exhibition, though in the event there were no annotations other than the statement itself (To Alfred Bruyas [11 May 1855], in *Letters of Gustave Courbet*, 141, 142n4).

10. T. J. Clark, *Image of the People: Gustave Courbet and the Second French Republic, 1848–1851* (Greenwich, CT: New York Graphic Society, 1973), 29.

11. To his family [10 January 1846]; [16 March 1846]; [17 April 1848], in *Letters of Gustave Courbet*, 59, 62, 79–80.

12. Petra ten-Doesschate Chu, *The Most Arrogant Man in France: Gustave Courbet and the Nineteenth-Century Media Culture* (Princeton, NJ: Princeton University Press, 2007), 9, 11–12, 5.

13. To his family [15 June 1852], in *Letters of Gustave Courbet*, 106.

14. To the editor of *La presse*, 13 (or 15 or 18?) May 1852; To the editor of *Le messager de l'assemblée*, 19 November 1851, ibid., 101–2, 103. On the fate of the second letter, see 104n2.

15. Claude Pichois, "Documents baudelairiens: Baudelaire, Courbet, Emerson," *Études baudelairiennes* 2 (1971): 69–71.

16. To Max Buchon [1 May 1850], in *Letters of Gustave Courbet*, 96. The article actually appeared in two journals, first in Besançon, where the exhibit originated, and then in Dijon: Courbet's letter concerns the former. On the showmanship behind this traveling exhibit, see Le Men, *Courbet*, 160–64.

17. To Max Buchon [August 1856], in *Letters of Gustave Courbet*, 152.

18. To the comte de Nieuwerkerke, 10 August 1866, ibid., 293.

19. Le Men, *Courbet*, 55–56. Cf. also Chu, *Most Arrogant Man in France*, esp. 5–16. Though I am deeply indebted to Chu's analysis of Courbet's relations with the press, I would stop short of her claim that "a primacy of the verbal over the visual, of text over image, marked his cognition of modern life" (16)—unless the emphasis falls on the narrower implications of the word "cognition."

20. Pichois, "Documents baudelairiens," 69–71; Chu, *Most Arrogant Man*, 80.

21. This is the wording Courbet entered by hand in the Salon register. The picture appears in the printed catalogue simply as *Un enterrement à Ornus* [*sic*]. See Toussaint et al., *Gustave Courbet*, 98, 28.

22. Michael Fried, *Courbet's Realism* (1990; rpt. Chicago: University of Chicago Press, 1992), 111, 315n1, 236. James Henry Rubin also remarks Courbet's curious variation on "tableau d'histoire," which he interprets as a claim for "the valid historical significance of the present." See *Realism and Social Vision in Courbet and Proudhon* (Princeton, NJ: Princeton University Press, 1980), 59.

23. E[tiénne]-J[ean] Delécluze, *Exposition des artistes vivants, 1850* (Paris: Comon, 1851), 32.

24. A[ugustin] J[oseph] Du Pays, "Exposition universelle des beaux-arts: Réalisme," *L'illustration: Journal universel*, 28 July 1855, 73.

25. Édouard Saint-Amour, *Exposition universelle. . .* (1855), 36, cited in René Huyghe, Germain Bazin, and Hélène Jean Adhémar, *Courbet, l'atelier du peintre, allégorie réelle, 1855* (Paris: Éditions des musées nationaux: Librairie Plon [1944]), 24.

26. James H. Rubin, *Courbet* (London: Phaidon, 1977), 154.

27. To Champfleury [November–December 1854], in *Letters of Gustave Courbet*, 131.

28. Champfleury [Jules Fleury-Husson], "Sur M. Courbet: Lettre à Madame Sand" (1855), in *Le réalisme* (Paris: Michel Lévy Frères, 1857), 279.

29. P[ierre]-J[oseph] Proudhon, *Du principe de l'art et sa destination sociale* (Paris: Garnier Frères, 1865), 285.

30. Rubin, *Realism and Social Vision*, 7–8, 36, 19–20, 51, 28.

31. I owe the comparison with Picasso to Le Men, *Courbet*, 19.

32. To Alfred Bruyas [3 May 1854], in *Letters of Gustave Courbet*, 122. Cf. Le Men, *Courbet*, 62–69.

33. "Beaux-arts: Sur le Muséum des arts de Paris," 215.

34. Gustave Planche, *Salon de 1831* (Paris: Pinard, 1831), 109. I am grateful to Werner Hofmann, "Courbet—Artist, Dreamer, and Philosopher," in *Courbet: A Dream of Modern Art*, ed. Klaus Herding and Max Hollein (Ostfildern: Hatje Cantz, 2010), 21, for directing me to this anticipation of the questions raised by Courbet's title.

35. T[héophile] Thoré, "Artistes contemporains: M. Eugène Delacroix," *Le siècle*, 25 February 1837, n.p. Henri Dorra parenthetically associates these words with Courbet's "real allegory" in "Castagnary et Courbet: Entre Romantisme et Naturalisme," in *La critique d'art en France, 1850–1900*, ed. Jean-Paul Bouillon ([Saint-Etienne]: Centre interdisciplinaire d'études et de recherches sur l'expression contemporaine, 1989), 65.

36. For a detailed account of this history, see Bernard Weinberg, *French Realism: The Critical Reaction, 1830–1870* (Chicago: Modern Language Association of America, 1937). According to Weinberg, it was Arsène Houssaye's *Histoire de la peinture flamande et hollandaise* of 1846 that first gave the words *réalisme* and *réaliste* in the aesthetic sense "any real prominence," though it was not until 1851 that they gained genuine currency (118–19).

37. Théodore Jouffroy, *Cours d'esthétique: Suivi de la thèse du même auteur sur le sentiment du beau et de deux fragments inédits* (Paris: Damiron, 1843), 202, 200, 203, 202. Compare Eugène Loudun's response to Courbet's work at the 1855 exhibit: "What M. Courbet seeks is the representation of people as they are, as ugly, as coarse as he finds them . . . but it is all at the tip of his brush; there is nothing noble, elevated, or moral in

the head that guides the hand; he invents nothing, he has no imagination; he just turns out the goods; he is a workman in painting as others are in furniture and shoes" (*Exposition universelle des beaux-arts: Le salon de 1855* [Paris: Ledoyen, 1855], 140).

38. Cf. Petra Chu, who cites the translation of Hegel's *Aesthetics* by Courbet's former teacher, Charles Bénard, to the effect that an allegorical personification is not a real individual (*personnage réel*) but a nominal being, and that allegory thus requires generalization (*Most Arrogant Man*, 98).

39. On this "indecision . . . de l'identité" in Courbet, see Thomas Schlesser, *Réceptions de Courbet: Fantasmes réalistes et paradoxes de la démocratie (1848–1871)* ([Dijon]: Presses du réel, 2007), 28–31.

40. For the *atelier* as a popular subject in the period, including possible models for Courbet's version, see Huyghe, Bazin, and Adhémar, *Courbet, l'atelier du peintre*, 19–21; Alan Bowness, "The Painter's Studio," in *Courbet in Perspective*, ed. Petra ten-Doesschate Chu (Englewood Cliffs, NJ: Prentice-Hall, 1977), 132–33; Alex Seltzer, "Gustave Courbet: All the World's a Studio," *Artforum*, September 1977, 44–50; and Le Men, *Courbet*, 191–94.

41. On the dreamlike lighting of the *Studio*, see Hélène Toussaint, "Le dossier de 'L'Atelier' de Courbet," in Toussaint et al., *Gustave Courbet*, 270. For the lack of "meaningful interaction" among the painting's figures as a key to its allegorical status, see especially Linda Nochlin, "Courbet's Real Allegory: Rereading *The Painter's Studio*" (1988), rpt. in Nochlin, *Courbet* (New York: Thames & Hudson, 2007), 155.

42. The relevant extract from Redgrave's journal, dated 6 April 1855, is reproduced as an appendix to Benedict Nicolson, *Courbet: The Studio of the Painter* (New York: Viking, 1973), 81–82.

43. Champfleury, "Sur M. Courbet: Lettre à Madame Sand," 280.

44. Eugène Delacroix, *Journal: 1822–1863*, ed. André Joubin and Régis Labourdette ([Paris]: Plon: [1981]), 529. The entry is dated 3 August 1855.

45. Rubin, *Realism and Social Vision*, 35; Nochlin, *Courbet*, 149–50.

46. The most useful summary of this history appears in Le Men, *Courbet*, 203–4. I have also drawn on Huyghe, Bazin, and Adhémar, *Courbet, l'atelier du peintre*, 22; Toussaint, "Le dossier de 'L'Atelier,'" 243; and Klaus Herding, *Courbet: To Venture Independence*, trans. John William Gabriel (New Haven, CT: Yale University Press, 1991), 45.

47. Rubin, *Courbet*, 135.

48. Le Men, *Courbet*, 203.

49. I owe the suggestion that Courbet announces his turn to landscape in the *Studio* to James Rubin (*Realism and Social Vision*, 8–9). For conflicting evaluations of this development, see Anne M. Wagner, "Courbet's Landscapes and Their Market," *Art History* 4 (1981): 410–31; and Chu, *Most Arrogant Man*, 138–69.

50. From an interview of 1961 as recorded in Alain Jouffroy, *Marcel Duchamp* (Paris: Centre G. Pompidou, 1997), 33.

51. Robert Fernier, "En 1920, 'L'atelier' de Courbet entrait au Louvre," *Les Amis de Gustave Courbet* 29 (1961): 1. This was apparently not the first time that Courbet's letter had been used to gloss the painting: according to Le Men, the critic Paul Mantz had already quoted "extensively" from it when he introduced the work in a sales catalogue of 1892 (*Courbet*, 191). But the picture failed to find a buyer on that occasion, and it was not until the Louvre subscription nearly three decades later that Courbet's monumental work seems to have caught the imagination of the public.

52. As quoted by Fernier, "'L'atelier' de Courbet entrait au Louvre," 1, 3.

53. Huyghe, Bazin, and Adhémar, *Courbet, l'atelier du peintre*, 3.

54. I quote from the English translation, published the following year: Werner Hofmann, *The Earthly Paradise: Art in the Nineteenth Century*, trans. Brian Battershaw (New York: George Braziller, 1961), 12.

55. Linda Nochlin, "The Invention of the Avant-Garde: France, 1830–80," *Art News Annual* 34 (1968): 13.

56. Nicolson, *Courbet: The Studio of the Painter*, 68.

57. To Champfleury [November–December 1854], in *Letters of Gustave Courbet*, 132.

58. Toussaint "Le dossier de 'L'Atelier,'" 246.

59. To Champfleury [November–December 1854], in *Letters of Gustave Courbet*, 132. Cf. Toussaint, "Le dossier de 'l'Atelier,'" 252–55.

60. Toussaint, "Le dossier de 'l'Atelier,'" 257–58, 251, 261–63.

61. For some telling objections to Toussaint's argument, including the overspecificity of her iconography and the tenuousness of her Masonic speculations, see Rubin, *Realism and Social Vision*, 41, 139n22, 140n29; and John F. Moffitt, "Art and Politics: An Underlying Pictorial-Political Topos in Courbet's 'Real Allegory,'" *Artibus et Historiae* 8 (1987): 193n24. In a recent attack on the entire business of searching for a governing allegory in the picture, James D. Herbert is still more dismissive, invoking the "Borgesian flavor" of Toussaint's detective work: "Courbet, Incommensurate and Emergent," *Critical Inquiry* 40 (2014): 374.

62. Herding, *Courbet: To Venture Independence*, 48, 57, 59, 61. Herding's interpretation of the *Studio* originally appeared in German in 1978.

63. To Alfred Bruyas [October (?) 1853], in *Letters of Gustave Courbet*, 115–16. Though Herding quotes extensively from this letter, he oddly does not cite this line. But cf. Chu, who does invoke it in the course of recounting and somewhat modifying Herding's argument (*Most Arrogant Man*, 106). As both scholars note, 1855 marked the end of a seven-year phase for the emperor as well as the artist, since Louis Napoleon had first been elected president of the French republic in 1848.

64. Nochlin, *Courbet*, 158, 167.

65. Fried, *Courbet's Realism*, 4, 148–88. For Fried's critique of Nochlin, see 324n17. On Courbet's title as a key to the entire oeuvre, cf. also Rubin: "For each of his works is a symbol, a physical incarnation, a 'real allegory' of the world comprehended by a new concrete consciousness" (*Realism and Social Vision*, 76).

66. On the cat, see Margaret Armbrust Siebert, "A Political and a Pictorial Tradition Used in Gustave Courbet's *Real Allegory*," *Art Bulletin* 65 (1983): 314–16.

67. Le Men, *Courbet*, 18.

68. To Louis Français [February (?) 1855], in *Letters of Gustave Courbet*, 135.

69. Art & Language, *Victorine* (1993), in *Art & Language* (Paris: Galerie nationale du jeu de paume, 1993), n.p. Quotations are taken from the introduction to the libretto (following p. 46) and the last lines of act 3, scene 2.

CHAPTER 14 Whistler's *Symphonies* and Other Instructive *Arrangements*

1. E[lizabeth] R. and J[oseph] Pennell, *The Life of James McNeill Whistler*, 2 vols. (Philadelphia: J. B. Lippincott, 1909), 1:69.

2. To his family [17 November 1865], in *Letters of Gustave Courbet*, 269.

3. To Henri Fantin-Latour [September 1867?], in *The Correspondence of James Mc-Neill Whistler, 1855–1903*, ed. Margaret F. MacDonald, Patricia de Montfort, and Nigel Thorp (Glasgow: University of Glasgow, online edition), GUW 08045. http://www.whistler.arts.gla.ac.uk/correspondence.

4. Sarah Burns, *Inventing the Modern Artist: Art and Culture in Gilded Age America* (New Haven, CT: Yale University Press, 1996), 224.

5. See Ernest Chesneau, "Le Japonisme dans les arts," *Musée universel* (1873), 2:216. Chesneau, who disapproved of the titles and paintings alike, says only that Durand-Ruel understandably shrank (*reculé*) from Whistler's request.

6. James McNeill Whistler, "Mr. Whistler's 'Ten O'Clock,'" in Whistler, *Gentle Art*, 146. The so-called Ten O'Clock lecture was originally delivered on 20 February 1885.

7. Whistler, "Whistler v. Ruskin: Art & Art Critics" (1878), in *Gentle Art*, 25.

8. To Champfleury [November–December 1854], in *Letters of Gustave Courbet*, 131.

9. Whistler, "Mr. Whistler's 'Ten O'Clock,'" in *Gentle Art*, 146–47.

10. The painting that inaugurated Whistler's musical nomenclature remains in one crucial respect an anomaly in his work: never again, to the best of my knowledge, would the artist inscribe the words of a title directly on the canvas. Indeed—with the single exception of a quotation from Walter Scott's *Heart of Midlothian* that someone recorded, probably at the owner's request, on an *Arrangement in Yellow and Grey* begun in 1876 that first publicly appeared in Edinburgh a decade later as *Effie Deans*—Whistler strenuously upheld the convention that had long banished words from the picture plane. Even the artist's signature was typically replaced after 1869 by the butterfly monogram he had adopted from his initials, as if further to distance his purely visual arrangements from the contamination of language (Young et al., *Paintings of James Mc-Neill Whistler*, 1:107, xvii–xviii).

11. Elizabeth Prettejohn, *Art for Art's Sake: Aestheticism in Victorian Painting* (New Haven, CT: Yale University Press, 2007), 169.

12. E. R. and J. Pennell, *Life*, 1:144.

13. See Young et al., *Paintings of James McNeill Whistler*, 1:18.

14. Levinson, "Titles," 33.

15. Prettejohn, *Art for Art's Sake*, 110. Prettejohn also remarks the distinctiveness of Whistler's title, while implicitly adopting his argument ("it is the picture itself that is the 'symphony'") in order to analyze the rhythmic compositional arrangements all three canvases share (111–12). On the resemblance to Moore's *Musician*, see also Young et al., *Paintings of James McNeill Whistler*, 1:36.

16. To Alfred Stevens [13/20 February 1867?], in *Correspondence of James McNeill Whistler*, GUW 08145. See editors' n8.

17. The list of titles is given in Chesneau, "Le Japonisme dans les arts," 216.

18. To George Aloysius Lucas [18 January 1873], in *Correspondence of James McNeill Whistler*, GUW 09182.

19. The relevant entry in the catalogue raisonné of Whistler's paintings records no occasion in the artist's lifetime at which the picture was not classified as a "Nocturne," apart from the passage in the interview quoted above. See Young et al., *Paintings of James McNeill Whistler*, 1: 100–101.

20. Whistler, "The Red Rag" (1878), in *Gentle Art*, 126–27 (second ellipsis in original).

21. Altick, *Paintings from Books*, 101.

22. For the quotation from Swinburne, see "Apostasy" (Whistler's title) in Whistler, *Gentle Art*, 256; for Whistler's letter in response, reprinted as "'Et tu, Brute!,'" see 259–61.

23. Whistler, "The Red Rag," in *Gentle Art*, 128.

24. For Whistler's letter and the relevant exchanges in the *Athenaeum*, see To William Hepworth Dixon, 1 July 1862, in *Correspondence of James McNeill Whistler*, GUW 13149; the letter appeared in the journal on 5 July. The editors identify the anonymous reviewer as Frederick George Stephens. On the implications of this episode, I am especially indebted to Aileen Tsui, "The Phantasm of Aesthetic Autonomy in Whistler's Work: Titling *The White Girl*," *Art History* 29 (2006): 444–75. Cf. also Robin Spencer, "Whistler's 'The White Girl': Painting, Poetry and Meaning," *Burlington Magazine* 140 (1998): 300–311.

25. Tsui, "Phantasm," 452.

26. To William Hepworth Dixon, 1 July 1862, n4; To George Aloysius Lucas, 26 June [1862], in *Correspondence of James McNeill Whistler*, GUW 13149; GUW 11977.

27. Whistler, "The Red Rag," in *Gentle Art*, 127. This was also not the last time that Whistler violated his professed principles by using a title drawn from literature, though such blatant departures from orthodoxy are quite rare. Among the exceptions are a commissioned painting from the late 1860s, originally called "the little Blue Girl," that was dispatched to its owner as *Annabel Lee* and the *Arrangement in Yellow and Grey: Effie Deans* mentioned in n10 above. It is not clear how and why the earlier picture acquired its titular reference to the poem by Poe; but in the latter case someone went so far as to inscribe the Scott quotation on the canvas, and *Effie Deans* remains the official subtitle. There is also an oil of 1884 entitled *Ariel* (Young et al., *Paintings of James McNeill Whistler*, 1:46, 107, 156).

28. Tsui, "Phantasm," 453–54, 461. Tsui also notes that Whistler seems to have done nothing to prevent the picture's appearing for a second time as *The Woman in White* when it was exhibited in London in 1863 (452).

29. Whistler, "The Red Rag," in *Gentle Art*, 126 (ellipsis in original).

30. John Welchman, who has written the only extended study of picture titles in English, reads the phrase in this second sense only (*Invisible Colors*, 123–24, 258).

31. Tsui, "Phantasm," 454, 452.

32. Th[éodore] Duret, "James Whistler," *Critique d'avant-garde* (Paris: G. Charpentier, 1885), 257, 250–56. The article on Whistler originally appeared in the *Gazette des beaux-arts* for April of 1881. On Duret, see also Welchman, *Invisible Colors*, 125–26.

33. John House, *Impressionism: Paint and Politics* (New Haven, CT: Yale University Press, 2004), 29–32.

34. Young et al., *Paintings of James McNeill Whistler*, 1:60.

35. To Théodore Duret [11 April 1881] and [2/9 May 1885], in *Correspondence of James McNeill Whistler*, GUW 09630 and 09647.

36. To George Aloysius Lucas [18 January 1873], ibid., GUW 09182.

37. Merrill, *Pot of Paint*, 144, 237. This was not part of his testimony that Whistler chose to reproduce in *The Gentle Art of Making Enemies*, perhaps because he immediately followed by observing, "it is an accident that I happened upon terms used in music" (144).

38. As quoted by David Park Curry, *James McNeill Whistler: Uneasy Pieces* (Richmond: Virginia Museum of Fine Arts, 2004), 324. By charging admission for his own

exhibits, Whistler was also following in the footsteps of Courbet and David before him. Curry cites a disgruntled reviewer in 1883: "Another comic element in the show is that [Mr. Whistler] expects you to pay to see it" (324).

39. "The Dudley Gallery," *Graphic*, 30 October 1875, 426.

40. "Whistler: A Fantasia in Criticism," *London*, 18 August 1877, 63.

41. [Tom Taylor], "The Grosvenor Gallery," *Times*, 2 May 1878, 7.

42. "A Symphony in Bronze," *Examiner*, 30 November 1878, 1516.

43. Merrill, *Pot of Paint*, 166.

44. The first title is cited in Whistler, *Gentle Art*, 324. For the Sambourne cartoon, I am indebted to Curry, *James McNeill Whistler*, 228.

45. Merrill, *Pot of Paint*, 127. Curry, who also reproduces Bryan's cartoon, detects multiple puns in its title, including a play on "dun" as both a shade of brown and "a persistent demand for money" (*James McNeill Whistler*, 34).

46. "A Derangement after Whistler," *Funny Folks*, 14 December 1878, 395.

47. *New York Express*, 9 April 1879, as cited by Nicolai Cikovsky, Jr., with Charles Brock, "Whistler and America," in Richard Dorment, Margaret F. MacDonald et al., *James McNeill Whistler* (New York: Abrams, 1995), 33.

48. Walter Hamilton, *The Aesthetic Movement in England*, 2nd ed. (London: Reeves and Taylor, 1882), 28.

49. Catherine Carter Goebel, "The Brush and the Baton: Influences on Whistler's Choice of Musical Terms for His Titles," *Whistler Review: Studies on James McNeill Whistler and Nineteenth-Century Art*, ed. Nigel Thorp, 1 (1999): 27–36.

50. "Fine Arts: Royal Academy," *Athenaeum*, 18 May 1867, 667. In *Whistler: A Retrospective*, ed. Robin Spencer (New York: Harry Lauter Levin Associates, 1989), Spencer identifies the author of this piece as F. G. Stephens (80).

51. "Fine Arts: Exhibition of the Royal Academy," *Illustrated London News*, 25 May 1867, 519.

52. Ibid.

53. [Tom Taylor], "Dudley Gallery—Cabinet Pictures in Oil," *Times*, 14 November 1871, 4.

54. Young et al., *Paintings of James McNeill Whistler*, 1:63.

55. "Mr. Whistler's Paintings and Drawings," *Art-Journal*, August 1874, 230.

56. Otto Scholderer to Henri Fantin-Latour, 19 May 1876, Brame and Lorenceau Archive, as quoted by Robin Spencer, "Whistler, Manet, and the Tradition of the Avant-Garde," in *James McNeill Whistler: A Reexamination*, ed. Ruth E. Fine (Washington, DC: National Gallery of Art, 1987), 63n53.

57. "An Aesthetic Valentine (*A la* Whistler)," *Moonshine*, 18 February 1888, 81.

58. To Thomas Waldo Story [5 February 1883], in *Correspondence of James McNeill Whistler*, GUW 09430.

59. Whistler, "Whistler v. Ruskin: Art and Art Critics," in *Gentle Art*, 30, 33–34.

60. Merrill, *Pot of Paint*, 2–3. Among other changes, Merrill notes, "he pointedly omitted the testimony of the three witnesses who spoke on his behalf, so that the victory, such as it was, could be construed as his alone" (2).

61. Max Beerbohm, "Whistler's Writing," *Pall Mall Magazine* 33 (1904): 138, 140.

62. Merrill, *Pot of Paint*, 148.

63. Paul Mantz, "Salon de 1863," *Gazette des beaux-arts*, 1 July 1863, 61.

64. Henry Murger, *Scènes de la bohème* (Paris: M. Lévy, 1851), 46; Théophile Gautier,

Émaux et camées (Paris: E. Didier, 1852), 33–38; Baudelaire, "Correspondances," in *Oeuvres complètes*, 1:11.

65. *Portrait of Manet by Himself and His Contemporaries*, ed. Pierre Courthion and Pierre Cailler, trans. Michael Ross (London: Cassell [1960]), 42. A number of commentators have noted this and other anticipations of Whistler's title. I am particularly indebted to Hilary Taylor, *James McNeill Whistler* (New York: G. P. Putnam's Sons, 1978), 28, 66.

66. Goebel, "The Brush and the Baton," 28–30. For a general discussion of this musical nomenclature in historical context, see also Ron Johnson, "Whistler's Musical Modes: Numinous Nocturnes," *Arts Magazine* 55 (1981): 169–76.

67. Whistler, "Autres Temps autres Moeurs," in *Gentle Art*, 190.

68. To Frederick Richards Leyland [2/9 November 1872], in *Correspondence of James McNeill Whistler*, GUW 08794. Prettejohn remarks Leyland's piano playing as well as the short pieces by Chopin from which he presumably drew his title (*Art for Art's Sake*, 175).

69. Ed Lilley, "How Far Can You Go? Manet's Use of Titles," *Word & Image* 10 (1994): 164, 169n13.

70. To the Editor of an American Newspaper [21/28 February 1873?], in *Correspondence of James McNeill Whistler*, GUW 07429. For another draft of this letter—which appears never to have been published—see GUW 09587. (Perhaps wisely, the second version drops the specific allusion to the *Symphony in White*.) The newspaper in question was probably the Baltimore *Gazette*.

71. To Walter Greaves [1871/1876], in *Correspondence of James McNeill Whistler*, GUW 11468.

72. According to the editors of the catalogue raisonné, it was not until Whistler's major retrospective at the Goupil Gallery in 1892 that he arrived at a consistent method of titling his pictures: beginning with a generic name, such as "Nocturne," and following it up first with an indication of the color scheme and then with a more descriptive identification, such as "Chelsea Embankment—Winter." Even so, uncertainties remain: while the term "Arrangement" was consistently used for portraits and "Symphony" usually designated a figure subject, "Harmony," they report, "could be applied both to portraits and to other subjects." The color designation of an individual painting could also alter over the years—perhaps because the color itself had faded or mellowed. See Young et al., *Paintings of James McNeill Whistler*, 1:xvi.

73. For an extended discussion of "Composition" and "Construction" as titles, including the differences between them, see Welchman, *Invisible Colors*, 169–208.

74. Kirk Varnedoe, *Pictures of Nothing: Abstract Art Since Pollock* (Princeton, NJ: Princeton University Press, 2006), 32. The title of Varnedoe's book comes from an essay of 1816 by William Hazlitt, which in turn invokes an unnamed viewer's dismissive characterization of some early landscapes of Turner: "pictures of nothing, and very like" (2, 44n1).

75. E. R. and J. Pennell, *Life*, 1:218.

76. Myers, "Naming Pictures," 69.

77. For a lively account of this history, see *Whistler's Mother: An American Icon*, ed. Margaret F. MacDonald (Aldershot, UK: Lund Humphries, 2003). The quoted headline comes from the *New York Times* Sunday magazine, 23 October 1932 (85).

78. E. R. and J. Pennell, *Life*, 1:168, 169, 170, 171, 172, 179, 212, 215, 226, 227, 297, 299; 2:3, 78, 93, 114, 116, 125, 130–31.

79. Ibid., 1:213, 228, 235; 2:4, 127. For more evidence of such designatory drift and the subsequent difficulty of tracking Whistler's canvases, see Kenneth John Myers, *Mr. Whistler's Gallery: Pictures at an 1884 Exhibition* (Washington, DC: Freer Gallery of Art, Smithsonian Institution, 2003), 82.

80. For Malevich, see, e.g., Alan C. Birnholz, "On the Meaning of Kazimir Malevich's 'White on White,'" *Art International* 21 (1977): 9–16, 55; Arthur Danto, *The Madonna of the Future: Essays in a Pluralistic Art World* (Berkeley: University of California Press, 2001), 277. For Irwin, see Varnedoe, *Pictures of Nothing*, 113.

81. A quick survey of the *Correspondence* turns up over thirty such instances, including minor variants like "my Mother's picture," "my Mother's portrait," and simply "the 'Mother.'" Whistler also repeatedly refers to the second such *Arrangement* as "the Carlyle" or "Carlyle."

CHAPTER 15 Magritte and *The Use of Words*

1. René Magritte, *Écrits complets*, ed. André Blavier (Paris: Flammarion, 1979), 538, 485. The interviewer was Jan Walravens; the letter was addressed to the poet André Bosmans.

2. Sylvester, *René Magritte: Catalogue Raisonné*, 1:312.

3. For one representative formulation among many, see the statement Magritte contributed to the catalogue for an exhibit at the Walker Art Center in Minneapolis in 1962: "Art, as I conceive it, is impervious to psychoanalysis: it evokes the mystery without which the world would not exist, that is to say the mystery that should not be confused with a sort of problem, however difficult it may be Psychoanalysis has nothing to say ... about works of art that evoke the mystery of the world. Perhaps psychoanalysis is the better subject for treatment by psychoanalysis" (Magritte, *Écrits*, 558). In *René Magritte: Beyond Painting* (Manchester: Manchester University Press, 2009), Patricia Allmer also invokes the artist's conflicts with Breton in connection with this *L'usage de la parole* in order to argue, implausibly in my view, that the painting critiques the practice of surrealist word association as "isolating and rigid," since the protagonists are "stuck on to the margins of the canvas" and "unable to access the light-blue lofty clouds of the upper half" (83).

4. Magritte, *Écrits*, 379 (emphasis in the original). The quotation comes from the draft of a letter dated 8 May 1959 to an unidentified "Monsieur Hornik."

5. Sylvester, *Magritte*, 174.

6. There seem to have been at least three other versions of *L'usage de la parole* that have not been traced. Sylvester reports that the canvases reproduced here are inscribed on the back (I) and (6), respectively; the other variant mentioned above is identified as (II). See *René Magritte: Catalogue raisonné*, 1:312–13; 4:365.

7. Ibid., 1:312. It remains unclear what Sylvester and his coauthor for this volume, Sarah Whitfield, mean when they claim that these "paired words or phrases relate to each other in the same sort of way as when they issued from talking heads," though their reading is obviously influenced by their assumption that the shared title of all three pictures means that *parole* should continue to be translated as "speech."

8. See, e.g., the draft of his letter to Hornick: "pour le peintre la pensée se manifeste

avec des *images* pour Proust, elle se manifeste par la *parole*" (Magritte, *Écrits*, 379; emphasis in the original). For related or ambiguous uses, see also 380, 392, 491. It is worth noting that the American artist and critic Suzi Gablik, whose pioneering study of Magritte grew out of her extended friendship with the artist, translates *L'usage de la parole* as *The Use of Words*—a title, however, that she oddly bestows on *La trahison des images* as well. See Gablik, *Magritte* (1970; rpt. New York: Thames and Hudson, 1992), 124–44.

9. Sylvester, *Magritte*, 168. The title of *La clef des songes* comes not from Freud but from Henry Vidal's French translation of the *Oneirocritica* of Artemidorus, itself translated into English as *The Interpretation of Dreams* (Sylvester, *René Magritte: Catalogue Raisonné*, 1:239).

10. The connection to *Larousse*, which served as a resource for other surrealists as well, has been frequently noted in the Magritte literature; the best treatment I know is Allmer, *René Magritte: Beyond Painting*, esp. 32–45. As she shows, models for a number of the artist's images, including the famous pipe, can be found in its pages. Cf. also Sylvester, *Magritte*, 122–28.

11. Stephanie Barron, "Enigma: The Problem(s) of René Magritte," in *Magritte and Contemporary Art: The Treachery of Images*, ed. Barron and Michel Draguet (Los Angeles: Los Angeles County Museum of Art; Ghent: Ludion, 2006), 17; Sylvester, *Magritte*, 207.

12. Interview with Claude Vial (1966), in Magritte, *Écrits*, 643. For an earlier version, which speaks of smoking rather than stuffing the pipe, see the 1947 interview with Louis Quiévreux (250).

13. See, e.g., A. M. Hammacher, *René Magritte*, trans. James Brockway (New York: Abrams, [1974]), 32–33; Clara Orban, *The Culture of Fragments: Words and Images in Futurism and Surrealism* (Amsterdam: Rodopoi, 1997), 117, 120; Frederik Leen, "A Razor Is a Razor: Word and Image in Some Paintings by René Magritte," in *Magritte, 1898–1967*, ed. Gisèle Ollinger-Zinque and Leen, trans. Tiffany Barnard Davidson et al. (Ghent: Ludion, 1998), 25–36; Roberta Bernstein, "René Magritte and Jasper Johns: Making Thoughts Visible," in *Magritte and Contemporary Art*, 117. Gablik, who comments at length on the resemblance to Wittgenstein, says there is no evidence that the painter ever read him (*Magritte*, 87).

14. Magritte, "Le Véritable Art de Peindre" (1969), in *Écrits*, 273.

15. Interview with Michel Georis (1962), ibid., 562.

16. Interview with Maurice Bots (1951); interview with Marcel Fryns (I) (1962), ibid., 320, 569.

17. Harry Torczyner, *Magritte: Ideas and Images* (New York: Abrams, 1977), 198.

18. Magritte, *Écrits*, 488 (editor's note).

19. Sylvester, *Magritte*, 173–74.

20. Magritte, *Écrits*, 140 (from a letter of November 1959 to Louis Scutenaire, as quoted in an editor's note). According to Sylvester, *Bel canto* remains among the rare paintings in Magritte's oeuvre that take their titles from words recorded on the canvas itself: "he was in fact dissatisfied but unable to find something he liked better" (*Magritte*, 222).

21. To Harry Torczyner, 13 August 1964, in *Magritte / Torczyner: Letters between Friends*, trans. Richard Miller (New York: Abrams, 1994), 97.

22. Interview for *Life* (1966), in Magritte, *Écrits*, 612.

23. Despite Sylvester's centrality to Magritte scholarship, this is a side of the artist for which he has little patience. "Contrary to the beliefs of many who were close to Magritte and contrary to Magritte's own professed belief, when he couldn't be bothered not to over-simplify it," he remarks sharply, "the picture is not a colour reproduction but a piece of painting" (*Magritte*, 286).

24. On the unimportance of technique or the material basis of an artwork, see Magritte, "La Poésie Visible" (1962), as well as the 1963 letter to Bosmans quoted in the notes, and the 1962 interview with Fryns; on reproductions, see the 1962 interview with Georis. *Écrits*, 565–66, 568, 562–63.

25. For various accounts of this episode, see Allmer, *René Magritte: Beyond Painting*, 186–88.

26. Interview with Fryns (I), in Magritte, *Écrits*, 568.

27. Sylvester, *Magritte*, 39, 402.

28. Didier Ottinger, "The Spiritual Exercises of René Magritte," in *Magritte*, ed. Ottinger (Montreal: Montreal Museum of Fine Arts, 1996), 18–23.

29. In addition to Ottinger, see, e.g., Daniel Abadie, "The Unclassifiable Painting of René Magritte," trans. Donald Pistolesi and Caroline Beamish, in *Magritte*, ed. Abadie (New York: Distributed Art Publishers, 2003), 18–20; Barron, "Enigma," and Thierry de Duve, "This Wouldn't Be a Pipe: Magritte and Marcel Broodthaers," in Barron and Draguet, *Magritte and Contemporary Art*, 12, 95–107.

30. Magritte, "Paroles Datées" (1956), in *Écrits*, 434.

31. Interview with Jean Stévo (II) (1959), ibid., 492.

32. "Question du titre" (1970); "L'Empire des Lumières" (1972), ibid., 263, 422.

33. As Sylvester observes, "What is special about the poetry of Magritte's titles [compared to those of other surrealists] is that, as in his paintings, the language is not ornate or arcane; it is banal, neutral, plain" (*Magritte,* 288).

34. Interview with Pierre du Bois (1966); "La Ligne de Vie" (I) (1938), in Magritte, *Écrits*, 652, 108.

35. Ibid., 498 (from a letter to André Bosmans of July 1959).

36. Interview with Walravens, ibid., 537.

37. Sylvester, *Magritte*, 288.

38. "Inspired Thought" (1964), in Magritte, *Écrits*, 589.

39. As translated by Theresa Papanikolas, "Alexander Iolas: The Influence of Magritte's American Dealer," in Barron and Draguet, *Magritte and Contemporary Art*, 69, from a letter to Iolas of 21 April 1947 in the Menil Collection archives, Houston, Texas.

40. "The Enigmatic Visions of René Magritte" (1966), in Magritte, *Écrits*, 614. For other such glosses on his titles, see also the manuscripts reproduced on 259–62.

41. Siegfried Gohr, *Magritte: Attempting the Impossible*, trans. John Gabriel and Donald Pistolesi (New York: Distributed Art Publishers, 2009), 263–65.

42. Max Ernst, "Au-delà de la peinture" (1936), rpt. in *Max Ernst: Oeuvres de 1919 à 1936* (Paris: Éditions "Cahiers d'art," 1937), 42.

43. Gablik, *Magritte*, 110. The letter is dated 19 May 1958; the translation is Gablik's.

44. Maurice Rapin, *Aporismes . . .* (Viry-Châtillon: S.E.D.I.E.P., 1970), 54–55. The letter is dated 22 May 1958.

45. Sylvester, *René Magritte: Catalogue Raisonné*, 3:288.

46. To Alexander Iolas, 4 December 1958, ibid., 289.

47. Fisher, "Entitling," 296.

48. Georges Roque, *Ceci n'est pas un Magritte: Essai sur Magritte et la publicité* (Paris: Flammarion, 1983), 13–14. For some brief, if suggestive remarks on Magritte's commercial work, see also Michel Draguet, "The Treachery of Images: Keys for a Pop Reading of the Work of Magritte," in Barron and Draguet, *Magritte and Contemporary Art*, esp. 29–31.

49. Roque, *Ceci n'est pas un Magritte*, 66, 140, 143–47. Magritte is quoted from a version of "La Ligne de Vie" recorded by Scutenaire, in *Écrits*, 122.

50. Roque, *Ceci n'est pas un Magritte*, 60.

51. Magritte, "La Ligne de Vie" (I); interview with Guy Mertens (1966), in *Écrits*, 110, 636.

52. For a psychoanalytic reading that is also heavily dependent on Magritte's titles, see Ellen Handler Spitz, *Museums of the Mind: Magritte's Labyrinth and Other Essays* (New Haven, CT: Yale University Press, 1994), esp. 44–55.

53. Gohr, *Magritte: Attempting the Impossible*, 168, 145–46.

54. Orban, *Culture of Fragments*, 122–23. Orban's reading is further complicated by the fact that she chooses to interpret what she characterizes as the picture's alternative title, *Le paysage fantasmagorique*, though Sylvester's catalogue raisonné records no time when it was not called *Le paysage fantôme* (1:272).

55. Allmer, *René Magritte: Beyond Painting*, 6–7.

56. I refer to *Magritte and Contemporary Art: The Treachery of Images*, ed. Barron and Draguet (2006), and Gohr, *Magritte: Attempting the Impossible* (2009). The former was also the title of an exhibition on the subject mounted in 2006–7 at the Los Angeles County Museum of Art.

CHAPTER 16 Johns's *No* and the Painted Word

1. The connection between the two painters was a central theme of the exhibit at the LA County Museum mentioned above. I am particularly indebted to Bernstein, "René Magritte and Jasper Johns," 109–23. The count of Johns's collection comes from 123n8; for the two versions of *The Human Condition*, see 114.

2. Abadie, "The Unclassifiable Painting of René Magritte," 18–19; Barron, "Enigma," 10.

3. For the sheet, see Johns's testimony (as originally recorded in 1970) in Emile De Antonio and Maurice Tuchman, *Painters Painting: A Candid History of the Modern Art Scene, 1940–1970* (New York: Abbeville Press, 1984), 97.

4. As Jeffrey Weiss reminds us, not all versions of *Flag* fully conform to the pattern: sometimes a margin remains around the depicted object. Nor does the complete coincidence of painting and thing ever fully pertain to the targets, since the targets themselves remain round ("Painting Bitten by a Man," in Weiss et al., *Jasper Johns: An Allegory of Painting, 1955–1965* [Washington, DC: National Gallery of Art, 2007], 6). Cf. also Roberta Bernstein, who notes that the monochrome targets are particularly dependent on their titles to preserve their status as objects: would we recognize Johns's *Green Target* as such if it were called, say, "Green Circle"? Bernstein, *Jasper Johns' Paintings and Sculptures, 1954–1974: "The Changing Focus of the Eye"* (Ann Arbor: UMI Research Press, 1985), 21.

5. Leo Steinberg, "Jasper Johns: The First Seven Years of His Art," in *Other Criteria: Confrontations with Twentieth-Century Art* (New York: Oxford University Press, 1972), 42. This is a revised and expanded version of a piece originally published in 1962.

6. The Magritte quotation comes from the first line of "Les mots et les images." See fig. 15–4 above.

7. Interview I-2, *Time* (4 May 1959), in *Jasper Johns: Writings, Sketchbook Notes, Interviews*, ed. Kirk Varnedoe (New York: Museum of Modern Art, 1996), 82.

8. Interview I-34, Roberta J. M. Olson (3 November 1977), ibid., 169.

9. See Lillian Tone, "Chronology," in *Jasper Johns: A Retrospective*, ed. Kirk Varnedoe (New York: Museum of Modern Art, 1996), 195: "Before Johns paints *Fool's House* [1961–62], David Hayes introduces him to the writings of Ludwig Wittgenstein. He reads the *Philosophical Investigations* and borrows the *Tractatus Logico Philosophicus* from Hayes. He will later read all of Wittgenstein's published writings, as well as a number of books about the philosopher."

10. Interview I-10, Yoshiaki Tono (spring 1964, published August 1964), in *Jasper Johns: Writings*, 97.

11. Alan R. Solomon, *Jasper Johns* (New York: The Jewish Museum, 1964), 8.

12. Interview I-10, Tono, in *Jasper Johns: Writings*, 98. For an extended discussion of *Flag*'s irresolution in this respect, see Fred Orton, *Figuring Jasper Johns* (Cambridge, MA: Harvard University Press 1994), 131–46.

13. Michael Crichton, *Jasper Johns* (New York: Abrams, 1977), 48. For helpful discussions of this painting, I am particularly indebted to Fisher, *Making and Effacing Art*, 72–75; and Weiss, "Painting Bitten by a Man," 2–5. The fullest and most provocative treatment of related issues in the artist's work is Harry Cooper, "Speak, Painting: Word and Device in Early Johns," *October*, no. 127 (Winter 2009): 49–76.

14. As Fisher wittily observes, "By including so many words within his paintings, Johns has made either a provincial or an imperial decision to—as we could say—paint in English" (*Making and Effacing Art*, 74).

15. Steinberg, "Jasper Johns: The First Seven Years of His Art," 32.

16. Cooper, "Speak, Painting," 53. Cf. also Gary Garrels, "Souvenir," *Jasper Johns: Seeing with the Mind's Eye*, ed. Garrels (San Francisco: San Francisco Museum of Art, 2012), 104.

17. Interview I-49, Ann Hindry (Spring 1989), in *Jasper Johns: Writings*, 228 (ellipsis in original).

18. Mark Rosenthal, "*Dancers on a Plane* and Other Stratagems for Inclusion in the Work of Jasper Johns," in Richard Francis et al., *Dancers on a Plane: Cage, Cunningham, Johns* (New York: Knopf, 1990), 125–27.

19. Johns, "Sketchbook Notes," Book A, p. 49 (1964), in *Jasper Johns: Writings*, 34 (transcribed, 56). Cf. Welchman, who also remarks the significance of this list (*Invisible Colors*, 316).

20. Varnedoe, "Introduction," in *Jasper Johns: Writings*, 13. For Duchamp's influence on the sketchbooks, see Barbara Rose, "Decoys and Doubles: Jasper Johns and the Modernist Mind," *Arts Magazine* 50, no. 9 (May 1976): 71; and Bernstein, *Jasper Johns' Paintings and Sculptures*, 61.

21. Johns, "Sketchbook Notes," S-9, Book A, p. 29 (c. 1963), and S-13, Book A, p. 34 (c. 1963–64), in *Jasper Johns: Writings*, 52, 53.

22. Johns, "Sketchbook Notes," Book A, p. 44 (1964) and p. 54 (1964), ibid., 32, 36 (transcribed, 55, 59).

23. Interview I-10, Tono, ibid., 96.

24. Johns, "Sketchbook Notes," Book A, p. 48 (1964), ibid., 33 (transcribed, 55).

25. Johns, "Sketchbook Notes," Book A, p. 53 (1964), ibid., 35 (transcribed, 58). For "No" in the first *Souvenir*, see Richard S. Field, *Jasper Johns: Prints 1970–1977* (Middletown, CT: Wesleyan University, 1978), 36n44. Field remarks the phonetic play on the Japanese and English in his earlier catalogue, *Jasper Johns: Prints 1960–1970* (New York: Praeger, 1970), n.p.

26. Interview I-11, Yoshiaki Tono (August 1964), in *Jasper Johns: Writings*, 104. Such evidence clearly calls into question Richard Shiff's blanket generalization that "like [Barnett] Newman, Johns settles on the name of a work only after its completion. Titling in advance would limit possibilities" (Shiff, "Metanoid Johns, Johns Metanoid," in James Rondeau and Douglas Druick et al., *Jasper Johns: Gray* [Chicago: Art Institute of Chicago, 2007], 122).

27. Interview I-40, Katrina Martin (December 1980, published 1990); interview I-46 (transcript of 1989 television documentary, *Jasper Johns: Ideas in Paint*), *Jasper Johns: Writings*, 210, 224.

28. Sol Worth, *Studying Visual Communication*, ed. Larry Gross (Philadelphia: University of Pennsylvania Press, 1981), 162–84. See also Ray Jackendoff, *Language, Consciousness, Culture: Essays on Mental Structure* (Cambridge, MA: MIT Press, 2007), 106.

29. For a related discussion of Johns's *No* as a kind of "logical paradox," see Fisher, *Making and Effacing Art*, 85.

30. Crichton, *Jasper Johns*, 27, 15.

31. See, e.g., Field, *Jasper Johns: Prints 1960–1970*, n.p.; Bernstein, *Jasper Johns' Paintings and Sculptures*, 77; Orton, *Figuring Jasper Johns*, 60; Weiss, "Painting Bitten by a Man," 3. Field also hears a possible reference to the Japanese ritual theater, "Noh," while Orton observes that "'no' is 'on' spelt backwards." The fact that the upper left-hand corner of the canvas includes an imprint of Duchamp's *Female Fig Leaf*—a sculpture seemingly cast from female genitalia—may even imply that this *No* includes an oblique reference to the artist's homosexuality. Given Johns's characteristic reticence about his private life, however—especially at this early stage of his career—it seems quite unlikely that any such reading would have been intended for public consumption. As Roberta Bernstein has noted, the shape itself would hardly be recognizable had the artist himself not later identified it ("'Seeing a Thing Can Sometimes Trigger the Mind to Make Another Thing,'" in Varnedoe, *Jasper Johns: A Retrospective*, 44).

32. Cooper, "Speak, Painting," 53.

33. Hoek, *Titres*, 176–78.

34. On Peto and Johns, I am indebted to Bernstein, *Jasper Johns' Paintings and Sculptures*, 87–88; and John Yau, *A Thing among Things: The Art of Jasper Johns* (New York: Distributed Art Publishers, 2008), 83–86. Yau suggests that the doubling of "The" in *4 the News* may also have been inspired by the last line of Wallace Stevens's "The Man on the Dump": "Where was it one first heard of the truth? The the" (83).

35. Hoek, *Titres*, 178.

36. Steven Pinker, *The Stuff of Thought: Language as a Window into Human Nature* (2007; rpt. New York: Viking Penguin, 2008), 332.

37. I refer only to the aspects of the Stroop test most relevant to Johns, but there have

been many variants of the experiment over the years, which even in its original form also sought to test other differences in response times. For the original paper, see J. Ridley Stroop, "Studies of Interference in Serial Verbal Reactions," *Journal of Experimental Psychology* 18 (1935): 643–61. For a useful summary of some later versions, see Arthur R. Jensen and William D. Rohwer, Jr., "The Stroop Color-Word Test: A Review," *Acta Psychologica* 25 (1966): 36–93. I am also indebted to Nelson Goodman, who invokes the test in order to demonstrate the difference between "samples and labels" (*Languages of Art*, 60–62).

38. Though Fisher makes no reference to the Stroop test, he implicitly registers this fact when he observes that "one of the things at risk within all Johns's word paintings has to be seen as the relative weakness of paint compared with words in the contest to attract the attention of the viewer" (*Making and Effacing Art*, 75).

39. A *Scientific American* article of 1971, "Multistability in Perception," for instance, appears to have inspired Johns to adopt several of its optical illusions in subsequent canvases. See Douglas Druick, "Jasper Johns: Gray Matters," in Rondeau and Druick, *Jasper Johns: Gray*, 91.

40. In a related discussion of *False Start*, Druick invokes Wittengenstein's *Philosophical Investigations*: "Could one define the word 'red' by pointing to something that was *not red*?" (ibid., 100). See also Peter Higginson, "Jasper's Non-Dilemma: A Wittgensteinian Approach," *New Lugano Review* 10 (1976): 53–60.

41. David Sylvester, "Jasper Johns 1965," in *Interviews with American Artists* (London: Chatto & Windus, 2001), 163; cf. 158–59.

42. Johns, "Duchamp" (23 December 1960), in *Jasper Johns: Writings*, 21.

43. Interview I-67, Barbaralee Diamonstein Spielvogel (1994), ibid., 298.

44. For Johns's general tendency "to slow perception down," see Kirk Varnedoe, "Fire: Johns's Work as Seen and Used by American Artists," in *Jasper Johns: A Retrospective*, 112.

45. For a useful description, see Yau, *A Thing among Things*, 133–39.

46. Ibid., 66.

47. Carol Mancusi-Ungaro, "A Sum of Corrections," in Weiss et al., *Jasper Johns: An Allegory of Painting*, 259.

48. Interview I-37, Christian Geelhaar (16 October 1978; published 1979), in *Jasper Johns: Writings*, 195.

49. Johns, "Sketchbook Notes," S-39, Book B (c. 1968), ibid., 64.

50. Marjorie Welish, *Signifying Art: Essays on Art after 1960* (Cambridge: Cambridge University Press, 1999), 96; Yau, *A Thing among Things*, 139.

51. Bernstein, *Jasper Johns' Paintings and Sculptures*, 134, 135.

52. Ibid., 135.

53. Esther Levinger, "Jasper Johns' Painted Words," *Visible Language* 23, nos. 2–3 (Spring/Summer 1989): 290–91; Rosenthal, "*Dancers on a Plane* and Other Stratagems," 123–24. For more on sound in Johns, including a lively excursus on the undecidable pronunciation of *The*—"thee" or "thuh"?—see Cooper, "Speak, Painting," esp. 65–76.

54. Weiss, "Painting Bitten by a Man," 49.

55. In the words of one of conceptual art's major theorists: "From the point of view of Art & Language, the more theoretically sophisticated the supporting structure of criticism by which abstract painting and sculpture was upheld in the 1960s, the more the art

in question was reduced to the status of mere demonstration, leaving the writing look-
ing more and more like the effective representational medium.... To paraphrase Mel
Ramsden, 'The time had come, finally, to put the writing on the wall.'" Charles Harri-
son, *Conceptual Art and Painting: Further Essays on Art & Language* (Cambridge, MA:
MIT Press, 2001), 24.

56. Garrett Stewart, *The Look of Reading: Book, Painting, Text* (Chicago: University of
Chicago Press, 2006), 348–49.

57. Joseph Kosuth, "Art as Idea as Idea: An Interview with Jeanne Siegel" (1970), rpt.
in Kosuth, *Art after Philosophy and After: Collected Writings, 1966–1990*, ed. Gabriele
Guercio (Cambridge, MA: MIT Press, 1991), 51.

58. Bruce Ferguson, "Wordsmith: An Interview with Jenny Holzer," *Art in America*
74, no. 12 (December 1986): 111. I am grateful to Welchman, *Invisible Colors*, for di-
recting me to this interview and for his account of Holzer's work (344–45).

59. Joseph Kosuth, "Introductory Note to *Art-Language* by the American Editor"
(1970), rpt. in Kosuth, *Art after Philosophy*, 39.

60. Gregory Battcock, "Painting Is Obsolete," *New York Free Press*, 23 January 1969,
7, rpt. in *Conceptual Art: A Critical Anthology*, ed. Alexander Alberro and Blake Stimson
(Cambridge, MA: MIT Press, 1999), 88–89. Cf. Johns the following year: "A lot of
people have said that painting is dead, but people continue to work; so I don't know
what they are going to call it. They tend to call it painting" (De Antonio and Tuchman,
Painters Painting, 163).

61. Levinger, "Jasper Johns' Painted Words," 291.

62. Johns, Interview I-13, Walter Hopps (March 1965), in *Jasper Johns: Writings*, 108.
Cf. Kosuth in 1969: "All art (after Duchamp) is conceptual (in nature) because art only
exists conceptually ("Art after Philosophy," rpt. in *Art after Philosophy*, 18). For Duch-
amp on "retinal" art, see Pierre Cabanne, *Dialogues with Marcel Duchamp*, trans. Ron
Padgett (New York: Viking, 1971), 39, 43.

63. Johns, "Sketchbook Notes," S-39, Book B (c. 1968), in *Jasper Johns: Writings*, 64.

64. Interview I-14, David Sylvester (June 1965; published 1974), ibid., 121.

65. Interview I-67, Spielvogel, ibid., 298.

INDEX

Works of art and literature are indexed under their creators, with alternative titles in parentheses. Locations of images are given in boldface. For the reader's convenience, first notes to all works cited are included in the index.

Abadie, Daniel, 308n29

Abse, Dannie: "Brueghel in Naples," 107–8, 285n27

abstract expressionism, 122, 144

Académie, 10, 39–49, 56, 127, 178, 270n25, 275n6, 276–77n9; David's relations with, 48, 153, 154–55, 161; displays arranged by, 39–43; engravers in, 277–78n2; Greuze's relations with, 63; minutes of, 42, 46–48, 52–54, 153, 276n6, 277n15, 278n6, 289n37; oath of membership in, 153, 161; reception pieces for, 47, 52, 54, 156, 158; in Rome, 150, 151; rules of, 46–47, 47–48, 277nn16 and 21; Watteau's relations with, 47. *See also* Salon

academies, 13, 39–51, 73, 164–65. *See also* Académie; Royal Academy

Adam, Lambert-Sigisbert, 44

Adam, Paul, 145

Adams, Hazard, 176–77, 268n14, 270n1

Adhémar, Jean, 286n8

Adriani, Giovan Battista, 21

advertisements, 37, 38, 61; and Chardin, 82, 198, 202; and Greuze, 63; and Hogarth, 65, 279n32; and Magritte, 237–39, **238**; of prints, 61, 82, 84, 279n21; for Royal Academy, 49, 277n20; and Turner, 171, 198; and Whistler, 212

Akenside, Mark, 171

Allart, Dominique, 284n6

allegory, 21, 44, 49, 88–89, 116, 129, 131; and Boucher, 124–25, 126; and Courbet, 186, 190–92, 193, 194–95, 199–203, 300nn38 and 41, 301nn61 and 65; and Delacroix, 193–94; and Holman Hunt, 136–37; and Magritte, 232

Allmer, Patricia, 306n3, 307n10, 308n25

Alpers, Svetlana, 280n4

Altick, Richard, 210, 288n20, 289n29, 291n19

Amsterdam, 29

Anderson-Riedel, Susanna, 277–78n2

Anfam, David, 292n8

Angers, David d', 200

Angiviller, comte d', 154

L'année littéraire, 146, 292–93n13

Antwerp, 25, 29, 56, 273n14, 274n26

Apollinaire, Guillaume, 82, 281n29, 282n5

Ariosto, Ludovico, 23

Armengaud, Françoise, 292n11

Armenini, Giovanni Battista, 289n26

Armory Show (New York), 7

Arquié-Bruley, Françoise, 279n29

Art & Language, 3, 312–13n55; *Victorine*, 203, 301n69

Artemidorus: *Oneirocritica*, 307n9

art historians, 9, 12, 81, 102, 105–6, 107, 195

art history, 13, 33, 117, 190, 192, 202, 243

Art-Journal, 219, 288n20

art market, 13, 20, 31, 56, 184, 187, 198, 213, 274n26; British, 31–32, 33–34, 59–60, 157, 275n4; French, 31, 32, 59–60, 275n4, 280–81n19; German, 275n4; Italian, 25, 270n3, 273–74n17; Netherlandish, 25, 28, 29–30, 31, 32, 274nn19, 20, and 26, 275n4; and reproductive prints, 120–21

Artschwager, Richard, 292n10

Art-Union, 138

Astruc, Zacharie: "La fille des îles," 286n6

Athenaeum, 132, 136–37, 137, 217

auction catalogues. *See* catalogues

Auden, W. H: "Musée des Beaux Arts," 97–99, 102–4, 107–9, 284nn5 and 13

Austin, J. L., 151